A BRIEF OVERVIEW WITH HISTORICAL DOCUMENTS AND LISTENING GUIDES

JAZZ BASICS

JAMES E.
SHEARER

Kendall Hunt
publishing company

www.kendallhunt.com
Send all inquiries to:
4050 Westmark Drive
Dubuque, IA 52004-1840

Copyright © 2002, 2006, 2011, 2017 by Kendall Hunt Publishing Company

Text + website ISBN 978-1-5249-9662-8
Text ISBN 978-1-5249-9664-2

Printed in the United States of America

Contents

Listening Guides and Spotify Playlist Location

Foreword

I have known Jim Shearer for over thirty years and have had the pleasure of working with him for the past twenty-five. One of the best descriptors for Dr. Shearer is "passion." He has a passion for performance, a passion for students, a passion for music, and a passion to bring all of these together. As academic department head of music at New Mexico State University, I had the opportunity to read students' reviews and evaluations of their music classes. They saw and talked about Dr. Shearer's passion as they commented on his Introduction of Jazz music appreciation course. He had to cut back on his teaching load in order to write this book, and once students learned that he was not going to teach a particular section of an honors course, enrollment dropped by half!

It is with this same passion that Dr. Shearer has created *Jazz Basics*. One of the most difficult tasks of teaching is deciding what to leave out. I think Dr. Shearer has captured the essentials needed to bring new jazz lovers into the fold. Music appreciation courses must be academically rigorous in a manner that builds our future audience. *Jazz Basics* offers the perfect balance of Dr. Shearer's commentary, historical documents, and listening excerpts. He gives students a unique opportunity to visit those who made jazz history through their writings as well as recordings. This is an outstanding addition to the available literature on jazz and a book I hope will find a permanent place in your personal library.

Greg Fant, Ph.D.
Associate Vice President and Deputy Provost
(former Music Academic Department Head)
New Mexico State University

Preface

The purpose of creating this book is to offer students with little or no background in the history of jazz a window into this very special style of music. This is truly a "basic" text. It has been intentionally written with very few complex musical terms, and all musical terms that are used are clearly defined. The use of specific dates has been kept to a minimum, with general style periods being grouped together by chapter. As much as was practical, artists' careers have been presented within the scope of one chapter even though their lives in the music business frequently spanned many decades. The two big exceptions to the previous statement are Miles Davis and John Coltrane, who were both highly creative in several different jazz styles. Students are encouraged to join in the discovery of a musical world that is rich in tradition and history but also remains a viable and highly creative art form for the world of today. Most importantly, remember that you don't have to like every style of music you hear as you study the artists in this book—you just have to give them a fair chance.

The following examples point out a few of the unique features found in *Jazz Basics: A Brief Overview with Historical Documents and Listening Guides*.

- Many chapters offer extended reading passages written by the artists who helped create the language of jazz, as well as noted historians and music critics who have contributed to the general body of jazz scholarship.

- Each chapter contains reproductions of numerous historical photographs and period print media advertisements. Many of these are being seen in print for the first time since their original publication.

- Those who purchase new copies of this book will have access to excellent music via Spotify, an Internet streaming-on-demand website. Each chapter features its own playlist, and every track is accompanied by a detailed listening guide. Together, they will help you explore over six hours of the greatest jazz ever recorded. In addition, if you've purchased a new copy, you will have access to web-only extras on the publisher's website.

- All important terms and concepts are presented in boldface. Wide outside margins also contain guide terms to help students quickly locate a specific term or concept. Information boxes titled *Dig Deeper* are located throughout the text in the margins. These boxes offer suggestions for great recordings, documentaries, films, and books that will help students more fully explore an artist or topic of particular interest. These wide margins also allow space for quick notes at any given point of interest.

- Each chapter contains a study guide that may be extracted from the text without the loss of other important book materials. These guides may be used by the student to prepare for an exam, by the professor as graded homework, or in any combination of the two during the semester.

- Useful appendices that direct new jazz fans to major jazz clubs, festivals, websites, and recordings are included at the end of the text.

It is the author's sincere hope that you find this a useful, engaging, and informative textbook. Comments and suggestions for improvement are both welcomed and sincerely appreciated. Please feel free to communicate with the author at the following e-mail address: jshearer@nmsu.edu.

Acknowledgments

My sincere thanks to the faculty, staff, and students of New Mexico State University for their kind assistance and patience during the creation of this textbook. Special thanks to NMSU Music Department Chairman Dr. Greg Fant for helping me secure classroom release time and to Sam Hollomon, Janet Loman, and Shelly Stovall for changing their teaching schedules to help cover my classes. Thanks also to my students in the NMSU euphonium and tuba studio for willingly rescheduling lessons, putting up with the phone ringing during their lessons, and for taking lessons week after week in a very messy office! NMSU teaching assistant Shanelle Jernigan offered a great deal of help in creating the study guides found at the end of each chapter, and music education major Daniel Hale helped with the microfiche research to locate a number of the period advertisements found throughout the book.

Thanks also to the many authors and teachers who helped inspire the creation of this textbook. While a list of this group is far too long to mention everyone by name, I feel I must single a few people out for special recognition. The use of much of the historical text found in this book was inspired by the fine book *Keeping Time*, compiled by Robert Walser. In addition, the books *Jazz Styles* by Mark Gridley and *The Complete Idiot's Guide to Jazz* by Alan Axelrod served as launching points for the development of this text. Thanks to noted jazz scholar Dan Morgenstern and the fine staff from the Institute of Jazz Studies at Rutgers University for their kind research assistance. Thanks are also due to my professors at the Eastman School of Music, Drs. Jonathan Baldo, Truman Bullard, Kim Kowalke, Ralph Locke, and Alfred Mann. All of these fine men did the best they could to make a writer out of me, and any failings in this area rest solely with me.

Unending love and gratitude goes to my wife, Celeste, for putting up with months of research and writing. She was also a great sounding board during the editing process, offering many useful suggestions and corrections. She was the first person to read every portion of the manuscript, and I can assure you she saved all the other editors on this project a great deal of time. Very special thanks to my parents, Ed and Betty Shearer, for their kind assistance during the editing process. As owners of Herald Publishers, Inc., they brought more than 100 years of collective writing and editing experience to the editing process of this book. NMSU Special Events Coordinator Bobbie Welch was also kind enough to read the manuscript and offer a number of very helpful suggestions and corrections.

Thanks to Dr. Allan Kaplan for access to his extensive collection of books and recordings and for reading early versions of the text. Thanks to Bob Burns for his support during the writing process and to Bob Foskett for access to his unpublished photographs. Photographer and computer artist Mike Laurence was his usual indispensable self, and, as always, a life saver.

In preparing the revision of this book, I returned to the Institute of Jazz Studies at Rutgers. Many of the new images you see in this version of the book were made possible by the kind assistance of Tad Hershorn. Although he was quite busy during my visit, Tad was always willing to drop whatever he was working on to give me access to some of the delicate archives at IJS. The scans of rare material

you will see throughout the book are a direct result of his generosity. I'd also like to thank Michael Cogswell, Director of the Louis Armstrong Archives at Queens College, for his help in acquiring all of the new Armstrong material in this revision. The book is much better for all of these additions. Finally, thanks to Dr. T. J. Ray for his willingness to help in the editing process of this revision.

My sincere thanks to everyone at Kendall/Hunt Publishing. From talking me into writing this book in the first place, to helping create the document and clearing the permissions to a number of photos, recordings and articles, these fine people have been extremely helpful and supportive. I never could have (or would have) done it without them.

This book is dedicated to jazz musicians around the world in search of an audience and to the students using this book who are their potential new fans. Let's all get together soon.

A Note about the Listening Guides, Spotify Access, and Other Online Materials

Throughout this text you will find detailed listening guides that correspond with musical selections in chapter playlists on Spotify.com. In addition, you'll find the respective Spotify tracks embedded directly into the HTML online version of this textbook, which comes free with purchase of the print book or is available for separate "online access only" purchase. In previous editions of this book, legal access to listening materials was bundled with the purchase of each new workbook in print and online versions. With the shift to using Spotify.com for access to listening materials, it is now the responsibility of each student to provide legal listening access to all required materials. This was done because most students already have legal access to the Spotify website, and the change to Spotify helps lower the cost of the workbook.

As you explore the world of recorded jazz, you will find that there are many performances of the same tune, often featuring the same artists. The recordings selected for use in this text are typically the first recording of a given piece, or, in a few cases, simply the most famous. Every listening guide in this book was created to accompany a specific recording, and all the recordings are conveniently gathered together for you in Spotify playlists that go along with each chapter of the book and, again, are also embedded into the HTML version of the text. The time codes, and often the general information about the music, will not match up with alternate recordings. Having said that, by all means explore other recordings of the same tune when you have the time. The differences between each improvised performance are what make jazz so special. It should also be noted that not all computers, smartphones, and other playback devices agree to the exact millisecond regarding time codes. Your player may be off from the printed time codes in the listening guides by as much as two or three seconds, but never more than that. You should also keep in mind that some clearly identifiable events in music can happen in much less than a single second. The printed time code may say "3:46" when the event really happens at "3:45:55."

Chapter 1

Basic Elements of Jazz

What is Jazz? It's almost like asking, "What is French?" Jazz is a musical language.
It's a musical dialect that actually embodies the spirit of America.

Branford Marsalis

Scholars have been arguing for centuries about the true definition of music. It's a very complicated discussion that centers around aesthetics, culture, and personal beliefs. So let's not even try for a working definition. You know what music is. You hear it every day. It's an integral part of your life from the time you wake up until the time you go to bed. Music just is … and really, that's all it needs to be.

One thing to keep in mind is that music is really just another language—another way for humans to communicate. The difference is that unlike other languages you don't need full use of the vocabulary to get a pretty good understanding of what is being said. Music, however, tends to function on many different levels. Peel away the outer layer and there is often more being said emotionally than meets the eye (or ear). In jazz there is obviously communication between the musicians and the audience, but dig inside the performance a bit and you will find there is a great deal of musical conversation or "back-and-forth" between the musicians themselves.

Here is some very basic music terminology to help you start digging a little deeper into the music. You don't have to know how to read music to apply any of this information to your experiences with jazz. In fact, about

PROF. RICE'S RAPID SYSTEM SELF TEACHING

RICE'S TEACHING ATTACHMENT

Music Self=Taught
PIANO, ORGAN, GUITAR AND VOICE.

Anyone can learn all **TUNES, NOTES, CHORDS, ACCOMPANIMENTS** and the **LAWS OF HARMONY** in a surprisingly short time. It is the **cheapest, easiest,** most rapid and correct way on earth to learn music. Over 40,000 strongest kind of testimonials received. Goes to the bottom of music—makes it clear to the beginner; creates a fondness for music because you succeed from the start. A few days practice and you play perfect **Accompaniments in all Keys.** We send our **Circulars free.** Write for them. You will be surprised to know what a marvelously complete music teacher this is. Worth hundreds of dollars to any one interested in **Music. 10 Lessons 10 cts.**
Address at once,

G. S. RICE MUSIC CO.,
241 Wabash Ave., - Chicago, Ill.

Prior to 1900, light classical music was very popular in American homes. Most middle- and upper-class homes had a piano in the front parlor, and it was considered a good pastime (especially for young women) to play piano or learn to sing. One of the best ways to make money in the music business at this time was to write or arrange sheet music that was sold to the amateur musician. When ragtime came around, it became extremely popular in this marketplace.

© 2002 www.arttoday.com

the only thing you really need to master is a new way of counting to four. With an attentive ear and some repeated listening to the same material, you should begin to hear *inside* the music. For musicians, this is where the really good stuff is. Yes, it is a little more complex than just humming along with the melody of a tune, but you may also find your listening experiences a lot more enjoyable as you dive inside the music.

Some Basic Jazz Terminology

Most music textbooks go into great depth about all the basic elements of music, with numerous complex terms and concepts many musicians don't really understand. Usually buried somewhere in these discussions are the terms "consonance" and "dissonance." These two basic elements are the core answer to the question of how music functions. Here are two simple definitions for you: **Consonance** - tones at rest. **Dissonance** - tones that need to be resolved. Almost all music is based on the contrast of movement between dissonance and consonance—similar to the basic concept of how drama and literature function, we create musical tension (dissonance) and then resolve it (consonance).

Dealing with consonance and dissonance means dealing with the movement of harmony or "chords." **Chords** are groups of notes that sound consonant or dissonant when played together. They can be played by one instrument such as a piano or guitar, or by a group of instruments including trumpets, saxophones, and trombones. A consonant chord is pretty stable. It either is or it isn't. Dissonant chords are a bit more complex, as there is a whole sound spectrum from mildly dissonant all the way up to sounding like you put a set of bagpipes through a limb shredder.

Let's focus on three big "building block" chords. These three chords are found in almost every piece of popular music ever written. Most obviously, they make up the basic structure of the blues. Think of them in terms of the various parts of a sentence you might study in English class.

- **Tonic** (I chord) - Home base. A consonant chord. Similar to the subject in a sentence and is the main focus of most pieces of music

- **Dominant** (V chord) - A dissonant chord. Similar to the verb in a sentence and is the action chord

- **Sub-dominant** (IV chord) - Also a dissonant chord but less dissonant than the dominant. Similar to a helping verb in a sentence and modifies the dominant

We'll get back to those chords in just a second, but first you need to learn about finding the **basic beat** in a piece of music. Finding the basic pulse of the music and counting along is the best way to figure out the structure of a piece. In music, we group sets of the basic beat together in something called a **measure** (or **bar**). To keep track of the measure groupings as they pass by, count like this: 1,2,3,4; 2,2,3,4; 3,2,3,4; 4,2,3,4; etc. Now, while groupings of four beats-per-measure are most common, we can also have groups of three: 1,2,3; 2,2,3; 3,2,3; as in a waltz; and groups of two: 1,2; 2,2; 3,2; 4,2; as in a march or ragtime piece.

Group those building block chords together with a certain basic-beat pattern and you've got the formula for thousands of songs. This format is called the **12-bar blues**. At the top of the next page is a chart with the beat numbers and the different bars marked for you in groups of four beats-per-measure. Also included are the chord symbols to show you where the consonance and dissonance occurs in the structure. The lyrics are from the *St. Louis Blues* by W. C. Handy.

consonance
dissonance

chords

tonic

dominant

sub-dominant

basic beat

measure (or **bar**)

12-bar blues

Dig Deeper
WEBSITE

www.musictheory.net

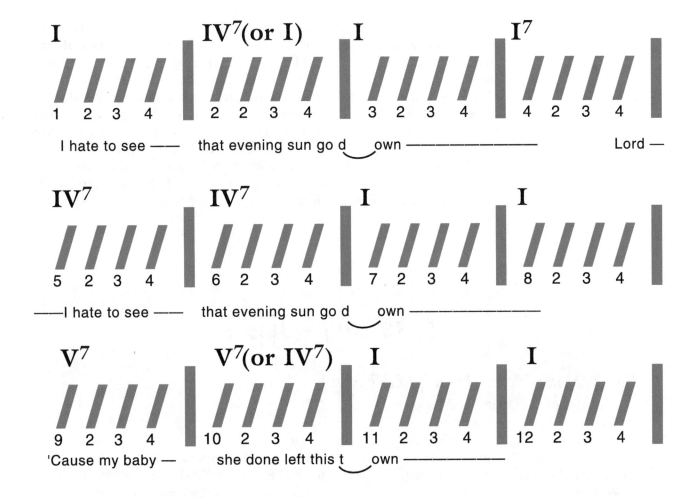

Now within the basic 12-bar blues pattern there can be a number of variations to the chord structure, as demonstrated above, but they all really work the same way. Here's a little list of tunes that use the blues as their basic structure.

West End Blues - Louis Armstrong
C Jam Blues - Duke Ellington
Billie's Bounce - Charlie Parker
Blue Monk - Thelonious Monk
All Blues - Miles Davis
Blue Train - John Coltrane
West Coast Blues - Wes Montgomery
Broadway Blues - Ornette Coleman
Rock Around the Clock - Bill Haley and the Comets
Maybellene - Chuck Berry
Hound Dog - Elvis Presley
Yer Blues (White Album) - Beatles
Little Wing - Jimi Hendrix
Ball and Chain - Janis Joplin
Cocaine - Eric Clapton
Cold Shot - Stevie Ray Vaughn
Bad to the Bone - George Thorogood

On your Spotify playlists, there are a number of examples of the blues drawn from many different musical contexts. To hear a couple of early recorded blues examples, listen to Blind Lemon Jefferson sing *Black Snake Moan* and Bessie Smith sing her version of the *St. Louis Blues*. With the *Black Snake Moan*, you will immediately notice that the previous counting example doesn't work so well, as Jefferson keeps altering the structure. The repeated material works the same, but he is not too concerned with keeping an even twelve measures to every chorus. The other tunes on your Spotify playlists that use the blues as a basic structure include *Dippermouth Blues*, *West End Blues*, *Back O' Town Blues*, *Creole Love Call*, *Main Stem*, *Every Day I Have the Blues*, *In the Mood*, *Bloomdido*, *Misterioso*, *Better Git It In Your Soul*, and *Cookin' at the Continental*.

Listening Guide

Black Snake Moan (Huddie Ledbetter)

Example of early blues style
Recorded ca. June 1926
Performed by Blind Lemon Jefferson, vocal and guitar
Blind Lemon Jefferson sings in more of a country blues style. His treatment of the 12-bar blues pattern is rather loose in that he follows the basic blues lyric format of A-A-B, but rhythmically he is not at all strict with the counting. Listen carefully to how he bends notes as he sings them. As we move through the text, you will notice that many great jazz players imitate that singing style on their instruments.
Total time: 3:03

:00	Guitar introduction.
:12	I ain't got no mama now, I ain't got no mama now, She told me late last night, "you don't need no mama no how."
:40	Um, black snake crawlin' in my room, Um, black snake crawlin' in my room, And some pretty mama had better come and get this black snake soon.
1:08	Oww, that must've been a bed bug, you know a chinch can't bite that hard, Oww, that must've been a bed bug, you know a chinch can't bite that hard, Asked my baby for fifty cents, she said, "Lemon ain't a child in the yard."
1:39	Mama that's alright, Mama that's alright for you, Mama that's alright, Mama that's alright for you, Say baby that's alright, holding me the way you do.
2:06	Um, what's the matter now? Um, honey what's the matter now? Tell me what's the matter, baby, I don't like no black snake no how.
2:32	Well, I wonder why this black snake's gone, Well, I wonder why this black snake's gone, Lord, that black snake, Mama, done run my darlin' home.

Listening Guide

St. Louis Blues (W. C. Handy)

Example of the blues, call and response, and improvisation
Recorded January 14, 1925
Performed by Bessie Smith, vocal; Louis Armstrong, cornet; and Fred Longshaw, organ

Written by W. C. Handy, the "father" of the blues, this song represents a more formal blues structure that was frequently used in the jazz world. It contains the typical 12-bar blues pattern for the chorus but also has a verse that makes use of a different melody and series of chords. In this particular tune, the verse is 16 measures long. Notice again how the singer, Bessie Smith, bends into and out of certain notes. Notice also that Louis Armstrong copies that vocal style on his instrument. This recording is an excellent example of call and response, as this performance is very much a musical conversation between the singer and the cornet player. In jazz, this technique is sometimes referred to as "dressing the windows."

Total time: 3:08

:00		Dominant chord (V^7) used as introduction.
:04	1st chorus:	I hate to see the evening sun go down …
:49	2nd chorus:	Feelin' tomorrow like I feel today …
1:33	Verse:	St. Louie woman, with all her diamond rings …
2:28	3rd chorus:	I got them St. Louie blues, just as blue as I can be …
		(Note altered melody in this chorus.)

Another popular formal structure used in jazz is the **32-bar (A-A-B-A) song form**. This form is divided into four symmetrical groups of eight measures each. (How about that cool math stuff?) The first eight bars are simply called letter A. Then we repeat that group of eight bars for a total of 16. Next, we have a new melody with a different set of chord changes for the third group of eight, which we call the bridge, the release, or simply letter B. Finally, we have yet another statement of the first eight-bar melody and chords, usually with some minor alterations to make the dissonance and consonance work out just right. This all looks kind of complicated when you read about it, but after you hear a few songs in this format, you'll start to pick out the different parts of the song with ease. The important thing to remember is to count the measures as they go by the way you learned on the previous page. Here are some songs that make use of the 32-bar (A-A-B-A) song form.

32-bar (A-A-B-A) song form

I've Got Rhythm - Every Jazz Player in the World
Ain't Misbehavin' - Fats Waller/Louis Armstrong
Take the "A" Train - Duke Ellington
Somewhere Over the Rainbow - Judy Garland
Anthropology - Charlie Parker and Dizzy Gillespie
Boplicity - Miles Davis
The Bridge - Sonny Rollins

rhythm
tempo

syncopation

Perhaps the most popular format for music today is the verse/chorus format. For example, a song might have a 16-measure verse, followed by a 16-measure chorus. You already know how this one works. When you're singing along with a song on the radio as you drive down the road, the chorus is the part that has the same words every time, as opposed to those other stupid words that you can never remember. Jazz tunes frequently use this format as well, but in jazz we tend to focus on the structure of the chorus, which is the part we like to improvise over.

In addition to these three forms, jazz makes use of many other formal structures. They all have different formats, but they all function basically the same as the three you just learned about. Count the measures, follow the melody, listen for symmetry in the phrases, and you'll quickly pick up what's going on in just about any tune you listen to. As an added bonus, this also works with just about any style of popular music. Try counting along with your current favorite. There really is a repetitive structure there. Music isn't just voodoo magic. We really do have a plan.

Here are a few more basic music terms you will run across in the course of learning about jazz. First up is "rhythm." **Rhythm** includes the basic beat and everything the musicians play in a given "tempo." **Tempo** is simply how fast or slow a piece of music is. For jazz in particular, you really must get behind the rhythmic concept of "syncopation." Technically, syncopation just means a polyrhythm, or two or more different rhythms grinding against one another. In jazz, however, **syncopation** is an essential rhythmic component that gives jazz its unique feel. It functions at its most simple level by "placing an accent on a normally weak beat or

Listening Guide

Two Manyanga Drum Rhythms

Example of syncopation and polyrhythms
Recorded by Alan Lomax in Mwanza, Tanganyika
Performed by Husuni Isike, Salumu Athman, and Ramadhani Knuluwa

In this performance, you can get a real sense of where the concept of syncopation originated. This recording, which features two separate performances on one continuous track, demonstrates how a group of drummers in African culture establish a beat pattern and then play endless variations on top of that basic beat. In particular, notice how after the first drummer establishes the basic beat, each subsequent entrance is improvised with constantly changing rhythmic ideas. This rhythmic style of syncopation and the freedom to embellish went on to play major roles in the development of jazz.

Total time: 2:43

First Recorded Example
- :00 1st drum enters, establishes basic beat.
- :03 2nd drum enters, establishes contrasting pattern.
- :07 3rd drum enters, establishes another contrasting rhythm.
- :12 Explorations of syncopated patterns continue to the end of the example.
- 1:20 Conclusion of first recorded example.

Second Recorded Example
- 1:23 1st drum enters, establishes basic beat.
- 1:25 2nd drum enters, establishes contrasting pattern.
- 1:29 3rd drum enters, establishes another contrasting rhythm.
- 1:33 Explorations of syncopated patterns continue to the end of the example.
- 1:53 Bells enter.
- 2:16 Bells stop.
- 2:41 Conclusion of second recorded example.

on a normally unaccented part of a beat."[1] To hear a great example of syncopation, listen to a track on your Spotify playlist titled *Manyanga Drum Rhythm*.

How a Jazz Band Works

The real key to understanding how jazz works is to understand the concept of "improvisation." Perhaps the most concise definition of **improvisation** is "spontaneous composition." **Embellishment** is simply adding extra rhythms and/or notes to an existing musical texture. Listen to the tune *Early in the Mornin'* on Spotify. In this performace, everyone is singing the same basic melodic shape at the same time, but no one performs the song exactly the same as his neighbor. Eventually, this leads us right to jazz, where we take the prearranged structure of a given tune and we improvise (make up) a new melody on top of the rhythm and harmony of the original song.

improvisation
embellishment

Listening Guide

Early in the Mornin'

Example of embellishment
Recorded by Alan Lomax at Parchman State Penal Farm, Mississippi, late 1940s
Performed by "22," Little Red, Tangle Eye, and Hard Hair, accompanied by double cutting axes
This work song uses a verse/chorus format with repeated lines of text. Each man sings the same basic melodic shapes and approximately the same text. Notice that no two men sing the song exactly the same way. This freedom to embellish is a musical style that came directly from Africa. Notice also how the rhythm of the work being accomplished drives the rhythm of the music, and, conversely, that the spirit of the music seems to spur on the pace of the work.
Total time: 4:38

:00	1st Verse:	Well, it's early in the morn –in the morning, baby
		When I rise, Lordy mama . . . (etc.)
:43	Chorus:	Well-a, it's-a, Lordy,
		Ro-Lordy-Berta,
		Well, it's Lord (you keep a-talkin'), babe,
		Well, it's Lord, Ro-Lordy-Rosie,
		Well, it's, o Lord, Gal, well-a.
:57	2nd verse:	Well-a, whosoever told it, That he told a- he told a dirty lie, babe.
		Well-a, whosoever told it, that he told a -he told a dirty lie, well-a . . . (etc.)
1:39	Chorus:	Well-a, it's-a, Lordy,
		Ro-Lordy-Berta,
		Well, it's Lord (you keep a-talkin'), babe,
		Well, it's Lord, Ro-Lordy-Rosie,
		Well, it's, o Lord, Gal, well-a.
1:52	3rd verse:	Well-rocks 'n gravel make -a
		Make a solid road . . . (etc.)
2:34	Chorus:	(Same as above with slight variations)
2:48	4th verse:	Boys, the peckerwood a-peckin' on the-
		On the schoolhouse door, sugar. . . (etc.)
3:29	Chorus:	(Same as above with slight variations)
3:43	5th verse:	Well, hain't been to Georgia, boys,
		but, Well, it's I been told, sugar. . . (etc.)

rhythm section

front line

collective
improvisation

solo improvisation

Most jazz groups use the basic format of front-line instruments and a rhythm section. As we trace the history of jazz, you will see that the basic set-up of the bands will change, but usually the main solo players will be supported by some type of rhythm section. The typical **rhythm section** includes a piano for filling in the harmony, a string bass for playing the bass notes of the harmony and for driving home the basic beat, and a drum set for helping keep time and adding rhythmic color. The **front-line** instruments include any of the solo-type instruments such as clarinet, saxophone, trumpet, and/ or trombone. The front-line players tend to do more of the solo (improvised) playing, and they usually start and end the tune by playing (or sometimes playing around) the melody.

Both the front line and the rhythm section can take part in two types of improvisation. The early jazz bands all played something called **collective improvisation**, in which all the members of the band improvised their musical or rhythmic lines at the same time. Later, jazz groups started to make more use of **solo improvisation**, in which one player breaks away from the entire group improvisation but continues to be supported by some or all of the rhythm section. Solo improvisations tend to allow the lead improviser more freedom, which has become the preferred method for most jazz players. Listening to jazz performances will make very clear to your ear how these two types of improvisation function.

A Few Thoughts on the Art of Active Listening

In general, people today tend to be passive listeners. Music is often playing in the background, but we don't really notice it. Tunes in the car, movie and TV soundtracks, music in the elevator and at the mall: all are examples of how music constantly surrounds us. In order to really get into jazz as an art form, you will need to become an active listener. First, you have to get into the song being played, and then you have to focus on how each musician improvises on the original tune. This is the thing that can make jazz so great—it never happens the same way twice. These constant variations on a theme, however, are sometimes the very thing that can turn people away from jazz. The continuous evolution of a song becomes overwhelming for people who aren't really connected with what the musicians are trying to say through their music. Here are some things to keep in mind as you begin (or continue) your journey in the world of jazz.

1. One time through the tune is not enough. The better you know the original tune and understand the basic structure, the more you will get out of the improvisations. If the tune has lyrics, it also doesn't hurt to sing along every once in a while. As you are singing along with the words and melody, listen to how the jazz musician improvises over the top of that structure.

2. Listen "down" into the band. Don't just follow what the melody or improvised solo is doing. At its best, jazz is really a musical conversation between the musicians on stage. What one player does on stage can have a great impact on what musical direction the other players take.

3. Try to keep the original melody in your head as you listen to the improvisation. Over time, this will become almost second nature as you will begin to "feel" the internal structure of the tune as it passes by. I know you might not really believe that statement as you read this, but trust me, it will come to you as if in a dream. Really.

Well, that's about it for the basics of how this music functions. You're ready to become the world's biggest jazz fan, and believe me, the world needs more jazz fans. In many ways, this music is America's greatest contribution to the artistic world. If nothing else, jazz is certainly one of the most unique artistic forms ever created. Before you dive into the history of jazz, consider this article written by Dr. Billy Taylor. One of the finest jazz pianists in the business, Dr. Taylor was also a great supporter of jazz education. In this article, he makes a very strong case for jazz as America's classical music. Read this article and see if you agree with him.

Dig Deeper
DOCUMENTARY

Jazz, a nine-part documentary by Ken Burns (PBS DVD Video)

J azz: America's Classical Music by Dr. Billy Taylor

Jazz is America's Classical Music. It is both a way of spontaneously composing music and a repertoire, which has resulted from the musical language developed by improvising artists. Though it is often fun to play, jazz is *very serious* music. As an important musical language, it has developed steadily from a single expression of the consciousness of *black* people into a *national* music that expresses American ideals and attitudes to Americans and to people from other cultures all around the world.

As a classical music, jazz has served as a model for other kinds of music; its influence is international in scope. It is studied, analyzed, documented, and imitated in India, Thailand, Finland, Sweden, Denmark, Holland, France, Belgium, Great Britain, Cuba and Japan. It is even studied and performed in Russia, Poland, Hungary, and other Iron Curtain countries. This last fact is most important because it is an indication of how jazz is used as a political statement—in a typical jazz performance each individual performer contributes his or her personal musical perspective and thereby

Pianist and jazz educator Dr. Billy Taylor.
Courtesy of Billy Taylor

graphically demonstrates the democratic process at work. There is no conductor directing the musical flow, but rather, the interaction of individuals combining their talents to make a unique musical statement.

Jazz is simple, complex, relaxed, and intense. It embodies a bold tradition of constantly emerging musical forms and directions. Jazz has developed its own standards of form, complexity, literacy, and excellence. It has also developed a repertoire, which codifies and defines its many varied styles—and its styles are really varied. There is a style of jazz which sounds like European classical music (i.e., the Modern Jazz Quartet); there is a style of jazz that sounds like Latin American Music (i.e., Eddie Palmieri, Machito, and Mongo Santamaria); there is a style of jazz which sounds like East Indian classical music (i.e., Mahavishnu, John Mayer/Joe Harriott). There are styles of jazz which sound like various other kinds of music heard in this country and elsewhere in the world.

Americans of African descent, in producing music which expressed themselves, not only developed a new musical vocabulary, they created a *classical* music—an authentic *American* music which articulated uniquely American feelings and thoughts, which eventually came to transcend ethnic boundaries.

This classical music defines the national character and the national culture. In one sense it serves as a musical mirror, reflecting who and what Americans were in their own view at different points in their development. Thoughts of the 1920s, for example, evoke memories of people dancing to the tune "Charleston," composed by jazz pianist James P. Johnson, *and* of folks from downtown going uptown to the Cotton Club in Harlem to hear Duke Ellington play "It Don't Mean a Thing if It Ain't Got That Swing." And thoughts of the 1930s remind us of the way Americans and others danced to the music of the great swing bands. You can pick your favorites—mine were Chick Webb, Benny Goodman, Artie Shaw, Jimmie Lunceford, and of course Count Basie. No matter when or where it is composed or performed, from the "good old days" to the present, jazz, our ubiquitous American music, speaks to and for each generation—especially the generation that creates it.

The jazz of today certainly underscores this point—it speaks to and for the contemporary generation. The work of Wynton Marsalis, Stanley Jordan, Paquito D'Rivera, Emily Remler, Jane Ira Bloom, Tiger Okoshi, Chico Freeman, Branford Marsalis, and Kenny Kirkland provide excellent examples of what I am speaking of in this regard. Their music and the music of many older musicians like Chick Corea, Herbie Hancock, Freddie Hubbard, Toshiko Akiyoshi, Bobby Hutcherson, and Kenny Barron are relevant to the moods and tempo of today's life. Their music expresses—in its melodies, rhythms and harmonies—feelings and emotions which people, regardless of their cultural and ethnic backgrounds, can understand and appreciate. Jazz, America's classical music, has indeed become multi-ethnic and multi-national in usage.

Let's examine this unique American phenomenon a little more closely. Black-American music, from the very beginning of its development in this country, incorporated elements from other musical traditions, yet it has retained its own identity throughout its history. Though jazz has utilized and restructured materials from many other musical traditions, its basic elements were derived from traditions and aesthetics which were non-European in origin and concept. It is an indigenous *American* music whose roots and value systems are *African*. Its basic rhythmic traditions are found throughout the African continent.

In the African tradition there were *no onlookers*, everyone was a participant in creating rhythm and responding to it. This adherence to African rhythmic practices made it easier for people to participate on their own level. They could play an instrument, dance, sing, clap their hands, stomp their feet, or combine these with other rhythmic methods of self-expression such as shaking or rattling makeshift instruments. Rhythm was fundamental in the African musical tradition and has remained so in jazz. It is interesting to note that when the use of African drums was banned by the slaveholders, all of those drums-inspired rhythms were incorporated into melodies which projected similar feelings and other rhythmic devices were substituted (i.e., Hambone, pattin' juba, etc.).

The basic elements of jazz can be found in the work songs, spirituals and other early forms of music created by slaves. When the blacks were brought to this country, they were forced to quickly adapt to new languages, strange new customs, new religious practices, and the cultural preferences of the slave owners. They were only allowed to retain those cultural traditions which in the opinion of the slave masters made them *better* slaves. Since African culture was considered inferior to European culture, it was systematically and deliberately destroyed by Americans engaged in the slave trade. Tribes and families were broken up on the auction block, and many slaves found themselves living and working with people whose language and customs they did not understand.

Since music had always played such an important part in the daily life of so many Africans, despite the fact that they belonged to different nations and had different backgrounds, it was quickly seized upon as a tool by the slaves to be used for communication and as relief from both physical and spiritual burdens. In the African societies they had come from, there was music for working, playing, hunting, and most daily activities. There was also music for important events, such as births, initiation rites, marriages, and much, much more. For those Africans, music had many uses; its rhythms and melodies were an integral part of whatever they did.

People who came to this country as free people brought with them the songs, customs, and attitudes of the various places of their origin. They also brought musical instruments and other artifacts with them. They were transplanted people, free to express themselves in ways which were traditional to them, so they were able to sustain and maintain their musical heritage without external need to change.

The transplanted Africans who were enslaved did not have the same freedom to maintain their cultural identity, so their musical traditions had to change. As they endured slavery, they were obliged to reshape and redefine work songs, religious music, leisure songs, dance music and other traditional African music to make that music useful in new situations. They also created new forms of musical expression when some of the old forms no longer satisfied their needs. In Africa, music had been used to accompany and define all the activities of life, so the slaves used well-established techniques to restructure the music they needed for survival tools in the hostile atmosphere of the "land of the free."

African-Americans endured indescribable hardships while they were surviving slavery and other forms of racism in America, but by retaining the cultural supports that worked and by restructuring or discarding those that did not, black Americans created something of

beauty from the ugliest of situations— human bondage. They created a new idiom—Afro-American music. This new music was the trunk of the tree from which another truly American music would grow—a classical music in every sense of the word—jazz. Classical music must be time tested, it must serve as a standard or model, it must have established value, and it must be indigenous to the culture for which it speaks. Jazz meets the criteria by which classical music is judged.

The syntax, semantics, and kinesthetics of jazz are American, and its attitudes reflect prevalent American viewpoints. The gradual changes which that syntax has undergone show a consistent process of developing a unique musical expression. This can be examined and analyzed in the same manner that one can examine and analyze the syntax and forms of other classical styles of music. One can study both the written scores and phonograph recordings of the jazz repertoire and the work of the artists who epitomize the chronological and historically-important styles of the music.

The semantics of jazz convey thoughts, impressions, and feelings which are relevant to generations of Americans through implicit and connotative musical symbols. Americans share an understanding of the emotional connotations of jazz which is based on an Afro-American value system, but the *interpretation* of the musical symbols varies a great deal because the music has transcended ethnic boundaries and reflects and defines the national character as well as the national culture. Pianists Chick Corea and Herbie Hancock have different priorities when they write and play jazz, yet their playing is very compatible when they improvise together in a twin-piano setting.

The kinesthetics or physical movements of jazz are important, but often underestimated, factors in the production of the music. Since jazz is a way of playing music as well as a repertoire, these factors must be considered in any discussion of its characteristics. The physiological aspects of jazz rhythms and tone production supply the music with many of its unique qualities. Because American cultural practices have determined *where* jazz could be played, those cultural practices have had an influence on *how* jazz would be played. In many cases the kinesthetics of jazz have been directly related to the place where the performance occurred and to the response of the audience. A night club, a park, or a riverboat might encourage dancing, handclapping, whistling, or stomping, while a church, a concert hall, a school auditorium, or a small classroom might produce a more subdued interaction between the jazz musicians and the audience.

From *The Black Perspective in Music,* 14:1, Winter 1986. Reprinted by permission of Alan S. Bergman & Associates, representative of the author.

Notes

1. David Sharp et al., *An Outline History of American Jazz* (Dubuque, IA: Kendall/Hunt Publishing Co., 1998), p. 128.

Chapter 2
Precursors of Jazz

Blues is to jazz what yeast is to bread—without it, it's flat.

Carmen McRae

When black slaves were brought from Africa to America and the Caribbean they arrived with nothing but their personal and cultural memories. For our discussion, the most important of those memories are the musical traditions that eventually led to the development of jazz. Before we take a look at some of the components that came together to create jazz, here are two definitions to keep in mind. Both terms apply roughly to the period 1890 to 1929. **Ragtime** - An early mixture of African, African American, and European musical elements—no improvisation. **Traditional Jazz (dixieland)** - A later mixture of African, African American, and European musical elements—lots of improvisation.

In his book *Writings in Jazz*, noted jazz scholar and performer Nathan Davis raises some interesting general questions about the unique situation that led to the development of jazz. Perhaps there are really no satisfactory answers to these questions, but they should certainly give you cause for thought. With the above definitions in mind, consider this:

> What kind of music might we have had if African slaves had been taken to China or Japan or any other part of Asia instead of to the Americas? On the other hand, what would have been the results if the Africans had been the captors and supplied various African territories with European slaves? Would we have a form of music similar to the music we now call jazz? These and similar questions arise when we try to solve the mystery of jazz.[1]

Much of the music the slaves carried in their memory was what we call functional music—music created for work, religion, and ceremony. World music scholar David Locke describes it this way: "African music often happens in social situations where people's primary goals are not artistic. Instead, music is for ceremonies (life cycle rituals, festivals), work (subsistence, child care, domestic chores,

Ragtime

Traditional Jazz (dixieland)

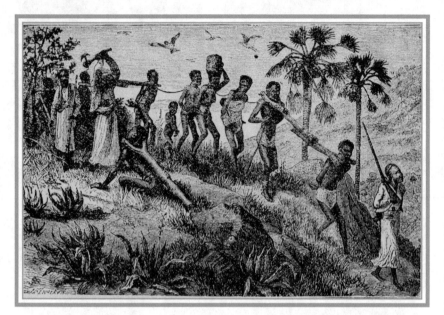

Historic woodcut offering a graphic illustration of slaves being captured in Africa.
© 2002 www.arttoday.com

wage labor), or play (games, parties, lovemaking). Music-making contributes to an event's success by focusing attention, communicating information, encouraging social solidarity, and transforming consciousness."[2]

As generations of slaves grew in a new land, their music underwent a series of transformations and transliterations that all played a role in the creation of jazz as a musical style. The key element to keep in mind is the concept of embellishment. All of the formats we will discuss from traditional African culture and music created by African American culture contain some type of musical embellishment, which gives the music an unending set of variations. These variations run the gamut from slight alterations to an almost total reworking of a given song. Said another way, the performers can sing the same song over and over again, but no two performances will be exactly alike.

Nineteenth-century woodcut of a chain gang chopping wood. This is the type of group that would sing the song Early in the Mornin' *found in your listening guide.*
© 2002 www.arttoday.com

call and response

Some Precursors of Jazz

Work Songs

Many different cultures have created music that coincides with the rhythm of movement required to perform a given task, basically following the philosophy of "whistle while you work." Most African slaves were brought to the new world to perform repetitive, manual labor. To help lighten the burden of this work, music was created that fit the work being done. This was a long-standing African tradition that was incorporated into African American slave culture. Many of the work songs featured the technique of **call and response** as a basic component. This technique of musical conversation was practiced in African drumming, ceremonies, and physical work situations. One singer or group of singers creates a musical line (the call), which is then repeated or in some way answered by another singer or group (the response). Different work situations created different types of songs, as dictated by the physical rhythm of the work. For example, one common form of work song was the ax song, which takes its rhythm from chopping down a tree. In general, you sing on beats one, two, and three, then swing the ax and hit the tree on

beat four. The ax song, like most work songs, tends to have a series of repeated lines similar to the blues format. Listen again to the song *Early in the Mornin'* on Spotify. This is a perfect example of a group of men singing a typical work song.

Listening Guide

Early in the Mornin'
Example of group embellishment
Recorded by Alan Lomax at Parchman State Penal Farm, Mississippi, late 1940s
Performed by "22," Little Red, Tangle Eye, and Hard Hair, accompanied by double cutting axes
This work song uses a verse/chorus format with repeated lines of text. Each man sings the same basic melodic shapes and approximately the same text. Notice that no two men sing the song exactly the same way. This freedom to embellish is a musical style that came directly from Africa. Notice also how the rhythm of the work being accomplished drives the rhythm of the music, and, conversely, that the spirit of the music seems to spur on the pace of the work.
Total time: 4:38

:00	1st Verse:	Well, it's early in the morn –in the morning, baby When I rise, Lordy mama . . . (etc.)
:43	Chorus:	Well-a, it's-a, Lordy, Ro-Lordy-Berta, Well, it's Lord (you keep a-talkin'), babe, Well, it's Lord, Ro-Lordy-Rosie, Well, it's, o Lord, Gal, well-a.
:57	2nd verse:	Well-a, whosonever told it, That he told a- he told a dirty lie, babe. Well-a, whosonever told it, that he told a -he told a dirty lie, well-a . . . (etc.)
1:39	Chorus:	Well-a, it's-a, Lordy, Ro-Lordy-Berta, Well, it's Lord (you keep a-talkin'), babe, Well, it's Lord, Ro-Lordy-Rosie, Well, it's, o Lord, Gal, well-a.
1:52	3rd verse:	Well-rocks 'n gravel make -a Make a solid road . . . (etc.)
2:34	Chorus:	(Same as above with slight variations)
2:48	4th verse	Boys, the peckerwood a-peckin' on the- On the schoolhouse door, sugar. . . (etc.)
3:29	Chorus:	(Same as above with slight variations)
3:43	5th verse	Well, hain't been to Georgia, boys, but, Well, it's I been told, sugar. . . (etc.)

Signifying Songs

Another form closely related to the blues is the signifying song, which also originated in Africa. Nathan Davis describes these pieces as songs of ridicule. "Members of a tribe who had committed a particular crime were often punished

Artist E. H. Suydam created this drawing of Congo Square in New Orleans. Slaves were allowed to convene here and take part in ritual dance ceremonies that made use of traditional African and Caribbean rhythms.
© 2002 www.arttoday.com

by being subjected to impromptu songs being sung by their fellow tribesmen about the deed or crime. Signifying songs in the U.S. had their beginnings on the plantation. In fact, it is safe to say that without the signifying songs, the blues we know today would not exist."[3] In general, the musical patterns found in these songs are the same basic forms used in the blues. Davis goes on to say that later the signifying songs in America made their way into minstrel shows and other gatherings during the nineteenth century. He finishes by suggesting that "the Afro-American signifying song can be compared to the West Indian calypso in that both were designed to carry a message of social significance."[4]

Religious Music

Most of the slaves who came to America eventually adopted Christianity as their major belief system. Over the generations, European hymns were adapted and incorporated into what we now call black gospel music. In addition, new music was created that made use of many of the African musical techniques we are discussing. Of those, perhaps the most important is the call and response format. Singers perform music in this give-and-take format, choirs and congregations create textures of call and response, and as the preacher delivers his sermon, he expects input from his parishioners. Most good sermons have an inherent rhythm, which often includes some singing from the preacher. At the same time, the crowd responds with shouts including "Amen," "tell it," and "God Almighty." There can also be responsive singing from the choir and/or the congregation. This singing can be actual words or a simple melodic moan.

The Blues

Basic forms and vocal techniques used in the blues can be traced directly back to various parts of Africa. The way certain notes are bent or otherwise embellished is one of the most important techniques a jazz player can learn. The ability to convincingly imitate vocal blues styles on a horn is considered a mark of musical maturity. Louis Armstrong was a master of both playing and singing the blues. All the wonderful nuances found in the blues are contained in his

performances. Also, as you saw in Chapter 1, the formal structure of the 12-bar blues was, and is, perhaps the most commonly used form in jazz music. If arriving at a solid definition for jazz is difficult, it's even harder to pin down exactly what the blues is. One of the most famous quotes from a musician is that "the blues ain't nothing but a good man feeling bad."[5] Listen again to the tunes *Black Snake Moan* and *St. Louis Blues* found on Spotify.

Courtesy of the author.

Listening Guide

Black Snake Moan (Huddie Ledbetter)
Example of early blues style
Recorded ca. June 1926
Performed by Blind Lemon Jefferson, vocal and guitar
Blind Lemon Jefferson sings in more of a country blues style. His treatment of the 12-bar blues pattern is rather loose in that he follows the basic blues lyric format of A-A-B, but rhythmically he is not at all strict with the counting. Listen carefully to how he bends notes as he sings them. As we move through the text, you will notice that many great jazz players imitate that singing style on their instruments.
Total time: 3:03

:00	Guitar introduction.
:12	I ain't got no mama now, I ain't got no mama now, She told me late last night, "you don't need no mama no how."
:40	Um, black snake crawlin' in my room, Um, black snake crawlin' in my room, And some pretty mama had better come and get this black snake soon.
1:08	Oww, that must've been a bed bug, you know a chinch can't bite that hard, Oww, that must've been a bed bug, you know a chinch can't bite that hard, Asked my baby for fifty cents, she said, "Lemon ain't a child in the yard."
1:39	Mama that's alright, Mama that's alright for you, Mama that's alright, Mama that's alright for you, Say baby that's alright, holding me the way you do.
2:06	Um, what's the matter now? Um, honey what's the matter now? Tell me what's the matter, baby, I don't like no black snake no how.
2:32	Well, I wonder why this black snake's gone, Well, I wonder why this black snake's gone, Lord, that black snake, Mama, done run my darlin' home.

Listening Guide

St. Louis Blues (W. C. Handy)

Example of the blues, call and response, and improvisation
Recorded January 14, 1925
Performed by Bessie Smith, vocal; Louis Armstrong, cornet; and Fred Longshaw, organ
Written by W. C. Handy, the "father" of the blues, this song represents a more formal blues structure that was frequently used in the jazz world. It contains the typical 12-bar blues pattern for the chorus but also has a verse that makes use of a different melody and series of chords. In this particular tune, the verse is 16 measures long. Notice again how the singer, Bessie Smith, bends into and out of certain notes. Notice also that Louis Armstrong copies that vocal style on his instrument. This recording is an excellent example of call and response, as this performance is very much a musical conversation between the singer and the cornet player. In jazz, this technique is sometimes referred to as "dressing the windows."

Total time: 3:08

:00		Dominant chord (V^7) used as introduction.
:04	1st chorus:	I hate to see the evening sun go down …
:49	2nd chorus:	Feelin' tomorrow like I feel today …
1:33	Verse:	St. Louie woman, with all her diamond rings …
2:28	3rd chorus:	I got them St. Louie blues, just as blue as I can be … (Note altered melody in this chorus.)

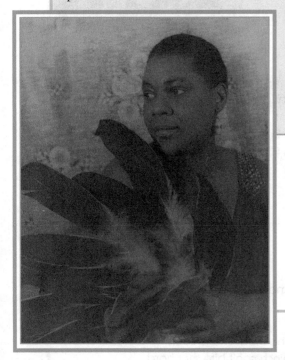

Bessie Smith.
© William P. Gottlieb.
From the Library of
Congress Collection.
Reprinted by permission.

*Artist William Sharp
created this image of
minstrel show musicians
pictured in full blackface
and typical costumes.*
© 2002 www.arttoday.com

Minstrel Shows

The history of American minstrelsy is one of the most complex and unpleasant components in the development of American popular music. These shows carried, and in some cases created, many of the most offensive racial stereotypes ever to appear in America. Some of the racial biases we battle to this day can trace at least a portion of their roots back to the American minstrel shows. At the same time, some unique styles of American humor and music were also widely exposed to the entire country for the first time via minstrel show performances and the published sheet music that followed.

In the early 1800s, white performers began to impersonate the music and dialect of black slave culture. Mostly in the American South, the syncopated rhythms of black society fascinated some white performers and composers. As the shows developed, white performers would put on "blackface" by covering their faces with burnt cork and using white and red makeup to exaggerate their eyes and mouth. The music they performed was often copied from (read "stolen from") black slaves. The shows contained comedy skits, solo song performances, and larger choruses of both singers and dancers. For many people outside the South, these shows were their first exposure to black culture. White minstrel performers created a highly stylized and usually negative picture of blacks in America. As minstrel shows became popular across America, some basic characters began to emerge. In his book *This Is Ragtime*, Terry Waldo offers this description: "During this period the comic image of the happy-go-lucky, wide-grinnin', chickenstealin', razor-totin' darky became rigidly embedded in the psyche of white America. And from this tradition came a flood of pseudo-Negro entertainment that persisted throughout the ragtime era."[6] A white performer named Thomas "Daddy" Rice is credited with creating two of the most lasting characters found in American minstrel shows. His *Jim Crow* character was a rural, uncultured, uneducated black with thick dialect and slow wit. This character was the butt of most jokes in the show. In fact, the term "Jim Crow law" was based on the wide knowledge of this characterization. The other major character "Daddy" Rice created was *Zip Coon*. This character was a "citified" fast-talking con man, full of humor and always ready for a party or a fight.

Historic woodcut of a typical "Jim Crow" character as featured in minstrel shows.
© 2002 www.arttoday.com

After the Civil War, many black artists also worked in minstrel shows. The height of irony was that these black performers also put on "blackface" makeup and copied many of the negative stereotypes created by white performers. The often overlooked fact, however, is that the quality of music being composed went way up. Yes, there were still very bad racial stereotypes being portrayed by both white and black artists, but the music created during the latter part of the 1800s opened the door for both ragtime and traditional jazz. Most important to our discussion is the dissemination of syncopation as a basic rhythmic structure. To this very day, these wonderfully complex rhythms are the basis for most jazz.

The Development of Ragtime

Ragtime music brought together many of the previously discussed elements and mixed them with the European march format. This style fused African syncopation with African American and European harmonic styles. In the years around the turn of the last century, almost every piano in the front parlor of an American home had a pile of sheet music on top of it. Remember, there was no radio or television. If you wanted entertainment at home, you had to make it yourself. The concept of rhythmic syncopation was brought into these homes first by music from the minstrel shows and

Making music at home around 1900, when ragtime music became the rage across America. Notice the big pile of sheet music on the upper right corner of the piano.
© 2002 www.arttoday.com

later by ragtime, the hottest musical rage of the late 1890s and early 1900s. To hear an example of ragtime, listen to Scott Joplin's *Maple Leaf Rag* on Spotify.

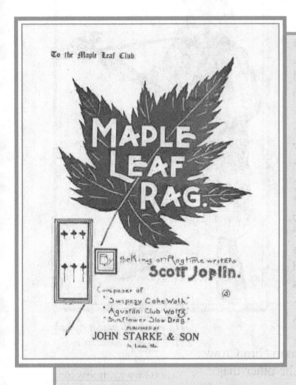

Listening Guide

Maple Leaf Rag (Scott Joplin)

Example of ragtime and a typical march form

The *Maple Leaf Rag* is a masterpiece of the ragtime style. The piece was named in honor of the Maple Leaf Club in Sedalia, Missouri, where Joplin often performed. This piece follows a typical march format of the day, with four different sections, or strains. In music, we typically use letters to represent the different sections of a piece like this one. As with most rags, this piece is in 2/4 time, meaning there are two basic beats per measure. As you are listening, if you find yourself counting to 32 measures instead of 16 at the end of every section, you are going twice as fast as the basic beat. You should also be aware of the fact that this piece has a pick-up note, meaning that the tune actually starts one note earlier than you want to start counting.

Scott Joplin, who viewed the music he was creating as classical in nature, wrote all of this music out. As such, he was known to have frowned upon performers who played his music too fast or added excessive unwritten embellishments, as we will discuss regarding some of the piano professors we will meet in the next section of this chapter. Having said that, what you are hearing on this recording is a player piano roll that Joplin created himself, and he does add a few embellishments here and there when compared to what is seen on the published sheet music.

Total time: 3:18

:00	Letter A, also called 1st theme. 16 measures.
:22	Repeat of 1st theme.
:44	Letter B, also called 2nd theme. 16 measures.
1:05	Repeat of 2nd theme.
1:27	Letter A (last statement, no repeat). 16 measures.
1:48	Letter C, also called 3rd theme. 16 measures. This melody is in a new key center and is played much higher up on the piano keyboard.
2:08	Repeat of 3rd theme.
2:29	Letter D, also called 4th (or last) theme. 16 measures. Rhythm in this section is the most syncopated of the entire work.
2:49	Repeat of 4th theme.

As you heard and saw in the previous example, one of the major creators of this new ragtime style was Scott Joplin. Mr. Joplin is often mistakenly given almost sole credit for creating this new music. Certainly there were other composers who also helped in developing the music that would become ragtime. At the same time, Joplin has been overlooked by some white-biased scholars who have tended to paint him as "only" a ragtime composer. Joplin wanted to be much more. In *This is Ragtime*, Terry Waldo, an accomplished ragtime and jazz musician in his own right, gives us a more balanced view of Scott Joplin's life.

Scott Joplin: The King of Ragtime Composers
by Terry Waldo

It is axiomatic that creative geniuses are seldom recognized in their own time (at least fifty years are generally required for full appraisal), and Joplin was no exception. He lived completely within the tradition of the true "suffering artist," producing a continuous flow of revolutionary musical thought that stemmed from deep frustration.

Joplin was first of all black, and he grew up in a paradoxical period of the late nineteenth century when black men were making great strides toward equality but simultaneously experiencing increased repression from white society. In addition, Joplin was the victim of a number of tragic personal circumstances that culminated in his complete insanity and death at the age of forty-nine.

He was born on November 24, 1868, near Marshall, Texas, and spent most of his youth in Texarkana, a city divided between Arkansas and Texas, with the black population living on the Arkansas side. Joplin's parents, newly freed slaves, were both musically inclined, as were all of their six children. Giles Joplin, Scott's father, had been a plantation violinist; his mother, Florence, played the banjo and sang. From his father Scott learned the waltzes, schottisches, and polkas that Giles had played for his white "employers" along with the syncopation that had been common on the plantation. But Scott probably picked up most of his musical education from his mother.

As a result of an early separation, Florence Joplin was left with the task of raising the six children alone. This she did by doing domestic work in the white folks' houses and by taking in laundry. Through her influence Scott was exposed to the Negro folk music of the local church. He demonstrated his remarkable musical ability as a small child by playing and improvising on numbers he had heard in church. And although his musical talent had been discouraged by his father, his mother supported it by taking Scott to the "big houses" that she worked in and allowing him to play the pianos there. Later she managed to scrape together the money to purchase a piano for him to use at home.

While still a youngster Joplin began actively to pursue a musical career. His talent attracted the attention of several local music teachers, who acquainted him with the classical music literature of the day, and it wasn't long before he was playing at various church functions and socials. But Joplin was also exploring the secular music of the Texarkana area. He visited and began playing at the various honky-tonks, clubs, and eating places where the "low down" transient musicians were entertaining. And it wasn't long before Joplin was joining them.

While still a teenager he organized the Texas Medley Quartet, which toured the Texas-Arkansas-Missouri area. By 1885, at the age of

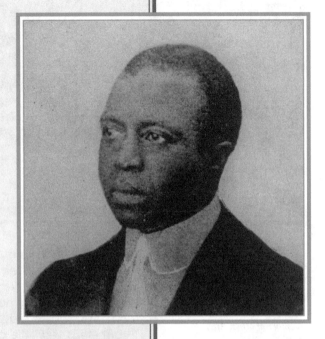

Rare photo of Scott Joplin, the "father" of ragtime music.
Courtesy of the Institute of Jazz Studies, Rutgers University

Dig Deeper

BOOKS

This Is Ragtime by Terry Waldo; *King of Ragtime: Scott Joplin and His Era* by Edward Berlin

WEBSITES

www.scottjoplin.org
www.terrywaldo.com

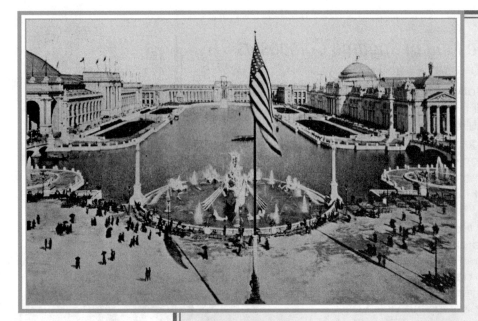

Main plaza at the World's Colombian Exposition, which was held in Chicago in 1893. Composer and pianist Scott Joplin joined a number of other African American musicians who took part in and around the exposition's many activities.
© 2002 www.arttoday.com

seventeen, he was singing, playing piano, mandolin, and guitar; and he had shifted his home base to St. Louis, where he worked at the Silver Dollar Saloon for "Honest John" Turpin, the father of Tom and Charlie Turpin.

For the next eight years Joplin built up his reputation as a performer all around the Midwest; then in 1893 he joined the hundreds of other itinerant musicians who congregated in Chicago for the World's Columbian Exposition. Although not involved in the fair proper, these traveling troubadours provided entertainment on the outskirts of the fairgrounds. It is reported that Joplin had a small band assembled for the event, consisting of cornet (which he played), clarinet, tuba, and baritone horn.

There is very little documentation as to exactly what Joplin did at the fair, but it is my impression that the experience must have been a real eye-opener to him in many ways. The fair featured, from time to time, several black concert artists, such as Madame Sissieretta Jones (the operatic vocalist who was known as Black Patti); violinist Joseph Douglas (who performed on "Colored American Day," one of the special features of the fair); and also, probably for the first time, there were assembled a number of black composers and artists who were and would continue to be working at the task of bringing American Negro folk music into the realm of legitimacy.

The fair had many messages: For one thing, it signaled the opening of a whole new world of technological advancement—a world of staggering potential. Secondly, it seemed to promise a piece of the action to blacks. Joplin returned from the fair with enough encouragement to work seriously toward publication of his music, and in 1895 he began doing just that.

Joplin's first published numbers were rather maudlin affairs in the genteel tradition, but during this time he was gaining experience and building a reputation both as a composer and performer. Finally he settled in Sedalia, Missouri, and it was here that he began his career as a composer of ragtime.

Sedalia, which was an end point for many cattle drives, was a thriving frontier town, and it held many attractions for Joplin. First, the Smith College for Negroes, which provided him with the opportunity to expand and refine his serious study of music, was located there. On the other hand, the city also had a large red-light district, which could provide work and contact with the underground world of Negro folk music. Sedalia also had several music publishers.

It would seem that Joplin actually had some of his rags in manuscript form as early as 1897 but was not able to sell them to a publisher until the ragtime vogue was in full swing. His "Maple Leaf Rag" was turned down in 1899 by Perry and Sons, of Sedalia, and also by Carl Hoffman, of Kansas City, who instead published his "Original Rags." But in the same year Joplin finally met John Stark, owner of a small music store in Sedalia, who did publish the "Maple Leaf Rag" and went on to become the lifelong champion of classic ragtime.

There are at least three different versions of how Stark happened to decide to publish Joplin's masterpiece. According to John Stark's son, Will, who did arrangements for Stark and was himself a ragtime composer, Joplin came into the store with a small boy, sat down at the piano, and played the "Maple Leaf Rag" while the youngster stepped it off. From Will's account, John Stark actually did not want to publish it, but Will was so taken by the lad's dance that they decided to buy it anyway.*

According to another version of the story, Joplin's lawyer called the attention of Stark to the music, and a third version sets the first Joplin-Stark meeting in the Maple Leaf Club, where Joplin played piano.

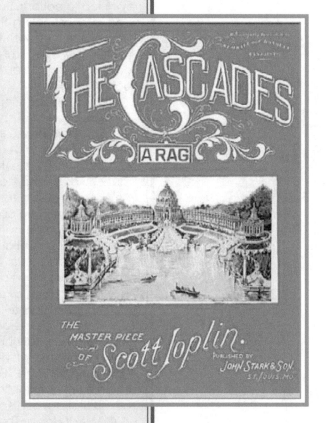

There are also varying descriptions of the Maple Leaf Club. By one account we get a picture of a social center of sorts with a fairly large room where various political meetings were held and where Joplin rehearsed with the Queen City Concert Band, in which he played second cornet. Other accounts portray the club as primarily a saloon where the piano players played for tips and the whores picked up their clientele. Most likely the club had at least two rooms and was certainly large enough to handle all of these various activities.

In any case, Stark was genuinely moved by the music and made what was at the time an unusual contract with Joplin: It allowed Joplin not only a flat fee of fifty dollars for the rag but also provided royalties on a continuing basis. Unfortunately, neither man foresaw the importance of procuring any musical rights other than publishing; neither Joplin nor Stark, therefore, ever saw any money from the mechanical rights for the rag. These included those for the popular player-piano rolls and phonograph records, which would soon assume a great importance on the commercial scene. Furthermore, Stark and Joplin made only one and one-half cents apiece for each piece of sheet music sold.

Stark, who might well be described as a romantic pragmatist, probably typified the somewhat naïve values of the United States "frontier" mentality. He was born in 1841, fought the good fight in the Civil War (on the Blue side), and then made his living with a Conestoga wagon as a frontier salesman, first of ice cream, and then organs. He does not

*Dorothy Brockgoff, "Missouri Was the Birth Place of Ragtime," *St. Louis Post-Dispatch*, January 1961.

appear to have been ruthless enough to be a great businessman, but with the "Maple Leaf Rag" he stumbled onto a good thing indeed. In spite of its difficulty, the sales of the piece were fantastic at the time— 75,000 copies in the first year. The music sold as fast as Stark could keep it in print.

The next rag to be published by Stark was "The Swipesy Cakewalk," a collaboration by Joplin and one of his young pupils, Arthur Marshall. It has been believed for years that in Joplin's early collaborations with Marshall and Scott Hayden, his other student, that one composer would do one or two strains and the other would complete the piece. It would appear, however, that in most cases the works were joint efforts from top to bottom. Joplin worked together with his pupils for hours on end in constructing these rags. There is even a possibility that Arthur Marshall helped with the composition of the "Maple Leaf Rag." Nevertheless, it was Joplin's inspiration that produced the music. As Marshall once said years later, "Ragtime was already around Sedalia, but Joplin got things going!" *

Within a year after his initial success with the "Maple Leaf Rag," Joplin was already pushing for an expanded form of ragtime. He rented Woods Opera House in Sedalia and staged "The Ragtime Dance," and apparently it was very well received. It was an extremely advanced composition for the time in that Joplin was attempting to integrate music, words, and dance in one work. This was common to the Afro-American musical tradition, but here was Joplin atempting to codify that tradition in European musical terms. Probably owing to the long and complicated nature of the work, it would seem to have had little commercial potential as sheet music. With reluctance Stark published it in 1902, and just as he had expected, despite its stage success, this ambitious effort was a smash flop. Two years later Stark issued the work in shortened form as a rag without verse, words, or dance directions.

Around 1900 Stark moved his operation to St. Louis, and Joplin, who was then at the height of his national popularity, soon followed. The next few years saw him in demand as a performer, and his rags sold well. By the end of 1902 Stark had published "Peacherine Rag," "The Easy Winners," and "Elite Syncopations," as well as the delightful "The Entertainer." But Joplin was still not satisfied; he continued to work for classical status of his music, and he composed a ragtime opera called *A Guest of Honor*. The work was copyrighted in 1903 and supposedly performed by the Joplin Ragtime Opera Company, but it was never published, and at present, despite rumors to the contrary, there are no known copies in existence.

While in Sedalia, Joplin had married Belle Hayden, the sister-in-law of Scott Hayden. But the marriage never worked and was dissolved in 1905. Contributing factors to the union's demise seem to have been the loss of a child and Belle's inability or unwillingness to adapt to Joplin's musical career; a complicated love life may also have played a part. (Charles Thompson, a St. Louis piano player, recalled one of Joplin's pieces, "Leola," which he said was written in 1904 for a girl Joplin was in love with.) In any case, by 1906 Joplin hit one of his nadirs of depression, and his compositional output nearly dried up.

By 1907 Joplin seems to have "bottomed out" and gotten himself sufficiently back together to start a new life. He settled in New York,

*Interview: Mildred Marshall Steward, daughter of Arthur Marshall.

where John Stark already had set up an office, and there he met and married Lottie Stokes, who, unlike Belle, was sympathetic to Joplin's ambitions. She provided a comfortable atmosphere and moral support for his musical activities throughout the rest of his life; for years after his death the Joplin house was still a meeting place for jazz and ragtime musicians in New York.

But even in this supportive domestic environment Joplin became increasingly tormented by his personal devils. The years 1907 to 1909 saw the publication of around fifteen more works of brilliant composition, but there is some doubt as to whether or not he could even play them. By that time syphilis was already taking hold, and by the time he was forty, his health was rapidly deteriorating. Eubie Blake recalls Joplin at this stage:

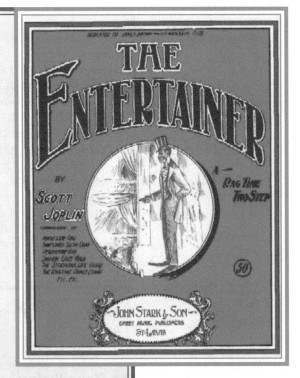

> They gave me an introduction to Scott—and—I talked to him about half an hour and I have never seen him since. You heard this tune "We Want Cantor, We Want Cantor." When I first heard that tune it was in nineteen—either seven, eight, or nine, in Washington. "We want Joplin. We want Joplin!"—and he kept saying, "Fellas, I don't play." He could hardly talk—he was sick—his health was gone, he was very ill. Hughie Wolford was sharp—Jimmie Meredith, sharp piano player. Philadelphia Jack "The Bear." These are piano players.—Sammy Ewell, the guy that played five-finger bass—five fingers! I've seen him do that! And Scott knew he couldn't compare with these fellas. So, they kept after him, and he went to the piano, and played. It was pitiful. I almost cried—and the guys, especially Hughie, you know, made a face at his playin'. They didn't think—that if it wasn't for him, that music would have been wiped out. Like I always tell people when I'm on the stage, "He had the *nerve* to put it down on paper."

Joplin's folk opera *Treemonisha* became his consuming passion and frustration from 1907 until his death. These last years were spent in a vain attempt to get the opera backed financially and performed. Stark, wisely from his point of view, refused to publish the work. Because of this and Stark's desire, now, to buy Joplin's rags outright with no royalty agreement, the two men split in 1909. Joplin retired more and more from performance into composition. By 1910 his published output had narrowed to a trickle: "Stoptime Rag" was published in 1910; the opera *Treemonisha* was published in 1911 by Joplin himself; "Scott Joplin's New Rag" appeared in 1912; and finally in 1914 the haunting "Magnetic Rag" was copyrighted by the Scott Joplin Music Company.

Joplin's consuming obsession was never brought to fruition. In 1915 he managed to organize a meager performance of *Treemonisha* without orchestra or costumes, and the production was poorly received by a black Harlem audience. This final setback put him over the hill. His periods of lucidity became ever more rare, and in 1916 Lottie was forced to have him committed to the Manhattan State Hospital on Ward's Island.

Earlier that same year Joplin had recorded several hand-played piano rolls. All of them seem to have been corrected for mistakes with one exception: a roll of the "Maple Leaf Rag" made for the Uni-Record piano-roll company. This roll provides a sad yet fascinating insight into Joplin's tortured mind a few months before the final breakdown. The playing is irregular and jerky and full of strange mistakes. The performance gives the horrible impression that the whole thing is somehow going to break down completely before the end.

When Joplin died on April 1, 1917, he left behind a number of unpublished scores, many of which Rudi Blesh saw in the 1940s when he was doing research for *They All Played Ragtime*. Tragically, at Lottie Joplin's death all of those scores disappeared and are presumed to have been discarded. Included were orchestrations for several rags, such as "Pretty Pansy" and "Recitative Rag," and the full orchestration for *Treemonisha*.

From *This is Ragtime*, Hawthorn Books. Copyright (C) 1976 by Terry Waldo. Reprinted by permission.

The Piano Professors

Out of the ragtime tradition came the piano "professors." These men were highly skilled piano players (mostly black) who performed ragtime and early jazz at social functions, dances, and in bars and houses of ill-repute. When several of these players came together, they would often take part in **cutting contests**. These competitions were usually in a festive party atmosphere where different "professors" would try to outplay one another. They frequently sped up known tunes to outrageous tempos and added radical embellishments. These embellishments were improvised on the spot, reflecting the spontaneous quality that makes jazz such a unique art form. Even today, the idea of a solo piano player taking a given song and adding his or her own musical ideas and embellishments is a mainstay in jazz culture. The difference today is that most cutting contests take place on the various commercial recordings released rather than face-to-face in front of an audience.

Ferdinand "Jelly Roll" Morton, one of the first true innovators of jazz as a musical style, describes a typical scene for a group of piano professors in New Orleans, and he also gives us a great description of after-hours life in the Crescent City.

cutting contests

Jazz Life in New Orleans by Jelly Roll Morton

So in the year of 1902 when I was about seventeen years I happened to invade one of the sections where the birth of jazz originated from. Some friends took me to The Frenchman's on the corner of Villery and Bienville, which was at that time the most famous nightspot after everything was closed. It was only a back room, but it was where all the greatest pianists frequented after they got off from work in the sporting-houses. About four A.M., unless plenty of money was involved on their

jobs, they would go to The Frenchman's and there would be everything in the line of hilarity there.

All the girls that could get out of their houses was there. The millionaires would come to listen to their favorite pianists. There weren't any discrimination of any kind. They all sat at different tables or anywhere they felt like sitting. They all mingled together just as they wished to and everyone was just like one big happy family. People came from all over the country and most times you couldn't get in. So this place would go on at a tremendous rate of speed—plenty money, drinks of all kinds—from four o'clock in the morning until maybe twelve, one, two, three o'clock in the daytime. Then, when the great pianists used to leave, the crowds would leave.

New Orleans was the stomping grounds for all the greatest pianists in the country. We had Spanish, we had colored, we had white, we had Frenchmens, we had Americans, we had them from all parts of the world because there were more jobs for pianists than any other ten places in the world. The sporting-houses needed professors, and we had so many different styles that whenever you came to New Orleans, it wouldn't make any difference that you just came from Paris or any part of England, Europe, or any place—whatever your tunes were over there, we played them in New Orleans.

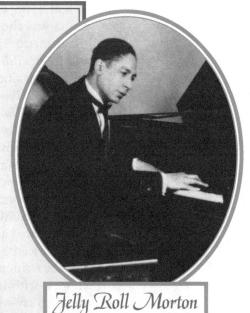

Jelly Roll Morton

Piano professor Ferdinand "Jelly Roll" Morton. Courtesy of the Institute of Jazz Studies, Rutgers University

From *Mister Jelly Roll: The Fortunes of Jelly Roll Morton* by Alan Lomax. Copyright by Alan Lomax. Reprinted by permission of the author's representative.

Band Traditions in America

The final element we need to bring into this mix is the tradition of band music in America. A man named **John Philip Sousa** directed a band in the Marine Corps called *The President's Own*. This band provided music for social occasions around Washington, D.C., as well as the traditional marches used by the military

John Philip Sousa

Early Victrola ad featuring John Philip Sousa and his band. The Sousa band was one of the first commercially recorded groups, and the popularity of the Sousa band's style helped lead to the creation of jazz.
© 2002 www.arttoday.com

in both Europe and America. In addition to being a world-renowned band leader, Sousa was also a great march composer. He wrote some of America's most famous marches including *The Stars and Stripes Forever*, *The Washington Post,* and *The Liberty Bell March*. You should recognize these march tunes even if you don't know their titles. *The Stars and Stripes Forever* is played every Fourth of July, *The Washington Post* is still one of the most popular marches used by American military bands, and *The Liberty Bell March* was used as the theme song for the comic television show *Monty Python's Flying Circus*.

After Sousa retired from military service, he started his own civilian band and began touring the country. He played his own marches, band transcriptions of classical music, and band arrangements of American popular music. Minstrel show tunes and ragtime pieces were also a popular part of the band's standard shows. More importantly for our discussion, the popularity of the Sousa band created a wave of imitators in almost every city and town in America. In New Orleans, bands made up of black and Creole musicians began to embellish the written music. Again, similar to the cutting contests held by piano professors, with the addition of improvisation, jazz was born. It's such a simple thing to say—jazz was born—but it changed the history of American popular music forever.

Notes

1. Nathan T. Davis, *Writings in Jazz*, 5th ed., (Dubuque, IA: Kendall/Hunt Publishing Co., 1996), p. 15.

2. David Locke, "Africa," in *Worlds of Music*, 3rd ed., ed. Jeff Titon, (New York: Schirmer Books, 1996), p. 74.

3. Davis, *Writings in Jazz*, p. 25.

4. Ibid.

5. Original source unknown.

6. Terry Waldo, *This is Ragtime*, (New York: Hawthorn Books, 1976), p. 12.

Chapter 3
Traditional Jazz

Jazz is played from the heart.
You can even live by it. Always love it.

Louis Armstrong

\mathcal{I}n order to bring together everything you've learned in the first two chapters, we need to take a look at the city of New Orleans, Louisiana. The ultimate party town, New Orleans was, and is, unique among American cities. It has existed under Spanish, French, and American rule, and the town's European flair is still quite evident in its food, architecture, and general lifestyle. While Louisiana was a slave state before the Civil War, New Orleans had both free black and slave populations. In addition, there was a white population of both European- and American-born citizens. Eventually, people who considered themselves indigenous to that region of Louisiana began using the term "Creole" to distinguish their cultural heritage from others who were moving into the area. The existence of a free black population in New Orleans led to the creation of a unique class of people known as "Creoles of Color," the term derived from the French *gens de couleur libres*, or literally, "free people of color." Furthermore, many Spanish, French, and other European men married or had affairs with women of color. The children of these unions were also called Creoles of Color and were generally treated as members of the aristocratic class until the late 1800s. Most of these Creoles were educated in Europe or at least in the European tradition. Important to our discussion is the fact that some of the most talented musicians in New Orleans during the late nineteenth and early twentieth centuries were Creoles of Color. For many years, Creoles were a powerful political and social force in New Orleans. In the years following the Civil War, however, many Southern whites feared they were losing their dominance, and eventually the Creoles of Color were reduced in social status

Dig Deeper
WEBSITE

www.frenchcreoles.com

to the level of blacks after Reconstruction. Both groups were forced to live under the oppressive restrictions of Jim Crow laws. From all this injustice, two musical traditions were forced together, and the birth of jazz as we know it was just a few small steps away.

New Orleans had a number of "sporting houses," where prostitution and gambling were the major sources of income. Of course, all these establishments wanted to offer the finest in musical entertainment. First they employed piano professors, and soon some were offering bands modeled on the popular tradition of the day. Eventually, crime and vice in the city grew out of control. At the same time, however, it was a major source of revenue for the city. A city councilman named Sidney Story came up with the idea of isolating the bars, sporting houses, and other dens of iniquity into one small area on the edge of the modern day French Quarter. This area, **Storyville**, was named in the councilman's honor. The development of Storyville helped accelerate the evolution of jazz by placing all

Storyville

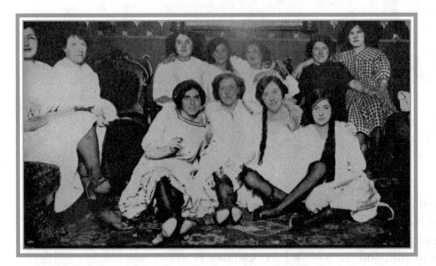

Prostitutes from around 1900. Many worked in the "sporting houses" that could be found all over Storyville in New Orleans.
© 2002 www.arttoday.com

these musicians in close proximity to one another. There was a wonderful and continuous exchange of musical ideas and techniques. At the same time, there was also a certain amount of showmanship as the different bands and piano players were constantly trying to outplay one another. In 1917, the U.S. Navy effectively shut down Storyville, fearing the spread of disease and a loss of control over its sailors. Around that same time, blacks from all over the South were traveling to northern cities including Chicago and New York

Waldo Pierce drew this illustration of a young sailor listening to a hot New Orleans jazz band in the early 1900s.
© 2002 www.arttoday.com

in search of a better way of life. As there was less work to be found in New Orleans, many of the city's best musicians followed.

From the book *Mister Jelly Roll*, here is Jelly Roll Morton's account of life in turn-of-the-century New Orleans. Take note of some of the musical terms, which you will see again in the next section of this chapter. One particular point of interest is Morton's discussion of what he called the **"Spanish tinge."** Many think that Latin influences in jazz are fairly recent additions, but Morton and others have pointed out that to some extent Spanish influences were in jazz from the very beginning.

Spanish tinge

The Development of Early Jazz by Jelly Roll Morton

Jazz music came from New Orleans and New Orleans was inhabited with maybe every race on the face of the globe and, of course, plenty of French people. Many of the earliest tunes in New Orleans was from French origin. Then we had Spanish people there. I heard a lot of Spanish tunes and I tried to play them in correct tempo, but I personally didn't believe they were really perfected in the tempos. Now take *La Paloma*, which I transformed in New Orleans style. You leave the left hand just the same. The difference comes in the right hand—in the syncopation, which gives it an entirely different color that really changes the color from red to blue.

Now in one of my earliest tunes, *New Orleans Blues*, you can notice the Spanish tinge. In fact, if you can't manage to put tinges of Spanish in your tunes, you will never be able to get the right seasoning, I call it, for jazz. This *New Orleans Blues* comes from around 1902. I wrote it with the help of Frank Richards, a great piano player in the ragtime style. All the bands in the city played it at that time. Most of these ragtime guys, especially those that couldn't play very well, would have the inspiration they were doing okay if they kept increasing the tempo during a piece. I decided that was a mistake and I must have been right, because everybody grabbed my style. I thought that accurate tempo would be the right tempo for any tune.

Regardless to any tempo you might set, especially if it was meant for a dance tune, you ought to end up in that same tempo. So I found that the slow tunes, especially the medium slow tunes, did more for the development of jazz than any other type, due to the fact that you could always hit a note twice in such a tune, when ordinarily you could only hit it once, which gave the music a very good flavor.

About harmony, my theory is never to discard the melody. Always have a melody going some kind of way against a background of perfect harmony with plenty of riffs—meaning figures. A riff is something that gives an orchestra a great background and is the main idea in

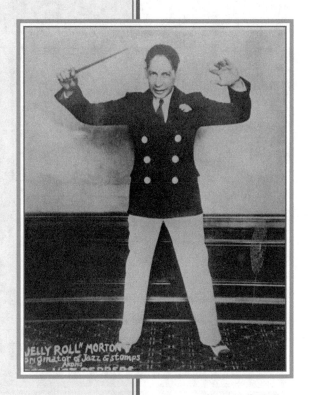

Famous photo of Jelly Roll Morton striking a dramatic conducting pose.
Courtesy of the Institute of Jazz Studies, Rutgers University

PLACES OF INTEREST IN NEW ORLEANS: 1. Jackson Statue; 2. Levee; 3. French Market; 4. Glimpse of the City; 5. Interior of French Market; 6. Building of the Louisiana Jockey Club; 7. Soldiers' Monument. 8. Robert E. Lee Monument.

*Travelogue illustration
displaying some of the high
points of the city of New
Orleans around 1880.
Many of these attractions
can still be visited today.*
© 2002 www.arttoday.com

playing jazz. No jazz piano player can really play good jazz unless they try to give an imitation of a band, that is, by providing a basis of riffs. I've seen riffs blundered up so many times it has give me heart failure, because most of these modern guys don't regard the harmony or the rules of the system of music at all. They just play anything, their main idea being to keep the bass going. They think by keeping the bass going and getting a set rhythm, they are doing the right thing, which is wrong.

Now the riff is what we call a foundation, like something that you walk on. It's standard. But without breaks and without clean breaks and without beautiful ideas in breaks, you don't even need to think about doing anything else, you haven't got a jazz band and you can't play jazz. Even if a tune haven't got a break in it, it's always necessary to arrange some kind of a spot to make a break.

A break, itself, is like a musical surprise which didn't come in until I originated the idea of jazz, as I told you. We New Orleans musicians were always looking for novelty effects to attract the public, and many of the most important things in jazz originated in some guy's crazy idea that we tried out for a laugh or just to surprise the folks.

Most people don't understand the novelty side of jazz. Vibrato—which is all right for one instrument but the worst thing that ever happened when a whole bunch of instruments use it—was nothing at the beginning but an imitation of a jackass hollering. There were many other imitations of animal sounds we used—such as the wah-wahs on trumpets and trombones. Mutes came in with King Oliver, who first just stuck bottles into his trumpet so he could play softer, but then began to use all sorts of mutes to give his instrument a different flavor. And I, myself, by accident, discovered the swats on drums.[1] Out in Los Angeles I had a drummer that hit his snares so loud that one night I gave him a couple of fly swatters for a gag. This drummer fell in with the joke and used them, but they worked so smooth he kept right on using them. So we have "the swats" today—a nice soft way to keep your rhythm going.

A lot of people have a wrong conception of jazz. Somehow it got into the dictionary that jazz was considered a lot of blatant noises and discordant tones, something that would be even harmful to the ears. The fact of it is that every musician in America had the wrong understanding of jazz music. I know many times that I'd be playing against

[1]Later known as "brushes."

different orchestras and I would notice some of the patrons get near an orchestra and put their hands over their ears. (Of course, I wouldn't permit mine to play that way.) Anyhow, I heard a funny fellow say once: "If that fellow blows any louder, he'll knock my ear drums down." Even Germany and Italy don't want this discordant type of jazz, because of the noise.

Jazz music is to be played sweet, soft, plenty rhythm. When you have your plenty rhythm with your plenty swing, it becomes beautiful. To start with, you can't make crescendos and diminuendos when one is playing triple forte. You got to be able to come down in order to go up. If a glass of water is full, you can't fill it any more; but if you have half a glass, you have the opportunity to put more water in it. Jazz music is based on the same principles, because jazz is based on strictly music. You have the finest ideas from the greatest operas, symphonies, and overtures in jazz music. There is nothing finer than jazz because it comes from everything of the finest-class music. Take the *Sextet* from *Lucia* and the *Miserere* from *Il Trovatore*, that they used to play in the French Opera House, tunes that have always lived in my mind as the great favorites of the opera singers; I transformed a lot of those numbers into jazz time, using different little variations and ideas to masquerade the tunes.

The *Tiger Rag*, for an instance, I happened to transform from an old quadrille, which was originally in many different tempos. First there was an introduction, "Everybody get your partners!" and the people would be rushing around the hall getting their partners. After a five-minute lapse of time, the next strain would be the waltz strain . . . then another strain that comes right beside the waltz strain in mazurka time.

We had two other strains in two-four time. Then I transformed these strains into the *Tiger Rag* which I also named, from the way I made the "tiger" roar with my elbow. A person said once, "That sounds like a tiger hollering." I said to myself, "That's the name." All this happened back in the early days before the Dixieland Band was ever heard of.[2]

[2]Morton is establishing that his success predates the fame of the Original Dixieland Jazz Band, which began with their recordings of 1917.

From *Mister Jelly Roll: The Fortunes of Jelly Roll Morton* by Alan Lomax. Copyright by Alan Lomax. Reprinted by permission of the author's representative.

Traditional Jazz Band Techniques

One of the most important things to remember as we discuss jazz in New Orleans is that no early recorded performances of traditional jazz in New Orleans exist. The first jazz recordings were made in New York and Chicago. Most of the traditional jazz recordings you will study were made in Chicago from 1923 to 1929 and use both solo and collective improvisation. Almost all of the jazz played by bands in New Orleans, however, was done in a collective improvisation style.

Most of the bands in New Orleans took their cues from the American band traditions discussed in Chapter 2. The big difference is that jazz musicians agree on a basic melody, chord structure, and rhythmic format; then they just improvise the rest. Each instrument has a specific role to play in the band, and the musicians learn how to improvise within the constraints of their individual jobs. The typical set-up for a

front line

rhythm section

Modern-day sign for New Orleans' most famous street. Today, Bourbon Street is the location of many of the city's most successful clubs.
©shutterstock.com

traditional jazz band consists of both front-line instruments and rhythm section instruments. The **front line** is usually made up of one clarinet, one trumpet, and one trombone. The **rhythm section** consists of a drummer, tuba or string bass, and chord instruments including banjo and/or piano. All of these instruments can function in the role of soloist. These are the main jobs for the instruments of a traditional jazz band:

- Clarinet—"noodles." Plays fast embellishments heard at the top of the musical texture
- Trumpet (or cornet)—plays the melody
- Trombone—plays the countermelody
- Drums—keep the basic beat going, add rhythmic color
- Tuba/string bass—plays the bass notes of the harmony, helps define the basic beat
- Banjo/piano—fills in the notes of the harmony, supports the basic rhythm

head

ensemble choruses

solo choruses

out chorus

solo break

stop-time chorus

trading fours

Some of the tunes these bands performed had many sections similar to a typical march or ragtime piece. Other tunes, like those based on the blues, could have a simple 12-bar format that was repeated over and over. Here are some structural terms to know. We call the main melody of a typical jazz tune the **head**. The head is almost always played at the beginning of a jazz tune's performance. Each player will embellish the written melody following the jobs described above. As the improvisation continues, you can have **ensemble choruses**, where everyone extends their embellishments. Remember that this was the common format for performances in New Orleans in the early 1900s. Later, musicians including Louis Armstrong and Sidney Bechet began to break away from the ensemble texture, which allowed them more freedom as soloists. These **solo choruses**, as they are called, continued to be supported by some or all of the rhythm section players. Keep in mind that these new solo improvisation techniques didn't start to happen until the mid-1920s in Chicago. Eventually, when the musicians are ready to end a tune, they perform the out chorus. The **out chorus** is a return to the melody of a jazz tune similar to the head, but the last chorus tends to be played more aggressively, with larger deviations from the original melody.

In addition to the basic format stuff above, here are a few general things to listen for during a typical dixieland tune. A **solo break** is where the band stops playing and one musician improvises (usually one or two measures). These breaks can occur in the head, the out chorus, and both ensemble and solo choruses. A **stop-time chorus** is a technique of accompaniment where the band plays just the first beat of every measure (or two) while one soloist improvises. You can hear Louis Armstrong playing a great stop-time chorus on *Potato Head Blues*. And finally, we come to the technique of **trading fours**, where two or more musicians alternate four-measure improvisations. This often becomes a sort of musical conversation that runs through one or more solo choruses. These are just a few of the

improvisation techniques you will run into as you learn more about jazz, but this is plenty to get you started. You can listen to Jelly Roll Morton's Red Hot Peppers playing *Black Bottom Stomp* to experience many of the techniques just introduced. To hear an example of a more modern style of traditional jazz, listen to the George Lewis Band play *When the Saints Go Marching In*.

Listening Guide

When the Saints Go Marching In (trad.)

Example of modern traditional jazz styles, collective and solo improvisation
Recorded October 1953
Performed by George Lewis, clarinet and vocal; Avery "Kid" Howard, trumpet; Jim Robinson, trombone; Alton Purnell, piano; Lawrence Marrero, banjo; Alcide "Slow Drag" Pavageau, bass; and Joe Watkins, drums

This recording represents a typical modern dixieland band performing what is perhaps the most famous traditional jazz tune of all time. It features vocal choruses, solo choruses, and collective improvisation. George Lewis was a clarinet player in New Orleans who came up in the generation following Louis Armstrong. All of the performers on this recording are from New Orleans and play in a style that is somewhat rougher than the musicians who moved on to Chicago and New York City. You should also notice that because this recording was made in the 1950s, the sound quality is much closer to what an actual performance sounded like.

Total time: 5:20

:00	Piano introduction. Bass and drums join at :04.
:08	Head. 1st chorus. Collective improvisation around melody. Trumpet plays the lead.
:24	2nd chorus. Same as 1st.
:39	Vocal chorus: Oh when the saints …
:55	Vocal verse: I once had a loved one …
1:12	Vocal chorus.
1:28	1st trombone solo chorus. Some collective backup.
1:45	2nd trombone solo chorus. Collective backup intensifies.
2:01	Vocal chorus.
2:17	Vocal verse: I once had a playmate …
2:33	Vocal chorus.
2:49	1st collective improvisation chorus.
3:05	2nd collective improvisation chorus.
3:22	Vocal chorus.
3:38	1st clarinet solo chorus. Some collective riff as backup.
3:54	2nd clarinet solo chorus. Riff continues.
4:10	1st piano solo chorus.
4:26	2nd piano solo chorus.
4:43	1st out chorus. Collective improvisation.
4:59	2nd out chorus. Collective improvisation.

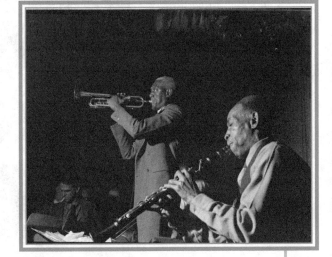

Portrait of clarinetist George Lewis performing with Bunk Johnson at the Stuyvesant Casino in New York City, ca. June 1946.
© William P. Gottlieb. From the Library of Congress Collection.

The People Who Made It Happen

Buddy Bolden

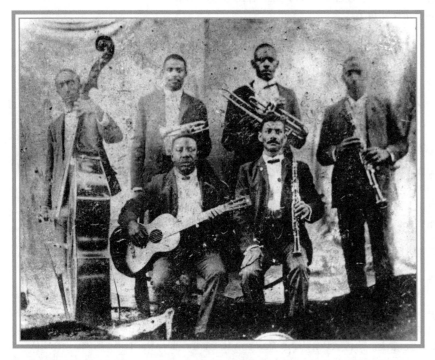

The only generally accepted photograph of the elusive Buddy Bolden, seen here with his band, ca. 1905. Standing, left to right: Jimmy Johnson, bass; Buddy Bolden, cornet; Willie Cornish, valve trombone; and William Warner, clarinet. Seated, left to right: Jefferson Mumford, guitar; and Frank Lewis, clarinet.
Courtesy of Frank Driggs

As you study the history of jazz, the first person you often come across is a New Orleans trumpet player named Buddy Bolden. Photos of Bolden are rare, and there are no recordings of his playing. All the New Orleans players who went on to Chicago talked of Bolden as being one of the first band players to add extensive embellishments to the written music, but this historically obscure pioneer never made it out of New Orleans. He was said to be a very loud player who could dominate an entire band with his sound. According to both jazz legend and written legal documents, Bolden eventually went insane and was in and out of a Louisiana asylum until his death in 1931.

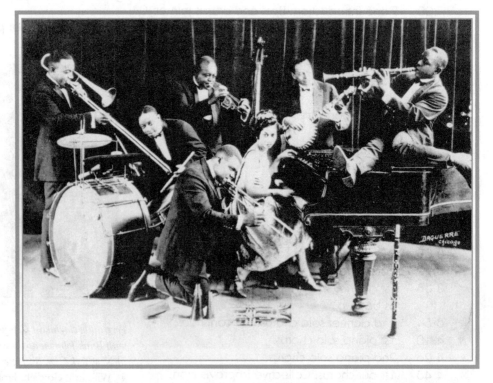

King Oliver's Creole Jazz Band in 1923. Left to right: Honore Dutrey, Warren "Baby" Dodds, Louis Armstrong (kneeling), King Oliver (standing), Lil Hardin, Bill Johnson, and Johnny Dodds.
Courtesy of the Institute of Jazz Studies, Rutgers University

Joe "King" Oliver

Joe "King" Oliver was another of New Orleans' great early improvisers. He was the lead trumpet player in several of the city's most popular bands. When Storyville shut down, Oliver was one of the first band leaders to take a group to Chicago. For our discussion, however, perhaps his most important contribution to jazz was his association with Louis Armstrong. As an older musician, Oliver served as a teacher and mentor to the young Armstrong. When Oliver went to Chicago, where he eventually formed his famous Creole Jazz Band, all of his best New Orleans jobs were passed on to Armstrong. A few years later, it was King Oliver who sent back to New Orleans and brought Louis Armstrong to Chicago in 1922. It was in Oliver's Creole Jazz Band that Armstrong first began to venture into more aggressive and innovative solo improvisation. In just a few years, Armstrong would completely revolutionize jazz in both Chicago and New York. You can hear Oliver and Armstrong perform together on the tune *Dippermouth Blues*.

Listening Guide

Dippermouth Blues (Joe "King" Oliver)

Example of collective improvisation and the beginnings of solo improvisation
Recorded April 6, 1923
Performed by King Oliver's Creole Jazz Band. Joe "King" Oliver and Louis Armstrong, cornets; Johnny Dodds, clarinet; Honore Dutrey, trombone; Lil Hardin, piano; Bud Scott, banjo and shout; and Warren "Baby" Dodds, drums

This recording is one of the most famous of the early traditional jazz recordings. It represents the transition among New Orleans musicians who established themselves in Chicago as they began to break away from total collective improvisation. Although he is not prominently featured here, Louis Armstrong was a pioneer in the art of solo improvisation, as you will hear in his recordings of *Potato Head Blues* and *West End Blues*. This was one of the first recordings Armstrong played on upon his arrival in Chicago.

Total time: 2:39

:00	4-bar introduction featuring Oliver and Armstrong.
:05	Head. 1st chorus. Played in collective improvisation. King Oliver plays the lead on cornet as others improvise their parts to accompany the melody.
:22	Head. 2nd chorus. Same as above.
:38	1st clarinet solo chorus. Uses 3-beat accompaniment, meaning the rest of the band plays simple chord notes on beats 1, 2, and 3, then rests on beat 4.
:55	2nd clarinet solo chorus. 3-beat accompaniment continues.
1:12	Collective ensemble chorus.
1:28	1st cornet solo chorus. Features King Oliver using a plunger mute. Other front-line instruments improvise soft collective accompaniments.
1:45	2nd cornet solo chorus. Same accompaniment.
2:01	3rd cornet solo chorus. Accompaniment gets stronger. Note that last 2 bars of this chorus are filled with banjo player Bud Scott shouting "Oh play that thing" at 2:16.
2:18	Out chorus. Strong collective improvisation with final 2-bar tag played at the conclusion of the tune.

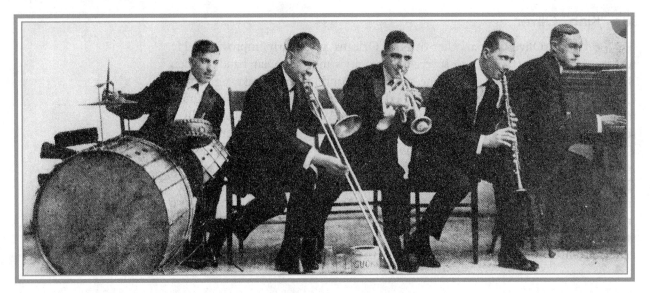

The Original Dixieland Jazz Band, pictured with the personnel lineup that made the first jazz recordings in 1917. Left to right: Tony Sbarbaro, Eddie Edwards, Nick LaRocca, Larry Shields, and Henry Ragas.
Courtesy of the Institute of Jazz Studies, Rutgers University

Original Dixieland Jazz Band

One of the most controversial early bands to come out of New Orleans was a group of white musicians called The Original Dixieland Jazz Band. Over the years the band members, especially trumpet player Nick LaRocca, have been vilified as racist musical imitators who blatantly stole from their black counterparts. Sadly, these facts are mostly true. These musicians were not great improvisers, but they were pretty good musicians who were able to copy the styles they heard in New Orleans. They are important to our discussion of jazz history for two reasons. For better or worse, in 1917 they were the first jazz band to be recorded, and the general American public was exposed to jazz styles for the first time via these recordings. They were also the first jazz band to take this new American art form to Europe. In his book *That Devilin' Tune*, Allen Lowe offers us a fairly balanced view of the ODJB.

*T*he Original Dixieland Jazz Band by Allen Lowe

The example of the Original Dixieland Jazz Band shows how certain notions of race and social determination can fatally contaminate our idea of history. They were a white band from New Orleans, and there is no doubt that racism, and only racism, allowed them to be the first jazz band to make records. It is also true that they virtually invented a style which came to be known, in the public mind, as Dixieland, and which tended to be seen, in stereotype, as the particular domain of reclining white men capable of playing smooth, silky lines with little feeling in front of audiences of other, similarly sloped, white men.

There is, however, much more to all this. I am convinced that, had the Original Dixieland Jazz Band been a band of African American musicians, and had they made the exact same recordings that they made in 1917 and 1918, they would today be regarded as a primary and precious source of jazz's origins. Their musicianship would be regarded as advanced for their day, and their failings would be forgiven as the typical failings of early jazz. In other words, their technical limitations would be viewed as representing a link with their communal past, and their somewhat primitive musical utterances would be seen as a sign of authenticity.

All of that would represent an accurate view of the Original Dixieland Jazz Band, whose early recordings I find to be still full of musical flesh and bone. Though the official party line has been that they were second-tier copyists of New Orleans' black musicians, nothing we hear on record after African American musicians began to record in real numbers sounds very much like anything which the Original Dixieland Jazz Band might have borrowed or stolen wholesale. If anything we hear indications that the opposite is happening, evidence of the Original Dixieland Jazz Band's influence on certain other groups of the time, like Wilbur Sweatman's and even the very interesting black group that began to accompany singer Mamie Smith on records in 1921.

Though its members recorded together in various combinations for a number of years, nothing matches the intensity and daring of the Original Dixieland Jazz Band's 1917-1918 recordings for Victor. These have been criticized as sounding too much like set-pieces, as matching other of their renditions too closely, but such memorization of solo and routine was not uncommon in the early years of jazz recording. Though it is true that these sometimes lack a certain spark of spontaneity, their routines are beautifully worked out and artfully executed. A real confirmation of their originality is that no other early group, black or white, succeeded in reproducing their singular sound, of modest, mid-range cornet, weepy clarinet, and sage-like trombone, with any accuracy. As with many great groups, it was a sound borne of a historically localized combination of technical skills and individual musical personality.

It is also true that Nick LaRocca, the Original Dixieland Jazz Band's cornetist, leader, and spokesman, later made some outrageous claims about the relative position of blacks and whites in the hierarchy of jazz creativity. Like others of his white New Orleans brethren, he was probably a racist. He was certainly a liar. But the band, like it or not, was a great one, creating a sound which not only changed the way popular music was heard in America, but which practically became encoded in our socio-cultural DNA. What would eventually become formula with certain other white groups was immediate and novel when played by the Original Dixieland Jazz Band, and in the process it established the standard for Dixieland's now-hoary repertoire. If we could erase historical memory and give the entire world of jazz critics a blindfold test, the Original Dixieland Jazz Band would be appreciated, justifiably, as not only a musical and historical landmark but as one with perpetual significance and lasting influence.

Prior to the 1917 recordings of the Original Dixieland Jazz Band, the commercial music industry was dominated by classical music. This 1919 Victrola ad features a typical classical program.
© 2002 www.arttoday.com

From *That Devilin' Tune* by Alan Lowe. Copyright © 2001 by Music and Arts Programs of America, Inc. Reprinted by permission.

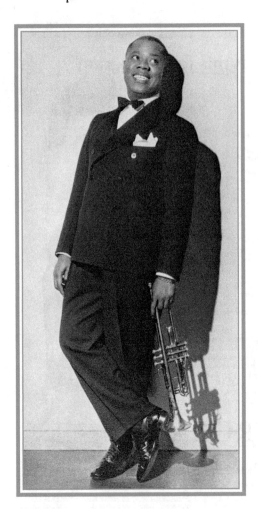

Louis Armstrong in a 1930s press photo. Courtesy of the Institute of Jazz Studies, Rutgers University

Dig Deeper

BOOK/ DOCUMENTARY

Satchmo: The Genius of Louis Armstrong by Gary Giddins

MOVIES

New Orleans; High Society

Louis Armstrong

Louis Armstrong is the most important figure in the history of jazz. He established many of the jazz traditions that continue to this day and broke down racial barriers throughout his career. After pioneering solo improvisation in the 1920s, he laid the groundwork for the swing style of the 1930s. In the 30s and 40s he was one of the first African Americans featured in films and on network radio, and he continued to be a major jazz performer until his death in 1971. One example of his continued dominance in the world of music was that in 1964 Armstrong knocked the Beatles out of the number one spot on the *Billboard* charts with his recording of *Hello Dolly*. Even today, his voice can be heard on television commercials and in the soundtracks of major Hollywood films. If you've got a happy ending in a movie, then it must be time for Louis Armstrong to sing.

For many years Armstrong's birthday has been officially listed as July 4, 1900. He liked to call himself a "child of the American century."[1] In fact, he was actually born on August 4, 1901, but as a young man he kept changing his birthdate to make himself seem older to the musicians with whom he was working. He was born in New Orleans to an extremely poor family and grew up in a very rough part of town called The Battlefield. At the age of 11, Louis was placed in a boys home in New Orleans after firing a pistol into the air to celebrate New Year's Eve. He joined the band at the boys home, and made very rapid progress as a young cornet player. Later, Louis spent time with New Orleans cornet legend Joe "King" Oliver. Much of Armstrong's early knowledge came from the great jazz musicians living in New Orleans. Of these, Armstrong always said it was King Oliver who was most willing to help out a younger musician like himself. Louis started to play jazz in and around New Orleans every chance he got. In his late teens he began to play in bands that traveled up and down the Mississippi River. He would sometimes be gone from New Orleans for months at a time, traveling as far north as Minneapolis, Minnesota and playing jazz all the way. As previously mentioned, when King Oliver left New Orleans, many of his best jobs were passed on to Louis Armstrong. A few years later, it was Oliver who sent back to New Orleans and brought Armstrong north to Chicago.

When Armstrong joined King Oliver's Creole Jazz Band in 1922, it made for an interesting band set-up. With two cornet players instead of one, Armstrong spent a great deal of his time improvising lines that accompanied what Oliver was playing as the lead cornet. Now remember that Oliver himself was improvising most of his material. Musicians were fascinated with Armstrong's ability to improvise the perfect harmony part no matter what Oliver played. As Armstrong's style of playing became more popular, Oliver occasionally let him stretch out musically, breaking away from the standard collective improvisation format. Armstrong's amazing skill at creating a coherent, dramatic improvised musical line could not be contained for long. He married King Oliver's piano player, Lil Hardin, and it was Lil who pushed Armstrong to go out on his own.

In 1924, New York band leader Fletcher Henderson asked Armstrong to join his band. Henderson was playing society dance music with a larger orchestra, but he wanted to play more of what people were starting to call "hot" jazz. He needed a skilled improviser, and Armstrong fit the bill. Within months, all the best jazz players were imitating Louis Armstrong's dramatic and innovative styles of improvisation. Just as in Chicago, when Armstrong hit town, the music started to change. Most accounts tell us that Armstrong enjoyed playing in this prototype of a swing-era big band, but he was often frustrated with the unprofessional behavior of some of the musicians. While all of Henderson's musicians were very talented, they often drank too much, showed up late to gigs, and sometimes skipped entire jobs. Armstrong eventually returned to his wife in Chicago and started his own band.

In the years 1925 to 1928 Armstrong made a series of recordings with various collections of musicians he called Louis Armstrong and his Hot Five, and later Louis Armstrong and his Hot Seven. These Hot Five and Hot Seven recordings, as they are usually referred to, codified the art of solo improvisation. Many people view them as the true start of traditional jazz, but in reality, they are the culmination of almost thirty years of musical evolution. In many ways, these recordings laid the groundwork for the swing era, which we will consider in Chapter 4. In these recordings, Armstrong not only produced one incredible improvised instrumental solo after another, he also raised the level of jazz vocals. He had been singing off and on for several years, but these recordings represent the first time he was really allowed to demonstrate his innovative vocal style. In addition to singing the regular song lyrics with his rough, sandpaper-like voice, Armstrong was the first singer to record **scat singing**. This technique of using nonsense syllables to imitate the sound of a horn with the human voice was not uncommon among New Orleans musicians, but Armstrong was the first to put it on record. Some of these early scat vocals included *Heebie Jeebies* and *Hotter Than That*. For years, instrumentalists and singers would study, imitate, and try to interpret the music of Louis Armstrong.

Of the 65 masterpiece recordings made by these bands, incredibly, Armstrong received only fifty dollars per side with no future royalty agreement.[2] The records sold many copies in their day, and they continue to be re-released in new packaging. They truly are the basis for much of what we do in the jazz idiom to

scat singing

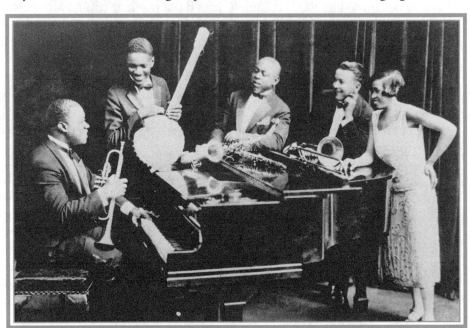

Louis Armstrong and his Hot Five in 1926. Left to right: Louis Armstrong, Johnny St. Cyr, Johnny Dodds, Kid Ory, and Lil Hardin. Note that in this relatively early photo Armstrong has already made the switch from cornet to the more powerful trumpet, which was quickly becoming the indurstry standard. Courtesy of the Institute of Jazz Studies, Rutgers University

this day, but Armstrong never saw another dime from them. You will find four recordings on your Spotify playlists that feature Louis Armstrong. These include *Potato Head Blues* and the tune *West End Blues* recorded with the Hot Seven and Hot Five respectively, the previously mentioned *St. Louis Blues* recorded with blues diva Bessie Smith, and *Back O' Town Blues* recorded with the All-Stars.

Listening Guide

Potato Head Blues (Louis Armstrong)

Example of progressive solo improvisation as pioneered by Louis Armstrong during the traditional jazz era

Recorded May 10 or 13, 1927

Performed by Louis Armstrong and His Hot Seven. Louis Armstrong, trumpet; Johnny Dodds, clarinet; John Thomas, trombone; Lil Hardin Armstrong, piano; Johnny St. Cyr, banjo; Peter Briggs, tuba; and Warren "Baby" Dodds, drums

This groundbreaking recording includes an amazing stop-time chorus from Louis Armstrong that takes place later in the track. This solo has often been imitated, including a harmonized trio version performed by the Jim Cullum Jazz Band on their tribute album to Louis Armstrong, *Super Satch*.

This piece uses a chorus structure that is basically 32 bars each time (really four groups of 8 bars each), but in the last 8-bar section the final few bars change harmony and shape slightly to reach a clear consonance or conclusion. The thematic structure is essentially A-B-A'-C. The A' simply means "prime," which indicates a return to clearly identifiable material but with some alterations. To make things more complicated, there is also one statement of the tune's verse, which is also 16 measures long. Don't worry too much about the particulars of form here; this recording is really all about Armstrong's great skill as a solo improviser.

Total time: 2:56

:00	Tune begins with the band playing the chorus in collective improvisation. The actual melody is being played by Louis Armstrong on trumpet. Notice at the end of the second 16-bar grouping (mm. 31-32) that the band drops out, and Armstrong plays a daring solo break (around :39) to begin his statement of the verse melody.
:43	Verse melody, embellished by Louis Armstrong.
1:03	32 bars of solo improvisation by clarinetist Johnny Dodds. Notice the great solo break in the middle of the chorus at mm. 15-16 and some other interesting solo break work from the rhythm section and Johnny Dodds later in the chorus.
1:46	4-measure banjo interlude leading to a stop-time trumpet chorus with an introductory solo break.
1:50	32-bar stop-time chorus featuring Louis Armstrong on trumpet.
2:33	Collective out chorus begins, but they actually play only the second half of the chorus, i.e., they start in the middle of the chorus at measure 17 (letter A') and play the last 16 measures only.

Listening Guide

West End Blues (J. Oliver and C. Williams)

Example of the blues, solo improvisation, early scat singing, and call and response
Recorded June 28, 1928
Performed by Louis Armstrong and His Hot Five. Louis Armstrong, trumpet and vocals; Jimmy Strong, clarinet; Fred Robinson, trombone; Earl "Fatha" Hines, piano; Mancy Carr, banjo; and Zutty Singleton, drums

Another of Armstrong's famous recordings, *West End Blues* has one of the most frequently copied introductions in all of jazz. The introduction was actually created by King Oliver, but over the years it has become very closely associated with Armstrong. Note the subtle interplay and gentle nuance between Armstrong's voice and the clarinet during the 3rd chorus. You should also be aware of the wide variety of volumes and the extreme range Armstrong is able to command on his trumpet.

Total time: 3:15

:00	Introduction. Solo trumpet.
:16	Head. Melody played on trumpet. Collective improvisation.
:50	Trombone solo chorus.
1:24	Call and response improvisation between clarinet and Armstrong's voice.
1:59	Piano solo chorus.
2:32	Out chorus. Collective improvisation.
2:56	Piano interlude as part of ending.
3:04	Band joins in to create ending chords.

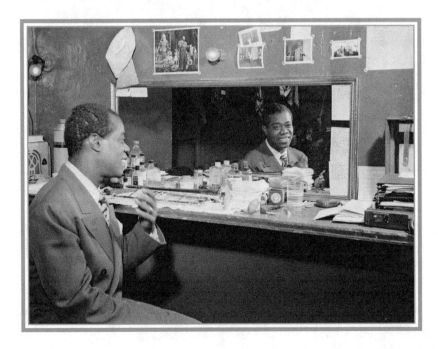

The following is the original caption for this photograph as it appeared in Down Beat *magazine in 1946: "These are the things that make up Louis Armstrong, as reflected in the mirror by Bill Gottlieb, staff lensman, in the third of his intimate studies of musical celebs in their dressing rooms. Here are his throat spray and other medications (Louie vocalizes as much as he plays trumpet, you know), the inevitable stack of handkerchiefs (he uses them by the dozen), and copies of the diet by which he lost 60 pounds in one year, distributed gratis to all over-weight friends and acquaintances."*
"Through the looking glass," *Down Beat,* v. 13, no. 15 (July 15, 1946), p. 21.
© William P. Gottlieb.
From the Library of Congress Collection.

The following three pages are reproductions from personal scrapbooks at the Louis Armstrong Archive at Queens College in New York. These contain both public and private images that offer the viewer a unique glimpse into the life and times of this great jazz artist.
Courtesy of the Louis Armstrong House Museum

Bright Spots

BY CHARLIE DAWN.

Playing "Dinah" and "Tiger Rag" in a manner that brought an applause response resembling a victory cheer at a football game, Louie Armstrong and his colored orchestra swept into town and the bright lights again at "The Show Boat," formerly My Cellar, Clark and Lake streets.

Most of Chicago's prominent band directors and their fellow musicians were in the initial audience that greeted Armstrong, who is conceded to be a wizard on the trumpet. And Louie, as a thank-you for the reception, sailed into the "Tiger Rag" number and before he had finished ten choruses had been completed, each in a different style. He took the highest of notes on the trumpet with ease and gave the visiting musicians something to think about in the line of "blue" chords.

With Armstrong and his organization on the stage, The Show Boat becomes one of the town's "late" spots, most of the activity taking place after midnight. It bids fair to become the after-theater rendezvous of stage celebrities and musicians because the Armstrong band is bringing something in dance music back to Chicago that has been lacking for a long time.

The Show Boat is under the management of Ralph Burke, who has operated many other popular cafes here. The combination of Armstrong's "torch" tunes and the service under Burke should keep The Show Boat in favor for many weeks to come.

Louis Armstrong
And His
Recording Orchestra
The King of Kings of Jazz
The World's Greatest Cornettist, Barring None

His red-hot music burns up the microphone with vibrant blues. Featured on several coast networks, talking pictures and vaudeville.

ONE NITE ONLY
Sunday, May 31st

SAVOY PACKED TO WELCOME ARMSTRONG

Louis Armstrong, direct from the southland, where he has appeared in all of the largest theatres, hotels, dined and wined by his thousands of friends, honoring him as the "King of Trumpeters," was at the Savoy Ballroom on Thursday night of last week and just about 5,000 souls danced and listened to him play the late song hits and jazz numbers.

At times it was so crowded, many were only able to reel and rock as Louis played the trumpet in a style most unique, singing and dancing at the same time, producing a melody that is impossible to duplicate. The dance fans roared with pleasure. They yelled for more and Louis gave it to them—the "boys" sang and did stunts that were hard to beat. Mr. Armstrong is an outstanding orchestra leader and his value to the band is recognized by being routed over the RKO circuit in all the large cities of the country. Little Joe Lindsay is traveling with "Louie."

Erskine Tate and his orchestra showed their ability to please, also, for they too played a brand of music that everyone enjoyed. They are calle dthe dispensers of harmony and rhythm and their music causes the Savoy to be packed every Sunday night.

It was a great night for Mr. Armstrong and the people of Chicago showed how much they loved him by turning out in such large numbers. According to the crowds there is no such thing as depression among dancers at least.

VARIETY

Disc Reviews
By BOB LANDRY

Louis Armstrong

(Okeh 41454) Hottest of the hot trumpeters, model of innumerable collegiate orchestras, a consistent recorder and a good seller. Armstrong herewith offers his trusty cornet alone and in feverish tremolo. His solo efforts concern themselves with "Dear Old Southland" and "Weather Bird." Both are remarkable demonstrations of his superior management of the three-finger clarion. As novelties and for the study and delight of his numerous followers it's certain to be a popular release.

Disc merchants will know their trade and feature accordingly.

LOUIS ARMSTRONG ORCHESTRA
Dance Music
Showboat Cafe
WIBO, Chicago

There's a head man in every show and nobody's going to take the honors away from this colored boy when it comes to tooting a trumpet. Armstrong was brought here from the Coast recently by Johnny Collins and in two weeks on the air shows promise of becoming a big fav.

Armstrong and his band broadcast from the Showboat, a cellar spot in the Loop, formerly known as "My Cellar." Doesn't make any difference whether it's a theatre or cafe, Armstrong will hold his own anywhere. He has a style bordering on the freakish when it comes to hitting top notes on the instrument, and with it a lowdown and blue crooning voice.

Armstrong's shuffling and personality is of course concealed behind the mike, but his trumpet solos make up for everything. Not unusual for him to go on a tear and run off 20 or 30 choruses to a high fevered pitch. One of his best numbers is "Rocking Chair Blues," which with repetition should become popular on the air. Armstrong's repertoire is elastic. Requests are meat to him.

Armstrong is conceded by dance bandmusicians to be the top trumpeter of them all. He doesn't go well out here because the kind of music Chicago is also a definite bet.

JOHN COLLINS PRESENTS

Louis Armstrong
"King of the Trumpet"
IN PERSON

And His Recording Orchestra

Hear America's Outstanding Colored Artist and
His Famous Aces

ONE DAY ONLY

SATURDAY, JUNE 13

MATINEE, 4 O'Clock
Admission, 50c

NIGHT, 2 PERFORMANCES, 7 and 8:45
Admission, 75c

Lincoln Theatre

N. O. La. 31

MAKING NEW ORLEANS
LOUIS ARMSTRONG AND HIS RECORDING ORCHESTRA
EVERY NIGHT
SUBURBAN GARDENS
New Orleans Most Popular
TEMPERATURE 68° — RESERVATIONS
CEDAR 1113
NO COVER CHARGE

Mr. and Mrs. L. Washington entertained on Thursday at a ... eon complimenary to Mr. ... Jackson, the trombone pla... Louis Armstrong's orchest... their residence, 3314 Short... Miss O. Dupaty was there a... ly as usual. They also enter... Mr. Gilbert Young and his ... king. *N. O. La.*

Connie Immerman halted Louie Armstrong's opening at the Suburban Gardens in New Orleans when he notified the union that Louie had jumped a New York contract. Louie, according to Immerman, was supposed to have opened at Connie's May 1, but instead played the Showboat in Chicago. Difficulties were...

Louis Armstrong's recording orchestra will waft torrid dance tunes...

Paris has a craving for "Race" phonograph records, says a correspondent. Recording companies can't supply enough of Louie Armstrong's torrid tooting and Duke's ferocious jungle notes ala disc.

We believe in giving credit where its due...and Earl Dalton has it coming...he brought Armstrong and his ensemble to town with just about everybody against the idea...you know the results...and Earl deserves all the credit...however he is not resting on his laurels but is lining up to follow...

| EASTER GREETINGS From LOUIS ARMSTRONG | ONE WEEK ONLY | **PEARL** THEATRE 21st ST. & RIDGE AVE. | ONE WEEK ONLY | EASTER GREETINGS From LOUIS ARMSTRONG |

LOUIS ARMSTRONG

KING OF JAZZ
LOUIS ARMSTRONG
—IN PERSON—
Direct From Chicago With His Own Show

12—BEAUTIFUL BROWN SKIN GIRLS—12

LOUIS ARMSTRONG OFFERS $5000.00 IN CASH
to any person who can hit as high a note as he can and hold same. This offer holds good during Mr. Armstrong's engagement at the Pearl Theatre Week of April 21st.

ONE WEEK ONLY

COMING WEEK OF APRIL 28th
ETHEL WATERS
IN PERSON

Scenery for this show has been specially designed by JACK FAY

SEE and HEAR
200 COLORED STARS 200

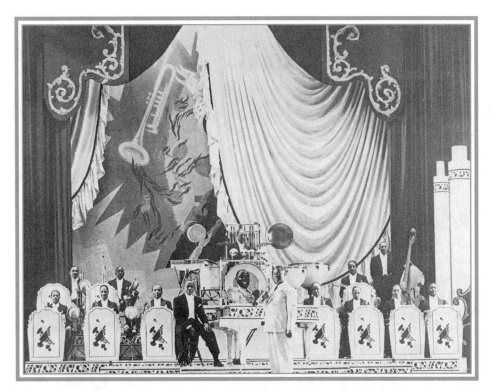

As swing and big band styles became more popular in the 1930s, Armstrong fronted a series of larger groups. He continued to make great recordings, but more and more he focused on popular tunes. No matter how commercial the piece of music, he still managed to add his unique jazz touch to the music. He enjoyed great commercial success for a time, both on radio and in film. In fact, he was the first African American featured on a network radio show. As successful as he was, his bands were eclipsed by more popular groups of the day including bands led by Duke Ellington, Count Basie, and Benny Goodman. In the 1940s, Armstrong returned to the small band format. For the rest of his life, he would perform around the world with some of the finest and highest paid musicians in the business. He called all of his bands after 1946 Louis Armstrong and His All-Stars. Eventually, Armstrong and the All-Stars were sent around the world as musical ambassadors for the U.S. government's Department of State. Perhaps one of the most overlooked aspects of Armstrong's career is his early work in the civil rights movement. Long before the serious racial conflicts of the 1960s, Armstrong was using his wit, charm, and talent to knock down many of the racial barriers he faced. You can hear Armstrong perform with the All-Stars on a song titled *Back O' Town Blues*, which can be found on Spotify.

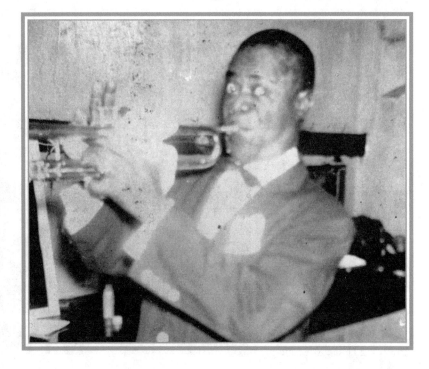

Listening Guide

Back O' Town Blues (L. Armstrong and L. Russell)

Example of a classic performance by Louis Armstrong and His All-Stars

Recorded September 28, 1955

Performed by Louis Armstrong and His All-Stars. Louis Armstrong, trumpet and vocals; Barney Bigard, clarinet; Trummy Young, trombone; Billy Kyle, piano; Arvell Shaw, bass; and Barrett Deems, drums

This tune, a standard 12-bar blues, was a regular feature on Armstrong's concert tours for many years, and each performer's comfort level with the material is evident in this relaxed, flexible, yet polished performance. Although the riffs have been worked out over 100s of live shows, the band has an amazing ability to make them sound freshly improvised. The vocal call and response between Armstrong and several of the other band members was different for every show, with each man often saying slightly different things to add extra humor to the performance and make the other band members laugh on stage. Finally, make sure you listen closely for the added call and response between Armstrong's vocals and the various solo instrumentalists as the choruses go by. This is very sensitive improvisation with the specific goal of enhancing, but never overshadowing, the vocal line.

Total time: 3:47

:00	Classic 4-bar piano introduction.
:14	Collective instrumental chorus with trumpet lead.
:57	1st vocal chorus with improvised trombone backing and vocal responses.
1:36	2nd vocal chorus with improvised clarinet backing and vocal responses.
2:17	3rd vocal chorus with a prearranged riff played by the band.
2:57	Out chorus with trumpet embellishment of the original melody, clarinet improvisation, and a prearranged trombone riff for most of the chorus.

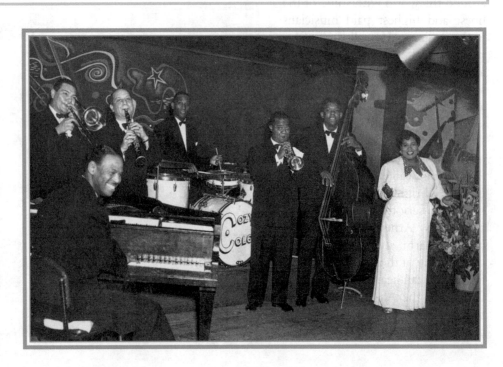

Classic nightclub photo of an early version of the All-Stars. L-R: Earl "Fatha" Hines, piano; Jack Teagarden, trombone; Barney Bigard, clarinet; Cozy Cole, drums; Louis Armstrong, trumpet and vocals; Arvell Shaw, bass; and Velma Middleton, vocals.
Courtesy of the Louis Armstrong House Museum

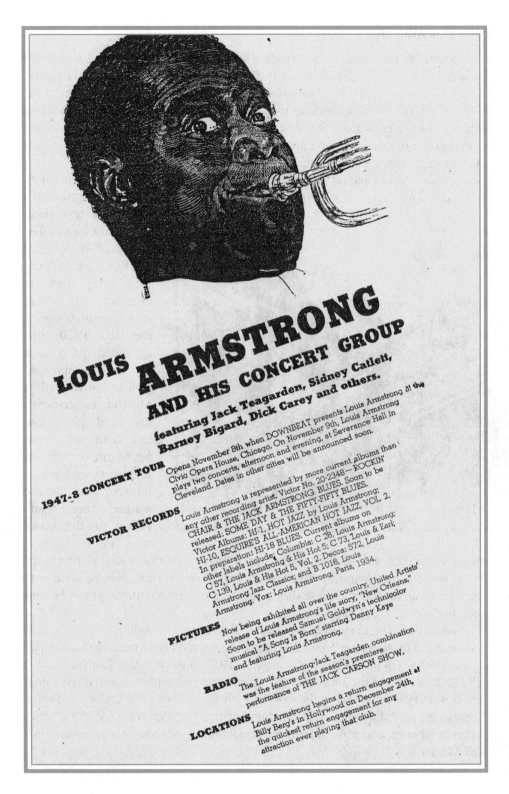

Page taken from Louis Armstrong's 1947 press and promotional packet as distributed by Joe Glaser's Associated Booking Corp. The booklet ran over 25 pages and included concert reviews, press clips, biographical information, and press photos. This packet covers the first full year that Armstrong was on the road with his All-Stars. Originally appeared as an advertisement in Down Beat Magazine

Jelly Roll Morton

As you can tell from the two reading selections in Chapters 2 and 3 from the book *Mr. Jelly Roll*, Ferdinand "Jelly Roll" Morton was a true American original. A Creole of Color and a New Orleans native, Morton was at the epicenter of the birth of jazz. In fact, he sometimes took sole credit for creating the art of jazz, but, while it makes a great story, it didn't quite happen that way. Certainly he was one of the earliest pioneers of true improvisation, and many historians point to him as the first important jazz composer, but he didn't do it all by himself.

As you read in Chapter 2, Morton worked as a piano professor playing both ragtime and early jazz, along with other light classical music. He later formed a very important traditional jazz band called Jelly Roll Morton and his Red Hot Peppers. This group made an excellent series of jazz recordings during the later 1920s that expanded the concept of both improvisation and orchestration. Morton insisted that his band play clean and crisp, and while he wanted everyone to have space for pure improvisation, he also wanted more organization in the music than was common at

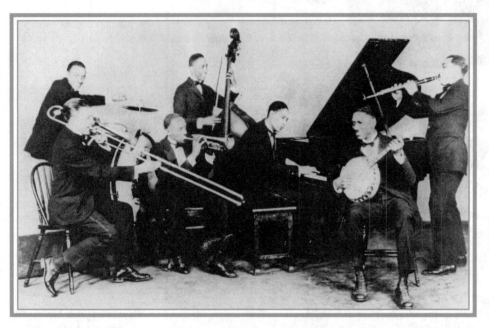

Classic photo of Jelly Roll Morton and his Red Hot Peppers. Left to right: Andrew Hillaire, Kid Ory, George Mitchell, John Lindsay, Jelly Roll Morton, Johnny St. Cyr, and Omar Simeon.
Courtesy of the Institute of Jazz Studies, Rutgers University

the time. To that end, Morton wrote out arrangements that added clarity to the music without destroying the freedom to improvise. In particular, he wanted to hear clean solo breaks, and these short, one- or two-bar solo interruptions became a regular feature in his music.

From 1926, you have an exciting Red Hot Peppers recording on your Spotify playlist titled *Black Bottom Stomp*. As the swing era took over from traditional jazz styles, Morton fell into relative obscurity. In 1938, historian Alan Lomax brought Jelly Roll Morton to the Library of Congress where he made a series of recordings that featured the artist telling the story of early jazz in both oral history and song. Lomax also played a major role in helping Morton set down his life story, which is preserved in the previously mentioned book *Mister Jelly Roll: The Fortunes of Jelly Roll Morton*.

Listening Guide

Black Bottom Stomp (Ferdinand "Jelly Roll" Morton)

Example of collective and solo improvisation and early arrangements in jazz

Recorded September 15, 1926

Performed by Jelly Roll Morton's Red Hot Peppers. Jelly Roll Morton, piano; George Mitchell, trumpet; Omer Simeon, clarinet; Edward "Kid" Ory, trombone; Johnny St. Cyr, banjo; John Lindsay, bass; and Andrew Hillaire, drums

Composer and pianist Jelly Roll Morton encouraged creative collective and solo improvisation among the members of his band, but he also believed that bands should play with clean solo breaks using some prearranged material. This recording is a solid example of great improvisations contained within a more formal structure. The tune itself follows a simple march structure, with an 8-measure first strain (repeated four times), followed by a 4-measure interlude, and then by a 20-measure trio, or chorus (repeated seven times). Many times in the first section and the chorus statements the tune is interrupted by short 2-measure solo breaks or a collective rhythm used to emphasize the end of a given chorus. Things happen so fast in this performance that some of the features listed actually occur just before or after the exact second given in the running time code.

Total time: 3:12

:00	4-measure introduction, played twice.	
:08	8-measure first strain in collective improvisation, played twice.	
:22	8-measure statement of first strain. 4 bars of trumpet solo followed by 4 bars of collective ensemble playing, played twice.	
:37	8-measure statement of first strain. Solo clarinet improvisation with special rhythmic accompaniment. Played twice, but note that the last 2 bars are a little ensemble fill prearranged by Jelly Roll Morton.	
:52	4-measure interlude, used to make a harmonic shift to prepare for the trio.	
:56	1st chorus. 20-measure collective improvisation, featuring a solo break for trumpet and trombone on measures 7 and 8.	
1:15	2nd chorus. 20-measure solo clarinet improvisation with special rhythmic accompaniment, featuring a solo break on measures 7 and 8. Note that the last 2 bars of this chorus feature an ensemble "shout."	
1:34	3rd chorus. 20-measure solo piano improvisation (rhythm section drops out). Note that last the 2 bars of the chorus feature an ensemble shout.	
1:52	4th chorus. 20-measure solo trumpet improvisation with special rhythmic accompaniment, featuring a solo break on measures 7 and 8. Note that the last 2 bars of this chorus feature an collective ensemble improvisation where the shout had been.	
2:11	5th chorus. 20-measure solo banjo improvisation featuring a solo break on measures 7 and 8. The last 2 bars of the chorus feature collective ensemble improvisation where the shout had been. Here, this little break is closer to the shout lick but still not the same as before.	
2:30	6th chorus (1st out chorus). 20-measure collective improvisation, featuring a solo break for cymbal in measures 7 and 8. Note that now the last 2 measures feature a clear return to the ensemble shout.	
2:49	7th chorus (2nd out chorus). 20-measure collective improvisation, featuring a solo break for trombone on measures 7 and 8. The tune concludes with an extra 2-bar tag to drive home the final consonance (tonic).	

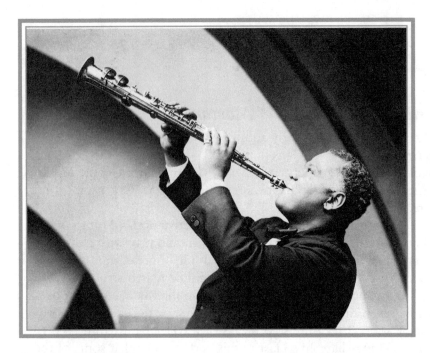

Press photo of Sidney Bechet playing soprano saxophone in 1938.
Courtesy of the Institute of Jazz Studies, Rutgers University

Sidney Bechet

A classically trained Creole musician, Sidney Bechet was another of the important early innovators of improvisation in New Orleans. Bechet started as a clarinet player but later pioneered the use of the soprano saxophone as a front-line instrument in the jazz band. He liked the sax because the sound was much more powerful than that of the clarinet. Instead of always playing the high embellishments on clarinet, Bechet sometimes liked to compete with trumpet players for the lead melodies in the band. A man of great skill but also great temper, Bechet was often in trouble with the law, both in this country and in Europe. In spite of his troubles in Europe, he spent much of his musical career overseas, and especially later in his career, European musical influences can be heard in his playing. Although often overlooked today, his improvisation skills rivaled those of Louis Armstrong.

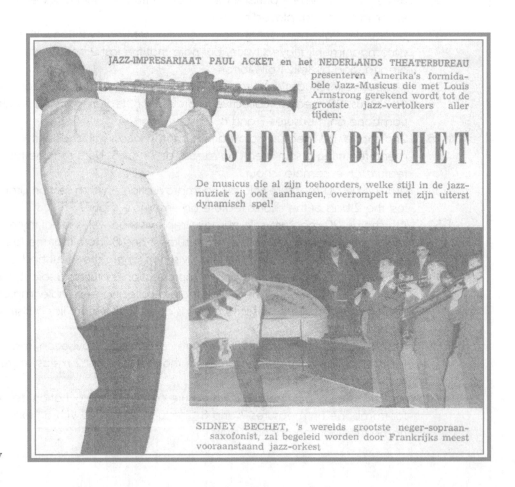

Concert flyer for a series of Sidney Bechet performances in The Netherlands.
Courtesy of Tad Hershorn at the Institute of Jazz Studies, Rutgers University

Bix Beiderbecke

In the years following the release of the Original Dixieland Jazz Band recordings, many young white musicians decided they also wanted to play jazz. Of these young musicians, cornet and piano player Bix Beiderbecke is considered by many to be the first serious white innovator in the history of jazz music. Bix lived a very short and troubled life. In Ken Burns' PBS documentary *Jazz* it's actually pointed out that Bix was one of the first white artists to really suffer the effects of a racially divided America. While it was true that black musicians weren't allowed to perform in public with a white band at this time, a white man like Bix couldn't regularly perform with a black band either. The best practitioners of the art that Beiderbecke wanted to create were black, and he was never afforded the opportunity to make music with them on a regular basis.[3] Today, Bix Beiderbecke is largely an unknown name outside of jazz circles. Nonetheless, he too was a jazz pioneer, and a tragic loss with his early departure from this earth. Had he lived into the 1960s or 70s it would have been very interesting to see what kind of music he might have created. You can hear Bix playing with saxophonist Frankie Trumbauer on the tune *Singin' the Blues*.

Cornet and piano virtuoso Leon Bix Beiderbecke. Courtesy of the Institute of Jazz Studies, Rutgers University

Listening Guide

Singin' the Blues (J. McHugh and D. Fields)

Example of a more melodic approach to improvisation in traditional jazz
Recorded February 4, 1927
Performed by Frankie Trumbauer and His Orchestra. Frankie Trumbauer, C-melody saxophone; Bix Beiderbecke, cornet; Jimmy Dorsey, clarinet and alto saxophone; Bill Rank, trombone; Paul Mertz, piano; Eddie Lang, guitar; and Chauncey Morehouse, drums

The main purpose for this example is to give you a chance to hear the melodic improvisational style of cornet player Bix Beiderbecke. The tune is a beautiful melody called *Singin' The Blues*, but you don't really get to hear the actual melody until the out chorus. The tune is a 32-bar song form, but instead of using the A-A-B-A format, it makes use of two 16-measure groups, always divided by a solo break on measures 15 and 16, halfway through the 32-bar form.

Total time: 3:00

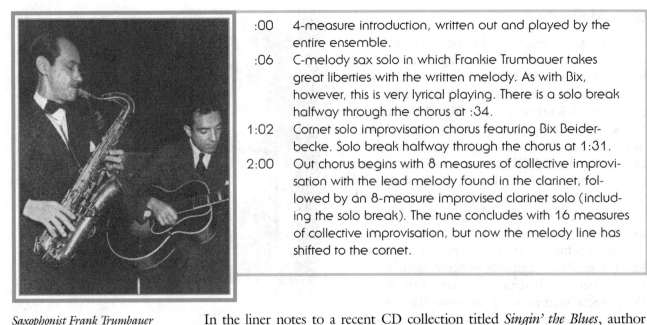

:00	4-measure introduction, written out and played by the entire ensemble.
:06	C-melody sax solo in which Frankie Trumbauer takes great liberties with the written melody. As with Bix, however, this is very lyrical playing. There is a solo break halfway through the chorus at :34.
1:02	Cornet solo improvisation chorus featuring Bix Beiderbecke. Solo break halfway through the chorus at 1:31.
2:00	Out chorus begins with 8 measures of collective improvisation with the lead melody found in the clarinet, followed by an 8-measure improvised clarinet solo (including the solo break). The tune concludes with 16 measures of collective improvisation, but now the melody line has shifted to the cornet.

Saxophonist Frank Trumbauer with guitarist Eddie Lang. Courtesy of the Institute of Jazz Studies, Rutgers University

In the liner notes to a recent CD collection titled *Singin' the Blues*, author Michael Brooks paints a good portrait of Bix Beiderbecke's short life.

Dig Deeper

WEBSITE

🎺

www.bix beiderbecke.com

BOOK

🎺

Bix: Man and Legend by Richard Sudhalter and Philip Evans

Bix Beiderbecke: Liner Notes from *Singin' the Blues* by Michael Brooks

He was a character out of an F. Scott Fitzgerald novel: the hair pomaded, center parting straight as a two-lane highway, the rosebud mouth proffering a sensitivity bordering on weakness. His musical contemporaries—the Howdys, Itzys, and Chaunceys—are curios frozen in the time frame of a John Held cartoon, while their equally quaintly named friend has become an American musical legend.

There have been other jazz trumpeters who died tragically young and certainly many others (Louis Armstrong is the prime example) whose overall musical achievements put Bix in the shade. But I don't believe that there is anyone in jazz history who possessed such a vibrant, pure tone on his instrument, the beauty of which transcended its surroundings and made the listener forget the often awful material he recorded.

Bix Beiderbecke was an icon, the stuff that legends are made from, and the myths surround him like dust storms blowing across the flat Iowa plains of his childhood. He was flaming youth snuffed out by the evils of commercialism. His musical partner, the saturnine Frank Trumbauer, manipulated him into joining the elephantine Paul Whiteman Orchestra, crushing his soul. He couldn't read music, and the complex big band arrangements led to the endless drinking until an insensitive Whiteman threw him on the scrap heap. He hated the musicians he had to work with and yearned for the freedom of a small-group Dixieland with such kindred spirits as Eddie Condon, Bud Freeman, et al. Like the aforementioned dust storms these stories are simply hot air. The truth—and the man—are more complex.

Leon Bix Beiderbecke was born in the Iowa city of Davenport on March 10, 1903, son of second generation German immigrants. Another myth is that he was actually christened Leon Bismark, the "Bix" being an affectionate diminution. Actually, the sobriquet was well established before this 1903 vintage was uncorked. His father was known by the same nickname, and when his older brother, Charles, was a baby he became known as "Little Bix" and his father as "Big Bix." The church's recognition of the name did little to dispel the confusion which lasted until Bix left home to go to college.

Like most middle-class homes in those precanned entertainment days, there was music in the home, but although the ground was fertile nothing could account for the young Bix's almost supernatural talent. At the age of three he was picking out tunes with one finger on the piano, and his pitch was perfect. Such talent can rarely be harnessed by conventional methods, and when his first piano teacher found he was duplicating the lessons by learning the tune by heart, rather than reproducing it from the score, he quit in disgust.

Early in 1919, Bix's elder brother, Charles, came back from the war and with his gratuity bought a Columbia Graphophone© and some records, including a batch by the Original Dixieland Jazz Band. They acted on Bix like a siren call. He would throw back the speed regulator to its slowest notch, duplicate the cornet part, note for note, on the piano, then transcribe it at its correct speed and pitch. Inevitably he went one stage further in emulating his idol, the ODJB's Nick LaRocca, and borrowed a disused horn from a classmate. Bix learned the hard way, playing around with the valves until he found the notes he wanted and developing a totally unorthodox method of fingering that caused him to be the despair of trained musicians.

Every summer the riverboats would come into Davenport from the south, and in August of 1919 the 16-year-old wandered down to the dock where the S.S. Capitol was moored and heard an 18-year-old horn player named Louis Armstrong. Borrowed plumage was no longer sufficient. Bix had to have a horn of his own.

The next two years saw him gaining valuable experience playing high-school dances, sitting in with local and visiting bands, and occasionally traveling to neighboring towns with them. At first there were groans when "that Beiderbecke kid" diffidently asked if he could sit in. Soon his presence meant "house full" signs on the door.

But according to his surviving contemporaries, his first love was still the piano. "Bix practiced the horn when he was on the bandstand," one of them remarked. "But he was never far away from a piano, always working out strange harmonic progressions and experimenting." Like most adolescents Bix was untidy, absentminded, and infuriatingly casual about things held sacred by his elders. It was only his essential sweetness of nature and utter unworldliness that saved him from the wrath of family and friends.

By 1921, his poor high-school grades forced his parents to send him to Lake Forest prep school in Illinois, where they hoped that the near-military discipline would wean him from the evils of popular music and prepare him for

college—preferably Princeton. It was like imprisoning a pyromaniac in a coal mine. All the ingredients for a conflagration were there; the only thing needed was to transfer the raw materials to an appropriate spot. That spot was Chicago, some 35 miles distant. It was there that Bix and like companions heard the New Orleans Rhythm Kings, with Paul Mares on cornet and Leon Roppolo on clarinet, and King Oliver's Creole Jazz Band, with Louis Armstrong on second cornet. He also made his first acquaintance with Hoagy Carmichael, then a sophomore at Indiana University.

By the summer of 1922, the Lake Forest authorities had had enough. Frequent warnings and probation orders failed to curb the musical and alcoholic excesses of young Beiderbecke, and they reluctantly expelled him in May of that year. Bix's family didn't exactly wash their hands of him, but somehow stood back and let fate take over. He returned to playing with local bands, falling afoul of various musicians' unions because he couldn't read well enough for membership, which precluded him taking full-time professional jobs in other states. In the fall of 1922 he made the longest trip of his young life, to Syracuse, New York, for a two-month engagement. During that time he visited New York City where he finally met his idol, Nick LaRocca. By all accounts the encounter was not a happy one. Like many secondrate talents, LaRocca was a mean-spirited, jealous man, and in later years he was supposed to have said: "Beiderbecke stole everything from me." It was like a quarry owner accusing Auguste Rodin of the same crime.

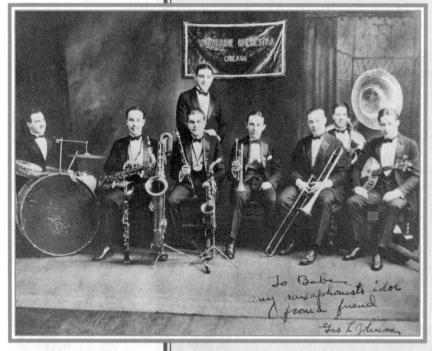

The Wolverine Orchestra featuring Bix Beiderbecke. Left to right: Vic Moore, George Johnson, Jimmy Hartwell, Dick Voynow (standing), Bix, Al Gande, Min Leibrook, and Bob Gillette.
Courtesy of the Institute of Jazz Studies, Rutgers University

In 1923, he formed a band with two ex-Academy students, then at Northwestern U. Calling themselves the Wolverines, the seven-piece group gigged around the Midwest for months until, in February of 1924, they drove to Richmond, Indiana, to make their first records. Heard today, the band does not stand comparison with their white counterparts, the New Orleans Rhythm Kings—save for one member. Bix is like a thoroughbred stallion yoked to a brewer's dray.

Such talent could not be held down for long. The following year he left the group to join Jean Goldkette's orchestra. His replacement, Jimmy McPartland, remembers Bix welcoming him with the utmost kindness and buying him a new cornet as a farewell gift.

The Goldkette engagement was not a success. Bix had still not mastered musical fundamentals, and the tough arrangements gave him trouble. Worse, the band recorded for Victor, and their A&R man,

Eddie King, hated jazz and took an immediate dislike to Bix. Goldkette fired him at the end of the year with the sound advice to brush up on his reading.

French-born Goldkette was a schooled classical musician who latched on to the commercial possibilities in American dance music and jazz. Working out of the Greystone Ballroom in Detroit, he controlled a number of bands and during the summer months sent contingents of his musicians to various holiday and lake resorts in the U.S. and Canada, while in the fall they would return to play extended engagements in the larger cities. Goldkette rehired Bix in July 1925 to join a group led by trumpeter Nat Natoli. A few weeks later a musical phenomenon from the Ray Miller Orchestra joined them. His name was Frank Trumbauer.

Trumbauer was as unlike Bix mentally as Laurel was to Hardy physically, but together they formed one of the most successful partnerships in musical history. Born in Carbondale, Illinois, in 1901, Trumbauer was part American Indian. His mother worked as a pit pianist, and the child spent much of his early life in theatrical surroundings. Another musical prodigy, he was proficient on piano, trombone, flute, and violin, but finally settled on the now obsolescent c-melody saxophone, then very popular with amateur musicians as it was pitched in the same key as the piano. A strong willed, taciturn man, "Tram," as he was nicknamed, knew what he wanted from an early age and let nothing stand in his way. At one time he worked as a locomotive fireman and always carried his instrument with him, practicing on the footplate and in the locomotive roundhouse. By the time he joined Goldkette he was a force to be reckoned with, and his solo on the Benson Orchestra recording of "I'll Never Miss The Sunshine" was as much a yardstick to young reedmen as the Charlie Parker Dials, 25 years later.

The Goldkette men were all top flight musicians who could hold their own in any company, but Bix and Tram were individualists. These oddly disparate figures took an immediate liking to

one another, and their diametrically opposed musical styles somehow worked together. Bix, sloppy, disorganized, and easily led, only showing his innate passion and intelligence through the bell-like tones of his cornet; and Tram's dry, vibratoless sax style, years ahead of its time, reflected the man: disciplinarian, responsible family provider, solid citizen with a surprisingly zany sense of humor that showed up at the most inappropriate times. For the rest of Bix's short life, Tram acted as a concerned, sometimes angry elder brother, and it was no fault of his that Bix slipped from the world. Although he had a successful career with

Headlines from a 1938 tribute to Bix Beiderbecke published in Metronome *magazine.* Courtesy of Tad Hershorn at the Institute of Jazz Studies, Rutgers University

Paul Whiteman after Bix's death and latterly formed his own big band, he was never the same musically. He was like an athlete who had lost a limb.

Although Goldkette's orchestra was considered to be the top outfit in the Midwest, the East had its own champions and a confrontation was inevitable. In 1926 Goldkette came to New York to appear at Roseland opposite Fletcher Henderson in a much-heralded "Battle Of The Bands." The latter group included Rex Stewart, Tommy Ladnier, and Coleman Hawkins.

Bill Priestley, then an architectural student, remembers the opening night. "The audience was a sea of white dress shirts.

Main gate at the annual Bix Beiderbecke Memorial Jazz Festival on the riverfront in Davenport, IA. Photo by James Shearer

No, it wasn't the socialite crowd. They were all musicians from other bands on their way to their jobs, just hoping to catch the first set. That's the sort of reputation these two bands had."

Rex Stewart picks up the story: "We were all very cocksure, up against a bunch of hicks from the sticks. Remember, we had those Don Redman arrangements and we tore into 'Stampede' I think it was and stood the place on its ear. There was no way they could top us."

Trumbauer, Goldkette's musical director, knew he had a problem on his hands if he tried to emulate them, so he threw them a curve. Bill Priestley: "Tram kicked off with a Bill Challis arrangement 'Valencia' which was a 6/8 one-step. The Henderson band started to laugh when they heard the corny old tune, but they stopped laughing when they heard the unison playing on what was a diabolically difficult chart. Christ! that brass section was like a machine-gun barrage, spraying out notes and cutting down the opposition. Then Don Murray turned to Tram and said: 'Let's give it to them with both barrels,' and they lit into 'Tiger Rag' and blew the place wide open. Bix was playing such a fierce horn that the audience was practically elevated by the heat, then Tram would cool them off with that bone-dry tone."

Rex Stewart: "They creamed us. Those little tight-assed white boys creamed us. Don Redman said those Challis charts cut us to ribbons. I don't like admitting it, but I was in the band and we were whipped!"

The success of the Roseland gig ultimately proved to be the band's undoing. Salaries and egos began to inflate, new men were hired, and internal strife began to tear the organization apart. In 1927, a severe slump hit the automotive industry, and Goldkette was unable to meet the massive payroll. An engagement at Atlantic City only postponed the final curtain. One of the best white jazz bands in history was bankrupt.

Trumbauer was approached by Paul Whiteman who was anxious to have him and Bix join him, but before a decision was reached bass saxophonist Adrian Rollini came up with a counter-offer. A new night

spot called the Club New Yorker was about to open in Manhattan and Rollini had the job of musical director. He had assembled a roster of impressive talent including trumpeter Sylvester Ahola from the Paul Specht Orchestra; multi-reedman Bobby Davis from the California Ramblers; and New York's busiest freelancers, violinist Joe Venuti and guitarist Eddie Lang. It was a dream orchestra: musicians loved it but couldn't afford to pay the high cover charge. New York's club clientele preferred their music on the sweeter side. Within a month the club had folded and Bix and Tram were at liberty again. But not for long.

Traditional Jazz Today

In the 1950s, perhaps partially as a reaction to bebop, traditional jazz (or dixieland, as it was mostly referred to at the time) enjoyed a great resurgence in popularity. Throughout the country professional and semiprofessional groups sprang up, usually playing a very raucous style of dixieland called "gutbucket." Today, many jazz festivals around

the country focus exclusively on traditional jazz styles (see Appendix B). There are even dixieland cruises that feature almost nonstop music over a three-to-seven day cruise. Some of the most popular bands, including the Dukes of Dixieland from New Orleans and the Jim Cullum Jazz Band from San Antonio, Texas, are full-time bands. Beginning over 30 years ago, Jim Cullum's group was featured on a weekly National Public Radio show called *Riverwalk, Live from the Landing*, with most of the shows originating from Cullum's nightclub on the Riverwalk in San Antonio, Texas. Sadly, that club closed a few years ago, but versions of the Jim Cullum Jazz Band continued to play regular gigs at various nightclubs and other music venues in San Antonio until the untimely passing of the band's leader in the fall of 2019. The legacy Jim Cullum left behind, however, will live on for many years to come. The radio show continues to air in syndication on some public radio stations, and the entire collection of almost 400 radio broadcasts are now housed in the library at Stanford University. This library hosts an extensive website, where many of the radio shows can be heard in their entirety, along with a great deal of other bonus content that cannot be found anywhere else. You'll find the *Riverwalk* archive website address in the *Dig Deeper* box in the margin of this page. The following listening guide features the Jim Cullum Jazz Band performing a version of Louis Armstrong's *Tight Like This* that honors the history of this music and brings new life to the genre at the very same time. Around this country and throughout Europe and even in Japan, many amateur and professional musicians spend a great deal of their spare time keeping the art of traditional jazz alive. While they often derive some income from their efforts, it is mostly the musicians' love of this musical style and desire to preserve a piece of history that keeps them playing.

The Jim Cullum Jazz Band. Left to right: Kenny Rupp, trombone; Ron Hockett, clarinet; Jim Cullum, cornet and leader; Hal Smith, drums; Steve Pikal, bass; Jim Turner, piano; and Howard Elkins, banjo.
Photo by William Carter
Courtesy of Jim Cullum

Dig Deeper
WEBSITES

*www.jimcullum.com
riverwalkjazz.
stanford.edu*

Listening Guide

Tight Like This (Langston A. Curl)

Example of a contemporary traditional jazz ensemble
Recorded May 2005
Performed by the Jim Cullum Jazz Band. Jim Cullum, cornet and leader; Ron Hockett, clarinet; Kenny Rupp, trombone; John Sheridan, piano; Howard Elkins, banjo; Don Mopsick, bass; and Michael Waskiewicz, drums

At the time of this recording, this band played together six nights a week at a club called The Landing, which was on the Riverwalk in downtown San Antonio, Texas. As you heard with the Louis Armstrong track *Back O' Town Blues*, one of the amazing things about performing live all the time is that a band of great musicians will develop a very relaxed yet polished feel while maintaining a high level of solid improvisation. After months or even years of improvising together, musicians learn each other's styles and habits. Even when undertaking daring flights of improvisation, the individual artists have a very good idea (at least in general) of what might happen next. The performance becomes a very cohesive, intimate conversation between old friends. Note, for example, how Jim Cullum improvises little fills as one chorus comes to a conclusion and the next one begins. This is something he often does in performance, and it becomes a sort of running commentary on the music as it unfolds. No matter how many times he and the band played a tune live, it never happened quite the same way twice. The Cullum band members were masters at the art of bringing new life to old material, adding their own embellishments and new improvisations to well known traditional jazz material.

Total time: 6:13

:00	Introduction featuring Jim Cullum on cornet, followed by a solo piano interlude played by John Sheridan. This is a very faithful recreation of the original Armstrong recording from 1928.
:24	Melody played collectively by the entire band with the cornet taking the lead voice. Each chorus of this tune is 16 measures long.
1:03	Improvised clarinet solo.
1:41	Improvised cornet solo.
2:19	Improvised trombone solo.
2:57	Improvised piano solo, two choruses. Note the band's nod to older recordings. Like many early ensemble recordings featuring Jelly Roll Morton, Earl Hines, and others, the rest of the group drops out for contrast and to allow the soloist more freedom during the piano solo. In the days before electronic amplification, this also helped with balance.
4:07	Recreation of Louis Armstrong's famous improvised solo as recorded in 1928, performed with minor embellishments by Jim Cullum. From here to the end of the performance the other band members also provide a faithful reproduction of the band accompaniments as they appeared on the original Armstrong recording.
4:43	2nd chorus of Armstrong's famous solo.
5:21	3rd chorus of Armstrong's famous solo, which leads directly to a simple ending by extending the last note played.

Notes

1. *Satchmo*, Dir. Gary Giddins, (New York: CBS Music Video Enterprises, 1989), videocassette.

2. *Jazz: A Film by Ken Burns*, Episode 3 (Washington DC: PBS, 2001), videocassette.

3. Ibid.

Chapter 4

The Swing Era

It don't mean a thing if it ain't got that swing.

Duke Ellington

From 1920 to 1933 there was a federal law banning the manufacture, sale, and transportation of alcohol. Prohibition, as this period was called, was brought on by an active temperance movement that wanted to stop the consumption of alcohol in this country. As usual, when you tell people they can't have something, it only makes them want it even more. Illegal nightclubs that served alcohol, called **speakeasies**, sprang up in every major city. In a recent interview, jazz historian and critic Gary Giddins makes the point that Prohibition was one of the best things that could have happened to jazz. It created a great deal of work for musicians, as all of these clubs needed entertainment.[1] Later, when Prohibition was repealed and legal nightclubs reappeared, owners wanted to hire the hottest musical acts as they competed for business. Today, most historians discuss swing in terms of its deep musical context. In truth, this was music for dancing. People were impressed with great skills in improvisation and enjoyed listening to a good singer, but what they wanted most was music with a solid, danceable beat. The best bands of the swing era created a smooth, steady groove that almost anyone could dance to. The swing era

speakeasies

Poster supporting Prohibition.
© 2002 www.arttoday.com

represents jazz at its most popular. From about 1930 to 1945, jazz was America's major form of popular music. Even during the Depression, jazz was a $100 million industry, employing between thirty and forty thousand musicians across America.[2] For many older people today, the big band sound brings back memories of World War II. This music, and the dancing associated with it, functioned as an escape from the harsh realities with which they were forced to cope. The end of the swing era coincided with the end of the war and the rise in popularity of solo vocalists including Frank Sinatra and Billie Holiday.

Swing and Big Band Techniques

swing

orchestration
arranging

riff

sweet

Paul Whiteman

Jazz itself was in transition during the late 1920s as traditional jazz styles expanded and gave way to the more modern **swing** style. Swing rhythms sound more relaxed when compared to dixieland rhythms, and swing music tends to focus on a smoother, four-beat rhythm with the syncopated rhythms falling more on the backside of the beat. In addition to a change in style, many of the bands were growing larger. With all of these extra musicians, the art of **orchestration**, or **arranging**, became an integral part of the jazz scene for some bands. Composers and arrangers would create musical road maps, or charts, for the musicians to follow. In these larger bands, collective improvisation was replaced by these written arrangements, but the best bands and their arrangers would create music that left a great deal of room for solo improvisation. To back up these improvised solos, and sometimes to create an entire tune, composers and arrangers would often use "riffs." A **riff** is a short, repeated, rhythmic and/or melodic phrase.

While improvised traditional jazz was reaching its high point toward the end of the 1920s, a new style of jazz was beginning to take shape in New York City. Large dance bands, often called **sweet** bands, were playing syncopated dance music based on ragtime and traditional jazz styles. The music was much more commercial, however, often with little or no improvisation. While sweet music is most closely associated with white bands, both black and white bands were playing this style. Even bands such as those led by Fletcher Henderson and Duke Ellington got their start playing this type of society music to some extent. Perhaps the best example of a sweet band is the group led by **Paul Whiteman**. Whiteman was a classically-trained musician who fell under the spell of jazz. His goal, however, was not to imitate the great black musicians he heard, but rather to adapt the jazz style to his strictly organized, classical view of how music should be performed. His larger orchestra format was typical of the society dance bands of the day. Saxes, trumpets, and trombones, along with a rhythm section, set the stage for the layout most big bands would use for years to come. On Spotify, listen to the Whiteman band performing the tune *Happy Feet*.

Listening Guide

Happy Feet (M. Ager and J. Yellen)

Example of the sweet band style of the late 1920s and early 1930s
Recorded February 10, 1930
Performed by Paul Whiteman and His Orchestra. Paul Whiteman, leader; Bernie Daly, clarinet and soprano sax; Izzy Friedman and Red Mayer, clarinet and tenor sax; Frank Trumbauer, clarinet, alto, and C-melody saxes; Charles Strickfaden, clarinet, oboe, soprano, and baritone saxes; Chester Hazlett, alto sax; Charlie Margulis, Harry Goldfield, and Andy Secrest, trumpet; Boyce Cullen, Bill Rank, Wilber Hall, and Jack Fulton, trombone; Kurt Dieterle, Otto Landau, Matty Malneck, Mischa Russell, and Joe Venuti, violin; Roy Bargy, piano; Mike Pingatore, banjo; Eddie Lang, guitar; Min Leibrook, tuba; Mike Trafficante, string bass; George Marsh, drums; The Rhythm Boys (Harry Barris, Bing Crosby, and Al Rinker), vocals; and Lennie Hayton, arranger

Paul Whiteman led a band of top-flight musicians, and a few of them were fine jazz improvisers as well. Unlike many of the typical sweet bands of the day, Whiteman's charts did actually include improvisation from time to time, though never as much as the band's great improvisers, including Joe Venuti, Eddie Lang, Frankie Trumbauer, and Bix Beiderbicke (not on this particular recording), would have liked. The style is typical of the day, with a 2-beat groove featuring the tuba pounding out beats 1 and 3 while the banjo and drums emphasize beats 2 and 4. Notice also how everyone in the band plays a rather frenetic rhythmic style, putting the heavy syncopation feel on the front side of each beat, versus the more relaxed swing style that was soon to follow from bands led by Fletcher Henderson, Duke Ellington, and Count Basie, among many others.

Total time: 2:58

- :00 Tune begins with the entire band playing an arranged version of the verse.
- :16 Statement of the chorus, played by the entire band.
- :48 Verse, played by the entire band.
- 1:04 Vocal chorus featuring The Rhythm Boys. Underneath this vocal chorus and the improvised solos that follow, pay careful attention to the licks guitarist Eddie Lang improvises to support the singers and the instrumental soloists. He was a brilliant improviser on the guitar and a man far ahead of his time. Sadly, he died due to complications following a simple tonsillectomy just a few years after this recording was made.
- 1:37 8-bar improvised sax solo by Frank Trumbauer.
- 1:45 8-bar improvised trumpet solo by Andy Secrest.
- 1:53 16-bar improvised violin solo by Joe Venuti. These three solos together constitute one entire solo chorus.
- 2:10 2-measure interlude played by the entire band.
- 2:12 Out chorus, performed by the entire band. Unlike most of the traditional jazz you studied in the previous chapter, here the out chorus is completely prearranged. There is no actual improvisation.

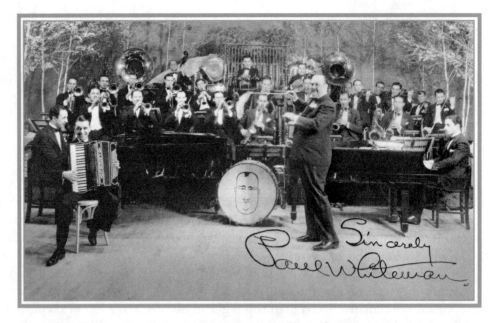

*The Paul Whiteman
Orchestra performing on the
Ziegfield Roof at the New
Amsterdam Theatre in New
York City. Noted saxophonist
Frank Trumbauer can
be seen just behind
Mr. Whiteman's shoulder.*
Courtesy of the Institute
of Jazz Studies, Rutgers
University

**typical set up for
a big band**

double

stride style

James P. Johnson

*James P. Johnson, the father
of stride-style piano.*
Courtesy of the Institute
of Jazz Studies, Rutgers
University

Although it took a little while to reach a standard size, the **typical set up for a big band** is as follows: five saxes (two altos, two tenors, one baritone), four trumpets, four trombones, and a rhythm section (piano, string bass, rhythm guitar, and drums). Some of the sweeter sounding bands also used a small string section to lend more of a classical style to their sound. In addition to playing the instruments listed above, some of the players in the band were expected to **double**, or play more than one instrument. For example, all the sax players were required to sometimes play other woodwind instruments, including clarinet and flute.

As we begin to explore the swing era, you should also be familiar with the **stride style** of piano playing. Stride-style piano players copied the written rhythmic styles of ragtime, but they increased the technical demands and, of course, improvised almost everything they played. A simple definition to remember is that the left hand plays the bass notes and the chords while the right hand plays the melody. This style was used by solo piano players including James P. Johnson, Willie "The Lion" Smith, and Art Tatum, and it was also the main style of playing used in a typical swing rhythm section. **James P. Johnson** is often referred to as the "father" of stride-style piano playing. His style had a far-reaching influence on swing era musicians, including his students Count Basie and Thomas "Fats" Waller. You can explore an excellent example of the stride style in the tune *You've Got to Be Modernistic* as performed by James P. Johnson on Spotify and described in the following listening guide.

Listening Guide

You've Got to Be Modernistic (James P. Johnson)

Example of solo stride-style piano
Recorded January 21, 1930
Performed by James P. Johnson, piano

This recording is a classic, albeit somewhat extreme, example of stride-style piano playing, but would you expect anything less from the man known as the "father" of the stride style? This piece, which Johnson composed, follows a typical ragtime or march format, but what is different here is the freedom to embellish and improvise. The work is in 2/4 time, and the basic beat is slower than the piece really feels. Each of the main sections is 16 measures long, so if you find yourself counting to 32 in each section you are actually counting twice as fast as the basic beat. The important difference from true ragtime here is that throughout the performance Johnson adds embellishments that are not on the written page. In addition, as you get into the third section of the piece, formally known as the trio, he begins to undertake a series of improvised choruses that move further and further away from the original melody. These choruses would be improvised differently at each performance. As you listen to this example, pay careful attention to the relentless bass-chord-bass-chord pattern played by the left hand that is the core element of the stride style.

Total time: 3:14

:00	4-bar introduction.
:04	Statement of the letter A theme, also called the first strain. 16 bars.
:20	Full repeat of the letter A material with subtle embellishments.
:34	Statement of the letter B theme, also called the second strain. 16 bars.
:48	Full repeat of the letter B material, again with embellishments added here and there. As the different sections go by, notice that he never plays the material exactly the same way twice.
1:05	Another statement of the letter A theme. Like most marches by Sousa and ragtime pieces by Joplin, after two statements of the letter B material there is usually a partial or full return to the letter A material. In this particular case, notice that Johnson has shifted to a higher octave compared to the first two statements and that he continues to embellish the original melody.
1:21	4-bar interlude used as a transition into the letter C material, also referred to as the third strain or the trio.
1:24	First statement of the letter C material. 16 bars total, as are all the choruses that follow.
1:40	2nd chorus, based on the letter C material but with improvised embellishments throughout. These embellishments will continue through the following choruses, with each chorus developing a unique character as Johnson explores melodic alterations and rhythmic shifts over the basic stride pattern.
1:54	3rd chorus.
2:10	4th chorus.
2:26	5th chorus.
2:41	6th chorus.
2:56	Out chorus. Johnson builds rhythmic intensity as he moves to a dramatic conclusion of the performance.

To get a better feel for what the new swing style was all about, read the following article written by Duke Ellington in 1938. Ellington created this explanation/defense of swing jazz for a short-lived British magazine called "Tops." Along the way, he offered his readers a brief overview of jazz history in general and a short biographical sketch of his own career.

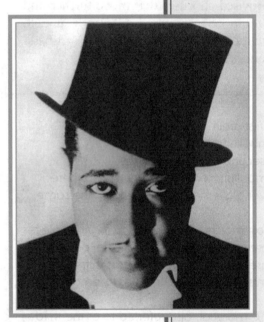

Duke Ellington.
Courtesy of the Institute of Jazz Studies, Rutgers University

*M*usic is "Tops" to You and Me . . . And Swing is a Part of It by Duke Ellington

Swing? Well, that's what they're calling it this year; and it's a good enough name. But it all goes back to something just about as old—and as natural—as the circulation of the blood. It belongs to everybody, whether he lives on Lenox, Park, or Second Avenue; whether he plays or dances or just listens. And it hasn't anything at all to do with "highbrow" or "lowbrow"—those terms are out, so far as music is concerned.

But here's a funny thing. Take a melody—either your own or one people have been singing for years, like "Annie Laurie." Turn it inside out; wrap your own ideas around it; vary the tempos. Now see what happens. If you're what people usually call a "serious" composer, what you have done is a theme and variations, and you publish it as part of an opus—or a big piece of work. But if you're a swing musician, you may not publish it at all; just play it, making it a little different each time according to the way you feel, letting it grow as you work on it. The people who like it are called alligators; the ones who don't like it say you are desecrating a fine old tune, and try to tune you off the air waves.

That's what happened in Detroit, when Tommy Dorsey was swinging "Comin' Through the Rye." Mr. Leo Fitzpatrick, general manager of WJR, had ordered that the plug be pulled out on all swing arrangements of old tunes. Swing fans howled about it; but there were lots of others who felt that the old songs were being saved from a fate worse than death.

Now what Mr. Fitzpatrick did is too bad, not because it does any harm to swing—you can tune in on Tommy Dorsey over hundreds of other stations—but because it shows a misunderstanding about the real nature of swing and, for that matter, of all music.

Sure, swing is a distinct class of music; and I'm proud to have had some part in its development. Pretty soon we'll try a definition—if you haven't had enough of them already, in a score of magazine and newspaper articles. But let's get this straight: the principles here are the same as those in all really great music. Syncopation? Beethoven was a master of that. Free improvisation? A specialty of any fine concert organist, sticking to the classics. Primarily dance music? Bach composed for the steps of his time; and some of Brahms's Hungarian dances are as frenzied as anything you'll hear in the night clubs.

The truth is, you could take all the swing bands on the earth and drop them into the middle of the Pacific; and, given civilization just as we knew it before, you'd probably have swing music back, going strong, in less than six months. Under another name, maybe; there have been lots of other names. Jazz for instance. . . .

About the time I was born in Washington, D.C., in 1899, my parents were hearing a great deal of what later came to be called jazz. This had come out of New Orleans where Negro bands, having added solemnity to a funeral by playing dirges en route to the cemetery, marched home at a quickstep touched up with their own variations. Each musician played on his own, spontaneously, yet kept in touch with the original composition. Whatever they called it then, it was something pretty close to swing.

This gets us back into history—history in which the Negro race has played a very important part. Remember that music speaks of the emotions, ranging from grave to gay. Back in the forests and on the plains of Africa the rhythm of nature surrounded the Negro, in the dropping of water from a cliff, in the ominous measured beat of the tom-tom. Transplanted to the fields of the deep South, the Negroes of the slavery period were still moved by these influences; and it is by these influences that their contribution to American music has been shaped. Because they remain so close to nature, they still express their emotions rhythmically.

And so when I came into the world, Southern Negroes were expressing their feelings in rhythmic "blues" in which Spanish syncopations had a part. As I grew to boyhood I lived through the era of rhythmic repetition or ragtime, whose most notable example—Irving Berlin's classic "Alexander's Ragtime Band"—is still going strong. My parents, natural lovers of music, had attached me to a piano keyboard; but it seems I was never destined for a conservatory. Although I liked music, I never got on with practicing lessons. Before I knew it, I would be fashioning a new melody and accompaniment instead of following the score.

Besides, I had other plans—then, I wanted to be an architect, and got as far as earning a scholarship at Pratt Institute. So look what happened: I got a job as soda jerker to make money for college; and instead of going to college I became a musician. There are probably plenty of architects anyway.

It worked out like this. My job was in a place called "The Poodle Dog." The piano player there had a leaning toward accepting free

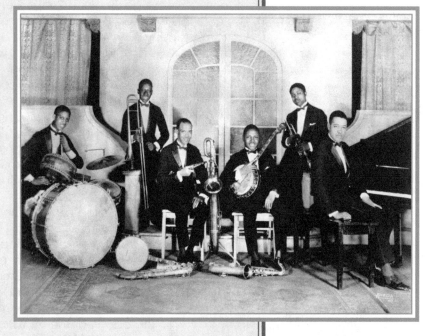

1924 photo of Duke Ellington and the Washingtonians. L-R: Sonny Greer, Charlie Irvis, Otto Hardwick, Elmer Snowden, Bubber Miley, and Duke Ellington. Courtesy of the Institute of Jazz Studies, Rutgers University

drinks; and when he wasn't able to sit up to the keyboard any longer I filled in, still improvising, composing, or otherwise making free use of some basic melody.

One day while I was playing my original "Soda Fountain Rag," doing it in a different tempo each time I played it, Oliver "Doc" Perry heard me and began coaching me for one of his orchestras. I really studied piano that time. Tussell Wooding was then directing a jazz concert orchestra of sixty pieces in a Washington theater; and—against his better judgment—he gave me a job at one of his five pianos. All went well until I came to a pause. Instead of remaining silent, as the score directed, I broke into a typical Ellington improvisation. Mr. Wooding very properly fired me.

Good "Doc" Perry gave me a job directing one of his orchestras. During 1923 and 1924 I worked with Wilbur Sweatman's band; then I came to New York with five men of my own selection. There followed some mighty hot nights and a few rather hungry dawns; and for a while it looked like no go. But in 1926 we went to work in a Broadway cellar café, The Kentucky Club, where I began to work out a new style of rhythmic playing.

Here we catch up with that history I mentioned a little while back—that trend of American music, in which Negroes have contributed so much. My own early efforts, for example, stemmed from the wild, melancholy trumpet playing of Buddy Bolden, a New Orleans Negro whose improvisations were popular about 1910. In the background, too, was William Christopher Handy's trek from Memphis to the North with his "St. Louis Blues"—and the subsequent frenzied variations by Negro bands which made hectic history and inspired many of the outstanding leaders of jazz bands to imitations.

"King" Oliver, in Chicago, had presented Louis Armstrong to a fascinated public in 1922. That amazing Negro trumpeter, who made free with any and every score offered him, had convinced young Bix Beiderbecke that his white man's trumpeting was corny. Bix adopted the Armstrong technique, became the greatest of white trumpeters, joined Paul Whiteman, and profoundly influenced all other contemporary trumpeters. That's all part of the history.

But swing, as a style, had not been discovered. I was helping to develop it, I suppose—along with lots of others. As far back as 1932—several years before anybody ever heard of jitterbugs or jam sessions—I composed, published, and played a piece entitled "It Don't Mean a Thing If It Ain't Got That Swing." Meanwhile I had built a five-piece combination around my piano, and people were coming around to listen. The music critics and Broadway commentators said it was good music; we were certainly trying hard to make it that.

Then a break came for me in the person of Irving Mills, farsighted manager of orchestra talent. Mr. Mills professionally adopted me and put me into the Cotton Club, which moved down from Harlem

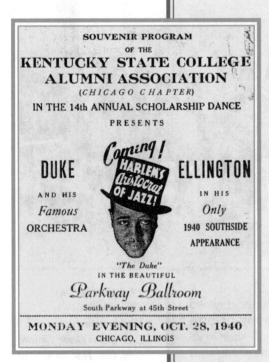

SOUVENIR PROGRAM
OF THE
**KENTUCKY STATE COLLEGE
ALUMNI ASSOCIATION**
(*CHICAGO CHAPTER*)
IN THE 14th ANNUAL SCHOLARSHIP DANCE
PRESENTS

DUKE *Coming!* ELLINGTON
HARLEM'S Aristocrat OF JAZZ!
AND HIS IN HIS
Famous *Only*
ORCHESTRA 1940 SOUTHSIDE
 APPEARANCE

"The Duke"
IN THE BEAUTIFUL
Parkway Ballroom
South Parkway at 45th Street

MONDAY EVENING, OCT. 28, 1940
CHICAGO, ILLINOIS

Program for a 1940 dance concert that featured Duke Ellington and his band. Even at the height of his popularity, Ellington continued to play "one-nighters" and did so well into the 1970s.

to Broadway not long after that. The rest is recent history: Hollywood, pictures, a tour of Europe, phonograph records, and a lot of radio.

The point of all this? I'm trying to give a rough idea of what music has meant to me personally. A rough idea, because the rewards go much deeper than publicity and contracts and European tours—pleasant as these all are. Things harder to talk about are the satisfaction of playing because it's the thing you'd rather do than anything else; the regard of many friends whom I have come to know through music.

Just a year ago, when I was celebrating the tenth anniversary of my début at the Cotton Club, there were messages of congratulation from such men as Ferde Grofé, the composer; André Kostelanetz, of the Columbia Broadcasting System; Irving Mills, who gave me my big chance; Paul Whiteman, Cab Calloway, Chick Webb, Louis Armstrong—and hundreds of others. Things like that keep me going.

For my part, I've tried to make the best contribution I could to native music—and I'm still trying. Nothing else has mattered to me. Naturally my own race is closest to my heart; and it is in the musical idiom of that race that I can find my most natural expression. Just now we're calling it swing—and that brings us to our definition.

In the beginning I pointed out that swing and classical music have principles in common. There is, however, one fundamental difference. In classical music, the composer and conductor are all-important: the score must be interpreted according to the teachings and traditions of the masters. But in swing the musician—the instrumentalist—is all-important: he must add something to the original composition and do it spontaneously—without preparation.

And that's not all. Your good swing man must have very deep feeling. If the feeling is honest, the music is honest. It is not pure showmanship that causes "Pee Wee" Russell, the great white clarinetist, to twist his eyebrows when swinging on a "gobstick" solo. Nor does Satchmo Armstrong, who learned to play a trumpet in a waifs' home, sweat over his swinging trumpet for effect. A good swinger gives everything he's got each time he goes into action.

By now you've probably worked out your own definition. Each player can give you a different one. I like the following because of its brevity: "Swing is an unmechanical but hard-driving and fluid rhythm over which soloists improvise as they play." Starting from there you can lose yourself in a whole new vocabulary used by swingers and their most enthusiastic followers, the jitterbugs.

During the past few years I have produced many samples of swing music. I can score it with a lead pencil on a piece of music paper while riding on a train. But usually I gather the boys around me after a concert, say about three in the morning when most of the world is quiet. I have a central idea which I bring out on the piano. At one stage, Cootie Williams, the trumpeter, will suggest an interpolation, perhaps a "riff" or obbligato for that spot. We try it and, probably, incorporate it.

A little later on Juan Tizol, the trombonist, will interrupt with another idea. We try that and maybe adopt it. It generally depends on the majority's opinion.

Thus, after three or four sessions, I will evolve an entirely new composition. But it will not be written out, put on a score, until we have been playing it in public quite a while. And—this is important to remember—no good swing orchestra ever plays any composition, with the same effect, twice. So much depends upon psychological and physical conditions. That's why they have to be good musicians. They must play from intuition or instinct backed by a liberal music education. If they have had a good academic schooling, so much the better. Most of my boys have gone through high school; many of them have had two or three years in college.

Advertisement announcing Duke Ellington concerts at Carnegie Hall. Note the lines stating that these performances will include the first American appearances by Gypsy guitarist Django Reinhardt.

And it's a mistake to think of swing men as a dissolute bunch of fellows. True, the unfortunate finish of the justly famous Bix Beiderbecke, who died of pneumonia in his twenty-seventh year, has been charged up to burning the candle at both ends. After a concert or dance engagement he would gather with a few cronies and a few bottles of gin and jam or jive for riotous hours. From that tragedy has arisen the tradition that all swing musicians must be bottle nurses or marijuana smokers. Well, it doesn't work out that way.

Take the Ellington organization. There's no rule against drinking, "reefing," or smoking. But we work at least twelve hours each day. We can't do our work unless we are in good mental and physical condition.

Even more absurd, I think, is the charge that swing encourages sexual immorality. One critic, a scientist, bases such a warning on comparing swing tempo with the beat of the heart—seventy-two to the minute, in each case. Well it makes it look bad for the United States Army, where the regulation marching cadence is one hundred and thirty-two beats to the minute. No; there's less of the lascivious in swing, by far, than in the seductively beautiful if more stately waltz. The Shag, the Big Apple, the Suzy Q all call for too much physical energy to leave a great deal more for romantic immoralities. Accept this, if you will, as the belief of a conductor who for many years, from his vantage ground, has seen pretty much all that is going on.

Swing, of course, is only part of the story: the young man with the horn knows something of classical backgrounds, and owes much to them. My own efforts have gone beyond swing in such compositions as "Mood Indigo," "Black and Tan Fantasy," "Sophisticated Lady," "Prelude to a Kiss," and others. I have been encouraged by the generous comments of Percy Grainger, Leopold Stokowski, and others famous in "legitimate" music. Unquestionably I have been greatly helped by studying Stravinsky, Debussy, Respighi, and Gershwin.

In my private life I am seldom eccentric. I do order fifteen suits of clothes at a time and then stick to one of them. I hate to go to bed and hate to get up. I'm pretty sure to be late one hour for a scheduled rehearsal. But I haven't changed a mannerism, an ideal, or a friend since I left Washington in 1924. My home is in Harlem, and I expect it to remain there.

It all started in The Poodle Dog; but it all adds up to a lot of satisfaction at the sharing in the achievement of the Negro race. That's why my greatest hope is that I may live to complete the opera in my mind: the story of the Negro's beginning and his migrations, both physically and spiritually. Maybe I'll call it "Boola"—maybe something else; that won't matter. If I can manage to make it worthy of the subject, it'll be the Tops.

Reprinted with the permission of the Estate of Duke Ellington.

The People Who Made It Happen

Fletcher Henderson

In the early 1920s, pianist Fletcher Henderson was leading a band that was performing society dance music. As you read in Chapter 3, Henderson and the members of his band wanted to branch out into playing some of the hotter styles of jazz they were hearing on recordings coming out of Chicago. In 1924, Louis Armstrong came to New York, joined Henderson's band, and basically taught everyone how to play jazz in his style. In fact, Gary Giddins refers to the big band styles of the swing era as "orchestrated Louis."[3] At the time, most of Henderson's charts were published dance band charts that were reworked by saxophone player Don Redman, who also wrote new charts for the band to play. As improvisation became an important part of their style, the tunes had to be expanded

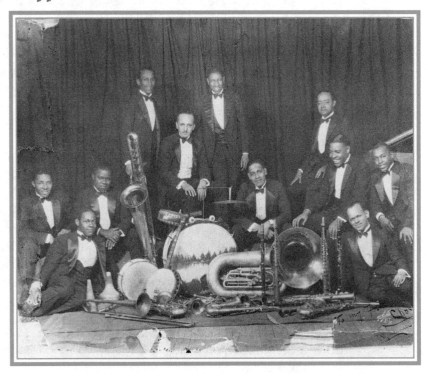

Fletcher Henderson's first "hot" orchestra pictured in 1924. Left to right: Howard Scott, trumpet; Coleman Hawkins, tenor sax; Louis Armstrong, trumpet; Charlie Dixon, banjo; Fletcher Henderson, piano and leader; Kaiser Marshall, drums; Buster Bailey, clarinet and saxes; Elmer Chambers, trumpet; Charlie Green, trombone; Bob Escudero, tuba; and Don Redman, alto sax and arranger.
Courtesy of Duncan Schiedt

to make room for more and more improvised solos. This added solo space is where the concept of the riff really came into play. After Don Redman left the band, Henderson went on to compose and arrange his own tunes, establishing a basic format that was copied by virtually every big band that followed.

Some of the most sparkling talents of the early swing era can be heard on the best Henderson band recordings. The transition from sweet band styles to true swing can clearly be traced just by listening to the Henderson band recordings from the years 1925 to 1932. Even in their early recordings, riff techniques and the idea of leaving open spaces in arrangements for improvisation are clearly evident. In particular, notice the great improvised solos of saxophonist Coleman Hawkins. Inspired by the improvisations of Louis Armstrong, Hawkins went on to become one of the most influential tenor sax players of all time. You can listen to the Henderson band in its prime while you study the following listening guide for the tune *Wrappin' It Up*.

RECORDING

A Study in Frustration: The Fletcher Henderson Story

Fletcher Henderson was a good musician, and he became a great arranger, but by all accounts he was never really a successful businessman. His band featured some of the most talented jazz players in New York, but they were undisciplined and often undependable. During the depression of the early 30s, Henderson's band fell on hard times, and he eventually sold his "book," or collection of arrangements, to Benny Goodman. Later, Henderson went on to create new charts for the Goodman orchestra and even joined Goodman's band as pianist.

Listening Guide

Wrappin' It Up (Fletcher Henderson)

Example of Fletcher Henderson's arranging style for a big band
Recorded September 12, 1934
Performed by Fletcher Henderson and His Orchestra. Fletcher Henderson, arranger and leader; Buster Bailey, Hilton Jefferson, and Russell Procope, clarinet and alto sax; Ben Webster, tenor sax; Henry "Red" Allen, Irving Randolph, and Russell Smith, trumpet; Keg Johnson and Claude Jones, trombone; Lawrence Lucie, guitar; Horace Henderson (Fletcher's brother), piano; Elmer James, bass; and Walter Johnson, drums

This track provides an excellent example of the mature Fletcher Henderson arranging style, a style that was widely imitated by others throughout the swing era. Great writing punctuated by the use of various riffs and solid improvisation are all evident throughout the performance. The basic structure here is 32 bars long, but it is not the typical A-A-B-A format. Instead it uses four 8-bar segments that present thematically as A-B-A-C.

Extra musician's info: While the form as just described is accurate, in practice, musicians often think about this format, and write it out in the charts, as two 16-bar phrases. What is actually seen on the music is the first eight bars (letter A) and then something that says "1st ending" (which is really our letter B). Then we simply read the same letter A material again and jump to what is called the "2nd ending" (our letter C). The material unfolds the same way no matter how you think about it. Two groups of 16 measures equals one 32-bar structure.

Total time: 2:42

:00	8-bar introduction featuring a written call and response between the brass and sax sections.
:09	The main 32-bar tune begins, continuing the call and response pattern established in the introduction.
:46	Improvised sax chorus featuring Hilton Jefferson, accompanied by melodic riffs played by the rest of the band.
1:23	Improvised trumpet solo played by Red Allen and accompanied by aggressive sax riffs. After the first 8 bars, the saxes and brass take over for the 2nd 8-bar group at 1:32 with an aggressive shout that leads back to another 16 bars of solo trumpet starting at 1:41. All of this material constitutes one 32-bar chorus.
1:59	The final 32-bar chorus begins with 8 measures of material harmonized for three clarinets and brass playing in call and response. This section is followed by an 8-bar improvised clarinet solo played by Buster Bailey that begins at 2:10. The last 16 bars of the piece feature a return to harmonized, written sax parts for 8 measures, followed by the entire band for the last 8 bars of the piece.

Duke Ellington

Like Fletcher Henderson, pianist Edward Kennedy "Duke" Ellington got his start in jazz by leading a society band. He was born in Washington, D.C. and had his first success as a musician there. In the mid-1920s Ellington and his band moved to New York City, where they fell under the spell of Louis Armstrong. Soon they too had abandoned sweet music in favor of playing more hot jazz, with lots of solo improvisation and riff-driven ensembles. As the band grew in both size and popularity, Duke moved into a regular performing spot at the Cotton Club. This club was the premiere nightspot in Harlem, and all of the best black performers played there. Ellington quickly established a creative style built around his own compositions. As swing music grew in popularity, the best musicians were in great demand by all the different band leaders. These players, known as **sidemen**, changed bands frequently looking for a better working situation. In this regard, Duke's band was unique. Many of Ellington's men stayed in the band through the entire swing era and beyond. A few, including Johnny Hodges and Harry Carney, were with him for more than forty years. One reason for this loyalty was that Ellington treated his band members with great respect. For example, during this time period, touring with an African American band was a very difficult proposition due to strict segregation laws. Especially in the South, there were few hotels and restaurants that would serve blacks. Unlike other bands that toured in buses or cars, Ellington rented Pullman cars and did his touring by train. No matter where they were, his men always had a place to eat and sleep.

Ellington made it a point to hire musicians with individual sounds and styles that matched the musical ideas he wanted to get across to an audience. Because the members of his band were so loyal, he was able to write charts requesting very specific sounds and techniques, knowing that the same man would be there every night to play his part. While Ellington is always listed as a piano player, his real instrument was The Duke Ellington Orchestra. A list of the great players who passed through the Ellington band reads like a "Who's Who" of jazz. Let's focus on two of the most easily identifiable sounds in the band: Cootie Williams on trumpet and Johnny Hodges on alto sax.

Charles M. "Cootie" Williams developed a wide range of sounds on the trumpet, often using different mutes and growling into the horn to give it a more vocal quality. He played with Ellington at the height of the swing era before joining Benny Goodman's band and then

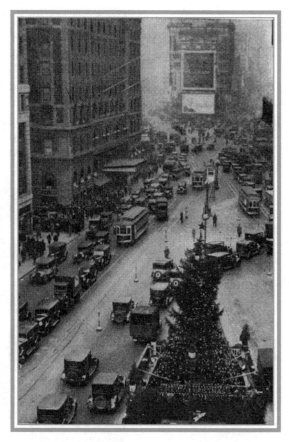

Times Square in New York City in the mid-1920s. Duke Ellington's first big job in New York City was at the Kentucky Club just off of Times Square.
© 2002 www.arttoday.com

sidemen

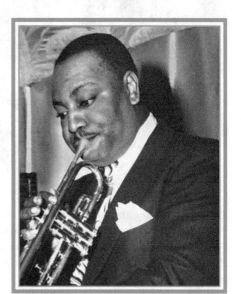

Charles M. "Cootie" Williams

Trumpet virtuoso Cootie Williams.
Courtesy of the Institute of Jazz Studies, Rutgers University

forming a big band of his own. After the swing era played out, Williams rejoined Ellington's band and stayed with it until Ellington's death in 1974. Williams had feature tunes written just for him such as the masterful *Concerto for Cootie*, recorded in 1940. Ellington also wrote parts in just about every chart the band did that emphasized the many different trumpet sounds Cootie Williams could make.

Johnny Hodges

One of the most original and unique tones ever heard from an alto saxophone was created by **Johnny Hodges**. He played with a sound that is often referred to as a bit sweet. He almost always played with a little vibrato, or quiver, in his tone. It added a certain warmth to his playing that no other sax player seemed

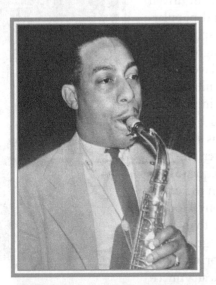

*Alto sax master
Johnny Hodges.*
Courtesy of the Institute
of Jazz Studies, Rutgers
University

able to reproduce in exactly the same way. Hodges also had an incredible ability to bend notes, sliding smoothly from one pitch to another, imitating the mournful quality found in a blues singer's voice. As he did for Cootie Williams and many other members of the Ellington orchestra, Duke wrote his compositions and arrangements in such a way that Hodges' sound and style were always presented in the best light. One of Hodges' most famous feature tunes was the Ellington composition *Prelude to a Kiss*. Get this sound in your ear, and you will hear Johnny Hodges' alto sax shimmering over just about every tune Duke Ellington ever recorded.

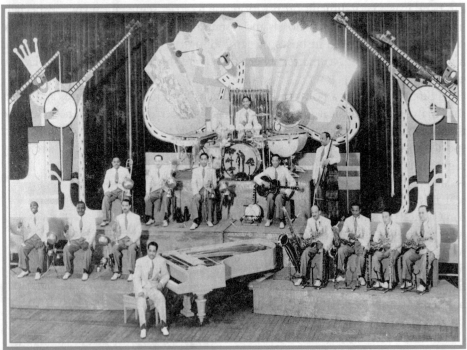

*Duke Ellington and His Famous Orchestra, London, 1933. Duke Ellington is seated at the piano.
Front row, left to right: Freddie Jenkins, Cootie Williams, and Arthur Whetsol, trumpet; Otto
Hardwick, Harry Carney, Johnny Hodges, and Barney Bigard, woodwinds. Back row, left to right:
"Tricky Sam" Nanton, Juan Tizol, and Lawrence Brown, trombone; Sonny Greer, drums; Fred Guy,
guitar; and Wellman Braud, bass.*
Courtesy of the Institute of Jazz Studies, Rutgers University

Listening Guide

Prelude to a Kiss (Edward Kennedy Ellington)

Example of Johnny Hodges' alto sax sound

Recorded July 15, 1956

Performed by Duke Ellington and His Orchestra. Duke Ellington, piano and leader; Johnny Hodges, alto sax; Russell Procope, clarinet and alto sax; Paul Gonsalves and Jimmy Hamilton, clarinet and tenor sax; Harry Carney, baritone sax; Ray Nance, Cat Anderson, Clark Terry, and Willie Cook, trumpet; John Sanders, Britt Woodman, and Quentin Jackson, trombone; Jimmy Wood, bass; and Sam Woodyard, drums [Note: performance lineup taken from concerts performed at Newport, Rhode Island, in early July, 1956 and on July 18, 1956 in Stratford, Ontario.]

This live recording comes from a concert at the Tanglewood Music Festival in Lenox, Massachusetts, that took place just a few days after the legendary Newport Jazz Festival performance that helped bring Ellington and his band back to prominence in the jazz world to some extent. This tune, which was again recorded in the same arrangement version for the 1957 studio album *Ellington Indigos*, features Johnny Hodges throughout. As Duke Ellington mentions in his introduction to this particular performance, Johnny Hodges had recently returned to the band after several years of pursuing his own projects. This chart was one of a number of pieces that were used to feature his unique style. Players often try to imitate Hodges' approach to improvisation and the sound he created on the alto saxophone, but as you can hear in this example, no one could ever really copy this sound. The tune is a standard 32-bar song form (A-A-B-A), although this performance modifies the form by playing one time all the way through, then skipping the first 16 bars and returning directly to the bridge and finishing the performance with the last 8 measures. Don't worry too much about the form. Spend your listening time getting Johnny Hodges' sound in your ear. Once you do, you will never forget it.

Total time: 4:21

:00	Duke Ellington, spoken introduction.
:13	Band and solo piano introduction.
:43	1st chorus begins. Letter A, 8 bars.
1:15	1st chorus, second time through letter A, 8 bars.
1:49	Bridge, or letter B, 8 bars.
2:23	Last 8 bars of 1st chorus, letter A material returns.
2:57	Bridge. Remember that we skipped 16 bars (or two statements of letter A material).
3:31	Last 8 bars (final return of letter A material).

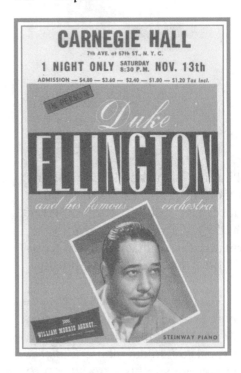

Over his long career, Duke Ellington played several very successful concerts at New York's famed Carnegie Hall. These images are taken from two of these programs. Courtesy of Tad Hershorn at the Institute of Jazz Studies, Rutgers University

Duke Ellington's band enjoyed great success throughout the swing era, turning out one hit record after another. Almost all of these tunes were geared toward dancing, but they also featured the many gifted soloists the band had to offer. A few of the band's most important recordings from this period include *Mood Indigo, It Don't Mean a Thing If It Ain't Got That Swing, Sophisticated Lady, Solitude, In A Sentimental Mood, Satin Doll, Take the A Train, Cottontail,* and *Main Stem*. To give you a better sense of some of the able soloists in a typical Ellington band, your Spotify playlist features a 1942 performance of the tune *Main Stem*. This tune is said to be a musical portrait of Broadway in New York City.

Listening Guide

Main Stem (Edward Kennedy Ellington)

Example of some of Ellington's great soloists and a good basic swing style with riffs
Recorded June 26, 1942
Performed by Duke Ellington and His Orchestra. Duke Ellington, piano; Johnny Hodges and Otto Hardwick, alto sax; Ben Webster, tenor sax; Barney Bigard, clarinet; Harry Carney, baritone sax; Wallace Jones, Cootie Williams, Rex Stewart, and Ray Nance, trumpet; "Tricky Sam" Nanton, Juan Tizol, and Lawrence Brown, trombone; Fred Guy, guitar; Alvin Raglin, bass; and Sonny Greer, drums

Beyond soloists Cootie Williams and Johnny Hodges, Duke Ellington's band always featured many gifted improvisers. This tune gives some of those fine players a chance to shine. All are accompanied by riffs from various parts of the orchestra. The structure for most of the tune is a standard 12-bar blues, but toward the end of the chart Ellington begins to play around with that structure. Don't worry if you can't get all of the counting figured out right away. Just focus on the solos.

Total time: 2:48

:00	Head. Played by the full band.
:14	2nd chorus. Saxes play melody riffs. Improvised trumpet solo by Rex Stewart.
:28	3rd chorus. Improvised sax solo by Johnny Hodges.
:41	4th chorus. Improvised trumpet solo by Rex Stewart.
:55	5th chorus. Improvised trumpet solo by Ray Nance, who is using a mute to change the sound of the instrument.
1:09	6th chorus. Improvised clarinet solo by Barney Bigard.
1:23	7th chorus. Improvised trombone solo by "Tricky Sam" Nanton. Note his use of the plunger mute and how he growls into the horn for effect.
1:36	6-measure shout played by the entire band.
1:43	18-measure section (4 bars of long-tones from the band, followed by 14 bars of improvisation by tenor sax player Ben Webster).
2:04	18-measure section (4 bars of long-tones from the band, followed by 14 bars of improvisation by trombonist Lawrence Brown).
2:24	Out chorus. Return to the 12-bar blues format used for much of the tune.
2:38	Additional 8-bar tag for conclusion of the tune.

Over his long and successful career, Duke Ellington constantly expanded the boundaries of what jazz music could be. Most dance numbers were designed to last three or four minutes each. This time frame coincided nicely with the 78-rpm recordings that were the dominant record format of the day. In jam sessions tunes often lasted longer, but for the public the general rule was to keep it short and swinging. Ellington created many of these typical swing numbers for his book, but he also began delving deeper into the world of classical music. He began to write musical "tone poems" that painted vivid musical pictures such as the tune *Harlem Airshaft*. On your Spotify playlist, notice that the 1927 recording of *Creole Love Call* uses a female voice as another instrumental tone color in the band—no lyrics, just melody. He also wrote more extended compositions and even multi-movement suites including *Black, Brown and Beige*. Later, Ellington ventured into orchestral composition, fusing together classical and jazz styles. He wrote works such as *New World A'Comin*, which is basically a one-movement piano concerto; *Harlem*, which is a tone poem that Ellington scored for both his big band and the full symphony orchestra; and music for film including the score to the movie *Anatomy of a Murder*.

Dig Deeper

BOOKS

Music Is My Mistress by Edward Kennedy (Duke) Ellington
Duke: A Life of Duke Ellington by Terry Teachout

RECORDINGS

Duke Ellington: Ken Burns Jazz Collection; Ellington at Newport; Ellington Indigos; The Far East Suite; …And His Mother Called Him Bill (a tribute to Billy Strayhorn)

MOVIE/ SOUNDTRACK

Anatomy of a Murder

WEBSITE

www.dukeellington. com

Listening Guide

Creole Love Call (Edward Kennedy Ellington)

Example of Ellington's unique style of composition and use of unusual tone colors

Recorded October 26, 1927

Performed by Duke Ellington and His Orchestra. Duke Ellington, piano; Otto Hardwick and Harry Carney, clarinet, alto and baritone saxes; Rudy Jackson, clarinet and tenor sax; Bubber Miley and Louis Metcalf, trumpet; "Tricky Sam" Nanton, trombone; Fred Guy, banjo; Wellman Braud, bass; Sonny Greer, drums; and Adelaide Hall, vocal

This recording represents one of Duke Ellington's early experiments with tone colors. He treats singer Adelaide Hall's voice as another instrument in the band. She has no lyrics to sing in the entire performance. Notice how different instrumentalists throughout the piece use mutes and bend pitches in an effort to create a wider sound palette. This tune follows a standard 12-bar blues with one minor exception. The song starts with 3 beats of pick-up notes. The easiest thing to do is pretend that the song has already started and you are going to begin your counting on beat 2 of measure 12. The sound you will hear in the melody goes something like "da-de, da-de, da-de, da-deee," and on that last long "deee" you will be at measure 1. Your actual counting will go 2, 3, 4; 1, with that last 1 being the downbeat of the first real measure of the tune. The entire performance consists of six choruses of the blues.

Total time: 3:14

:00	1st chorus. Tune begins with call and response. The melody is played in the clarinets (da-de, da-de, da-de, da-deee) and is answered by the solo voice.
:31	2nd chorus. Improvised trumpet solo. Note how Bubber Miley uses a plunger mute and adds a vocal quality to his sound by growling into the horn as he plays.
1:01	3rd chorus. Improvised clarinet solo.
1:31	4th chorus. More call and response with the melody in the brass and the answer played by the sax section.
2:01	5th chorus. Melody is harmonized with clarinets and is answered by the brass.
2:31	6th chorus. Format is similar to the 1st chorus, but the voice is more aggressive here. Tune ends with a short solo break for the voice, followed by a final chord from the entire band.

Billy Strayhorn

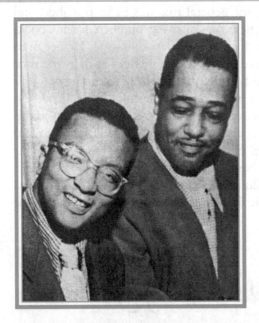

Billy Strayhorn and Duke Ellington.
Courtesy of the Institute of Jazz Studies, Rutgers University

Dig Deeper

**BOOK/
DOCUMENTARY**

🎺

Lush Life: A Biography of Billy Strayhorn by David Hajdu

RECORDING

🎺

The Peaceful Side of Billy Strayhorn

WEBSITE

🎺

www.billystrayhorn. com

Perhaps the most unique feature of Duke Ellington's compositional style was his working relationship with pianist/composer **Billy Strayhorn**. Though very different in personality, these two men formed a working relationship that pushed both their creative abilities to new levels. They worked so well together that many times after a composition or arrangement was finished neither man could remember just who wrote what. Their styles were so complimentary that one man could stop at any given measure of a new work, tell the other what he had done, and the work would be completed the next day. Strayhorn also occasionally played piano with the orchestra when Ellington wanted to conduct from the front of the band. Furthermore, Ellington's theme song, *Take the A Train*, was actually composed by Billy Strayhorn.

At the end of World War II, many of the big bands were in decline and began to break up. People weren't going out as much, the popular solo singer was taking over, and it was just too expensive to keep a big band with 15 to 20 musicians working. Ellington's band was one of the few groups to survive. Ellington paid his men a regular salary, and they got paid whether the band worked or not. During the 1950s and 60s the Ellington band continued to enjoy success as both a recording unit and a touring band. By this time, 33 1/3-rpm long-play records had taken over as the standard record format. Now a band could record almost thirty minutes of music per side of an album. Unlike any band before him, Ellington was able to put on vinyl just about every note he ever put on paper. He created major

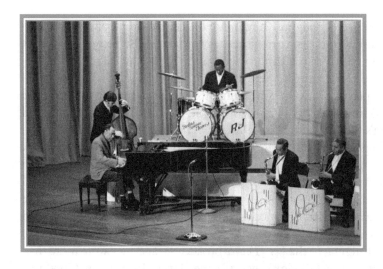

Duke Ellington and His Orchestra performing at Liberty Hall in El Paso, Texas in 1969.
Courtesy of Bob Foskett

successes, including the album *Ellington Indigos* that your recording of *Prelude to a Kiss* is taken from, and he was also able to record much of his more obscure music that tested the limits of what jazz could be. Often working closely with Billy Strayhorn, Ellington created extended suites, including jazz versions of classical pieces such as *The Nutcracker Suite* (originally a ballet by Tchaikovsky) and *Peer Gynt Suite* (based on music by Norwegian composer Edvard Grieg). There were also extensive original multi-movement compositions such as *Suite Thursday* (based on works by writer John Steinbeck), the *Far East Suite* (inspired by the band's extensive travels as part of the American Department of State's Jazz Ambassadors program), and *Such Sweet Thunder* (inspired by the works of Shakespeare). Finally, starting in 1965, Ellington undertook the creation and production of three programs he called *Sacred Concerts*, with much of the material being preserved on recordings, on film, and/or in archived manuscripts. Ellington passed away in 1974 after an extended battle with lung cancer, just six short months after the premiere of the third *Sacred Concert*. There are many who suggest the creation of this final *Sacred Concert* project was strongly influenced by Ellington's knowledge of his pending demise.

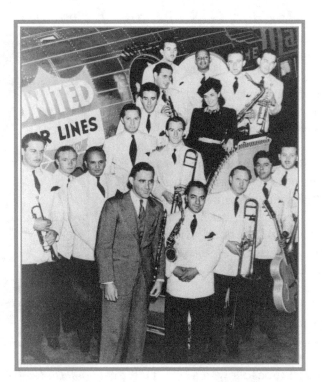

The Benny Goodman Orchestra in a 1939 press photo. Goodman is standing in the dark suit at the front of the group. Fletcher Henderson can be seen third from the left just behind Goodman's right shoulder.
Courtesy of the Institute of Jazz Studies, Rutgers University

Dig Deeper
WEBSITE

www.benny goodman.com

Benny Goodman

Benny Goodman was born into a very poor Jewish family in Chicago, Illinois. Goodman began to study the clarinet and became a talented classical player by the time he was a teenager. After hearing the outstanding New Orleans jazz musicians who had relocated to Chicago, he became consumed with an interest in the new

art form. Goodman began playing in white dance bands and eventually was able to support his entire family from his earnings as a musician. He settled in New York City, where he attempted to form a band based on the models of Fletcher Henderson and Duke Ellington. He went to great lengths to find like-minded white musicians who wanted to play hot jazz. In continuing his pursuit of the hot-jazz style, he bought arrangements from Fletcher Henderson, giving his band the exciting material it needed. Goodman's big break came in 1934 when his band got a regular spot on the *Let's Dance* radio program. When the show ended in 1935, the band undertook a disastrous cross-country tour. Outside of New York City, people were behind the curve when it came to contemporary music. Most folks in the Midwest were still dancing to sweet band music. They just weren't ready for hot jazz, and many of the band's engagements were limited or canceled altogether. The big change came when the band finally reached the Palomar Ballroom in Los Angeles. Young people on the West Coast had been listening to the *Let's Dance* broadcasts, and they were more than ready for the new music that Goodman was playing. From this success, Goodman was labeled the "King of Swing," and his band was in great demand on the radio, in films, and in live performances. From your Spotify playlist, listen to a 1939 recording of the Goodman band playing *Let's Dance*.

Listening Guide

Let's Dance (F. Baldridge, G. Stone, and J. Bonime)

Example of the big band swing style as practiced by the Benny Goodman Orchestra
 Recorded October 24, 1939
 Performed by Benny Goodman and His Orchestra. Benny Goodman, clarinet and leader; Toots Mondello and Buff Estes, alto sax; Bus Bassey and Jerry Jerome, tenor sax; Jimmy Maxwell, Ziggy Elman, and Johnny Martel, trumpet; Red Ballard, Vernon Brown, and Ted Vesely, trombone; Fletcher Henderson, piano; Arnold Covey, guitar; Artie Bernstein, string bass; Nick Fatool, drums; and George Bassman, arranger

This band had its first big break on a 1934-35 series of radio broadcasts, also titled *Let's Dance*, and this tune was Goodman's theme song. As you will hear, the chart is clearly built around Goodman's talents as an improviser. While others do get a chance to play, the chart keeps coming back to Goodman. This is a later recorded version of the tune, performed with a band of seasoned professionals that includes the great Fletcher Henderson on piano. The tune follows a 32-bar pattern of A-B-A-C.

Total time: 2:34

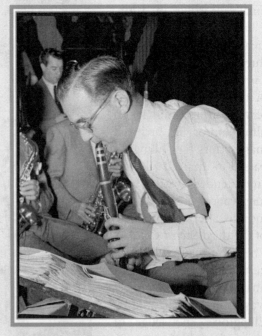

Benny Goodman performing with his band at the 400 Restaurant in New York City in the mid-1940s.
©William P. Gottlieb/Ira and Leonore S. Gershwin Fund Collection, Music Division, Library of Congress

:00 Tune begins with no introduction. The band plays for 7 measures before Goodman begins improvising over the top of the written structure.

:35 Goodman's real improvised solo begins with a nice solo break in mm. 31-32 at the end of the 1st chorus. He then continues to improvise throughout the 2nd 32-bar chorus, supported by riffs played by the rest of the band.

1:15 Improvised alto sax solo performed by Toots Mondello, accompanied by riffs in the rest of the band. Mondello's solo actually ends 2 bars early (around 1:50) so the band shout that will dominate the first part of the next full chorus can begin. Although he is improvising, Mondello has to plan his licks knowing exactly when the band is going to come back in.

1:53 Written shout chorus played by the entire band for 16 bars, followed by another short thematic statement by Goodman starting at 2:11. The tune finishes with another brief melodic statement by the full band and a solo tag played by Goodman, which is followed by one more full band chord for a final punctuation.

In addition to performing with his big band, Goodman began recording with African American pianist Teddy Wilson and drummer Gene Krupa. For a time, the **Benny Goodman Trio** was only a recording ensemble. There was some demand for public performances, but Goodman was a bit reluctant to jeopardize his career by performing in public with a mixed race band. According to most accounts of his life, Goodman was not racist in any way, but he was conscious of the general mood of the country. When the trio did perform in public to great acclaim, Goodman realized that it was possible to be successful with a mixed band.[4] He went on to hire other black musicians and continued to have one of the most successful bands in America. With the addition of Lionel Hampton on the vibraphone, the trio was expanded to a quartet. The **Benny Goodman Quartet** was one of the most creative groups of improvising musicians ever assembled. They played "head charts" with a great deal of collective improvisation. The format was similar to that of a traditional jazz band, but the rhythmic style was pure swing. While the quartet did play ballads and medium-tempo numbers, they specialized in fast numbers that built in intensity all the way to the end of the tune.

On January 16, 1938, the Benny Goodman Orchestra and Quartet played the first jazz concert in New York's Carnegie Hall. In addition to his regular groups, Goodman featured guest artists from Duke Ellington's band. He was also joined by Count Basie and members of his band. This concert is considered one of the monumental and pivotal moments in jazz history. It was this event that really proved to the world that jazz was a legitimate art form that deserved to be taken as seriously as classical music. As important as we now know this concert was, however, at the time it was looked at by many outside the jazz world as something of an oddity and perhaps even an annoyance. For example, read the concert review that appeared in the *New York Times* the day after the show (found on the next page).

The Carnegie Hall concert was recorded, but the tapes were largely forgotten until the 1950s. With a few years of hindsight, and admittedly a different perspective on jazz, consider Irving Kolodin's liner notes that accompanied the recordings when they were released in 1950, which can be found on page 91, following the *New York Times* review.

Benny Goodman Trio

Benny Goodman Quartet

Dig Deeper

MOVIES

The Benny Goodman Story; A Song Is Born

RECORDINGS

Benny Goodman: The Complete Carnegie Hall Concert; The Benny Goodman Sextet Featuring Charlie Christian: 1939-1941

NEW YORK TIMES, M[...]

GOODMAN IS HEARD IN 'SWING' CONCERT

Carnegie Hall Crowded for Orchestra's Rendition of 'New Kind of Music'

'JAM SESSION' A FEATURE

Soloists Join in Collective Improvisation — Virtuosity of Players Much Admired

By OLIN DOWNES

The writer of these lines, whose principal occupation it is to report performances of symphony and opera, is much interested in jazz and other forms of American popular music. He thinks, as Debussy put it, that there is only one music, which may exist in a dance, a folk-song, a waltz or a symphony, and is often to be encountered in undignified places. He therefore hurried with much curiosity and anticipation to the concert given last night in Carnegie Hall by Bennie Goodman and his famous "swing" orchestra.

He went expecting a new, original, and elemental kind of music; one that we had been told marks a novel and original form of expression. This is not the sort of thing that Paul Whiteman triumphed in introducing to the polite musical world some fourteen years ago in this city. In those fourteen years a great deal of water flowed under the bridge. In the interim the pioneer Whiteman has been practically canonized by the younger generation, and relegated to last by the Goodmans, Dorseys, Duke Ellingtons and such of the present. In a word, jazz has given way to "swing." "Swing" is that subtle creative something, the je ne sais quoi in popular music, which has superseded the older product and gained a greater power of popular appeal, according to its special proponents, than jazz ever exerted.

Leader Warmly Welcomed.

It may therefore be imagined with what a thumping of the heart the present scribe got into his seat, in good time before the concert began, to hear the very first notes of Goodman's orchestra. It may be said immediately that he was enormously impressed, though not in the precise way he expected. When Mr. Goodman entered he received a real Toscanini send-off from the excited throng. It took some minutes to establish quiet. There was quivering excitement in the air; an almost electrical effect, and much laughter. The audience broke out before the music stopped, in crashing applause and special salvos as one or another of the heroes of the orchestra rose in his place to give his special and ornate contribution to the occasion.

That is almost the sum of it. We went to discover a new, original, thrilling music. We stayed to watch a social and physical phenomenon. For the great gathering was almost off its head with joy. The "hotter" the pace, the louder the blasts, the better it went. Sometimes shouts threatened to vanquish the orchestra.

This form of sound is a curious reduction, almost disintegration of music into its component elements. There is hardly an attempt at beauty of tone, and certainly none at construction of melody. A few fragments of well-known popular tunes suffice for a sort of rough material, subject to variation by the players. They do such feats of rhythm and dexterity as occur to them on the tune's basis. The tone of the brass instruments, almost continually overblown, is hard, shrill and noisy. The other instruments add what they can to swell the racket.

What Rhythm Can Do.

But why claim that this is new? These are effects and devices as old as the hills to any one who has listened in the last fifteen years to jazz music. They are merely carried to extremes. It is very interesting to see what rhythm can do. It can get an audience wild, and it did. But it did not seem to be able to generate music.

Attend a Negro camp meeting. The people shout and become possessed by rhythm. This invariably produces music. Song is thrown off as a sort of grand ferment of the tumult. The playing last night, if noise, speed and syncopation, all very old devices, are heat, was "hot" as it could be, but nothing came of it all, and in the long run it was decidedly monotonous.

Nor is Mr. Goodman, when he plays his clarinet, anything like as original as other players of the same instrument and the same sort of thing that we have heard. Nor did we hear a single player, in the course of a solid hour of music, invent one original or interesting musical phrase, over the persistent basic rhythm. Not that they lacked technical accomplishment and amazing mastery of their medium. Musically, they let us down.

Much was expected of the "jam session." A "jam session" is improvisation, free for all members of the band, over a basic rhythm, and the devil take the hindmost. Such a form is a special test of the players' invention. No doubt a "jam session" can be dull as ditchwater one night and inspired at the very next meeting. Last night's "jam session" seemed to last a good ten minutes, and though soloist after soloist of the band tried in turn to contribute something original to the ensemble, little or nothing of the sort materialized.

If this is the ideal presentment of "swing" we must own to a cruel disillusion. We may be a hopeless old-timer, sunk in the joys of Whiteman jazz, unable to appreciate the starker, modern product. But we greatly fear we are right, and venture the prediction that "swing" of this kind will quickly be a thing of the past. Some say that it doesn't pretend to be music, but to be "something else." That is perhaps true. If so, rhythms that carry music with them will supplant it.

It is to be recorded that last night's audience remained applauding and cheering till a late hour. It is to be added, so far as one observer's reaction is concerned, that "swing" is a bore, long before an evening has ended.

ℬenny Goodman Live at Carnegie Hall
by Irving Kolodin

The first intimation I had that there might be such a thing as a concert by Benny Goodman's band in Carnegie Hall came one December afternoon in 1937. I was on a journalistic mission to Gerald Goode, press chief for S. Hurok, when he excused himself to answer the phone. After absorbing the information from the other end, he closed off the mouthpiece and said: "What would you think of a concert by Benny Goodman's band in Carnegie?" "A terrific idea," I responded, "Why?" "It's somebody from Goodman's radio program," Goode stated. "He wants Hurok to run it."

'Somebody from Goodman's radio program' turned out to be Wynn Nathanson, of the Tom Fizdale agency, then promoting the *Camel Caravan* on which Goodman was appearing. The thinking was reasonable enough: the "King of Jazz" in the previous decade (Paul Whiteman) had done it; why not the "King of Swing" in the present (1930) one? Ellington and Armstrong had both given jazz concerts abroad, and in the early days of his national prominence, Goodman had in the Congress Hotel (in Chicago) one Sunday afternoon. Nightly at the Pennsylvania Hotel (now the Statler), the number of those who stood around the band stand, or sat at tables listening, far outnumbered those on the dance floor. It didn't seem any question to me that there would be thousands to pay Carnegie Hall prices.

My brash enthusiasm, aroused by Goodman's records, was passed along to the interested parties. For this, as well as much better reasons, a contract was signed for Sunday night, January 16, 1938, announcements were printed, advertisements placed, and a program book commissioned. The professional misgivings were stronger than my amateur confidence. Hurok was somewhat reassured when he came to the Madhattan Room of the Pennsylvania one night, and was quite taken aback by the uproar of the band, and the artistry of the Goodman-Krupa-Wilson-Hampton quartet. So many well-dressed people spending money on an attraction was obviously a good omen. The deluge of money orders and cash when the tickets went on sale was an even better one.

Goodman's problem was a special one. Naturally he wanted to fill the house, if for no other reason than pride. The probability of making money was remote, if even contemplated, for the program required special rehearsing, a few new arrangements, the disbursement of some free tickets to those in the profession. For that matter, Goodman was so confident that tickets could be purchased whenever he might want them that he had to patronize a speculator during the last week, when his family decided to come on from Chicago. Needless to say, the publicity could not have been purchased for any price.

I knew then that Goodman was concerned about the musical content of the program (Carnegie Hall, after all, was not the Congress Hotel). I didn't know that he asked Beatrice Lillie to go on

PROGRAM CONTINUED ON SECOND PAGE FOLLOWING

List of major New York City concerts as they appeared in the New York Times *on January 16, 1938, the day of Benny Goodman's famous Carnegie Hall concert. This is the only ad for the concert that appeared in the* Times *that day.*

for comedy relief, for fear that the evening might wear thin. Miss Lillie wisely declined—wisely, I say, because she had a fortunate premonition what the program might be like, and reckoned rightly that her talents might be a little on the quiet side.

One fact was firmly settled at the outset. The concert would consist of the Goodman band and allied talent only. There would be no special "compositions" for the occasion. The musicians, in this kind of music, were the thing, and so it would remain. The regular book built by Fletcher Henderson, Jim Mundy, Edgar Sampson, etc., which had built Goodman's reputation— or vice versa—would suffice. For a little freshness, Henderson was asked to do a couple of standard tunes (Dick Rodgers' *Blue Room* came in time to be used) and Edgar Sampson—whose *Stompin' At The Savoy* was a by-word with Goodman fans—was asked to bring around a few things.

Here was a singular stroke of luck. Among the arrangements that were passed out at the first rehearsal on the stage of Carnegie Hall was a new version of a piece Sampson had done previously for the band led by the great drummer Chick Webb. The title was *Don't Be That Way*. Benny decided immediately that this was his ice breaker, a decision fully justified by its reception, its subsequent popularity and its history on discs.

The idea for the historical "Twenty Years Of Jazz" was, I am afraid, mine. I apologize for it because it probably caused more trouble in listening to old records and copying off arrangements than it was worth. However, it brought out that family feeling that all good jazz musicians have for their celebrated predecessors, permitting a backward look at such landmarks of the popular music field as the Original Dixieland Band, Bix Beiderbecke, Ted Lewis, Louis Armstrong, and the perennial Duke Ellington. Only a few New Yorkers then knew of Bobby Hackett, an ex-guitar player from New England, who had been impressing the nightclub trade with his feeling for the Beiderbecke tradition on cornet. A lean trumpet player named Harry James, who then occupied the Goodman first chair, vowed sure, he could do the Armstrong *Shine* chorus. For the Ellington episode, only Ellington musicians would suffice, and the calendar was gracious in permitting Johnny Hodges, Harry Carney, and Cootie Williams to participate. The Duke himself was invited, but reasonably demurred, looking ahead to the time when he would make a bow of his own in Carnegie, as, needless to say, he has since.

The jam session was frankly a risk, as the program stated: "The audience is asked to accept the jam session in a spirit of experimentation, with the hope that the proper atmosphere will be established." At the suggestion of John Hammond, Jr., some key members of the then-rising band of Count Basie were invited to sit in, along with Hodges and Carney, and Goodman, James, Krupa and Vernon Brown of the host ensemble. The calculated risk was only too plain in the performance; what remains in this presentation is the kind of edited reconstruction possible in this day of magnetic tape.

With these elements of the program defined, the rest was easy. The trio would have a spot, and then the quartet with Hampton. Nothing could follow this but intermission, and it did. (Goodman was asked

the day before: "How long an intermission do you want?" "I dunno," he replied, "how much does Toscanini have?") In the second half, there would be arrangements of tunes by Berlin and Rodgers, some of the recorded specialties of the band—*Swingtime In The Rockies*, *Loch Lomond*, and a current hit, *Bei Mir Bist Du Schon*, leading to an inescapable conclusion with *Sing Sing Sing* which had become, by this time, a tradition, a ritual, even an act. I don't suppose that Louis Prima, who wrote the tune, was around Carnegie Hall that night. It is not often that Bach or Beethoven are rewarded, in Carnegie Hall, with the hush that settled on the crowded auditorium as Jess Stacy plowed a furrow—wide, deep and distinctive—through five choruses of it.

Well, that was all yesterday. A chilly, January yesterday, which somehow seems warm and inviting because twelve years have passed, along with a war and some shattering upheavals in the world. But it wasn't warm outside Carnegie Hall that night, as a picture in a contemporary paper, showing an overcoated, begloved line of prospective standees, attests.

Inside, the hall vibrated. Seats had been gone for days, of course, but one of those last minute rushes had set in, when all New York had decided that this was the place it wanted to be on the night of that particular January 16. The boxes were full of important squatters, and a jury-box had been erected on stage to care for the overflow. Tension tightened as the orchestra filed in, and it snapped with applause as Goodman, in tails, strode in, clarinet in hand, bowed, and counted off *Don't Be That Way*.

From then on, one climax piled on another. I remember the critic of the *Times* (who next day wrote, "When Mr. Goodman entered, he received a real Toscanini send-off from the audience") fretting because his teen-aged daughter beside him was bouncing in her seat and he felt nothing . . . a spontaneous outburst for James when he took his first chorus . . . ditto for Krupa . . . a ripple of laughter when Krupa smashed a cymbal from place in a quartet number, and Hampton caught it deftly in the air, stroking it precisely in rhythm . . . the corruscating sound-showers from Hampton's vibes that culminated the first half of the concert, and the reasonable doubt that anything afterwards could come close to matching it . . . until the matchless Stacy resolved all that had preceded with his *Sing Sing Sing* episode . . . the crowd howling its pleasure, the band taking its bows, and the boys dispersing to "cool out" race-horse fashion, all over town (the favored spot was the Savoy Ballroom, in Harlem, where Martin Block presided over a battle of music between the orchestras of Chick Webb and Count Basie). Next day, contemplating the diverse reviews, the interested editorial opinions in the *Times* and *Herald-Tribune*, someone said to Goodman, "It's too damned bad somebody didn't make a record of this whole thing." He smiled and said: "Somebody did."

Incredulously, I heard those "takes" (relayed to the CBS studios from a single overhead mike from Carnegie Hall) and relived the experience detailed above. Thereafter, one set was destined for the Library of

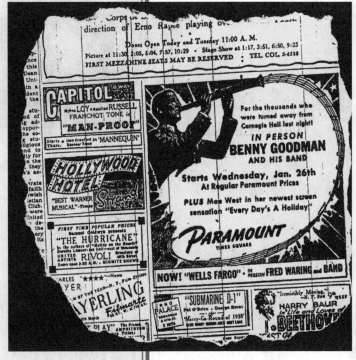

This ad ran next to the New York Times review of the famous Carnegie Hall concert on January 17, 1938. Notice how the ad is directed at the many Goodman fans who were turned away from the concert.

Congress, the other—who knows? Twelve years passed, and the whole thing was but a memory, when the other set turned up in a closet of the Goodman home a few months ago. Daughter Rachel came upon it and asked: "Daddy, what's this?" Daddy took a look, and wisely decided to have it transferred to tape before listening again. So has been preserved, in a representative way, one of the authentic documents in American musical history, a verbatim report, in the accents of those who were present, on "The Night of January 16, 1938."

From CD Recording Liner Notes from Columbia Records G2K 40244 *by Irving Kolodin. Courtesy of Columbia Records with permission.*

El Paso musician Bob Foskett made this photo of Benny Goodman during a concert with the El Paso Symphony during the 1970s. This photo has never before been published.
Courtesy of Bob Foskett

Charlie Christian

Many of the musicians who achieved fame with the Benny Goodman Orchestra went on to form their own successful big bands. Teddy Wilson, Gene Krupa, Harry James, Cootie Williams, and Lionel Hampton all went on to front their own groups. The Lionel Hampton band in particular is interesting, as some of the rhythmic styles they began to explore in the 1940s are considered to have laid the groundwork for the birth of rock and roll.

One other important musician who passed through the Goodman ranks was guitarist **Charlie Christian**, who joined a sextet Goodman was fronting in 1939. Unlike most guitarists of the day, Christian improvised in flowing single melodic lines rather than just strumming chords in a straight four-beat pattern. To make his instrument heard over the rest of the band, Christian played an amplified acoustic guitar. You can listen to Charlie Christian play with the Benny Goodman Sextet on the tune *Air Mail Special*.

Listening Guide

Air Mail Special (J. Munday, B. Goodman, and C. Christian)
also known as *Good Enough to Keep*
Example of small-group swing and early use of electric guitar
Recorded June 20, 1940
Performed by the Benny Goodman Sextet. Benny Goodman, clarinet; Lionel Hampton, vibes; Charlie Christian, electric guitar; Dudley Brooks, piano; Artie Bernstein, bass; and Harry Jaeger, drums

With all of his small groups, Benny Goodman returned to the "head chart" style used by many traditional jazz bands. The big difference here is the use of the modern swing style and an increased focus on solo improvisation. This tune uses a standard 32-bar format (A-A-B-A), but the chord changes and the rhythm of the melody have an unusual format. This is especially true in the out chorus, so don't worry too much about the form: just listen to the improvisation. Pay particular attention to the improvisational style and sound of Charlie Christian on electric guitar.

Total time: 2:55

:00	Head.
:35	Vibe solo.
1:10	Guitar solo.
1:44	Clarinet solo.
2:18	Riff played by the entire band as out chorus.

Press photo of the Benny Goodman Sextet. Left to right: Lionel Hampton, Artie Bernstein, Benny Goodman, Nick Fatool, Charlie Christian, and Dudley Brooks.
Courtesy of the Institute of Jazz Studies, Rutgers University

Dig Deeper
BOOK

Good Morning Blues: The Autobiography of Count Basie by William "Count" Basie with Albert Murray

While Christian wasn't the first person to play an amplified guitar, his playing and his electric guitar are still looked upon as precursors to some rock-and-roll styles. Interestingly enough, Christian is also considered to have been a real inspiration to the young creators of bebop. Christian used to jam with players such as Dizzy Gillespie, Charlie Parker, and Thelonious Monk, but sadly he passed away in 1942 at the age of 26, several years before the bebop style really broke onto the New York scene. We will take a long look at the bebop style in Chapter 5.

Count Basie

In Kansas City, a more open, relaxed style of swing music was taking shape. Unlike the more commercial bands in New York City, Kansas City bands used few written arrangements. Instead, their performances, called **head charts**, were based on a series of riffs, call and response passages between sections of the band, and great improvised solos. In general, the rhythmic style of swing music in Kansas City was smoother. Fast or slow, there was always a very steady four-beat rhythmic pattern. Perhaps the biggest thing the Kansas City bands had in common was a strong focus on the blues. Both playing and singing styles from Kansas City were deeply rooted in the language of the blues. Musicians from many different parts of the country congregated in

head charts

Dig Deeper

RECORDINGS

The Complete Decca Recordings (1937-1939); April in Paris; Count Basie at Newport; 88 Basie Street

WEBSITE

http://newarkwww.rutgers.edu/ijs/cb/index.html

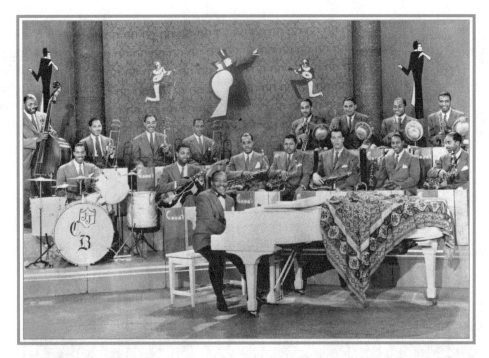

1947 promotional photograph of the Count Basie Orchestra on the set of the film Ebony Parade. *This film also featured Cab Calloway and Dorothy Dandridge.*
Courtesy of the Institute of Jazz Studies, Rutgers University

Kansas City in the 1930s and contributed to this common language. Although he was born in New Jersey, learned to play jazz piano in New York, and traveled the country in vaudeville shows, William "Count" Basie and his band are considered masters of the Kansas City style.

One of the things that made the Basie sound so special was the cohesive, relaxed swinging sound of his rhythm section. Walter Page on bass, Jo Jones on drums, Freddie Green on rhythm guitar, and Count Basie on piano are considered by many to be the finest swing rhythm section that ever played this style of music. Walter Page played a note on every beat in a very smooth, even pattern. The technique came to be known as **walking bass**. On drums, Jo Jones shifted the emphasis of the main beat from the bass drum up to the cymbals. This change gave the music a lighter, more buoyant feel. Freddie Green followed the walking-bass rhythm and strummed chords in a very straight four-beat pattern. He was considered to be a solid time machine by those who worked with him.

Green worked with Count Basie for more than forty years and never played a solo. In fact, it became a running gag with the band that Green would be taking a rare solo on the next tune. Then the band would play through the entire number and only at the end of the song would Green be featured. When the band would quit playing, Green would play one extra chord all by himself, always to thunderous applause.

Basie started in the music business by playing in the stride style of James P. Johnson and Fats Waller. As his style progressed, however, he began to play fewer and fewer notes. He would let the other players in the rhythm section take care of creating a nice, steady rhythm while he would sporadically interject little groups of chords or even just single notes. This sparse, new style would eventually be called **comping**. Short for *complimenting*, comping meant that Basie listened carefully to what was going on around him and improvised accordingly. This new comping style would become the standard technique for pianists in the bebop era and well beyond. Listen to the incomparable swing style of the Count Basie Band on the tune *9:20 Special* found on Spotify.

walking bass

comping

Listening Guide

9:20 Special (E. Warren and B. Engvick, arr. B. Harding)

Example of the Basie band's relaxed swing style
Recorded April 10, 1941
Performed by Count Basie and His Orchestra. Count Basie, piano; Tab Smith and Earle Warren, alto sax; Jack Washington, alto and baritone saxes; Don Byas and Buddy Tate, tenor sax; Buck Clayton, Harry "Sweets" Edison, Ed Lewis, and Al Killian, trumpet; Dickie Wells, Dan Minor, and Ed Cuffee, trombone; Freddie Green, guitar; Walter Page, bass; Jo Jones, drums; and special guest soloist Coleman Hawkins, tenor sax

Here is another tune that makes use of the standard 32-bar song form (A-A-B-A). There are a couple of minor alterations, as arranger Buster Harding throws in interludes occasionally between full statements of the 32-bar form. Even though the tune itself is rather fast, listen to how relaxed everyone plays. The biggest reason for this relaxed atmosphere is the smooth manner in which the rhythm section plays. Spend some time focusing on how each member of the rhythm section does his job.

Total time: 3:10

:00	10-measure introduction.
:12	1st chorus. Trumpets play melody over letter A material.
:31	Bridge. Sax ensemble is featured.
:40	Trumpets return with letter A melody for the last 8 bars.
:50	Interlude, 8 measures long.
1:00	2nd chorus. Begins with Count Basie piano solo over letter A chord changes.
1:19	Bridge. Alto sax solo featuring Tab Smith.
1:29	Basie returns for the last 8 bars, joined by trombones for the last 4 measures.
1:40	3rd chorus. Features trumpet player Harry "Sweets" Edison accompanied by the sax ensemble.
1:59	Bridge. This bridge starts with 2 bars of a unison brass riff, followed by 2 more bars of "Sweets" Edison's improvisation, and concludes with 4 bars of Count Basie playing a brief piano solo.
2:09	Last 8 bars feature a return to the trumpets playing a statement of the original letter A melody.
2:19	6-measure interlude, featuring a drum break for the last 2 measures.
2:27	4th chorus. Begins with with a 4-bar riff played by the brass and is followed with a tenor sax solo by Coleman Hawkins.
2:47	Bridge. Hawkins' solo continues.
2:57	Last statement of letter A material begins with trumpets playing the melody as before. They are soon interrupted by a solo break played by Hawkins, and the song concludes with one big chord played by the entire band.

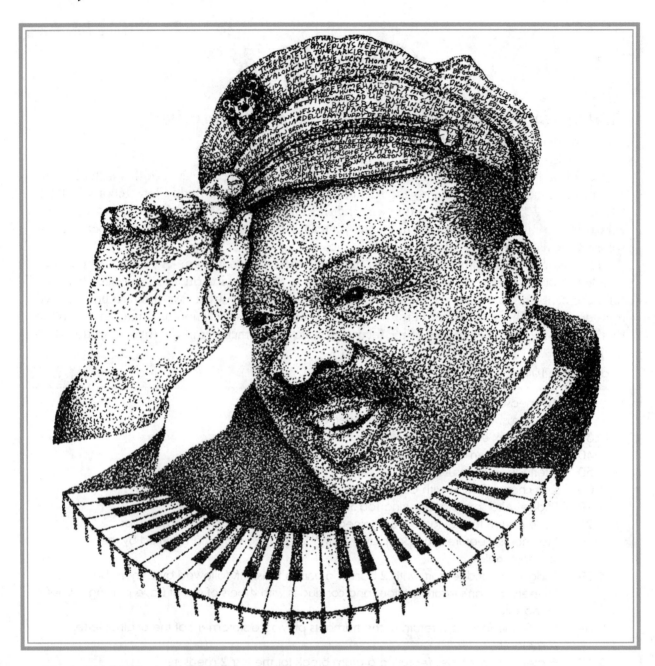

Thanks Basie Thanks, by Gene-K. This pen-and-ink
illustration was created by artist and jazz fan Gene Wilson
on the occasion of a visit Count Basie and his band made
to El Paso, Texas. If you look carefully, you will notice that
Basie's hat (one of his trademarks during his later years) is
made up entirely of song titles, album titles, and names of
musicians that worked with Basie.
Courtesy of the Wilson family on behalf of Gene K. Wilson

As with Duke Ellington's band, the list of musicians who passed through Count Basie's band over the years reads like a roll call of some of the finest jazz musicians who ever practiced the art. Men such as Lester Young, Harry "Sweets" Edison, Clark Terry, Louie Bellson, Don Byas, Illinois Jacquet, Curtis Fuller, and Snooky Young all went on to have major careers in the world of jazz. Of all the fine players just listed, perhaps the most influential was **Lester Young**. Unlike other saxophone players of his day, Young played with a lighter, smooth tone with less vibrato than was common at the time. He also put together longer strings of unbroken notes, a technique that looks forward to bebop. You can hear a great example of Lester Young's playing in a small-group recording made by Count Basie and His Kansas City Seven titled *Lester Leaps In*.

In his recent book on jazz, Alan Axelrod points out that like Louis Armstrong, Cab Calloway, and many other jazz musicians over the years, Lester Young developed a unique pattern of speech that many other jazz musicians and fans would try to copy.

Lester Young

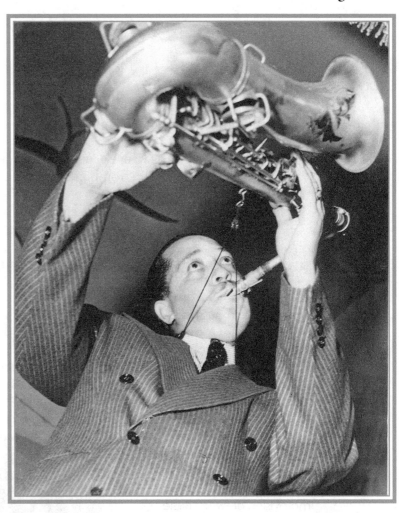

Tenor saxophone titan Lester Young.
Courtesy of the Institute of Jazz Studies, Rutgers University

It was Lester Young who gave Billie Holiday the nickname "Lady Day" (she called Young "Prez," declaring him president of saxophonists). But then, Young called a lot of people "Lady," male or female. In fact, he invented his own language, pinning idiosyncratic labels on a great many things. A white person he might call a "gray," and a black would be an "Oxford gray." When his saxophone keys got bent, he took the instrument to fellow tenor saxophonist and amateur repairman Flip Phillips: "Lady Flip, my people won't play!" Young called policemen "Bob Crosbys," marijuana was "ettuce," and the bridge section of a tune became a "George Washington." If something was a bore or a pain, he'd call it a "von Hangman." If someone slighted him (or he encountered racial discrimination), he'd declare that he was "feeling a draft." And when the Basie band would hit a town that was home to an old girlfriend, he'd excuse himself, saying that he was "going to see a wayback."[5]

Listening Guide

Lester Leaps In (Lester Young)

Example of small-group swing, Young's more modern approach to improvisation, and Basie's rhythm section style, including his piano comping

Recorded September 5, 1939

Performed by Count Basie and His Kansas City Seven. Count Basie, piano; Lester Young, tenor sax; Buck Clayton, trumpet; Dickie Wells, trombone; Freddie Green, guitar; Walter Page, bass; and Jo Jones, drums

Like the previous Goodman Sextet tune, this performance is a head chart that focuses mostly on solo improvisation. As you listen to Lester Young, notice his lighter tone on the tenor saxophone, as well as the longer strings of improvised notes. These techniques will have a big impact on some of the bebop players featured in Chapter 5. This tune uses the standard 32-bar song form (A-A-B-A).

Total time: 3:13

:00	4-measure introduction played by rhythm section.
:03	1st chorus. Letter A material played by entire band. Bridge material played by Count Basie on piano accompanied by the rhythm section.
:35	2nd chorus. Features improvisation by Lester Young throughout.
1:06	3rd chorus. Features Basie and Young improvising while the rhythm section varies their accompaniment between stop-time and regular time-keeping on the bridge.
1:37	4th chorus. Features Basie and Young improvising by trading fours.
2:08	5th chorus. Features call and response between front-line instruments playing a 4-measure riff and Basie and Young improvising answers. Basie improvises through the entire bridge.
2:39	6th chorus. Continues format of 5th chorus until the last 8 measures when everyone plays the riff one more time, then breaks into collective improvisation for the conclusion of the tune.

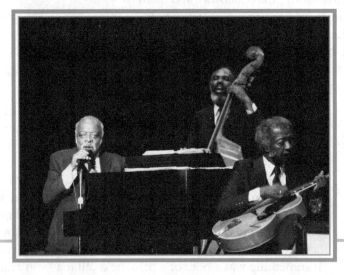

Count Basie, piano, performing in El Paso, Texas with guitarist Freddie Green and bassist Cleveland Eaton.
Courtesy of Bob Foskett

Count Basie was one of the few band leaders to survive the end of the big band era. Except for a brief period in the late 1940s, Basie continued fronting a big band for most of his career. Over the years, his band became a training ground for young jazz musicians and arrangers. In later years, Count Basie was in great demand at jazz festivals and in regular concert tour appearances around the world. He also recorded and toured with many great singers including Ella Fitzgerald, Joe Williams, and Frank Sinatra. You can listen to Joe Williams singing with a later version of the Count Basie Orchestra on the tune *Every Day I Have the Blues*.

Listening Guide

Every Day I Have the Blues (P. Chatman, arr. E. Wilkins)

Example of Kansas City blues style with vocal
Recorded July 17-26, 1955
Performed by the Count Basie Orchestra with vocalist Joe Williams. Count Basie, piano and leader; Marshall Royal and Frank Wess, alto sax; Frank Foster and Bill Graham, tenor sax; Charlie Fowlkes, baritone sax; Reunald Jones, Thad Jones, Wendall Curley, and Joe Newman, trumpet; Henry Coker, Bill Hughes, and Ben Powell, trombone; Freddie Green, guitar; Eddie Jones, bass; and Sonny Payne, drums

After the decline of the big bands at the end of the swing era, Count Basie fronted a series of smaller groups. He never gave up on the idea of a big band, however, and went back to the large-group format as soon as he could. This recording represents one of his most successful bands formed after the end of the swing era. This tune, featuring the great blues shouter Joe Williams, ended up being one of Basie's—and Williams'—biggest hits. The entire song is based on a standard 12-bar blues pattern.

Total time: 5:24

:00	10-measure introduction, featuring Count Basie for the first 6 bars, followed by 4 bars played by the entire band.
:21	Head. Played by the sax section.
:49	Shout chorus. Count measures with care; this is still a 12-bar blues chorus.
1:17	Interlude. 8 bars to set up the vocal.
1:35	1st vocal chorus.
2:02	2nd vocal chorus.
2:30	3rd vocal chorus.
2:58	4th vocal chorus.
3:25	5th vocal chorus.
3:53	6th vocal chorus.
4:20	7th vocal chorus.
4:48	8th (and last) vocal chorus.
5:11	4-measure tag for conclusion of tune.

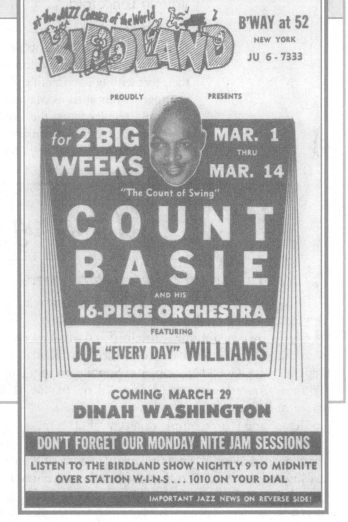

Concert flyer announcing a two-week engagement for the Count Basie Orchestra at the New York nightclub Birdland.
Courtesy of Tad Hershorn
at the Institute of Jazz Studies, Rutgers University

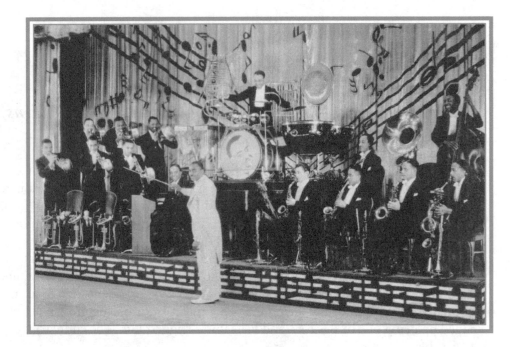

Jimmie Lunceford and His Orchestra. Courtesy of the Institute of Jazz Studies, Rutgers University

Jimmie Lunceford

One of the more overlooked bands of the swing era, the Jimmie Lunceford Orchestra was known for its swinging arrangements and great stage shows. The Lunceford band was the ultimate dance band, never failing to bring everyone to their feet with bold ensemble playing and dramatic flights of melody. Long before trumpet players such as Maynard Ferguson were playing way above the musical staff on a regular basis, the Lunceford band made screaming trumpet sounds a regular part of their performances. You can hear the band play one of its signature arrangements titled *Lunceford Special*.

Listening Guide

Lunceford Special (J. Lunceford, arr. E. Durham)

Example of big band playing in the swing style

Recorded December 14, 1939

Performed by Jimmie Lunceford and His Orchestra. Willie Smith, Ted Buckner, and Dan Grissom, alto sax; Joe Thomas, tenor sax; Earl Carruthers, alto and baritone sax; Eddie Tompkins, Paul Webster, Gerald Wilson, and Snooky Young, trumpet; Elmer Chumbley, Russell Bowles, and Trummy Young, trombone; Eddie Wilcox, piano; Al Norris, guitar; Moses Allen, bass; and Jimmy Crawford, drums

This tune is an example of a typical up-tempo big band dance number, complete with improvised solos and riffs. It follows the standard 32-bar song format (A-A-B-A). Remember that this form is divided into four symmetrical groups of 8 measures each, with the bridge (or letter B material) being significantly different from the three statements of the letter A material.

Total time: 2:49

:00 Introduction. 4 measures of bass and drums, followed by 8 measures of saxes and brass, and concluded with a 4-measure sax ensemble break.

:16 1st 32-bar chorus begins with two statements of the 8 measures of letter A material. Melody is played in the saxes with brass punctuations mostly on beats 1 and 3.

:33 Bridge. Brass ensemble takes the lead.

:41 Last 8 measures with a return to letter A material. Solo trumpet break on the last 2 measures of this section at :47.

:49 2nd 32-bar chorus begins with improvised trumpet solo accompanied by riffs in the sax section. Trumpet solo ends and improvised alto sax solo begins on the last 2 measures of this section at 1:03.

1:05 Bridge. Alto sax solo continues.

1:13 Last 8 measures. Return to letter A chord changes. Improvised alto sax solo continues.

1:21 3rd 32-bar chorus begins with improvised trombone solo accompanied by riffs in the sax section.

1:37 Bridge. Trombone solo ends and improvised tenor sax solo begins.

1:45 Last 8 measures. Return to letter A chord changes. Improvised tenor sax solo continues. Solo break on the last 2 measures of this section at 1:51.

1:53 4th 32-bar chorus begins with the full ensemble playing an altered version of the melody with aggressive instrumental shouts throughout the band. Solo drum break on the last 2 measures of this section at 2:07.

2:09 Bridge. Full band continues.

2:16 Last 8 measures. Return to letter A material with the addition of high solo trumpet soaring over the top of the band.

2:24 24-measure coda alternates between full band riff with solo trumpet and bold, final chords.

Rare ad copy from an old Down Beat *magazine featuring Jimmie Lunceford endorsing the Conn Band Instrument Company.* Reprinted by permission of Conn-Selmer, Inc. www.conn-selmer.com

Dig Deeper

MOVIES

🎺

The Glenn Miller Story; Orchestra Wives

RECORDING

🎺

Glenn Miller: Best of the Lost Recordings & The Secret Broadcasts

Trombonist, arranger, and bandleader Glenn Miller. Courtesy of the Institute of Jazz Studies, Rutgers University

Glenn Miller

Perhaps no band better represents the music popular during World War II than the Glenn Miller Orchestra. Miller got his start as a freelance trombonist, playing with several successful white dance bands. He also took an interest in arranging and began searching for a sound that would make his own band unique. He eventually arrived at a somewhat sweet-sounding group that used a clarinet in the lead over a large group of saxes, trumpets, and trombones. The band was more of a dance band than a true jazz band in the sense of Basie, Goodman, or Ellington. Miller's book relied heavily on smooth, medium-tempo dance numbers, ballads, and lots of vocals. There were some solid jazz players in Miller's group, however, and he did use charts that featured them to good advantage. *In the Mood*, one of the band's most popular tunes, almost single-handedly represents the swing era in general today, and the war years in particular. You can explore the original recording of this chart on Spotify.

Listening Guide

In the Mood (Joe Garland)

Example of one of the most popular big band tunes ever recorded
Recorded August 1, 1939
Performed by Glenn Miller and His Orchestra. Glenn Miller, trombone and leader; Wilbur Schwartz, clarinet and alto sax; Harold Tennyson, clarinet, alto and baritone saxes; Hal McIntyre, alto sax; Tex Beneke and Al Klink, tenor sax; Clyde Hurley, Legh Knowles, and Dale McMickle, trumpet; Al Mastren and Paul Tanner, trombone; Chummy MacGregor, piano; Richard Fisher, guitar; Rowland Bundock, string bass; and Maurice Purtill, drums

Perhaps more than any other single tune, *In the Mood* has come to represent the swing era in general and the war years in particular. In truth, it's just a catchy little riff tune based on the blues (followed by a second melody that is not the blues), but the main tune was one that really connected with audiences, and one that continues to engage listeners today. It should be noted that there is a great deal of controversy about who actually wrote this little riff. Before Miller recorded his famous version, there were many bands that recorded variations on the tune, each claiming credit for the composition on their respective recordings.

Total time: 3:31

:00 8-bar introduction.

:12 Main riff melody, played over the standard 12-bar blues pattern.

:29 Second full statement of the main melody.

:46 A second, 8-bar melody is introduced and played twice, for a total of 16 measures. The chord pattern here is not the blues.

1:09 The same chord pattern of the second melody continues with improvised tenor sax solos by Tex Beneke and Al Klink. The soloists trade 2-bar licks throughout the 16-bar pattern, with full band shouts in mm. 7-8 and 15-16.

1:32 The final 2-bar shout of the previous solo chorus is followed by an extra 4-bar interlude, again played by the entire band but without the rhythm section for the first 2 bars of the shout section.

1:37 Improvised trumpet solo by Clyde Hurley over yet another chord pattern. This section is 16 measures long, followed by a 2-bar interlude that takes us back to the original blues melody.

2:04 Full statement of the 12-bar blues pattern, followed by an extra 2 bars of the band extending the last note of the tune.

2:24 Another full 12-bar statement, followed by another extra 2 bars. Notice that each time the band does this pattern they get softer.

2:45 A third statement of the same pattern, the softest yet. This time, however, there is no 2-bar extension. Instead, after playing softer and softer through three choruses, the band comes out of the very end of this soft chorus with a big shout into the final chorus.

3:02 Final 12-bar chorus over the same material, which comes to a conclusion with several extended measures that take the trumpet section through a dramatic, harmonized technical passage and ends with one player sailing up to a final high note.

At the height of his success during the war, Miller joined the U.S. Army Air Corps. He eventually led a big band in the service. Made up of many of the best civilian jazz players, this band entertained troops in the European war theater. Miller died in a plane crash somewhere over the English Channel while traveling ahead of his band to the next gig. The band continued on after his death under a succession of leaders. Even today, there is a group of musicians touring the world using the Glenn Miller Orchestra book and name.

Headlines from the October 1942 issue of Metronome *magazine. War news dominated most major publications during this time.*
Courtesy of the Institute of Jazz Studies, Rutgers University

*Fats Waller on the street in
Juarez, Mexico during a
tour that included a stay in
El Paso, Texas.*
Courtesy of the Institute
of Jazz Studies, Rutgers
University

Thomas "Fats" Waller

Fats Waller was a musical triple threat. He was a great stride-style piano player and singer, a gifted composer, and a hilarious entertainer as well. Waller's emphasis on humor often led to him being overlooked as a serious artist, but his recordings reveal that he had tremendous technical facility on the piano. In addition, many of his compositions were big hits in their day and have gone on to become jazz standards. Songs including *Honeysuckle Rose*, *Ain't Misbehavin'*, *Black and Blue*, *Keepin' Out of Mischief Now*, and *The Jitterbug Waltz* have been performed and recorded by musicians of every jazz era since the 1930s. While Waller did occasionally front a big band, his most famous recordings were done by Fats himself on solo piano, or with a small swing combo he called Fats Waller and His Rhythm. Listen to an excellent (and hilarious) example of Waller with his small group performing *Your Feet's Too Big*.

Dig Deeper

MOVIE

🎺

Stormy Weather

RECORDINGS

🎺

Fats Waller and His Rhythm: If You Got to Ask, You Ain't Got It; Turn on the Heat: The Fats Waller Piano Solos

WEBSITE

🎺

http://newark www. rutgers.edu/ijs/fw/ fatsmain. htm

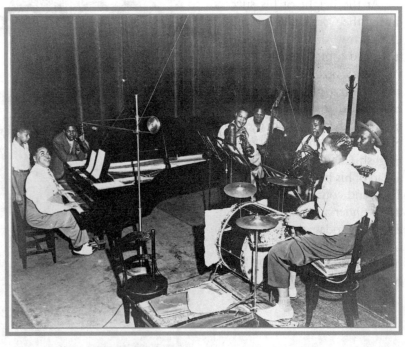

*Fats Waller and His Rhythm pictured during a recording session. Left to right:
Maurice Waller (Fats' son); Fats Waller, piano and vocal; arranger Don Donaldson,
next to Fats behind piano; John Hamilton, trumpet; Cedric Wallace, bass; Gene Sedric,
clarinet; Al Casey, guitar; and Arthur Trappier, drums.*
Courtesy of the Institute of Jazz Studies, Rutgers University

Listening Guide

Your Feet's Too Big (F. Fisher and A. Benson)

Example of Fats Waller's unique performing style
Recorded November 3, 1937
Performed by Fats Waller and His Rhythm. Thomas "Fats" Waller, piano and vocals; Gene Sedric, clarinet; John Hamilton, trumpet; John Smith, guitar; Cedric Wallace, bass; and Slick Jones, drums

This is one of Fats Waller's most famous recordings, and while his great piano playing skills are overshadowed a bit by his antics and singing on this particular track, it is still a great example of his style as a performer. The form here is a little tricky, so don't worry too much about counting along with this one. Just enjoy the skills of a great entertainer as he practices his craft.

Total time: 3:04

:00	Introduction and first thematic statements played by Waller on piano using the stride style.
:39	Vocal begins, backed by clarinet and trumpet with rhythm section.
1:12	Shout material performed simultaneously by Waller as a vocal and a piano lick. This little 4-bar section is followed by more of the vocal text.
1:53	Solo clarinet chorus with call and response licks spoken and played on piano by Waller.
2:25	Final vocal statement, followed by a shout from the full band with running commentary from Waller.

Coleman Hawkins

Coleman Hawkins occupies a unique position in the world of jazz in general and of sax playing in particular. Born in 1904, Hawkins played the blues, traditional jazz, swing, bebop, and even more modern styles of jazz over the course of his long career. Prior to Hawkins, the saxophone was viewed as something of a novelty instrument, used in vaudeville shows and cheesy society dance orchestras. He is frequently credited with being the first serious tenor sax soloist in the jazz style, and he went on to be a musical inspiration for several generations of sax players who followed in his footsteps. Even modern players such as Sonny Rollins point to Coleman Hawkins as a major influence.

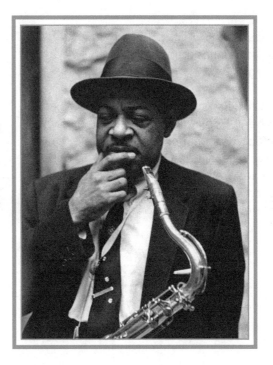

Dig Deeper

RECORDING

Coleman Hawkins: Ken Burns Jazz Collection

Coleman Hawkins.
Courtesy of the Institute of Jazz Studies, Rutgers University

Hawkins' first big break came in the early 1920s as an accompanist for blues singer Mamie Smith. He later settled in New York City, where he joined the groundbreaking Fletcher Henderson band. It was in Henderson's band that Hawkins was inspired by the solo improvisations of Louis Armstrong and later went on to become a major innovator in the art of improvisation himself. After leaving Henderson's band in 1934, Hawkins traveled to Europe, where he enjoyed great success until the outbreak of World War II. Upon his return to America, Hawkins made a series of excellent recordings including the masterpiece *Body and Soul*, which codified his approach to improvisation. You can experience this amazing performance on Spotify. This recording is a very good example of a smaller ensemble playing in the swing style.

Listening Guide

Body And Soul (J. Green, R. Sauer, E. Heymann, and F. Eyton)

Example of extended improvisation in the swing style

Recorded October 11, 1939

Performed by Coleman Hawkins and His Orchestra. Coleman Hawkins, tenor sax; Jackie Fields and Eustis Moore, alto sax; Joe Guy and Tommy Lindsay, trumpet; Earl Hardy, trombone; Gene Rogers, piano; William Oscar Smith, bass; and Arthur Herbert, drums

This recording was something of a surprise hit for Coleman Hawkins. Unlike most performances during the swing era, Hawkins doesn't actually play the melody for *Body and Soul*. Instead, he spends the entire recording improvising a new melody over the written chord changes of the original tune. After a brief piano introduction, the true melody is briefly played by Hawkins, but he quickly drifts off into embellishment and full improvisation. This tune follows the standard 32-bar song form (A-A-B-A).

Total time: 3:02

:00	4-measure piano introduction.
:10	1st chorus begins.
:51	Bridge.
1:11	Last 8 measures. Return to letter A chord changes.
1:31	2nd chorus begins. Sax solo continues. Other horns join with soft accompaniment.
2:12	Bridge. Sax solo continues. Other horns drop out.
2:32	Last 8 measures. Return to letter A chord changes. At the end, other instruments drop out and sax improvises freely. Horns rejoin sax to play the final chord.

Never one to rest on his laurels, Hawkins continued to embrace new innovations in jazz throughout the 1940s, 50s, and early 60s. He was a champion of the younger be-bop players you will meet in Chapter 5, and he even explored the more aggressive styles of hard bop found in Chapter 7. Hawkins made a number of great recordings, both on 78-rpm record and 33 1/3 long-play albums. Beyond the previously mentioned *Body and Soul*, some of Hawkins' best recordings available on CD include *In Europe 1934-39*, *Classic Tenors: Lester Young & Coleman Hawkins*, *Coleman Hawkins and Johnny Hodges in Paris*, *Duke Ellington Meets Coleman Hawkins*, and *Night Hawk*, made with tenor sax player Eddie "Lockjaw" Davis.

Django Reinhardt

Django Reinhardt was a Gypsy guitarist who did most of his performing and recording in and around Paris, France. In truth, his playing style does not fit neatly in any one period of jazz, but most of his important recordings were made during the swing era. Django is really the first major figure in jazz not born in America. Building on his European musical sensibilities, jazz from Django is just . . . different. As a young man, Django was badly burned in a fire, and his left hand was crippled. Because he had only limited use of that hand, he developed a rapid single-note style of playing that imitated the facility of a great piano player. He would also occasionally bar his finger across the entire fretboard and bang out crashing chords in a way no guitarist had done before. Many of his best recordings were done with a group called the Quintet of the Hot Club of France. The group was made up of three guitars, a string bass, and a violin. The violinist, Stephane Grappelli, went on to become a major jazz

Django Reinhardt and The Quintet of the Hot Club of France on the May 1936 cover of the French music magazine Jazz Hot. *Courtesy of Tad Hershon at the Institute of Jazz Studies, Rutgers University*

Dig Deeper

BOOKS

Django: The Life and Music of a Gypsy Legend by Michael Dregni; *Django Reinhardt* by Charles Delaunay (revised 1993 edition)

RECORDINGS

Djangology (Capitol Records box set); *Djangology 49* (Bluebird); *The Best of Django Reinhardt* (Blue Note)

MOVIE

Sweet and Lowdown

star in his own right. Although Reinhardt died in 1955, he still has a passionate cult following. Many bands in various musical styles have drawn influence from Django Reinhardt. Even today his music, or at least his playing style, is frequently heard in film soundtracks and television commercials.

In his fascinating and sometimes tragic book *La Tristesse de Saint Louis: Swing under the Nazis*, Mike Zwerin offers a brief overview of the formation of the Hot Club quintet and the impact World War II had on Django Reinhardt.

One night in 1934, the violinist Stephane Grappelli and Django Reinhardt were working a dance together in Louis Vola's fourteen piece orchestra at the Claridge Hotel. They had met but were not friends. Grappelli broke a string, went to change it and came back tuning up with "Dinah". This is a famous story, historic folklore. Django joined in. They had both started playing music on the streets. Like Dave Brubeck with Paul Desmond and Charlie Parker with Dizzy Gillespie, the two of them were, for all their differences, made to improvise music together. That was about all they shared. Grappelli was personally about as different from Django Reinhardt as possible.

Together they formed the Quintet of the Hot Club de France, with Vola on bass and Joseph's [Reinhardt's brother's] rhythm guitar. They were idolized by violinists and guitarists everywhere; soon every European country had a drumless string band along the lines of their quintet, which also had a profound effect on the Afro-Americans who inspired it. It was the four of them until Django complained to Grappelli: "It's not fair. you have two guitars backing you up. I only have one."

A third guitar was added. This was one odd jazz band, without a saxophone, trumpet or drums. Grappelli has since called it "the first rock 'n' roll band. I don't know anybody else who had three guitars before us." The gay and swinging chamber sound of this string quintet was in fact the first European contribution to America's native art form.

On 3 September 1939, the quintet was in London. At 7:30 p.m. there was an air-raid alert. Thousands of civil-defence workers wearing white helmets patrolled the streets, blowing whistles and directing pedestrians to shelter. The streets were soon empty except for security people and their equipment. Searchlights probed the sky.

"It's war," Django said to Grappelli.

That night at the State Kilburn Theatre, one Gypsy was missing. They looked for Django for days. Scotland Yard was put on the case. But he had taken a train for Paris after the first siren. Eating a *choucroute* in a Montmartre brasserie, Django explained to a friend: "you're less afraid at home."[6]

Although one track is not enough to clearly express everything that was unique about Django Reinhardt's music and his playing style, you can get a good sense of the Hot Club quintet by listening to the original recording of a tune titled *Minor Swing* found on Spotify. You will also find over 200 other recordings on this website devoted to Django and his music.

Listening Guide

Minor Swing (Django Reinhardt)

Example of Django Reinhardt and The Quintet of the Hot Club of France
Recorded November 25, 1937
Performed by Django Reinhardt, lead guitar; Stéphane Grappelli, violin; Joseph Reinhardt and Eugene Vees, rhythm guitars; and Louis Vola, bass

Gypsy guitarist Django Reinhardt began playing jazz by interpreting American tunes, but he eventually started to compose his own numbers. It is in these original compositions that his music most noticeably reflects a decidedly European flair. While all of his music is clearly American-influenced jazz, it also has unique harmonic and rhythmic elements that bring something new to the jazz party. His classic Hot Club quintet of one solo guitar, two rhythm guitars, violin, and bass generated an iconic sound that is highly respected and imitated by many musicians today. *Minor Swing* is a simple 16-measure chorus firmly rooted in a minor key center (sad sounding).

Total time: 3:16

:00 The melody is presented with solo breaks left open for the bass player to fill.

:20 1st solo guitar chorus for Django Reinhardt. In this chorus and the two that follow it, you will get a good sense of the sweet, singing tone he was able to produce. You'll also hear his amazing technique as he explores a single-string approach to improvisation.

:39 2nd guitar chorus.

:59 3rd guitar chorus.

1:18 4th and final solo guitar chorus. Here, Reinhardt switches to a pounding chordal approach that was another element of his signature style. As this chorus progresses, he alternates between single-string picking and full chords.

1:37 1st solo violin chorus. The following four choruses will serve as an excellent introduction to Stéphane Grappelli's approach to jazz violin playing. Throughout his solo, you should also pay careful attention to Django Reinhardt's amazing improvised accompaniments.

1:56 2nd violin chorus.

2:15 3rd violin chorus.

2:34 4th violin chorus.

2:52 The original melody returns for the out chorus. Halfway through, a solo break is again left open for the bass player to fill. When the band reaches the end of the tune, however, the expected bass break is replaced by a prearranged tag played by the entire band.

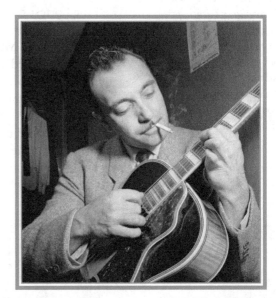

Famous William Gottlieb image of guitarist Django Reinhardt. This photo was made during a 1946 visit to America that was made possible with the help of Duke Ellington.
©William P. Gottlieb. From the Library of Congress Collection.

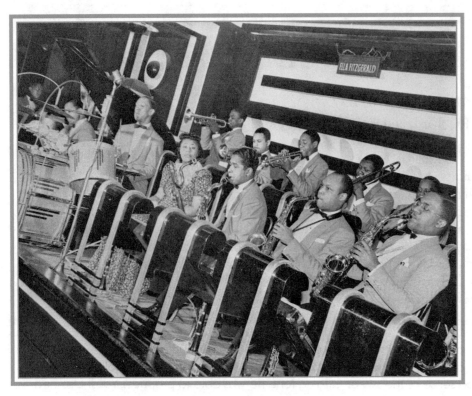

Ella Fitzgerald fronted the Chick Webb Orchestra after the drummer's death, later renaming the band after herself. This photo shows Ella and the band at the Savoy Ballroom in 1940 with Bill Beason on drums.
Courtesy of the Institute of Jazz Studies, Rutgers University

Chick Webb and Ella Fitzgerald

During the swing era one of the hottest bands in New York City was a group run by drummer Chick Webb. This band played regularly at a Harlem dance hall called the Savoy Ballroom. The Savoy was so big that it had two bandstands, and often a second band would be hired so that the dance music would never stop. Many bands, including the Benny Goodman Orchestra and the Count Basie Orchestra, came to the Savoy to play opposite the Chick Webb band. These "battle of the band" playoffs as they were called almost always ended with Chick Webb and his band being voted the hottest band of the day. Webb wanted to expand his horizons beyond the Savoy, however, and knew that he had to find a great singer to help him make that happen. Many of the most successful big bands featured one or more singers that worked regularly with the group, and often their most commercially successful tunes featured a vocal. Though she was considered less attractive than most of the girl singers of the day, it was the wonderful vocal style of Ella Fitzgerald that helped Chick Webb achieve the success he desired. Unfortunately, Webb had always suffered from poor health, and he passed away soon after his music came to national prominence. The band stayed together, and Ella Fitzgerald, now fronting the band, went on to have many hit recordings. One of her biggest hits of the swing era was the novelty tune *A Tisket, A Tasket*.

Listening Guide

A Tisket, A Tasket (A. Feldman and E. Fitzgerald)

Example of a vocal feature during the swing era
Recorded May 2, 1938
Performed by Ella Fitzgerald with the Chick Webb Orchestra. Pete Clarke, clarinet and alto sax; Louis Jordan, alto sax; Teddy McRae and Wayman Carver, tenor and baritone saxes; Mario Bauza, Bobby Stark, and Taft Jordan, trumpet; Sandy Williams, Nat Story, and George Matthews, trombone; Tommy Fulford, piano; John Trueheart, guitar; Beverly Peer, bass; and Chick Webb, drums

Total time: 2:39

:00	Introduction. 12 measures.
:18	Vocal chorus. 32 measures, following the typical 32-bar song format of A-A-B-A.
1:04	12-bar instrumental interlude similar to the introduction. Notice that the final bar of the previous chorus and the first bar of this section are what are called an "elision," meaning they overlap. Measure 32 of the previous section and measure 1 of this section are the same bar. Notice also that the last 2 bars of this section go from a major key center (happy-sounding) to a minor key center (sad-sounding) to set up the next vocal section, also in a minor key.
1:21	Letter A vocal melody returns for 8 measures, but this time the material is presented in a minor key to better reflect the text.
1:33	This next section breaks the standard 32-bar song form. You will hear a 4-bar "call" from Fitzgerald, followed by a 4-bar "response" from the rest of the band. This call and response passage is repeated twice, for a total of 16 measures.
1:55	Now the tune continues with the standard B section, also called the bridge.
2:07	With some very creative blues-tinged vocal embellishments, Fitzgerald sings the last 8 bars (the final letter A) of the standard 32-bar song form.
2:19	The song concludes with an extra 12 measures of call and response between Fitzgerald and the orchestra.

Source: Barry Kernfeld, ed., *The Blackwell Guide to Recorded Jazz* (Oxford, UK, and Cambridge, MA: Blackwell Reference, 1991), 115-120.

Like Louis Armstrong, Ella Fitzgerald became a master of scat singing. Perhaps more than any other female singer, she was readily accepted by instrumentalists because of her precise sense of pitch, her excellent control of rhythm, and her great ability to improvise. She continued singing well into the 1990s, and many of her recordings are considered masterpieces of the vocal art. You can hear Ella sing in more of a bebop style on the tune *Lemon Drop* featured in Chapter 5.

The following is an article taken from Joe Smith's book *Off The Record: An Oral History of Popular Music*. In this selection, Ella Fitzgerald shares some stories about her life in the music business.

\mathcal{P}ersonal Memories of Ella Fitzgerald

Chick Webb had one of the greatest bands. Nobody gave him the credit for the band he had. When Chick died in 1939, everyone in the band tried to keep it together. I sang in that band, but I didn't do much leading. They finally ended up having one of the musicians direct the band, but all we were doing was trying to keep the band together. It was a way for me to work.

I did more dancing on the floor than I did singing. I used to love to do the Lindy hop. People called me a tomboy because on our day off I would go play ball. But I always wanted to be a dancer. I had gone on the "Amateur Hour" to dance, and my girlfriend and myself had made a bet that we would all be signed to work at the Apollo Theater, and I was the one that got the call to come down. I lived in Yonkers then. When I walked out on the stage, I was trying to do something good

Dig Deeper

RECORDINGS

The Complete Ella Fitzgerald Songbooks; Ella: The Legendary Decca Recordings; The Complete Ella Fitzgerald & Louis Armstrong on Verve; Twelve Nights in Hollywood

BOOK

Ella Fitzgerald: A Biography of the First Lady of Jazz by Stuart Nicholson

because they were going to call me "chicken" if I lost my nerve. The man said, "You're out there. Do something." So I started to sing a Connee Boswell song called "Judy, the Object of My Affection."

I never thought I was going to be a singer. What I really did was dance a lot. My cousins would say, "Let's go to the movies," and I'd end up dancing in the streets and people would give us money. At that time, they used to have block parties and I'd go and dance. When I got called to go audition at the Apollo, I was very surprised because there were two sisters who were the greatest dancers at that time, and they were closing the show. I was the first amateur. I tried to sing like Connee Boswell and I won first prize. A man had a radio show, and my mother had to sign for me because I was only fourteen and I wasn't old enough. From there, I went from amateur show to amateur show and I kept on winning.

I was promised a week at the Apollo, but that never came through. But I kept right on. The first time I lost a contest was at the Lafayette Theater in New York. I sang "Lost in the Fog," and the piano player couldn't get the chords right.

But I kept right on, and the man at the Apollo said, "If you win this time. I'll give you a week." Finally I did a week at the Apollo and then I went to the Harlem Opera House. They had number-one acts at the Harlem Opera House, acts like the Nicholas Brothers, and they put me on at the end of the show. They said, "We have a little girl here who sang at the Apollo." Then they all cheered at the end of my songs. I sang "Judy" and "Believe It, Beloved." Chick Webb was playing there and he finally gave in and said he'd listen to me. He was big time and that was a big job for me.

I did a show with a disc jockey somewhere, and on a song called "Simple Melody" I started doing a do-do-do-do-doodley-do, and this man said I was scat singing. I never considered it jazz or bop. I learned how to sing like that from Dizzy Gillespie. In New York there were plenty of after-hours clubs, and I hung out with the guys and learned that technique. I didn't pay much attention to what people were calling it. That's what's so funny.

I've worked with so many great people. For me, Louis Armstrong was a lesson in love. This was a man everybody loved, no matter what he did. He just had that "way" and that "want." There are just some people that you can come up to and say something to and you know something nice will be said back.

I messed up a lot on Louis' records because he always wore his socks rolled down, and I would look and see his socks down and I'd start laughing. Or he would say something funny while we were recording, and I would laugh. He made recording sessions a joy.

Count Basie was just like Louis. Everybody loved him so much. I could go to him with anything and he'd help me. I used to call him one of my lawyers. He would give me such beautiful advice. And he would phrase that advice into these little sayings. One saying of Count Basie's that I'll always remember pertains to when my husband and I broke up. Basie said, "It's like a toothache. It hurts now, but if you take that tooth out, you'll miss it but you'll feel better."

I also remember one my mother told me when I thought I was such a good dancer in Yonkers. She said, "Don't you ever, ever feel that you are bigger than anybody else, because some man could be lying in

the gutter and he could get up the next day and be the one person to give you help. So always remember to speak to everybody."

In the fifties I started singing with a different kind of style. That came about because Norman Granz felt that there was something else to my voice besides just singing. Basin Street and Birdland had closed down, and I was wondering where I was going to work. All the bop/jazz clubs were gone. So we tried this new style, picking out songwriters and singing their songs. Cole Porter was the first. It was like beginning all over again. People who never heard me suddenly heard songs which surprised them because they didn't think I could sing them. People always figure you could only do one thing. It was like another education. Here I am with Cole Porter, and it became such a big hit that we tried it with Gershwin. Then we did a Harold Arlen songbook, then an Irving Berlin songbook. We just went from one songwriter to another, all the great ones, and it opened up another whole level of audience for me. People started saying, "You know, no matter what this lady sings, she's still singing a pretty tune."

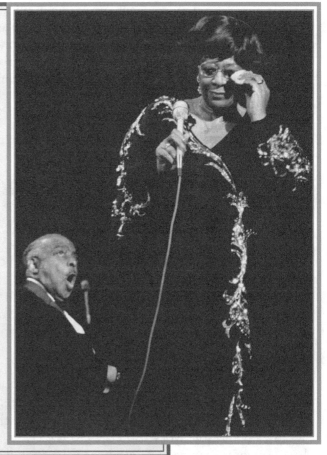

From *Off the Record* by Joe Smith. Copyright © 1988 by Unison Productions. By permission of Grand Central Publishing.

Count Basie and Ella Fitzgerald performing in San Antonio, Texas in 1979.
Photograph by Tad Hershorn

Tommy Dorsey and Frank Sinatra

Trombonist Tommy Dorsey ran a band that leaned heavily toward the sweeter side of swing, similar to the style of the Glenn Miller Orchestra. In fact, the common tag line for Dorsey was "the sentimental gentleman of swing." He had a beautiful, smooth tone on the trombone, which he liked to feature in flowing ballads such as *I'm Getting Sentimental Over You* and in bouncier numbers including *Marie*. While the band would "swing out" a bit in faster numbers, Dorsey's tone would glide over the top of the ensemble. Like many of the most popular big bands of the day, the Tommy Dorsey Orchestra featured several gifted solo singers and a sensational vocal ensemble called the Pied Pipers. Frank Sinatra, perhaps the best pop singer of all time, got one of his first big breaks with the Dorsey band.

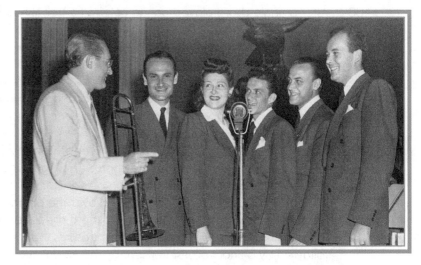

Tommy Dorsey with Frank Sinatra and the Pied Pipers in the early 1940s. Left to Right: Tommy Dorsey, Chuck Lowrey, Jo Stafford, Frank Sinatra, Clark Yocum, and John Huddleston.
Courtesy of the Institute of Jazz Studies, Rutgers University

Frank Sinatra grew up in Hoboken, New Jersey, just outside of New York City. His first important job as a professional singer came on a tour with trumpet player Harry James' Orchestra in 1939. Soon after, he joined the Tommy Dorsey Orchestra, with whom he recorded many hit songs in the 1940s. Their biggest hit, *I'll Never Smile Again*, is featured on your Spotify playlist and in the accompanying listening guide.

Listening Guide

I'll Never Smile Again (Ruth Lowe)

Example of the Tommy Dorsey Orchestra and the early vocal style of Frank Sinatra
Recorded May 23, 1940
Performed by Tommy Dorsey and His Orchestra with Frank Sinatra and the Pied Pipers, vocals. Don Lodice, Paul Mason, Johnny Mince, Hymie Schertzer, and Fred Stulce, saxes; Bunny Berigan, Jimmy Blake, Leon Debrow, and Ray Linn, trumpet; George Arus, Tommy Dorsey, Les Jenkins, and Lowell Martin, trombone; Joe Bushkin, piano; Clark Yocum, guitar; Sid Weiss, bass; and Buddy Rich, drums

The story of the creation of this song is a sad one. Composer Ruth Lowe was a working professional musician at a very young age. She married in her early 20s and was a widow by the age of 24. The lyrics of this song reflect the despair she was feeling over the loss of her husband. After the song became popular, the lyrics also began to reflect the mood of much of her Canadian homeland and, later, America as young men began dying in great numbers during World War II. This song was a big hit for the Tommy Dorsey Orchestra and a major boost for the vocal career of a young Frank Sinatra. The piece follows a 32-bar song form that uses the A-B-A-C format. In this slow ballad performance, however, you will hear the tune all the way through only once at the beginning of the recording. The second statement begins with solo trombone for 8 measures over letter A material, followed by the final 8-bar statement of the letter C material and a short tag to bring the tune to its conclusion.

Total time: 3:10

:00	After a single chord played on the celesta (a bell-like keyboard instrument), the Pied Pipers and Frank Sinatra enter with a tightly harmonized version of the melody. The 32-bar tune begins with three pick-up notes. You will hear the words "I'll ne-ver..." and when you hear the word "smile" you will be on the downbeat of measure 1. The ensemble sings for a few bars and then turns the lyric over to Sinatra for a solo vocal. They pass the tune back and forth like this throughout the entire recording. As you explore this recording, notice the gentle but steady time that makes this performance a perfect cheek-to-cheek dance number.
1:55	As with the vocal at the beginning of the track, Tommy Dorsey's trombone solo begins with a 3-note pick-up into the 2nd chorus. This high, lyrical trombone sound was Dorsey's trademark. It is often imitated but can be very difficult to faithfully reproduce. This instrumental solo is 8 measures long, played over the original letter A material.
2:27	Sinatra returns with a final statement of the 8 measures of letter C material. This concluding section is followed by a few extra measures that begin with Dorsey on trombone, followed by a final vocal statement by the Pied Pipers and Frank Sinatra.

Sources: J.R. Hafer, "Brief Bios: The Story of a Song," accessed March 16, 2011, http://www.grubstreet.ca/articles/bio/bb-storyofasong.htm.

"Frank Sinatra Discography," accessed March 29, 2011, http://www.steve-albin.com/Artists/Sinatra/dorseyyears.htm.

Sinatra's incredible audience appeal led him to become a solo act a few years later. Realizing that solo singers were cheaper to hire than a nationally recognized big band with a singer, promoters began to focus more on solo talent. Coupled with the end of World War II, these economic shifts started to signal the end of the big band era. Frank Sinatra, of course, went on to a major career as an entertainer in films, television, and nightclubs. Throughout his long career, many of his best recordings continued to feature excellent jazz players.

In *Off The Record: An Oral History of Popular Music*, singer Jo Stafford reminisced about her time as a member of the Pied Pipers. She has some fond, and not so fond, memories of Tommy Dorsey and Frank Sinatra.

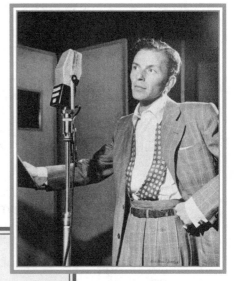

Personal Memories of Jo Stafford

Originally, the Pied Pipers were made up of seven boys and me. Alyce King of the King Sisters was going with Paul Weston, and Alyce's sister, Yvonne, was going with Axel Stordahl. Paul and Axel were arrangers with Tommy Dorsey's orchestra.

Alyce went to Paul one day and said, "You've got to hear this group that's just formed. They're really good." So we got together one afternoon and had a jam. Paul and Axel then told Tommy about the group, and he hired us, not as a part of his orchestra, but as an act on his radio show.

We did Tommy's radio show for about seven weeks, and then we starved to death for the next seven months before returning to California.

Then, I'll never forget, it was a Friday. I had just picked up my last unemployment check, and when I got home there was a message for me to call an operator in Chicago. It was free, so I made the call. It was Tommy. He said he couldn't handle a group of eight, but if we were a quartet we could join his organization.

I said, "Funny you should ask. Some of the guys have dropped out, and we're already down to a quartet." That's how the Pied Pipers joined Tommy.

Two weeks later, Frank Sinatra joined the band. We'd just finished an engagement at the Palmer House in Chicago, and now we were on our way to another engagement in Minneapolis. We went up by train. It wasn't very far. We didn't have to rehearse because we knew our part of the presentation. But Frank was new and he had to rehearse.

The first time I ever saw him, or heard him, was that night when Tommy introduced him as the new vocalist, and he walked on to do his stint.

This classic William P. Gottlieb photograph of a young Frank Sinatra was shot during a recording session at Liederkrantz Hall in New York City in 1947.
©William P. Gottlieb/Ira and Leonore S. Gershwin Fund Collection, Music Division, Library of Congress

This photo was used to accompany a 1946 Down Beat *magazine article. The original caption read: "This intimate shot of singer Jo Stafford, taken in her dressing room by Bill Gottlieb, reflects Jo not once, but twice, as well as the innumerable bottles of perfume and make-up necessary for her stage appearances. It would seem that Jo is a collector of exotic perfumes, from the assortment on her dressing table."*
©William P. Gottlieb/Ira and Leonore S. Gershwin Fund Collection, Music Division, Library of Congress

About eight bars into the song I thought, "Boy, this is something else. This is new. No one has ever sounded like this before." And it was an entirely new sound. Most boy singers in those days sounded like Bing Crosby. Crosby was the big thing. But this kid didn't sound like Crosby. He didn't sound like anybody I'd ever heard before. And he was sensational.

The Pipers joined Tommy's orchestra in December of '39, and we stayed three years, until November of '42. We left because of a fight Tommy got into with one of the Pipers, Chuck Lowrey. We were at a train station, about to board our train. It was eight o'clock in the morning. It was during one of the periods when Tommy was drinking. He asked Chuck which train was ours, and Chuck gave him the wrong information. Not purposely. But "Little Tom," as we used to call him, had a bit of a hangover that morning, and he got very mad and started screaming and yelling. The four of us walked off the train in a huff and that was it.

From *Off the Record* by Joe Smith. Copyright © 1988 by Unison Productions. By permission of Grand Central Publishing.

Dig Deeper

MOVIES

🎺

Stormy Weather;
The Blues Brothers

After Duke Ellington, Cab Calloway was one of the most popular artists to ever play the Cotton Club. This ad was taken from a January 1938 The New York Times.

Dig Deeper

MOVIE

🎺

New Orleans (with Louis Armstrong)

Cab Calloway

Next to Duke Ellington, the man who reigned supreme at the Cotton Club in the 1930s was singer Cab Calloway. With a flare for outrageous performances complete with zoot suits and big hats, Calloway fronted a very popular band. He was known as a good vocalist, with great ability as a scat singer. He was humorous and energetic on stage. Like Lester Young, Calloway developed his own "jive" language, which he often incorporated into his songs. Legend has it that George Gershwin, a regular at the Cotton Club, based the character Sportin' Life in his opera *Porgy and Bess* on the stage antics of Calloway. In later years, Calloway himself would play the role in a revival performance of the opera. In 1931, Cab Calloway had his most popular hit with a song titled *Minnie The Moocher*. It became his signature tune, and he would perform it regularly over the next 60 years. In 1980, he had the opportunity to perform the song in the film *The Blues Brothers* with Dan Aykroyd and John Belushi, which brought Calloway to the attention of yet another generation of music fans.

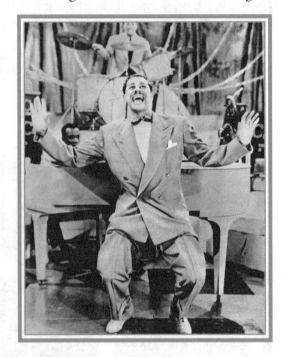

The flamboyant bandleader and vocalist Cab Calloway strikes a classic pose.
Courtesy of the Institute of Jazz Studies, Rutgers University

Billie Holiday

Following in the vocal footsteps of Louis Armstrong, Billie Holiday has become an icon of jazz music in general and the swing era in particular. Many people who know nothing about jazz are familiar with the music of Billie Holiday. Her style is direct and penetrating. All of her joy, pain, sadness, and anger are clearly displayed in

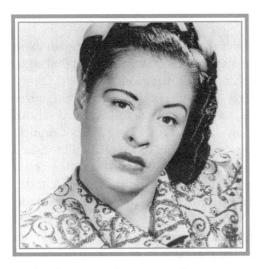

Billie Holiday in an undated (but relatively early) press photo.
Courtesy of the Institute of Jazz Studies, Rutgers University

her singing. Holiday's first big breaks came with the bands of Count Basie, Louis Armstrong, and Artie Shaw. Overall, however, she preferred performing in smaller, intimate club settings where she could really communicate with her audience. Unlike Ella Fitzgerald, Holiday had a limited vocal range. In place of extreme vocal technique, Holiday had a very expressive style that displayed an innate sense of rhythm and a deep understanding of the blues. Many of her recordings have been released on compact discs and are available in most record stores. You can hear Billie Holiday sing Hoagy Carmichael's classic ballad *Georgia On My Mind* on Spotify.

Dig Deeper
DOCUMENTARY

Lady Day: The Many Faces of Billie Holiday
RECORDINGS

Lady Day: The Complete Billie Holiday on Columbia (1933-1944); The Complete Decca Recordings; The Complete Billie Holiday on Verve (1945-1959)

Listening Guide

Georgia on My Mind (H. Carmichael and S. Gorrell)

Example of Billie Holiday's use of blues inflections and rhythmic alterations in jazz vocals
Recorded October 11, 1937
Performed by Billie Holiday and Her Orchestra. Billie Holiday, vocal; Eddie Barefield and Leslie Johnakins, alto sax; Lester Young, tenor sax; Shad Collins, trumpet; Eddie Heywood, piano; John Collins, guitar; Ted Sturgis, bass; and Kenny Clarke, drums

Here is a classic ballad as sung by Billie Holiday. Pay attention to her relaxed phrasing and the way she attacks and releases certain notes with her voice. Among vocalists, Billie Holiday was truly unique, as this recording demonstrates. The song is presented in two choruses of the standard 32-bar song form (A-A-B-A).

Total time: 3:19

:00	4-measure introduction.
:10	1st chorus begins. Holiday's vocal dominant all the way through.
:55	Bridge.
1:18	Last 8 bars. Return to letter A material.
1:42	2nd chorus begins. Piano solo by Eddie Heywood for 1st half of chorus.
2:30	Bridge. Holiday returns with vocal.
2:54	Last 8 bars. Vocal continues to end of song.

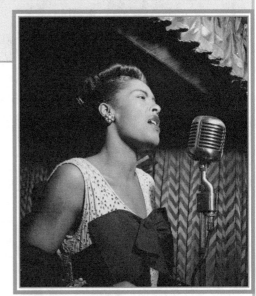

Billie Holiday performing at the Downbeat Club in New York City in 1947.
© William P. Gottlieb. From the Library of Congress Collection.

Swing Today

In the 1990s, swing enjoyed something of a resurgence as young adults in large cities across America discovered the pleasures of a great martini, a good cigar, and driving dance music. In search of a different style, bands such as Royal Crown Review, The Squirrel Nut Zippers, Cherry Poppin' Daddies, The Brain Setzer Orchestra, The Mighty Mighty Bosstones, and 8 ½ Souvenirs all explored various aspects of the swing style. More mainstream jazz artists including Harry Connick, Jr., Diana Krall, and John Pizzarelli (among many, many others) have all revisited the vocal styles of the big band jazz singers from the 1930s and 40s. Perhaps even more telling about the deep impact swing music still has on many people today are the special jazz projects created by mainstream artists such as Linda Ronstadt, Robert Palmer, Sinéad O'Connor, Barry Manilow, Rod Stewart, Bob Dylan, Boz Scaggs, and Sir Paul McCartney, as well as k.d. lang and Lady Gaga, both of whom have enjoyed the honor of recording with the great jazz crooner Tony Bennett.

Furthermore, film soundtracks such as *When Harry met Sally . . . , Sleepless in Seattle, French Kiss,* most of Woody Allen's films, and more recent projects such as the award-winning *Whiplash,* have all made use of swing music. The film *Whiplash* paints a rather dark picture of the state of jazz education today (at least in some circles), but the music is amazing. This film in particular also speaks to the important point that the big band format has long been a staple in music training programs in both high schools and colleges. While current tastes for swing music have cooled somewhat in more recent years, swing dancing, often to live bands, continues to enjoy a solid cult following in towns across America and around the world. In addition, as with our previous discussion of traditional jazz today, there are jazz festivals and theme cruises that regularly feature music drawn from the swing era.

Notes

1. *Jazz: A Film by Ken Burns,* Episode 3 (Washington, DC: PBS, 2001), videocassette.

2. Ibid., Episode 5.

3. Ibid.

4. Ibid.

5. Alan Axelrod, *The Complete Idiot's Guide to Jazz* (Indianapolis, IN: Alpha Books, 1999), p. 147.

6. Mike Zwerin, *La Tristesse de Saint Louis: Swing under the Nazis,* (London: Quartet Books, 1985), pp. 121-22.

Chapter 5

Bebop

Music is your own experience, your thoughts, your wisdom.
If you don't live it, it won't come out of your horn.

Charlie Parker

*A*merican popular music began to move in several different directions between 1945 and 1955. At first, pop singers such as Frank Sinatra, Doris Day, Perry Como, and Dinah Shore were at the top of the charts. As a younger generation of listeners began to control the pop charts, however, early rock-and-roll music began to take over. By the mid-1950s, the big stars of the day were Chuck Berry, Little Richard, Bill Haley and the Comets, and Elvis Presley.

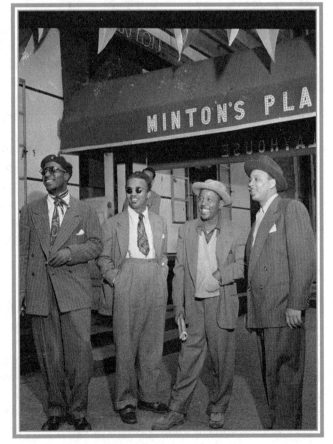

One of the most famous photographs in jazz, this picture features four important figures from the early days of bebop standing in front of Minton's Playhouse. Left to right: Thelonious Monk, Howard McGhee, Roy Eldridge, and Teddy Hill.
© William P. Gottlieb,
From the Library of
Congress Collection.

Meanwhile, a more advanced jazz style was taking shape in some of the after-hours clubs in New York City. In search of a more challenging musical experience, younger swing players including Charlie Parker, Dizzy Gillespie, and Thelonious Monk started to make some radical changes to jazz. Inspired by Art Tatum, Lester Young, and Charlie Christian, among others, the "beboppers," as they came to be known, began to speed up tempos, dramatically alter supporting chord structures, and frequently abandon the original melodies to songs altogether. In late-night jam sessions at clubs including **Minton's** and **Monroe's**, musicians pushed the envelope of what jazz could be throughout the early 1940s. By 1945, **bebop** had arrived in New York City. For most music fans in America, however, this new style was largely unknown. Even in New York there was a great deal of resistance to the new musical style. Some older swing musicians had very negative things to say about these young musical upstarts and their strange new ideas.

One of the major difficulties in discussing the evolution of bebop is the fact that in 1942 the American Federation of Musicians issued a recording ban. The union was fighting radio and record companies over royalty payments for recording musicians. Very few recordings were made for several years at the exact time bebop was taking shape. Historically, the result is that bebop seems to arrive fully formed in 1945, after the recording ban was lifted. While we have excellent written accounts of how bebop evolved, and we have great recordings from the periods before and after the AFM ban, we can only guess at what the historical jam sessions might have sounded like. Even the earliest bebop recordings are not quite true representations of what was going on in the clubs. In the mid-40s, music was still being recorded on 78-rpm discs that could only contain about four minutes of music per side. In live performances, bebop tunes frequently lasted much longer.

Minton's
Monroe's
bebop

Metronome
MODERN MUSIC AND ITS MAKERS
Volume LVIII Contents Copyrighted 1942 AUGUST, 1942 By Metronome Corporation Number 8

Recording Stops on August 1st

New Action Taken By James Petrillo; No Action Taken By Disc Companies

after receipt of the AFM edict. This is the music union president's first major step toward getting remuneration for musicians from the performances of records over the air and in juke boxes. Petrillo's first announcement, at the Dallas, Texas, convention of the American Federation of Musicians, was that record companies could go on making discs for home consumption, but absolutely could not use musicians on records used by juke boxes and radio stations. Having found no machinery to effect that vital distinction in record sales, this new order was issued by President Petrillo last month.

All transcription and recording companies have been notified that their AFM licenses which expire

Bebop Techniques

With just a few exceptions, bebop used a small band format. Most bands consisted of one to three horn players in the front line backed up by the traditional rhythm section of piano, bass, and drums. Most bebop tunes were complex newly created lines, called **contrafacts,** over a set of standard chord changes. The 32-bar format for the tune *I've Got Rhythm* and the basic 12-bar blues were two of the most popular sets of chord changes used. Other dixieland and swing tunes that Charlie Parker and Dizzy Gillespie created new melodies over included *Indiana*, *Cherokee*, *How High the Moon*, and *Honeysuckle Rose*. The bebop style tended to increase the tempo

Contrafacts

and expand both the rhythmic and harmonic complexity of jazz. The main goal for most bebop players, however, was extended improvisation. Some of the younger players felt constrained by the big band texture, where improvised solos were fitted around the written sections of most charts. At these late-night jam sessions players were allowed much more freedom to break away from the written melody. They took four, five, or even more solo choruses, allowing their improvisations much more time to evolve and expand. A tune's melody would be played once at the beginning of a performance and then again at the end. Often there would be more than ten minutes of improvisation between statements of the written melody.

In the book *Hear Me Talkin' To Ya* both Charlie Parker and Dizzy Gillespie make comments on the beginnings of the bebop style. Notice that in both cases they discuss extending the harmonic language of the music as a major component of bebop. For most new listeners, this new harmonic complexity is perceived as more dissonance in the music.

Charlie Parker

I remember one night before Monroe's I was jamming in a chili house on Seventh Avenue between 139th and 140th. It was December, 1939. Now I'd been getting bored with the stereotyped changes that were being used all the time at the time, and I kept thinking there's bound to be something else. I could hear it sometimes but I couldn't play it.

Well that night I was working over *Cherokee*, and, as I did, I found that by using the higher intervals of a chord as a melody line and backing them with appropriately related changes, I could play the thing I'd been hearing. I came alive.[1]

Dizzy Gillespie

No one man or group of men started modern jazz, but one of the ways it happened was this: Some of us began to jam at Minton's in Harlem in the early 'forties. But there were always some cats showing up there who couldn't blow at all but would take six or seven choruses to prove it.

So on afternoons before a session, Thelonious Monk and I began to work out some complex variations on chords and the like, and we used them at night to scare away the no-talent guys.

After a while, we got more and more interested in what we were doing as music, and, as we began to explore more and more, our music evolved.[2]

The other major change in this new bebop style was faster tempos. Influenced by Lester Young, Charlie Christian, and especially pianist Art Tatum, the beboppers began to double, triple, and even quadruple the basic tempo of many jazz tunes. Like the transition from traditional jazz to swing, the rhythmic change from swing to bebop was also an evolutionary process. While the expanded technical facility of players such as Parker and Gillespie was truly amazing, much of the new rhythmic style of bebop was focused on the function of the rhythm section.

Bebop pianists, inspired by Art Tatum and Count Basie, broke away from stride-style playing in favor of the new **comping** style. Pianists would leave the basic time-keeping duties to the bass player and the drummer while they concentrated on playing musical fills that "complimented" what the main soloist was doing. This comping style could take the form of sporadic interjections of a full chord or simple melodic lines that either filled a silent space left by a soloist or

comping

dropping bombs

modern jazz

provided a counterpoint line that fit what the soloist was playing. Pianists also used the comping style to accompany their own solos, playing occasional chords with their left hand while their right hand did most of the improvisation. Bass players continued to play in the straight-four walking style popular in the swing era. In addition, both piano and bass players were faced with handling the more complex harmonic language of bebop. Led by drummers Kenny Clarke and Max Roach, the drum set became an active weapon in this new musical style. In the manner of Jo Jones in the Count Basie rhythm section, basic time-keeping was taken away from the bass drum in favor of the lighter, crisper sound of the cymbals. Bebop drummers played with more rhythmic complexity, often using loud outbursts to spur the improvising soloist on to new heights of creativity. One of their favorite tricks was **dropping bombs,** playing complex unexpected accents randomly within a piece of music.

Most of the jazz styles that are still played today can trace at least some of their roots back to the development of bebop. Many historians refer to the creation of bebop as the birth of **modern jazz.** At the time, however, there were two radically different views of this new musical style. During the same time frame bebop was evolving, there was also a resurgence in the popularity of traditional jazz. Louis Armstrong had gone back to a small dixieland band format in 1946. In addition, swing music (though waning in popularity) and pop singers, including Frank Sinatra, still maintained the lion's share of popular music fans. The modern jazz players were called "beboppers," "reboppers," or just plain "boppers," while the older-style musicians and fans were referred to as "moldy figs." No one really knows who first coined the term bebop, but most historians gave credit to drummer Kenny Clarke. Apparently he was scat singing in an attempt to describe the sound of this new music and kept using the nonsense syllables "bebop" as he sang. Eventually, the term was picked up by the media and fell into common use.

In the following two articles, you can get a taste of the differing views about bebop in the 1940s. The first article by Leon Wolff appeared in *Down Beat* magazine in 1949. It does a good job of explaining how most non-bebop people felt about the new style. It also clearly demonstrates a lack of willingness to explore these younger musical artists' motivations. The longer second article is an excerpt from Dizzy Gillespie's autobiography *To Be, or Not to Bop*. In many ways, Gillespie became an icon for the entire bebop era. His look, his pattern of speech, and his supposed lifestyle all became media focuses. He wore a beret, a goatee, and horn-rimmed glasses, and that look was taken on by other musicians and bebop fans alike. Many bebop musicians had drug and alcohol problems, and this issue also became a media focal point. In all, Gillespie picks eleven things he feels the media got wrong regarding bebop and its practitioners. He often digresses into other topics, but his writing should give you a good overall sense of the jazz scene in the 1940s.

Iconic composite image of Dizzy Gillespie created by jazz photographer William Gottlieb. Note Dizzy's signature beret, horn-rimmed glasses, and goatee. This look became his trademark and was viewed by many outside the jazz world as representative of the entire bebop movement.
© William P. Gottlieb.
From the Library of Congress Collection.

*B*op is Nowhere by Leon Wolff

Bop cannot continue in its present form. Its list of liabilities is staggering, and there is serious doubt whether its apparent acceptance is authentic. Many of bop's characteristics lead to the suspicion that, as a postwar fad, it will inevitably succumb to a natural reaction.

Bop violates one of the major characteristics of good art—ease. The best that is done, written, said, or played ordinarily gives the effect of grace and fluidity. Sam Snead hits a golf ball 280 yards with ease; the duffer nearly bursts an artery to get 200. A comedian who tries too hard usually falls flat. Good jazz, however exciting, rarely gives the impression of pressing for effect. This is true, for example, of Count Basie's early band, the Duke, and Muggsy Spanier's Ragtimers. But bop has carried frantic jazz to the ultimate. In its feverish search for the superkick, it has entered a blind alley. Bop gives itself away. Its considerable reliance on faster tempos, higher registers, and more notes per bar is in itself a strong indication of insecurity and over-compensation. The more frantic jazz gets (any jazz) the more it frustrates itself to the listener.

While not all bop is frantic (Charlie Parker, for example, is usually contained and "thoughtful"), most bop is unbeautiful. Normal standards in music (any music) have been cynically bypassed by shallow bop musicians. The thin, toneless intonation of trumpet and alto adds nothing. Grotesque phrase endings (most of them are terribly banal by now) seem almost deliberately ugly. Strained, elongated phrases add up to unpleasing tension. There is a spendthrift use of notes, often meaningless and placed at random. Clinkers pass easily in bop. Since it is doubtful whether a planned melodic line exists in most solos at up tempo, and since the bizarre is normal, complete fluffs must be greeted by a dubious silence. ("Who knows? Maybe he meant it.") One of the poorest recorded solos in jazz, an almost too-perfect illustration of this point, is Howard McGhee's side on *Jazz at the Philharmonic's Perdido*. Such an aggregation of mistaken notes coupled with the depths of taste is extremely rare, even for bop. McGhee is one of the greatest bop improvisers.

The characteristic *pound* of jazz rhythm has been discarded by bop in favor of a steady uproar. It might almost be said that bop is a-rhythmic. Ross Russell writes in *Record Changer*: "Be-bop drummers no longer try to keep time with the bass pedal . . . the principal objective is to produce a legato sound. . . . To achieve this legato effect the drummer makes almost constant use of the top cymbal." This sounds interesting and perhaps constructive, but the end result is more

chaotic and stupefying than it is rhythmically satisfying to the listener. The impact of dynamics, contrasts, and *silences* is gone. In its place is a sustained crash almost without accents. Note, at the extreme, the terrific rhythmic hypnosis of swing-propelled records such as Roy Eldridge's *Wabash Stomp*, Juan Tizol's *Zanzibar*, and Benny Goodman's *Swingtime in the Rockies*.

More than ever before, the jazz piano has been emasculated by bop into a single-finger toy, utilizing whole tone runs, banal triplets, and slurs in lieu of improvisation. The utter monotony and thinness of bop piano is characterized by Lou Levy. It goes without saying that bop has lost all feeling for the blues. It is now an exercise in "let's see what funny things *you* can do to it." Bop will never produce a blues of genuine emotion like Bob Crosby's *Milk Cow Blues* or Teddy Wilson's *Just a Mood*.

Bop solos, while complex, are in general *predictable*. Standard phrases are repeated incessantly with little or no variation. Triplets and awkward phrase endings are stereotyped. The pattern of most solos is widely spaced ascending notes and rapid whole tone or chromatic descensions. (Serge Chaloff is unusually typical.) The impression is one of emptiness, lack of form, nervousness, and a contempt for beautiful notes and ideas. It is significant that *not one bop musician was ever a well-regarded swing musician*. Thirdraters and unknowns of yesterday are today's geniuses of bop. McGhee was nowhere, as were Parker, Fats Navarro, Thelonious Monk, Max Roach, Tadd Dameron, and Stan Getz. The major figure, Dizzy Gillespie, was a sideman with Jimmie Lunceford chiefly noted for his ability to hit high notes. The greatest swingmen have largely spurned bop. It is inconceivable to assume that their playing and their medium has suddenly become inferior to that of former inferiors.

Bop, essentially, is an aberration in jazz, a frenetic experiment replete with clichés. It is ballyhooed as the "new direction." Some of its innovations, a few of its creators, are not without merit. But whatever path jazz takes, it is doubtful whether this will be it. There is no future in bop, though a very few of its devices may be incorporated in the jazz repertoire. The Mississippi may [be] deflected a mile or two, but it is not likely to be rerouted due east via Jackrabbit creek.

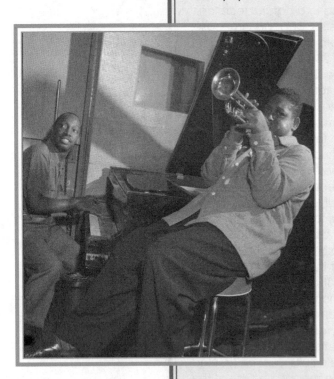

Pianist Tadd Dameron with trumpet player Fats Navarro ca. 1946 - 1948. Jazz history has clearly shown they were not "thirdraters" in any way.
©William P. Gottlieb. From the Library of Congress Collection.

From *Down Beat*, June 17, 1949. By D. Leon Wolff. Copyright © 1949 by Maher Publications. Reprinted by permission.

The Cult of Bebop by Dizzy Gillespie

Around 1946, jive-ass stories about "beboppers" circulated and began popping up in the news. Generally, I felt happy for the publicity, but I found it disturbing to have modern jazz musicians and their followers characterized in a way that was often sinister and downright vicious. This image wasn't altogether the fault of the press because many followers, trying to be "in," were actually doing some of the things the press accused beboppers of—and worse. I wondered whether all the "weird" publicity actually drew some of these way-out elements to us and did the music more harm than good. Stereotypes, which exploited whatever our weaknesses might be, emerged. Suable things were said, but nothing about the good we were doing and our contributions to music.

Time magazine, March 25, 1946, remarked: "As such things usually do, it began on Manhattan's 52nd Street. A bandleader named John (Dizzy) Gillespie, looking for a way to emphasize the more beautiful notes in 'Swing,' explained: 'When you hum it, you just naturally say be-bop, be-de-bop....'"

"Today, the bigwig of bebop is a scat named Harry (the Hipster) Gibson, who in moments of supreme pianistic ecstasy throws his feet on the keyboard. No. 2 man is Bulee (Slim) Gaillard, a skyscraping zooty Negro guitarist. Gibson and Gaillard have recorded such hip numbers as 'Cement Mixer,' which has sold more than 20,000 discs in Los Angeles alone; 'Yeproc Heresay,' 'Dreisix Cents,' and 'Who Put the Benzedrine in Mrs. Murphy's Ovaltine?'"

The article discussed a ban on radio broadcasts of bebop records in Los Angeles where station KMPC considered it a "degenerative influence on youth" and described how the "nightclub where Gibson and Gaillard played" was "more crowded than ever" with teen-agers who wanted to be bebopped. "What bebop amounts to: hot jazz

Dig Deeper
BOOK

To Be, or Not ... to Bop by Dizzy Gillespie with Al Fraser

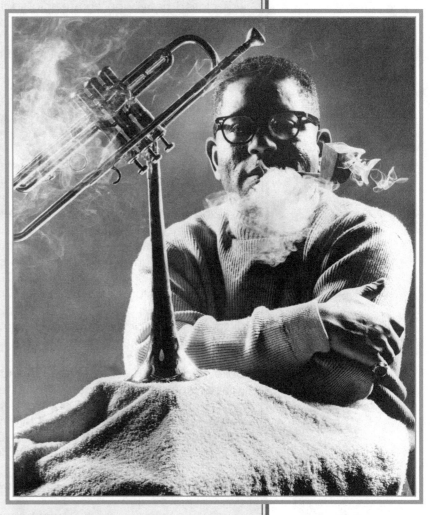

Dizzy Gillespie and his unique trumpet with upturned bell in an undated press photo.
Courtesy of the Institute of Jazz Studies, Rutgers University

overheated, with overdone lyrics full of bawdiness, references to nar-cotics and doubletalk."

Once it got inside the marketplace, our style was subverted by the press and music industry. First, the personalities and weaknesses of the in people started becoming more important, in the public eye, than the music itself. Then they diluted the music. They took what were oth-erwise blues and pop tunes, added "mop, mop" accents and lyrics about abusing drugs wherever they could and called the noise that resulted bebop. Labeled bebop like our music, this synthetic sound was played heavily on commercial radio everywhere, giving bebop a bad name. No matter how bad the imitation sounded, youngsters and people who were musically untrained liked it, and it sold well be-cause it maintained a very danceable beat. The accusations in the press pointed to me as one of the prime movers behind this. I should've sued, even though the chances of winning in court were slim. It was all bulls--t.

Keeping in mind that a well-told lie usually contains a germ of truth, let's examine the charges and see how many of those stereotypes ac-tually applied to me.

Lie number one was that beboppers wore wild clothes and dark glasses at night. Watch the fashions of the forties on the late show, long coats, almost down to your knees and full trousers. I wore drape suits like everyone else and dressed no differently from the average leading man of the day. It was beautiful. I became pretty dandified, I guess, later during the bebop era when my pants were pegged slightly at the bottom, but not unlike the modestly flared bottoms on the slacks of the smart set today.

We had costumes for the stage—uniforms with wide lapels and belts—given to us by a tailor in Chicago who designed them, but we didn't wear them offstage. Later, we removed the wide lapels and sport-ed little tan cashmere jackets with no lapels. This was a trendsetting innovation because it made no sense at all to pay for a wide lapel. *Es-quire* magazine, 1943, America's leading influence on men's fashions, considered us elegant, though bold, and printed our photographs.

Perhaps I remembered France and started wearing the beret. But I used it as headgear I could stuff into my pocket and keep moving. I used to lose my hat a lot. I liked to wear a hat like most of the guys then, and the hats I kept losing cost five dollars apiece. At a few record-ing sessions when I couldn't lay my hands on a mute, I covered the bell of the trumpet with the beret. Since I'd been designated their "leader," cats just picked up the style.

Lie number two was that only beboppers wore beards, goatees, and other facial hair and adornments. I used to shave under my lip. That spot prickled and itched with scraping. The hair growing back felt uncomfortable under my mouthpiece, so I let the hair grow into a goatee during my days with Cab Calloway. Now a trademark, that tuft of hair cushions my mouthpiece and is quite useful to me as a player; at least I've always thought it allowed me to play more effectively. Girls like my goatee too.

I used to wear a mustache, thinking you couldn't play well without one. One day I cut if off accidentally and had to play, and I've been playing without a mustache ever since. Some guy called me "weird" because he looked at me and thought he saw only half a mustache.

The dark spot above my upper lip is actually a callus that formed because of my embouchure. The right side of my upper lip curls down into the mouthpiece when I form my embouchure to play.

Many modern jazz musicians wore no facial hair at all. Anyway, we weren't the only ones during those days with hair on our faces. What about Clark Gable?

Number three: that beboppers spoke mostly in slang or tried to talk like Negroes is not so untrue. We used a few "pig Latin" words like "ofay." Pig Latin as a way of speaking emerged among blacks long before our time as a secret language for keeping children and the uninitiated from listening to adult conversations. Also, blacks had a lot of words they brought with them from Africa, some of which crept over into general usage, like "yum-yum."

Most bebop language came about because some guy said something and it stuck. Another guy started using it, then another one, and before you knew it, we had a whole language. "Mezz" meant "pot," because Mezz Mezzrow was selling the best pot. When's the "eagle gonna" fly, the American eagle, meant payday. A "razor" implied the draft from a window in winter with cold air coming in, since it cut like a razor. We added some colorful and creative concepts to the English language, but I can't think of any word besides bebop that I actually invented. Daddy-O Daylie, a disc jockey in Chicago, originated much more of the hip language during our era than I did.

We didn't have to try; as black people we just naturally spoke that way. People who wished to communicate with us had to consider our manner of speech, and sometimes they adopted it. As we played with musical notes, bending them into new and different meanings that constantly changed, we played with words.

Number four: that beboppers had a penchant for loose sex and partners racially different from themselves, especially black men who desired white women, was a lie.

It's easy for a white person to become associated with jazz musicians, because most of the places we play are owned and patronized by whites. A good example is Pannonica Koenigswater, the baroness, who is the daughter of a Rothschild. She'll be noticed when she shows up in a jazz club over two or three times. Nica has helped jazz musicians, financially. She saw to it that a lotta guys who had no place to stay had a roof or put some money in their pockets. She's willing to spend a lot to help. There's not too much difference between black and white women, but you'll find that to gain a point, a white woman will do almost anything to help if it's something that she likes. There's

Big "triple-bill" concert flyer for two weeks of great music with Dizzy Gillespie at Birdland in New York City. Courtesy of Tad Hershorn at the Institute of Jazz Studies, Rutgers University

almost nothing, if a white woman sees it's to her advantage, that she won't do because she's been taught that the world is hers to do with as she wants. This shocks the average black musician who realizes that black women wouldn't generally accept giving so much without receiving something definite in return.

A black woman might say: "I'll love him . . . but not my money." But a white woman will give anything, even her money, to show her own strength. She'll be there on the job, every night, sitting there supporting her own goodies. She'll do it for kicks, whatever is her kick. Many white women were great fans and supporters of modern jazz and brought along white males to hear our music. That's a secret of this business: Where a woman goes, the man goes.

"Where you wanna go, baby?"

"I wanna go hear Dizzy."

"O.K., that's where we go." The man may not support you, but the woman does, and he spends his money.

As a patron of the arts in this society, the white woman's role, since white males have been so preoccupied with making money, brought her into close contact with modern jazz musicians and created relationships that were often very helpful to the growth of our art. Some of these relationships became very personal and even sexual but not necessarily so. Often, they were supportive friendships which the musicians and their patrons enjoyed. Personally, I haven't received much help from white female benefactors. All the help I needed, I got from my wife—an outspoken black woman, who will not let me mess with the money—to whom I've been married since 1940. Regarding friendships across racial lines, because white males would sometimes lend their personal support to our music, the bebop era, socially speaking, was a major concrete effort of progressive-thinking black and white males and females to tear down and abolish the ignorance and racial barriers that were stifling the growth of any true culture in modern America.

Number five: that beboppers used and abused drugs and alcohol is not completely a lie either. They used to tell jokes about it. One bebopper walked up to another and said, "Are you gonna flat your fifths tonight?" The other one answered, "No, I'm going to drink mine." That's a typical joke about beboppers.

When I came to New York, in 1937, I didn't drink or smoke marijuana. "You gonna be a square, muthaf---a!" Charlie Shavers said and turned me on to smoking pot. Now, certainly, we were not the only ones. Some of the older musicians had been smoking reefers for forty and fifty years. Jazz musicians, the old ones and the young ones, almost all of them that I knew smoked pot, but I wouldn't call that drug abuse.

The first guy I knew to "take off" was Steve, a trumpet player with Jimmie Lunceford, a young college kid who came to New York and got hung up on dope. Everybody talked about him and said, "That guy's a dope addict! Stay away from him because he uses s--t." Boy, to say that was really stupid, because how else could you help that kinda guy?

Dope, heroin abuse, really got to be a major problem during the bebop era, especially in the late forties, and a lotta guys died from it. Cats were always getting "busted" with drugs by the police, and they had a saying, "To get the best band, go to KY." That meant the "best band" was in Lexington, Kentucky, at the federal narcotics hospital. Why

did it happen? The style of life moved so fast, and cats were struggling to keep up. It was wartime, everybody was uptight. They probably wanted something to take their minds off all the killing and dying and the cares of this world. The war in Vietnam most likely excited the recent up-surge in heroin abuse, together with federal narcotics control poli-cies which, strangely, at certain points in his-tory, encouraged nar-cotics abuse, especially among young blacks.

Everybody at one time or another smoked marijuana, and then coke became popular— I did that one too; but I never had any desire to use hard drugs, a drug that would make you a slave. I always shied away from anything pow-erful enough to make me dependent, because realizing that every-thing here comes and goes, why be depen-dent on any one thing? I never even tried hard drugs. One time on Fifty-second Street a guy gave me something I took for coke and it turned out to

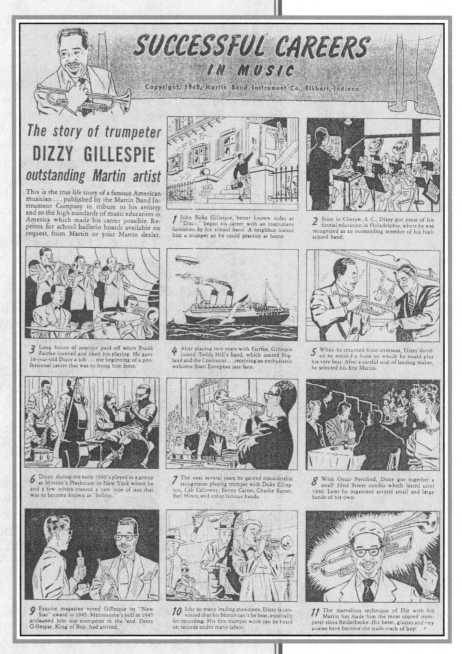

Extremely rare cartoon biography that tells the story of Dizzy Gillespie and his Martin trumpet. This originally appeared in a 1949 issue of Down Beat *magazine.*
Reprinted by permission of Conn-Selmer, Inc.
www.conn-selmer.com

be horse. I snorted it and puked up in the street. If I had found him, he would have suffered bodily harm, but I never saw him again.

With drugs like benzedrine, we played practical jokes. One record date for Continental, with Rubberlegs Williams, a blues singer, I espe-cially remember. Somebody had this date—Clyde Hart, I believe. He got Charlie Parker, me, Oscar Pettiford, Don Byas, Trummy Young, and Specs Powell. The music didn't work up quite right at first. Now, at that time, we used to break open inhalers and put the stuff into coffee or Coca-Cola; it was a kick then. During a break at this record date, Charlie dropped some into Rubberlegs's coffee. Rubberlegs didn't drink or smoke or anything. He couldn't taste it. So we went on with the record date. Rubberlegs began moaning and crying as he was singing. You

should hear those records! But I wouldn't condone doing that now; Rubberlegs might've gotten sick or something. The whole point is that, like most Americans, we were really ignorant about the helpful or deleterious effects of drugs on human beings, and before we concluded anything about drugs or used them and got snagged, we should have understood what we were doing. That holds true for the individual or the society, I believe.

The drug scourge of the forties victimized black musicians first, before hitting any other large segment of the black community. But if a cat had his head together, nothing like that, requiring his own indulgence, could've stopped him. I've always believed that. I knew several guys that were real hip, musically, and hip about life who never got high. Getting high wasn't one of the prerequisites for being hip, and to say it was would be inaccurate.

Number six is really a trick: that beboppers tended to express unpatriotic attitudes regarding segregation, economic injustice, and the American way of life.

We never wished to be restricted to just an American context, for we were creators in an art form which grew from universal roots and which had proved it possessed universal appeal. Damn right! We refused to accept racism, poverty, or economic exploitation, nor would we live out uncreative humdrum lives merely for the sake of survival. But there was nothing unpatriotic about it. If America wouldn't honor its Constitution and respect us as men, we couldn't give a s--t about the American way. And they made it damn near un-American to appreciate our music.

Music drew Charlie Parker and me together, but Charlie Parker used to read a lot too. As a great reader, he knew about everything, and we used to discuss politics, philosophy, and life-style. I remember him mentioning Baudelaire—I think he died of syphilis—and Charlie used to talk about him all the time. Charlie was very much interested in the social order, and we'd have these long conversations about it, and music. We discussed local politics, too, people like Vito Marcantonio, and what he'd tried to do for the little man in New York. We liked Marcantonio's ideas because as musicians we weren't paid well at all for what we created.

There were a bunch of musicians more socially minded, who were closely connected with the Communist Party. Those guys stayed busy anywhere labor was concerned. I never got that involved politically. I would picket, if necessary, and remember twice being on a picket line. I can't remember just what it was I was picketing for, but they had me walking around with a sign. Now, I would never cross a picket line.

Paul Robeson became the forerunner of Martin Luther King. I'll always remember Paul Robeson as a politically-committed artist. A few enlightened musicians recognized the importance of Paul Robeson, amongst them Teddy Wilson, Frankie Newton, and Pete Seeger—all of them very outspoken politically. Pete Seeger is so warm; if you meet Pete Seeger, he just melts, he's so warm. He's a great man.

In my religious faith—the Baha'i faith—the Bab is the forerunner of Baha'u'llah, the prophet. "Bab" means gate, and Paul Robeson was the "gate" to Martin Luther King. The people in power made Paul Robeson a martyr, but he didn't die immediately from his persecution. He became a martyr because if you are strangled for your principles,

whether it's physical strangulation or mental strangulation or social strangulation, you suffer. The dues that Paul Robeson paid were worse than the dues Martin Luther King paid. Martin Luther only paid his life, quick, for his views, but Paul Robeson had to suffer a very long time.

When the play *Othello* opened in New York with Paul Robeson, Jose Ferrer, and Uta Hagen, I went to the theater to see it. I was sitting way up in the highest balcony. Paul Robeson's voice sounded like we were talking together in a room. That's how strong his voice was coming from the stage, three miles away. Paul Robeson, big as he was, looked about as big as a cigar from where I was sitting. But his voice was right up there next to me.

I dug Paul Robeson right away, from the first words. A lot of black people were against Paul Robeson; he was trying to help them and they were talking against him, like he was a communist. I heard him speak on many occasions and, man, talk about a speaker! He could really speak. And he was fearless! You never hear people speak out like he did with everything arrayed against you and come out like he did. Man, I'll remember Paul Robeson until I die. He was something else.

Paul Robeson became "Mr. Incorruptibility." No one could get to him because that's the rarest quality in man, incorruptibility. Nothing supersedes that because, man, there are so many ways to corrupt a personality. Paul Robeson stands as a hero of mine and he was truly the father of Malcolm X, another dynamic personality who I talked to a lot. Oh, I loved Malcolm, and you couldn't corrupt Malcolm or Paul. We have a lot of leaders that money corrupts, and power. You give them a little money and some power, and they nut. They go nuts with it. Both Malcolm and Paul Robeson, you couldn't get to them. The people in power tried all means at their disposal to get them. So they killed Malcolm X and they destroyed Paul Robeson. But they stood up all the time. Even dying, their heads were up.

One time, on the Rudy Vallee show, I should've acted more politically. Rudy Vallee says, introducing me, "What's in the Ubangi department tonight?" I almost walked off the show. I wanted to sue him but figured there wasn't any money in it, so I just forgot about it and we played. Musicians today would never accept that, but then, somehow, the money and the chance to be heard seemed more important.

We had other fighters, like Joe Louis, who was beautiful. I've known Joe Louis since way, way back when I hung out in Sugar Ray's all the time, playing checkers. Sugar Ray's a good checker player, but dig Joe Louis. He'd come down to hear me play, and people would want Joe Louis to have a ringside seat. He'd be waaay over in a corner someplace, sitting there digging the music. If you announced him, "Ladies and gentlemen, the heavyweight champion of the world, Joe Louis, is sitting over there," he'd stand up to take a bow and wave his hands one time. You look around again, he's gone. Other guys I know would want a ringside seat, want you to announce them and maybe come up on the stage. But Joe Louis was like that. He was always shy, beautiful dude. He had mother wit.

It's very good to know you're a part of something that has directly influenced your own cultural history. But where being black is concerned, it's only what I represent, not me, myself. I pay very little attention to "Dizzy Gillespie," but I'm happy to have made a contribution. To be a "hero" in the black community, all you have to do is make the white folks look up to you and recognize the fact that you've contributed something worthwhile. Laugh, but it's the truth. Black people appreciate my playing in the same way I looked up to Paul Robeson or to Joe Louis. When Joe would knock out someone, I'd say, "Hey . . . !" and feel like I'd scored a knockout. Just because of his prowess in his field and because he's black like me.

Oh, there was a guy in Harlem, up there on the corner all the time preaching. Boy, could he talk about white people! He'd get a little soap box. I don't know his name, but everybody knew him. He wasn't dressed all fancy, or nothing, and then he had a flag, an American flag. Ha! Ha! That's how I became involved with the African movement, standing out there listening to him. An African fellow named Kingsley Azumba Mbadiwe asked me who I was and where I came from. I knew all the right answers. That was pretty hip being from South Carolina and not having been in New York too long. Our friendship grew from there; and I became attached to this African brother. One time, after the Harlem riots, 1945, Mbadiwe told me, "Man, these white people are funny here."

"Whaddayou mean . . . ?"

"Well, they told me to stay outta Harlem," he said.

"Why is that?" I asked.

"They say that it's dangerous for me up here. I might get killed."

"What'd you tell them?"

"Well, I asked them how they gonna distinguish me from anybody else up here? I look just like the rest of them."

Heh, heh, heh. It was at that time I observed that the white people didn't like the "spooks" over here to get too close to the Africans. They didn't want us—the spooks over here—to know anything about Africa. They wanted you to just think you're somebody dangling out there, not like the white Americans who can tell you they're German or French or Italian. They didn't want us to know we have a line so that when you'd ask us, all we could say was we were "colored." It's strange how the white people tried to keep us separate from the Africans and from our heritage. That's why, today, you don't hear in our music, as much as you do in other parts of the world, African heritage, because they took our drums away from us. If you go to Brazil, to Bahia where there is a large black population, you find a lot of African in their music; you go to Cuba, you find they retained their heritage; in the West Indies, you find a lot. In fact, I went to Kenya and heard those cats play and I said, "You guys sound like you're playing calypso from the West Indies."

A guy laughed and he said to me, "Don't forget, we were first!"

But over here, they took our drums away from us, for the simple reason of self-protection when they found out those cats could communicate four or five miles with the drums. They took our language away from us and made us speak English. In slavery times, if they found out that two slaves could speak the same African language, they sold off one. As far as our heritage goes, a few words crept in like *buckra*—I used to hear my mother say, "that ole poor buckra"—buckra meant white. But with those few exceptions when they took our drums away,

our music developed along a monorhythmic line. It wasn't polyrhythmic like African music. I always knew rhythm or I was interested in it, and it was this interest in rhythm that led me to seize every opportunity to find out about these connections with Africa and African music.

Charlie Parker and I played benefits for the African students in New York and the African Academy of Arts and Research which was headed by Kingsley Azumba Mbadiwe. Eventually, Mbadiwe wound up becoming a minister of state in Nigeria under one of those regimes, but over here, as head of the African Academy, he arranged for us to play some benefit concerts at the Diplomat Hotel which should've been recorded. Just me, Bird, and Max Roach, with African drummers and Cuban drummers; no bass, nothing else. We also played for a dancer they had, named Asadata Dafora.* (A-S-A-D-A-T-A D-A-F-O-R-A—if you can say it, you can spell it.) Those concerts for the African Academy of Arts and Research turned out to be tremendous. Through that experience, Charlie Parker and I found the connections between Afro-Cuban and African music and discovered the identity of our music with theirs. Those concerts should definitely have been recorded, because we had a ball, discovering our identity.

Within the society, we did the same thing we did with the music. First we learned the proper way and then we improvised on that. It seemed the natural thing to do because the style or mode of life among black folks went the same way as the direction of the music. Yes, sometimes the music comes first and the life-style reflects the music because music is some very strong stuff, though life in itself is bigger. Artists are always in the vanguard of social change, but we didn't go out and make speeches or say "Let's play eight bars of protest." We just played our music and let it go at that. The music proclaimed our identity; it made every statement we truly wanted to make.

Number seven: that "beboppers" expressed a preference for religions other than Christianity may be considered only a half-truth, because most black musicians, including those from the bebop era, received their initial exposure and influence in music through the black church. And it remained with them throughout their lives. For social and religious reasons, a large number of modern jazz musicians did begin to turn toward Islam during the forties, a movement completely in line with the idea of freedom of religion.

Rudy Powell, from Edgar Hayes's band, became one of the first jazz musicians I knew to accept Islam; he became an Ahmidyah Muslim. Other musicians followed, it seemed to me, for social rather than religious reasons, if you can separate the two.

"Man, if you join the Muslim faith, you ain't colored no more, you'll be white," they'd say. "You get a new name and you don't have to be a nigger no more." So everybody started joining because they considered it a big advantage not to be black during the time of segregation. I thought of joining, but it occurred to me that a lot of them spooks were simply trying to be anything other than a spook at that time. They

*The first African dancer to present African dance in concert form in the United States. Dafora is called "one of the pioneer exponents of African Negro dance and culture." Born in Sierra Leone in 1890, Mr. Dafora studied and performed as a singer at La Scala before coming in 1929 to the United States where he died in 1965. Dafora also staged the voodoo scene in the Orson Welles production of *Macbeth*.

had no idea of black consciousness; all they were trying to do was escape the stigma of being "colored." When these cats found out that Idrees Sulieman, who joined the Muslim faith about that time, could go into these white restaurants and bring out sandwiches to the other guys because he wasn't colored—and he looked like the inside of the chimney—they started enrolling in droves.

Musicians started having it printed on their police cards where it said "race," "W" for white. Kenny Clarke had one and he showed it to me. He said, "See nigger, I ain't no spook; I'm white, 'W.'" He changed his name to Arabic, Liaquat Ali Salaam. Another cat who had been my roommate at Laurinburg, Oliver Mesheux, got involved in an altercation about race down in Delaware. He went into this restaurant, and they said they didn't serve colored in there. So he said, "I don't blame you. But I don't have to go under the rules of colored because my name is Mustafa Dalil."

Didn't ask him no more questions. "How do you do?" the guy said.

When I first applied for my police card, I knew what the guys were doing, but not being a Muslim, I wouldn't allow the police to type anything in that spot under race. I wouldn't reply to the race question on the application blank. When the cop started to type something in there, I asked him, "What are you gonna put down there, C for me?"

"You're colored, ain't you?"

"Colored . . . ? No."

"Well, what are you, white?"

"No, don't put nothing on there," I said. "Just give me the card." They left it open. I wouldn't let them type me in W for white nor C for colored; just made them leave it blank. WC is a toilet in Europe.

As time went on, I kept considering converting to Islam but mostly because of the social reasons. I didn't know very much about the religion, but I could dig the idea that Muhammad was a prophet. I believed that, and there were very few Christians who believed that Muhammad had the word of God with him. The idea of polygamous marriage in Islam, I didn't care for too much. In our society, a man can only take care of one woman. If he does a good job of that, he'll be doing well. Polygamy had its place in the society for which it was intended, as a social custom, but social orders change and each age develops its own mores. Polygamy was acceptable during one part of our development, but most women wouldn't accept that today. People worry about all the women with no husbands, and I don't have any answer for that. Whatever happens, the question should be resolved legitimately and in the way necessary for the advancement of society.

The movement among jazz musicians toward Islam created quite a stir, especially with the surge of the Zionist movement for creation and establishment of the State of Israel. A lot of friction arose between Jews and Muslims, which took the form of a semiboycott in New York of jazz musicians with Muslim names. Maybe a Jewish guy, in a booking agency that Muslim musicians worked from, would throw work another way instead of throwing to the Muslim. Also, many of the agents couldn't pull the same tricks on Muslims that they pulled on the rest of us. The Muslims received knowledge about themselves that we didn't have and that we had no access to; so therefore they tended to act differently toward the people running the entertainment business. Much of the entertainment business was run by Jews. Generally, the Muslims fared

well in spite of that, because though we had some who were Muslim in name only, others really had knowledge and were taking care of business.

Near the end of the forties, the newspapers really got worried about whether I'd convert to Islam. In 1948 *Life* magazine published a big picture story, supposedly about the music. They conned me into allowing them to photograph me down on my knees, arms outstretched, supposedly bowing to Mecca. It turned out to be a trick bag. It's (one) of the few things in my whole career I'm ashamed of, because I wasn't a Muslim. They tricked me into committing a sacrilege. The newspapers figured that if the "king of bebop" converted, thousands of beboppers would follow suit, and reporters questioned me about whether I planned to quit and forsake Christianity. But that lesson from *Life* taught me to leave them hanging. I told them that on my trips through the South, the members of my band were denied the right of worshipping in churches of their own faith because colored folks couldn't pray with white folks down there. "Don't say I'm forsaking Christianity," I said, "because Christianity is forsaking me—or better, people who claim to be Christian just ain't. It says in the Bible to love thy brother, but people don't practice what the Bible preaches. In Islam there is no color line. Everybody is treated like equals."

With one reporter, since I didn't know much about the Muslim faith, I called on our saxophonist, formerly named Bill Evans, who'd recently accepted Islam to give this reporter some accurate information.

"What's your new name?" I asked him.

"Yusef Abdul Lateef," he replied. Yusef Lateef told us how a Muslim missionary, Kahlil Ahmed Nasir, had converted many modern jazz musicians in New York to Islam and how he read the Quran daily and strictly observed the prayer and dietary regulations of the religion. I told the reporter that I'd been studying the Quran myself, and although I hadn't converted yet, I knew one couldn't drink alcohol or eat pork as a Muslim. Also I said I felt quite intrigued by the beautiful sound of the word "Quran," and found it "out of this world," "way out," as we used to say. The guy went back to his paper and reported that Dizzy Gillespie and his "beboppers" were "way out" on the subject of religion. He tried to ridicule me as being too strange, weird, and exotic to merit serious attention.* Most of the Muslim guys who were sincere in the beginning went on believing and practicing the faith.

*Playing on this, sometimes in Europe I'd wear a turban. People would see me on the streets and think of me as an Arab or a Hindu. They didn't know what to think, really, because I'd pretend I didn't speak English and listen to them talk about me. Sometimes Americans would think I was some kind of "Mohommedan" nobleman. You wouldn't believe some of the things they'd say in ignorance. So to know me, study me very closely; give me your attention and above all come to my concert.

THE NEW JAZZ FOUNDATION
Presents
DIZZY GILLESPIE
and his Orchestra
WITH AN AUGMENTED AFRO-CUBAN RHYTHM SECTION

CHRISTMAS NIGHT,
SATURDAY, DEC. 25, 1948 — at 8:30 P. M.
CARNEGIE HALL

The Concert will be highlighted by the presentation of Awards to winners of the first All Star Poll of the New Jazz, Conducted by the New Jazz Foundation and Radio Stations WMCA and WMGM. Among the Artists who will appear are Billy Eckstine, Charley Ventura, Tadd Dameron and Charlie Parker, plus many others.

Tickets on sale now at CARNEGIE HALL . . . $1.20 to $3.60 tax included

Number eight: that beboppers threatened to destroy pop, blues, and old-time music like Dixieland jazz is almost totally false.

It's true, melodically, harmonically, and rhythmically, we found most pop music too bland and mechanically unexciting to suit our tastes. But we didn't attempt to destroy it—we simply built on top of it by substituting our own melodies, harmonies, and rhythms over the pop music format and then improvised on that. We always substituted; that's why no one could ever charge us with stealing songs or collect any royalties for recording material under copyright. We only utilized the pop song format as a take-off point for improvisation, which to us was much more important. Eventually, pop music survived by slowly adopting the changes we made.

Beboppers couldn't destroy the blues without seriously injuring themselves. The modern jazz musicians always remained very close to the blues musician. That was a characteristic of the bopper. He stayed in close contact with his blues counterpart. I always had good friendships with T-Bone Walker, B. B. King, Joe Turner, Cousin Joe, Muddy Waters—all those guys—because we knew where our music came from. Ain't no need of denying your father. That's a fool, and there were few fools in this movement. Technical differences existed between modern jazz and blues musicians. However, modern jazz musicians would have to know the blues.

Another story is that we looked down on guys who couldn't read [music]. Erroll Garner couldn't read and we certainly didn't look down on him, even though he never played our type of music. A modern jazz musician wouldn't necessarily have to read well to be able to create, but you couldn't get a job unless you read music; you had to read music to get in a band.

The bopper knew the blues well. He knew Latin influence and had a built-in sense of time, allowing him to set up his phrases properly. He knew chord changes, intervals, and how to get from one key to another smoothly. He knew the music of Charlie Parker and had to be a consummate musician. In the current age of bebop, a musician would also have to know about the techniques of rock music.

Ever since the days at Minton's we had standards to measure expertise in our music. Some guys couldn't satisfy them. Remember Demon, who used to come to play down at Minton's; he came to play, but he never did, and he would play with anybody, even Coleman Hawkins. Demon'd get up on the stand and play choruses that wouldn't say s--t, but he'd be there. We'd get so tired of seeing this muthaf---a. But he'd be there, and so we let him play. Everybody had a chance to make a contribution to the music.

The squabble between the boppers and the "moldy figs," who played or listened exclusively to Dixieland jazz, arose because the older musicians insisted on attacking our music and putting it down. Ooooh, they were very much against our music, because it required more than what they were doing. They'd say, "That music ain't s--t, man!" They really did, but then you noticed some of the older guys started playing our riffs, a few of them, like Henry "Red" Allen. The others remained hostile to it.

Dave Tough was playing down at Eddie Condon's once, and I went down there to see Dave because he and his wife are good friends

of mine. When he looked up and saw me, he says, "You the gamest muthaf---a I ever seen in my life."

"Whaddayou mean?" I said.

"Muthaf---a, you liable to get lynched down in here!" he said. That was funny. I laughed my ass off. Eddie Condon's and Nick's in the Village were the strongholds of Dixieland jazz.

Louis Armstrong criticized us but not me personally, not for playing the trumpet, never. He always said bad things about the guys who copied me, but I never read where he said that I wasn't a good trumpet player, that I couldn't play my instrument. But when he started talking about bebop, "Aww, that's slop! No melody." Louis Armstrong couldn't hear what we were doing. Pops wasn't schooled enough musically to hear the changes and harmonics we played. Pops's beauty as a melodic player and a "blower" caused all of us to play the way we did, espe-

> # Dizzy attacks Louis
>
> I HAVE just received the galley proofs of a piece which will appear in the up-coming issue of Esquire Magazine. The author is one John Birks "Dizzy" Gillespie (with Ralph Ginzburg)—and it's one of the tail-twisters of the year.
> The title is "Jazz T...
>
> ### 'TOO MUCH UNCLE TOM'
>
> pioneer modernist, jazz, which "was once well on its way to becoming the real folk music of America," has been replaced by a "mongrel
>
> jazz magazine, "Down Beat," has a circulation of about 60,000, never having succeeded in becoming a mass periodical. "While MELODY MAKER, its English counterpart, has sky-rocketed to a circulation more than twice that size."
> Meanwhile there was one

cially trumpet players, but his age wasn't equipped to go as far, musically, as we did. Chronologically, I knew that Louis Armstrong was our progenitor as King Oliver and Buddy Bolden had been his progenitors. I knew how their styles developed and had been knowing it all the time; so Louis's statements about bebop didn't bother me. I knew that I came through Roy Eldridge, a follower of Louis Armstrong. I wouldn't say anything. I wouldn't make any statements about the older guys' playing because I respected them too much.

Time 1/28/47 quoted me: "Louis Armstrong was the one who popularized the trumpet more than anyone else—he sold the trumpet to the public. He sold it, man.

"Nowadays in jazz we know more about chords, progressions—and we try to work out different rhythms and things that they didn't think about when Louis Armstrong blew. In his day all he did was play strictly from the soul, just strictly from his heart he just played. He didn't think about no chords—he didn't know nothing about no chords. Now, what we in the younger generation take from Louis Armstrong . . . is the soul."

I criticized Louis for other things, such as his "plantation image." We didn't appreciate that about Louis Armstrong, and if anybody asked me about a certain public image of him, handkerchief over his head, grinning in the face of white racism, I never hesitated to say I didn't like it. I didn't want the white man to expect me to allow the same things Louis Armstrong did. Hell, I had my own way of "Tomming." Every generation of blacks since slavery has had to develop its own way of Tomming, of accommodating itself to a basically unjust situation. Take the comedians from Step 'n Fetchit days—there are new comedians now who don't want to be bothered with "Ah yas-suh, boss. . . ." But that doesn't stop them from cracking a joke about how badly they've

been mistreated. Later on, I began to recognize what I had considered Pops's grinning in the face of racism as his absolute refusal to let anything, even anger about racism, steal the joy from his life and erase his fantastic smile. Coming from a younger generation, I misjudged him.

Entrenched artists, or the entrenched society, always attack anything that's new coming in—in religion, in social upheavals, in any field. It has something to do with living and dying and the fear among the old of being replaced by the new. Louis Armstrong never played our music, but that shouldn't have kept him from feeling or understanding it. Pops thought that it was his duty to attack! The leader always attacks first; so as the leader of the old school, Pops felt that it was his duty to attack us. At least he could gain some publicity, even if he were overwhelmed musically.

"It's a buncha trash! They don't know what they're doing, them boys, running off."

Mezz Mezzrow knocked us every time he'd say something to the newspapers over in Europe about bebop. "They'd never play two notes where a hundred notes are due."

Later, when I went to Europe in 1948, they put a knife in my hand, and Mezz Mezzrow was holding his head down like I was gonna chop it off. They printed headlines: Dizzy is Gonna Carve Mezz Mezzrow. . . Thank goodness this is the age of enlightenment, and we don't have to put down the new anymore; that ferocious competition between the generations has passed.

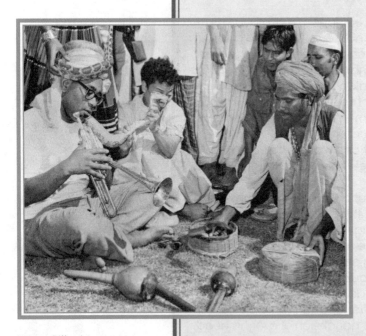

Dizzy Gillespie meets a snake charmer during his 1956 State Department tour. Trombonist Melba Liston is helping hold the snake.
Courtesy of the Institute of Jazz Studies, Rutgers University

In our personal lives, Pops and I were actually very good friends. He came to my major concerts and made some nice statements about me in the press. We should've made some albums together, I thought, just to have for the people who came behind us, about twenty albums. It seemed like a good idea some years later, but Pops was so captivated by Joe Glaser, his booking agent, he said, "Speak to Papa Joe." Of course that idea fizzled because Joe Glaser, who also booked me at the time, didn't want anybody encroaching on Louis Armstrong. Pops really had no interest in learning any new music; he was just satisfied to do his thing. And then *Hello Dolly!* came along and catapulted him into super, super fame. Wonder if that's gonna happen to me? I wonder. Playing all these years, then all of a sudden get one number that makes a big hero out of you. History repeating itself.

Number nine: that beboppers expressed disdain for "squares" is mostly true.

A "square" and a "lame" were synonymous, and they accepted the complete life-style, including the music, dictated by the establishment. They rejected the concept of creative alternatives, and they were just the opposite of "hip," which meant "in the know," "wise," or one with

"knowledge" of life and how to live.* Musically, a square would chew the cud. He'd spend his money at the Roseland Ballroom to hear a dance band playing standards, rather than extend his ear and spirit to take an odyssey in bebop at the Royal Roost. Oblivious to the changes which replaced old, outmoded expressions with newer, modern ones, squares said "hep" rather than "hip." They were apathetic to, or actively opposed to, almost everything we stood for, like intelligence, sensitivity, creativity, change, wisdom, joy, courage, peace, togetherness, and integrity. To put them down in some small way for the sharp-cornered shape of their boxed-in personalities, what better description than "square"?

Also, in those days, there were supposedly hip guys who really were squares, pseudohip cats. How do you distinguish between the pseudo and the truly hip? Well, first, a really hip guy wouldn't have any racial prejudice, one way or the other, because he would know the hip way to live is with your brother. Every human being, unless he shows differently, is your brother.

Number ten: that beboppers put down as "commercial" people who were trying to make money is 50 per cent a lie, only half true. We all wanted to make money, preferably by playing modern jazz. We appreciated people who tried to help us—and they were very few—because we needed all the help we could get. Even during the heyday of bebop, none of us made much money. Many people who pretended to help really were there for a rip-off. New modern jazz nightclubs like the Royal Roost, which had yellow leather seats and a milk bar for teenagers, and the Clique were opening everyday, all over the country. Bebop was featured on the Great White Way, Broadway, at both the Paramount and the Strand theaters. We received a lot of publicity but very little money.

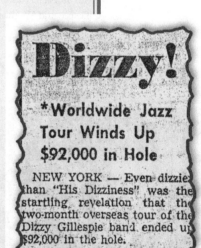

People with enough bucks and foresight to invest in bebop made some money. I mean more than just a little bit. All the big money went to the guys who owned the music, not to the guys who played it. The businessmen made much more than the musicians, because without money to invest in producing their own music, and sometimes managing poorly what they earned, the modern jazz musicians fell victim to the forces of the market. Somehow, the jazz businessman always became the owner and got back more than his "fair" share, usually at the player's expense. More was stolen from us during the bebop era than in the entire history of jazz, up to that point. They stole a lot of our music, all kinds of stuff. You'd look up and see somebody else's name on your composition and say, "What'd he have to do with it?" But you couldn't do much about it. Blatant commercialism we disliked because it debased the quality of our music. Our protests against being cheated and ripped off never meant we stood against making money. The question of being politically inclined against commercialism or trying to take over anything never figured too prominently with me. The people who stole couldn't

*"Hip cat" comes from Wolof, "hipicat"—a man who is aware or has his eyes open.

create, so I just kept interested in creating the music, mostly, and tried to make sure my works were protected.

Number eleven: that beboppers acted weird and foolish is a damned lie. They tell stories about people coming to my house at all hours of the day and night, but they didn't do it. They knew better than to ring my bell at four o'clock in the morning. Monk and Charlie Parker came up there one time and said, "I got something for you."

I say "O.K., hand it to me through the door!" I've been married all my life and wasn't free to do all that. I could go to most of their houses, anytime, because they were always alone or had some broad. Lorraine never stood for too much fooling. My wife would never allow me to do that.

Beboppers were by no means fools. For a generation of Americans and young people around the world, who reached maturity during the 1940s, bebop symbolized a rebellion against the rigidities of the old order, an outcry for change in almost every field, especially in music. The bopper wanted to impress the world with a new stamp, the uniquely modern design of a new generation coming of age.

From *To Be, or Not to Bop* by Dizzy Gillespie and Al Fraser. Copyright © 1979 by John Birks Gillespie and Wilmot Alfred Fraser. Reprinted by permission of the authors.

The People Who Made It Happen

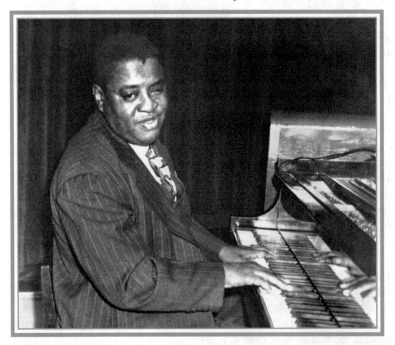

Pianist Art Tatum.
Courtesy of the Institute of Jazz Studies, Rutgers University

Art Tatum

Born in Toledo, Ohio, pianist Art Tatum had a major impact on the emerging bebop style. Almost completely blind, Tatum was always noted for his incredibly perceptive ear and his astounding technique. Some legends have it that as a young pianist Tatum heard a recording of two piano players performing a tune. Not realizing it was two people with four hands and twenty fingers, Tatum recreated the recording all by himself! Although he is commonly associated with stride-style players James P. Johnson and Fats Waller, in truth, Tatum was much more than a swinging stride-style piano player. Fats Waller is reported to have once introduced Art Tatum by saying "Ladies and gentleman, I'm a pretty good piano player, but God is in the house tonight." Tatum was respected by his peers and always won every cutting contest and jam session he took part in. Usually he would end up playing last because no one would sit down at the piano after he was through performing. Charlie Parker once took a job washing dishes in a nightclub just to be able to listen to Art Tatum play.

Although he sometimes worked with a trio, Tatum is best known for his solo recordings. To be clear, in many ways he is best associated with the swing styles discussed in Chapter 4. He is included here not because he was a bebop style player himself but because the techniques he used and the amazing improvisational concepts he displayed were direct inspirations for the people who did create bebop. He would often reharmonize tunes on the spot. He would frequently change key centers in the middle of a tune. Musicians who regularly listened to Tatum would often think he was improvising himself into a musical situation he could never get out of. Without fail, however, Tatum would be able to seamlessly wend his way back to the original tune without ever missing a beat. His prodigious technical ability allowed him to improvise extended runs and flurries of notes all over the piano keyboard, often playing lines four to six times as fast as the basic beat of the tune he was performing. Many of the best bebop horn players, including Charlie Parker and Dizzy Gillespie, applied Tatum's harmonic and rhythmic approach to their own improvisations. Furthermore, pianists Bud Powell, George Shearing, Oscar Peterson, and Johnny Costa (from *Mister Rogers' Neighborhood*) were all heavily influenced by the playing style of Art Tatum. You can study Art Tatum's style for yourself on your Spotify playlist's version of *Willow Weep for Me*.

> ## *Dig Deeper*
> ### RECORDINGS
>
> *Art Tatum: The Complete Capitol Recordings; Art Tatum: The Complete Pablo Solo Masterpieces; Art Tatum: The Complete Pablo Group Masterpieces*

Listening Guide

Willow Weep for Me (Ann Ronell)

Example of Art Tatum's solo piano style
Recorded July 13, 1949
Performed by Art Tatum, piano
Art Tatum recorded *Willow Weep for Me* many times during his career, and this version does an excellent job of displaying the many different musical skills he possessed. To fully experience Tatum's ability and his innovative approach to improvisation, however, spend some time on Spotify listening to other versions he recorded. You'll find a number of them on the website. This particular version was recorded for Capitol Records and was later featured in the *Smithsonian Collection of Classic Jazz* boxed set. The tune follows the typical A-A-B-A 32-bar song form, and this performance has two complete statements of the entire structure, but, as you will hear, with a number of dramatic variations. Tatum, unconstrained by a rhythm section, is free to

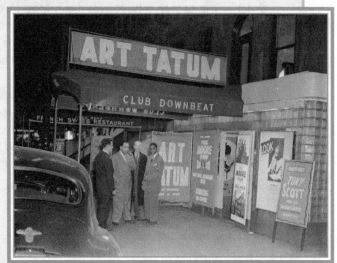

Pianist Art Tatum (far right) appeared at the Club Downbeat in 1948 on a double bill with Phil Moore (second from left). This classic 52nd St. nightclub was one of the most popular venues in a one-block long section of jazz clubs between 5th and 6th Avenues (known as "Swing Street") during the height of the bebop era.
©William P. Gottlieb/Ira and henore S.Gershwin Fund Collection, Music Division, Library of Congress

speed up, slow down, and alter harmonies on the fly, never playing anything the same way twice. This is a complex performance, requiring a very detailed listening guide. It is suggested that you listen to this track a few times with your eyes closed. Simply take in Art Tatum's amazing style for a bit before you attempt to explore this listening guide for more in-depth information.

Total time: 2:54

:00 Performance begins with a 4-bar introduction. The material Tatum uses here will appear at several points throughout the performance, lending a high level of musical cohesion to the entire track. In addition, when you listen to other versions of Tatum performing this tune, you will notice that he uses at least some elements of this musical gesture in each performance.

:09 Letter A, 8 bars, played with a good bit of rhythmic and harmonic freedom.

:27 Repeat of letter A material, 8 bars, again played quite freely.

:46 Letter B, 8 bars. Here, Tatum briefly establishes a nice stride style with the left hand before breaking away from it to embark on a dramatic ascending run (starting at :56) from the bottom of the keyboard *while* continuing to play the melody in the right hand. A few bars later he abandons the original melody entirely for a bit, building musical drama toward the return of the letter A material.

1:06 Final 1st chorus statement of letter A material, 8 bars. Notice once again the use of the opening gesture to lead this section smoothly into the next chorus.

1:27 The 2nd chorus begins with Tatum simply holding a chord in the left hand while the right hand explores an improvisation that embraces the blues. This episode lasts for 4 measures, after which Tatum sets up an even stride pattern. Almost as quickly as he firmly establishes a stride feel, however, he breaks away from it for a more adventurous harmonic and rhythmic exploration. In fact, he strongly hints at doubling the feel of the basic beat toward the end of this second 4-bar section.

1:49 This 8-bar section of improvisation is built over a repeat of the letter A material. Tatum follows the same basic format as the previous section, i.e., blues to stride, but again he takes great liberties with both the harmony and the rhythm.

2:10 This section is built over the bridge (letter B) material. Tatum begins with a clear stride pattern, but within a couple of bars he begins to hint at doubling the time again. Through the rest of this 8-bar section he uses a technique called "double-time feel," which means while the basic beat remains the same, he plays a rhythmic feel that makes the piece seem twice as fast as it really is.

2:31 For this last statement of the letter A material Tatum comes sailing out of the double-time feel and switches seamlessly into actual double time. He is now playing the original melody over a basic beat that is twice as fast as the rest of the performance. This rhythmic drama lasts for 4 measures, followed by a return to the original tempo, played quite freely, which takes us through the last few measures of the piece.

Dig Deeper

BOOK/ DOCUMENTARY

Celebrating Bird: The Triumph of Charlie Parker by Gary Giddins

MOVIE

Bird

Charlie Parker

Like Louis Armstrong in the era before him, alto saxophone player Charlie Parker revolutionized solo improvisation and changed the face of jazz forever. Born in Kansas City, Parker got his start playing in the wide-open clubs and dance halls that spawned the relaxed, swinging style of bands like those led by Count Basie. While traveling to a gig in the mid-1930s, Parker got the nickname "Yardbird" when the car he was riding in hit a chicken that had run into the middle of the road. Parker made the driver go back to pick up the dead bird. When the band arrived at the home they were staying in, Parker had the lady of the house cook up the chicken for a personal feast. After that episode, he was often referred to as "Yardbird," "Yard," or "Bird."[3] On another fateful car trip, Parker injured his back in an accident. Apparently he became addicted to the pain medication morphine, and when he could no longer get the drug legally, he switched to heroin. There are

other legends of how Parker's addiction began, but regardless of how it started, both heroin and alcohol would play a major role in his short and troubled life.

Inspired first by Kansas City sax players Lester Young and Buster Smith and later by very diverse influences including Art Tatum, Jimmy Dorsey, and twentieth-century classical composers Igor Stravinsky and Paul Hindemith, Charlie Parker almost single-handedly created many of the most important elements of the new bebop style. He was an active listener who took in everything he heard and synthesized it into his own unique musical approach. From players such as Lester Young he took the long, flowing improvised lines and pure, light tone that made Young so successful. From Art Tatum and Jimmy Dorsey he copied the rapid, almost frantic passages that displayed amazing technical facility. Drawing from Art Tatum and also from modern classical music, Parker helped create the complex extended harmonies that would become a trademark of the bebop style.

Parker's greatest successes came in New York City in the after-hours jazz clubs frequented by many of the city's best musicians. Parker, along with Thelonious Monk and Dizzy Gillespie, became a major figure in this evolving new style, and the three of them created many of the most important bebop tunes ever composed. In his book *Jazz Styles* Mark Gridley describes Parker's compositions and their impact on jazz:

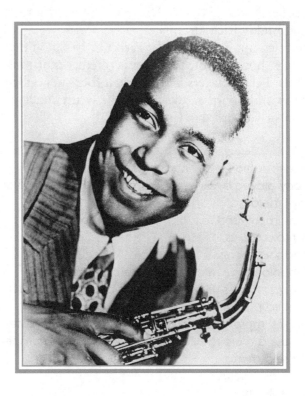

1940s press photo of Charlie Parker.
Courtesy of the Institute of Jazz Studies, Rutgers University

> Parker wrote a sizable body of tunes, and their character set the flavor for bop as much as his improvisations did. Though not melody-like in the pop tune sense, they were catchy lines in a jazz vein. Most were accompanied by chord progressions borrowed from popular songs. Many used accompaniments of the twelve-bar blues chord progression. Their phrases were memorized and analyzed by hundreds of jazz soloists. His "Now's the Time," "Billie's Bounce," and "Confirmation" were played at jam sessions for decades after he introduced them. This was the musical language of bop.[4]

Many of bebop's early hits (such as they were) were recorded by bands that featured Parker and Gillespie in the front line. Two of their best tunes, *Bloomdido* and *Anthropology*, can be found on Spotify. Over the years, Gillespie and Parker would continue to work together off and on, but Parker's unpredictability strained his professional relationship with Gillespie. They were always close personal friends, but Gillespie began looking in other directions musically.

Listening Guide

Bloomdido (Charlie Parker)

Example of the bebop style
Recorded June 6, 1950
Performed by Charlie Parker, alto sax; Dizzy Gillespie, trumpet; Thelonious Monk, piano; Curly Russell, bass; and Buddy Rich, drums

This original melody, composed by Charlie Parker, is based on the 12-bar blues pattern. In the hands of bebop musicians, however, the tempo was often two or three times as fast as was typical for jazz performances. For bebop players, most of their focus in performance was on improvisation. As you listen, notice how much farther away from the written melody these players go compared to most of the swing music you heard in Chapter 4.

Total time: 3:29

:00		9-measure introduction featuring drums and piano.
:09		Head. Melody played by Gillespie on muted trumpet and Parker on sax.
:21		Full repeat of melody.
:34		Parker begins improvised sax solo. Plays four choruses total.
	:34	1st solo chorus.
	:47	2nd solo chorus.
	1:00	3rd solo chorus. More use of the blues here.
	1:12	4th solo chorus. Parker opens this chorus with a quote from the old "shave and a haircut" jingle.
1:25		Gillespie begins improvised trumpet solo. Plays three choruses total. Note that he continues to use a mute to alter the basic sound of his trumpet.
	1:25	1st solo chorus.
	1:38	2nd solo chorus.
	1:51	3rd solo chorus.
2:04		Monk begins improvised piano solo. Plays two choruses, placing more emphasis on dissonance and percussive sounds on the piano. Unlike both Parker and Gillespie, Monk makes less use of fast strings of running notes.
	2:04	1st solo chorus.
	2:17	2nd solo chorus.
2:30		Rich begins improvised drum solo. Plays two choruses. Unlike some bebop drummers, Buddy Rich tends to keep a very steady beat even in his extended solos. Listen to the steady rhythm of the bass drum to count the measures as they go by.
	2:30	1st solo chorus.
	2:42	2nd solo chorus.
2:55		1st out chorus. Return to the original melody heard at the beginning.
3:09		2nd out chorus. Tune ends with both Parker and Gillespie falling off the final note of the song.

Listening Guide

Anthropology (C. Parker and D. Gillespie)

Example of the bebop style
Recorded March 31, 1951
Performed by Charlie Parker, alto sax; Dizzy Gillespie, trumpet; Bud Powell, piano; Tommy Potter, bass; and Roy Haynes, drums

When the beboppers began creating their own tunes, they frequently composed new melodies over altered versions of existing chord changes. One of their favorite set of changes was originally created by George Gershwin for his tune *I've Got Rhythm*. These "Rhythm changes," as they came to be called, were used in literally thousands of tunes. The chord changes follow the standard 32-bar song form (A-A-B-A), with some harmonic additions to add more complexity to the music. This recording is taken from a live radio broadcast from Birdland.

Total time: 5:22

:00	Radio annoucement by "Symphony Sid" Torrin.	
:14	4-measure drum introduction.	
:17	Head. New melody composed by Charlie Parker and played in unison by Dizzy Gillespie and Parker. To give you a clear idea of how fast this tune is going, look at the breakdown of 8-bar phrases below. To really get an exact start for each event, the time code would need to run at 1/10 of a second. Most of these phrases begin somewhere within the second noted and not right on the beginning of that second.	
	:17	1st 8 bars, letter A melody.
	:23	2nd 8 bars, repeat of letter A melody.
	:29	3rd 8 bars, bridge or letter B melody.
	:35	4th 8 bars, return to letter A melody.
:42	Parker begins improvised sax solo. Plays three choruses total.	
	:42	1st solo chorus.
	1:07	2nd solo chorus.
	1:33	3rd solo chorus. Parker opens chorus with one of his most classic lines.
2:00	Gillespie begins improvised trumpet solo. Plays three choruses total.	
	2:00	1st solo chorus.
	2:25	2nd solo chorus.
	2:50	3rd solo chorus.
3:15	Powell begins improvised piano solo. Plays two choruses.	
	3:15	1st solo chorus.
	3:39	2nd solo chorus.
4:04	Parker, Haynes, and Gillespie begin trading fours. Order of solos is sax, drums, trumpet, drums, sax, drums, trumpet, drums.	
4:29	Another trading-fours chorus, same format as above.	
4:53	Out chorus. Return to same material used in the head at the beginning of the performance.	

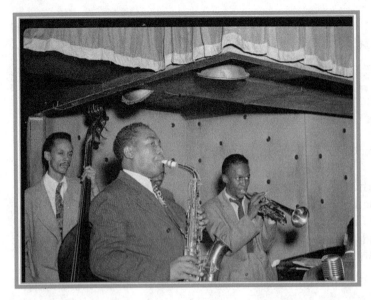

Alto sax player Charlie Parker and a very young Miles Davis, trumpet, performing at the Three Deuces Jazz Club in New York City in 1947. This band also featured Tommy Potter, bass; Duke Jordon, piano; and Max Roach, drums (not pictured).
©William P. Gottlieb. From the Library of Congress Collection.

Several other famous trumpet players got early breaks playing with Charlie Parker. Miles Davis, Chet Baker, and Red Rodney all gained valuable experience playing in groups with Bird. Sadly, all three used illegal drugs at some point in their lives. For most of his career, Parker fronted a series of quintets playing in the bebop style. He frequently worked with pianist Bud Powell, and enjoyed playing with drummer Kenny Clarke as well. Parker's genius was recognized by avid bebop fans, who began following him with a primitive tape recorder, taking down every note that Bird played. Unfortunately, to conserve tape, they frequently only recorded Parker's solos, so the modern listener is forced to guess at what the other players' improvisations might have been like. Toward the end of his career, Parker had the opportunity to make a series of recordings backed by a small chamber orchestra. These recordings, now known collectively as *Charlie Parker with Strings*, opened the door for many musicians in later years who would blend classical music with jazz. You will find the tune *Just Friends*, perhaps the most famous track from this groundbreaking album, on your Spotify playlist.

Listening Guide

Just Friends (J. Klenner and S. Lewis)

Recorded November 30, 1949

Performed by Charlie Parker with chamber orchestra. Charlie Parker, alto sax; Mitch Miller, oboe; Bronislav Gimpel, Max Hollander, and Milt Lomask, violin; Frank Brieff, viola; Frank Miller, cello; Myor Rosen, harp; Stan Freeman, piano; Ray Brown, bass; Buddy Rich, drums; and Jimmy Carroll, arranger and conductor

Saxophonist and bebop pioneer Charlie Parker had a deep interest in classical music, particularly music of the twentieth century. He had dreams of creating extended chamber music works that would blend jazz with classical music, but sadly he did not live long enough to make that happen. This project, *Charlie Parker with Strings*, gives us a brief glimpse into what he might have done had he lived beyond the age of 34. Organized by Norman Granz, this recording featured Parker performing brief but brilliant improvisations on jazz and popular tunes, backed by a small chamber ensemble that included strings joined by a few wind and brass instruments, depending on the specific arrangement requirements. The style here is a unique mix of bebop techniques with lush string writing. Many jazz musicians have recreated this format over the years, leading to a series of "with strings" recordings.

The tune *Just Friends* is written in a common 32-bar song format of A-B-A-C.

Total time: 3:30

:00 8-bar introduction. The first 4 measures are played rather freely by the strings and harp, followed by a dramatic 4-bar improvisation by Charlie Parker in a stricter time, accompanied by the entire rhythm section and strings, which leads right into the opening statement of the tune's melody.

:19 Parker plays a highly embellished version of the *Just Friends* melody. He holds the lead for 16 bars, stating the letter A material (8 bars) and the letter B material (also 8 bars). At the end of the letter B material notice how he again plays an improvised line that links this statement to the next letter A theme that follows, just as he did at the end of the introduction.

:47 Strings take over the next letter A melody statement and keep the lead for the full 8 measures.

1:01 Parker returns with an embellished statement of the letter C material, which brings the first full chorus to a close.

1:15 4-bar interlude featuring Mitch Miller on oboe that links the 1st chorus to the next solo chorus.

1:21 Full 32-measure solo chorus improvised by Charlie Parker, with written accompaniments played by the entire group.

2:18 2-bar interlude that ties to the string gesture heard at the end of the last chorus and links that section to the next chorus.

2:21 The 3rd chorus begins with a 16-measure piano solo played over the letter A and letter B material.

2:49 Parker enters playing highly embellished lines over the final 16 measures of letter A and letter C material that has been slightly altered at the end to allow for the following concluding material.

3:17 The performance comes to a close with an extra 6 measures, over which Parker unleashes one final flurry of improvised lines.

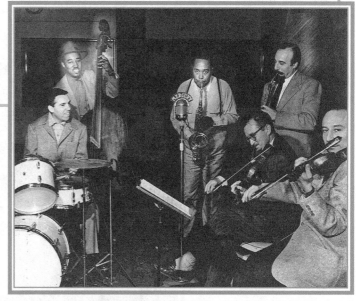

Promotional photo for the Charlie Parker with Strings *project. Left to right: Buddy Rich, drums; Ray Brown, bass; Charlie Parker, alto sax; Mitch Miller, oboe and English horn; Max Hollander, violin; and Milt Lomask, violin.*
Courtesy of Frank Driggs

In trying to imitate everything that Charlie Parker did, many musicians followed him into a lifestyle of drug abuse. They wanted to play like Bird, and many seemed to think the drugs were what made it all happen. Players seemed to disregard the fact that Parker was truly gifted with a natural ear for music, and that he practiced relentlessly. Parker himself admitted that drugs and alcohol actually hindered his performances. He was known to encourage other players and fans to avoid the mistakes he made in his life, but this advice often fell on deaf ears. Charlie Parker died of lobar pneumonia in 1955 at the age of 34, his health condition exacerbated by years of drug and alcohol abuse. It has been said that the New York medical examiner estimated Parker's physical age to be between 55 and 60 at the time of his death.

Dizzy Gillespie

Along with Charlie Parker, trumpet player Dizzy Gillespie was one of the first bebop musicians to speed up tempos, alter chords, and focus on extended improvisations. In addition, it was Gillespie's personal look, speech patterns, and mannerisms that the mainstream media presented as characteristics of the bebop style. Like Parker, Gillespie started out playing music in a series of swing bands, including those of Cab Calloway, Earl Hines, and Billy Eckstine. Later, Gillespie went on to front a big band of his own. Although only somewhat commercially successful, Gillespie led one of the first big bands to play music in the "modern" jazz style. In fact, the cool jazz group the Modern Jazz Quartet got its start together as members of Dizzy Gillespie's big band rhythm section.

Dizzy Gillespie's trumpet playing was full of velocity. He had a great ability to play extended passages in the upper register of the trumpet, and he performed music with a real sense of drama. Although a member of the modern jazz circle, Gillespie was conscious of needing to play music with some audience appeal. He created tunes such as *Salt Peanuts* and *Op Bop Sh'bam* that added nonsense vocals the audience found engaging. While musically uncompromising, these witty vocal additions helped some listeners connect with this complex new music. Gillespie was also one of the first modern jazz musicians to explore Latin rhythms. As you read in the excerpt from his book *To Be, or Not to Bop*, he found many Latin and African rhythms to be very pure musical expressions. Listen to one of his early explorations of Latin jazz in the song *Manteca*.

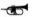

Dig Deeper

DOCUMENTARY

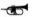

A Night in Havana: Dizzy Gillespie in Cuba

RECORDINGS

Dizzy Gillespie: Ken Burns Jazz Collection; At Newport; Sunny Side Up; Dizzy's Diamonds: Best of the Verve Years

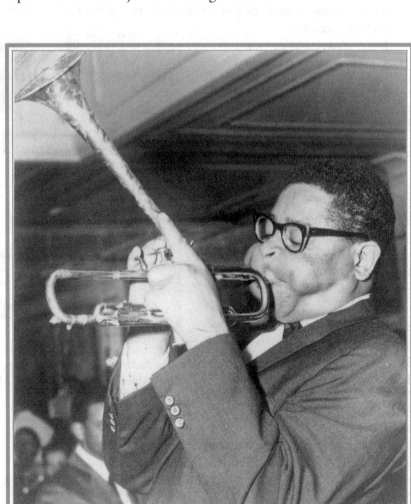

Dizzy Gillespie playing his signature up-bent trumpet with his typical puffed cheeks.
Courtesy of the Institute of Jazz Studies, Rutgers University

Listening Guide

Manteca (D. Gillespie and C. Pozo, arr. G. Fuller)

Example of bebop performed by a big band and also use of Latin rhythms
Recorded December 30, 1947

Performed by Dizzy Gillespie and His Orchestra. Dizzy Gillespie, solo trumpet; Howard Johnson and John Brown, alto sax; George Nicholas and Joe Gayles, tenor sax; Cecil Payne, baritone sax; Dave Burns, Elmon Wright, Lamer Wright, Jr., and Benny Bailey, trumpet; Ted Kelly and Bill Shepard, trombone; John Lewis, piano; Al McKibbon, bass; Kenny Clarke, drums; and Chano Pozo, conga drums and shouts

This recording represents the growing interest in Latin rhythms during the bebop era. Gillespie, among others, was interested in incorporating more Latin rhythms (which they mostly called Afro-Cuban rhythms) into jazz music. The formal structure is a bit unusual, so don't worry too much about trying to count all of the measures. Where logical 16-measure phrases occur, they are marked. It is more important to get into the rhythmic groove of the piece and notice where the rhythmic styles change.

Total time: 3:06

:00	Latin rhythmic groove is established by congas and bass. Other instruments join in one by one playing contrasting melodic and rhythmic ideas.
:19	Opening solo licks by Gillespie are played over the established rhythmic texture.
:30	Large ensemble shout, followed by more rhythm section in Latin groove.
:38	Main melody begins. 16 measures total, but really an 8-bar phrase played twice.
1:00	Lyrical contrasting melody is introduced. 16 measures total, 8 played by the full band and then 8 featuring a Gillespie solo.
1:23	Latin groove returns.
1:48	Tenor sax solo begins. The basic rhythmic groove changes to swing, but the congas continue to play. Total solo is 16 bars long.
2:10	Another 16-bar swing section begins. First 8 bars feature the full band, and the second 8 bars feature another Gillespie solo.
2:33	Latin groove returns. Tune ends with instruments dropping out in the reverse order of their entry at the beginning of the tune.

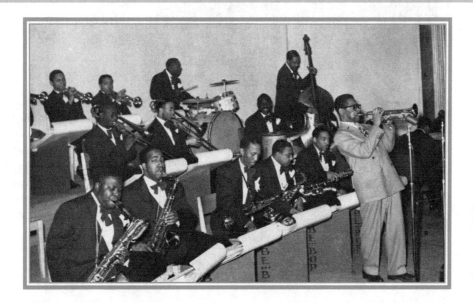

Dizzy Gillespie and his orchestra performing at the Winter Palace in Stockholm, Sweden.
© Bettman/Contributor/ Getty images

Unlike Charlie Parker, Dizzy Gillespie lived well into his seventies and continued playing music right up until his death in 1993. Over the years, he received numerous honors and awards for his many contributions to the world of music. Gillespie was also an active educator who often took time to work with younger students. As jazz education became a regular part of the curriculum at colleges and high schools across America, Gillespie was in great demand as a guest clinician and soloist. Over the course of his career, he made well over 100 recordings and was a frequent featured soloist on other musicians' records as well. He made international tours under the auspices of the Department of State and was honored with a Kennedy Center Lifetime Achievement Award. In 1992, National Public Radio honored his 75th birthday with a series of shows called *Dizzy's Diamond*.

Thelonious Monk

Without a doubt, pianist and composer Thelonious Sphere Monk was one of the most innovative but misunderstood musicians in the history of jazz. He wrote and performed music with a wry sense of humor, which played into both his use of dissonance and his exploration of complex, often asymmetrical, rhythms. While some of his compositions were new lines written over old formal structures, many of his tunes were brand new works. Even more than Charlie Parker and Dizzy Gillespie, Monk is important to the history of bebop as a truly original creator of modern jazz compositions. Tunes including *Straight, No Chaser*; *Well, You Needn't*; *Blue Monk*; and *'Round Midnight* have all become jazz standards. Monk was involved in the now historic late-night jam sessions that led to the development of bebop, but he was considered more radical than both Parker and Gillespie by the general music-buying public. On the other hand, Thelonious Monk has always been considered a "musician's musician," highly respected and looked up to in the musical community involved with modern jazz. Obviously it is important to listen to a musician play to get a true sense of his or her style, but with Monk it is absolutely imperative. Things that can never be satisfactorily explained with words can be clearly understood once you hear Monk perform. You can explore Monk's music on a 1948 recording titled *Misterioso*.

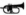
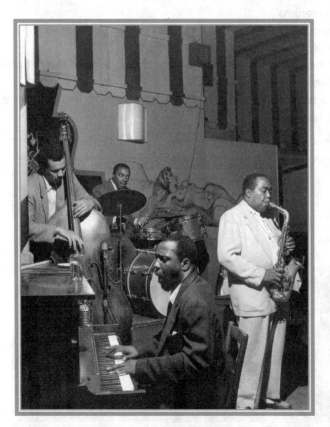

Charlie Parker fronting an all-star quartet at New York City's Open Door nightclub in 1953. Left to right: Charles Mingus, bass; Roy Haynes, drums; Thelonious Monk, piano; and Charlie Parker, alto sax.
Courtesy Bob Parent Archive

Listening Guide

Misterioso (Thelonious Monk)

Example of Thelonious Monk's unique approach to jazz composition and improvisation
Recorded July 2, 1948
Performed by Thelonious Monk, piano; Milt Jackson, vibraphone; John Simmons, bass; and Shadow Wilson, drums

 This is another example of jazz musicians improvising over the 12-bar blues, but the structure can be heard in an entirely new way in the hands of Thelonious Monk. His melody is intentionally architectural and not very melodic. The tune simply walks a string of broken intervals (the interval of a 6th) up and down the keyboard.

Total time: 3:23

:00	4-measure introduction where Monk outlines the principal theme of the melody on piano.
:11	Head. The full melody is stated over the 12-bar blues pattern. Monk is joined by vibraphonist Milt Jackson and the rest of the rhythm section.
:46	Vibraphone solo begins. Listen carefully to Monk's comping style. Rather than playing full chords like most pianists of the day, Monk simply sets up a rhythmic pattern. Then, as soon as your ear settles on what that pattern is going to be, he takes it away for a bit and keeps your ear guessing for the rest of the chorus.
1:22	The 1st chorus of Monk's piano solo begins. Throughout his improvisation, Monk explores unresolved dissonance, whole-tone scales, and other non-Western harmonic patterns while embracing some rather asymmetrical rhythmic structures as well.
1:59	Monk's 2nd solo chorus begins. Be careful with your counting here. At the end of the last chorus, the bass clearly leads into the start of the next 12-bar blues pattern. Monk's improvisation seems to follow, but somewhere in the first 4 bars of the 2nd chorus an extra measure is added. Everyone seems to handle it well, and unless you are actively counting along you might not even notice. You will hear the bass firmly move to the IV chord (the sub-dominant) at 2:15, and the performance progresses normally from there. It's just a 13-measure chorus this time around.
2:40	Milt Jackson returns to the melody on vibraphone as the out chorus begins. Monk, however, continues to explore rhythmically asymmetrical harmonic ideas. His playing in this section is almost a sort of chord distillation or a version of musical pointillism. He simply plays one note now and then, selecting the single tone he wants the audience to deeply experience within that given moment.
3:02	Monk finally rejoins the out chorus melody statement for the last 4 bars. The band slows down in the last few measures, and right at the very end, Monk adds a big descending whole-tone scale passage to punctuate the ending.

Thelonious Monk at the piano in Minton's Playhouse in New York City, 1947.
©William P. Gottlieb. From the Library of Congress Collection.

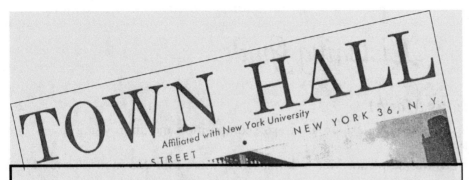

Town Hall, Saturday Evening, February 28, 1959 at 8:30 p.m.

•

AN EVENING WITH

THELONIOUS MONK

•

QUARTET

INTERMISSION

ORCHESTRA

 a) Monk's Mood

 b) Friday the 13th

 c) Little Rootie Tootie

INTERMISSION

QUARTET

ORCHESTRA

 d) Off Minor

 e) Thelonious

 f) Crepescule with Nellie

PERSONNEL

THELONIOUS MONK, Piano EDDIE BERT, Trombone

CHARLES ROUSE, Tenor Saxophone ROBERT NORTHERN, French Horn

DONALD BYRD, Trumpet JAY McALLISTER, Tuba

PHIL WOODS, Alto Saxophone SAM JONES, Bass

PEPPER ADAMS, Baritone Saxophone ARTHUR TAYLOR, Drums

Thelonious Monk was an introverted and deeply introspective man. Musicians often told stories of how Monk would be on a gig for several weeks and never say a word to anyone. Others tell of how they would be having a conversation with Monk and he would just wander off. Several days later he would resume the thread of the conversation as if no time had lapsed. These personal traits are clearly reflected in his music. He improvised with a composer's flare, often using long silences coupled with sporadic outbursts of notes that seem to come completely out of the blue. In truth, Monk was concentrating so hard, searching for the absolutely perfect note to play, that he just left open space until the right notes came to him. These silences, and the random musical explosions that followed, became a trademark of Monk's style.

Long after bebop players Charlie Parker, Dizzy Gillespie, and Miles Davis had gained a national reputation, Monk continued to be something of an underground cult figure. It wasn't until the late 1950s and early 1960s that major record contracts came his way, and the musical world began to take Thelonious Monk seriously. In 1964, Monk was featured on the cover of *Time* magazine, one of only a few jazz musicians to ever receive that honor. The older Monk got, the more reclusive he became. By the late 1970s he hardly ever spoke to anyone and almost never touched the piano. His music, however, only grew in popularity. Musicians from many different backgrounds have explored Monk's compositions. Over the years, many musicians have focused entire recording projects on Monk's music. Even today, Monk's compositions remain challenging and engaging material for jazz musicians to tackle.

Bud Powell

Born into a family of musicians, pianist Bud Powell became a regular at the after-hours sessions at Minton's. Inspired by the playing of Art Tatum and encouraged by Thelonious Monk, Powell developed a very versatile style that alternated between feats of technical prowess and intensely beautiful melodic lines. As a rhythm section player, Powell was in great demand. Many of the finest bebop players of the day wanted to work with him. Unfortunately, Powell was mentally unstable and could be quite unpredictable. Some scholars have suggested that Powell's mental state had a major impact on his playing style. Alan Axelrod describes Powell's playing style and also offers one possible reason for his often erratic behavior.

Bud Powell.
Courtesy of the Institute of Jazz Studies, Rutgers University

> Powell's pianism has a vulnerability about it, the demonstrations of technical prowess alternating with tenderness that never verges on sentimentality. Perhaps this fragility reflects Powell's own tortured life. Plagued by mental instability, he was frequently confined in institutions. Some believe his precarious mental health was the result of a beating dealt him by the Philadelphia police when he was arrested for disorderly conduct in 1944. Perhaps we are fortunate to have any music from this seemingly cursed genius, who died at 41 of a combination of alcoholism, tuberculosis, and malnutrition. The 1986 film *'Round Midnight*, starring tenor legend Dexter Gordon, is loosely based on the life of Bud Powell.[5]

Other Instrumentalists

Obviously there were many other great bebop players we cannot explore in depth here. There were pioneers on virtually every jazz instrument, and skills and techniques were rapidly expanding. To go deeper into the world of bebop, check out some of the following players. For trumpet, listen to Howard McGhee, Kenny Dorham, and Red Rodney. Some saxophone greats beyond Charlie Parker include Charlie Rouse (a regular with Thelonious Monk), Sonny Criss, Sonny Stitt, Dexter Gordon, and the often overlooked Lucky Thompson. There were several great bebop guitarists including Tiny Grimes, Tal Farlow, Jimmy Raney, and Barney Kessel. Because of the technical demands of the music, some trombonists struggled with this modern style of improvisation. Players including J.J. Johnson and Frank Rosolino, however, managed to develop new techniques for playing the instrument that allowed the trombone to be played with the same facility as any other musical instrument. In addition to the laundry list of players above, we will examine some bebop-influenced musicians in the mainstream jazz world in Chapter 10.

Dig Deeper

RECORDING

Bud Powell: Complete Blue Note and Roost Recordings

BOOKS

Dance of the Infidels: A Portrait of Bud Powell by Francis Paudras; *The Glass Enclosure: The Life of Bud Powell* by Alan Groves and Alyn Shipton

MOVIE

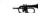

'Round Midnight

Bebop Singers

Due to the rapid tempo and complex melodies of most bebop tunes, singers at first found this new music very difficult to take part in. A few, including Sarah Vaughan and Ella Fitzgerald, began to scat sing in a more modern jazz style. Listen to Ella Fitzgerald sing the tune *Lemon Drop* on Spotify.

Listening Guide

Lemon Drop (George Wallington)

Example of Ella Fitzgerald's scat-singing in the bebop style

Recorded April 11, 1974

Performed by Ella Fitzgerald, vocal; Tommy Flanagan, piano; Joe Pass, guitar; Ketter Betts, bass; and Bobby Durham, drums

This piece features Ella Fitzgerald in a live performance singing a tune with no real lyrics. She scats the opening melody, using her voice to imitate a horn. She then proceeds to improvise a number of solo choruses in the same manner that any other bebop horn player would do. The only difference is that she is scat singing. The song follows the standard 32-bar song form (A-A-B-A). Ella is accompanied by a fine rhythm section. Pay close attention to how they immediately respond to anything unique Ella sings in her improvisation. This is truly a five-way conversation. In particular, notice how Ella improvises a riff in her 4th solo chorus that the rest of the musicians quickly pick up on and begin to actively take part in.

Total time: 3:53

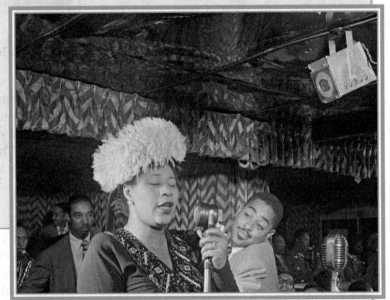

:00	Piano introduction.
:11	Fitzgerald scats the head, or written melody, of the tune.
:40	1st solo chorus.
1:08	2nd solo chorus.
1:35	3rd solo chorus.
2:02	4th solo chorus. Ella sets up a riff pattern here.
2:28	Out chorus. Return to original melody.

Ella Fitzgerald sings at the Downbeat Club in New York as Dizzy Gillespie looks on. You can also see bass player Ray Brown (Ella's future husband) in the background, ca. Sept. 1947.

© William P. Gottlieb. From the Library of Congress Collection.

| 2:55 | Fitzgerald sings a long tag over a pedal point (note how left hand of piano and bass keep playing the same note). In the course of this tag, Ella quotes lines from several different tunes and sings her own little line to tell the audience the title of the song she has been singing for the last few minutes. |

Eventually, the singers King Pleasure and Eddie Jefferson developed new vocal techniques for the modern jazz era. The new style was called **vocalese,** and it involved singing a word or syllable for every note on a bebop recording. Singers would listen to recorded performances by players such as Charlie Parker, Coleman Hawkins, and Dizzy Gillespie and memorize every note they played, both in the written melody *and* the entire improvised solo. They would then write words to every note and, using these lyrics, sing an exact recreation of the recording. Later, a group called Lambert, Hendricks & Ross came along doing the same style of vocalese, but they did it in three-part harmony. In addition, they also did a lot of scat singing, using their voices to make up new improvised solos just as any bebop instrumentalist would do. You can hear an example of vocalese in the tune *Cottontail*, by Lambert, Hendricks & Ross, on Spotify. These lyrics were based on a recording of the same tune made by the Duke Ellington Orchestra.

Press photo of vocalese singer Eddie Jefferson.
Courtesy of the Institute of Jazz Studies, Rutgers University

vocalese

Dig Deeper
RECORDINGS

Eddie Jefferson: *Letter From Home* Lambert, Hendricks & Ross: *The Hottest New Group in Jazz*

WEBSITES

www.ellafitzgerald. com
www.hancockinstitute. org

Listening Guide

Cottontail (Edward Kennedy Ellington, lyrics by Jon Hendricks)

Example of vocalese
Recorded June 2, 1960
Performed by Dave Lambert, Jon Hendricks, and Annie Ross, vocals; Gildo Mahones, piano; Ike Issacs, bass; and Jimmy Wormsworth, drums

This tune was written by Duke Ellington and recorded by his orchestra in 1940. The main soloist on that recording was tenor saxophonist Ben Webster. When the technique of vocalese first came around in the bebop era, Eddie Jefferson and King Pleasure were creating lyrics mostly to bebop tunes. When the vocalese trio of Lambert, Hendricks & Ross came together, however, they also sang vocal versions of big band charts, complete with riffs, improvised solos, and lots of intricate harmony. In the vocalese tradition, they have written a word or syllable for every note played on the original Duke Ellington recording of *Cottontail*. The tune itself mostly follows the standard 32-bar song form (A-A-B-A), but it has some altered phrases and chord changes during the course of the performance.

Total time: 2:55

:00	Head. Everyone sings the melody.
:15	Bridge. Annie Ross sings solo as played by Cootie Williams.
:22	Shortened statement of letter A material. 4 bars.
:26	2nd chorus begins. Jon Hendricks sings solo as improvised by Ben Webster.
:41	Bridge and Last 8, letter A. Solo continues, Ross and Lambert enter singing riffs behind the improvised solo.
:55	3rd chorus. Solo continues, with altered chords for the first 8 bars.
1:25	4th chorus. All vocalists sing brass ensemble lines.
1:39	Bridge. Jon Hendricks sings solo as improvised by Harry Carney.
1:46	Last 8, letter A. All sing solo as improvised by Duke Ellington with some band licks as well.
1:53	5th chorus. All vocalists sing sax ensemble lines.
2:22	6th (and last) chorus. Hendricks and Lambert continue singing sax ensemble lines as Ross sings licks played by the brass section.
2:36	Bridge. All sing.
2:43	Last 8. All sing a return to the original melody.

Dave Lambert, Annie Ross, and Jon Hendricks of Lambert, Hendricks & Ross. Courtesy of the Institute of Jazz Studies, Rutgers University

Bebop Today

The bebop styles of the 1940s became the foundation for most of the modern jazz styles that would follow. Bebop techniques are freely mixed with other musical styles to create much of the jazz we hear today. Players including Wynton and Branford Marsalis, Joshua Redman, Terence Blanchard, Randy and the late Michael Brecker, and even more mainstream players such as Paul Shaffer, George Benson, and Harry Connick, Jr. are thoroughly skilled in the musical traditions of bebop. Even when they are not playing music in a purely bebop tradition, the style tends to permeate everything they play. At the high school and college levels, students regularly study the playing and compositional styles Charlie Parker, Dizzy Gillespie, and Thelonious Monk. In addition, the vocal groups Manhattan Transfer, Take 6, and New York Voices all perform in the traditions established during the bebop era.

Notes

1. Nat Shapiro and Nat Hentoff, *Hear Me Talkin' To Ya* (New York: Dover Publications, 1955), p. 354.

2. Ibid., p. 337.

3. *Celebrating Bird: The Triumph of Charlie Parker*, Dir. Gary Giddens, (Long Beach, CA: Pioneer Entertainment, 1999), videocassette.

4. Mark Gridley, *Jazz Styles*, 7th ed., (Upper Saddle River, NJ: Prentice Hall, 2000), p. 152.

5. Alan Axelrod, *The Complete Idiot's Guide to Jazz* (Indianapolis, IN: Alpha Books, 1999), p. 167.

Study Guide

Chapter 5 Review Questions

True or False

___ 1. Bebop tends to use faster tempos than swing.

___ 2. In bebop solo improvisations on the piano, the left hand handles most of the improvisation duties.

___ 3. Dizzy Gillespie was the only trumpet player who would work with Charlie Parker because Parker's drug habit made him so difficult to work with.

___ 4. Bebop evolved in after-hours night clubs in New York City including Minton's and Monroe's.

___ 5. Bebop is impossible to play in a large ensemble format.

___ 6. Bebop improvisations are full of sudden shifts and surprises.

___ 7. Vocalists immediately embraced the bebop style.

___ 8. Most modern jazz styles have been influenced by bebop.

___ 9. Most professional jazz musicians today are expected to be able to improvise in the bebop style, even if they often perform in other styles.

___10. Bebop musicians employ a more complex harmonic language than swing musicians.

Multiple Choice

11. Saxophone player Charlie Parker influenced bebop musicians by:
 a. his drug use.
 b. his amazing technical abilities.
 c. adding new chord changes in the middle of an improvisation.
 d. all of the above.
 e. none of the above.

12. Which musician added nonsense vocals to bebop to increase audience appeal?
 a. Art Tatum d. Dizzy Gillespie
 b. Bud Powell e. Thelonious Monk
 c. Charlie Parker

13. What is the biggest trademark of Thelonious Monk's style of improvisation?
 a. The use of silence paired with sudden musical outbursts.
 b. Traditional stride-style piano playing.
 c. Improvisations performed in fast tempos.
 d. Beautiful, highly melodic lines.
 e. Scat singing.

14. Lambert, Hendricks & Ross often sang in:
 a. unison.
 b. two-part harmony.
 c. three-part harmony.
 d. four-part harmony.

15. Which bebop musician was featured on the cover of *Time* magazine?
 a. Charlie Parker d. Art Tatum
 b. Dizzy Gillespie e. Bud Powell
 c. Thelonious Monk

16. Which instrumentalists are known for "dropping bombs?"
 a. pianists d. vocalists
 b. trumpet players e. drummers
 c. saxophonists

Fill in the Blank

17. Comping is short for _____.

18. _____ is the title of the album Charlie Parker made with a small chamber orchestra.

19. _____ and _____ developed new techniques for the trombone so they could improvise in the bebop style.

20. Bud Powell's instrument was the _____.

21. The singing style in which a word or syllable is written for every single note of a bebop recording is called _____.

22. Pianist _____ won every cutting contest he entered and was respected by his peers.

Short Answer

23. List three differences between swing and bebop.

24. Why aren't there any bebop recordings from the early 1940s?

25. In Monk's playing on the recording *Misterioso* do you hear more use of dissonance or consonance?

Essay Questions

1. Discuss the life of Charlie Parker and his contributions to the world of music. Using the Internet and other current media sources, consider Parker's place in music history.

2. Compare the swing music of Chapter 4 with the bebop music you have explored in Chapter 5. Do you think music fans of the 1940s were too closed-minded, or were they right to abandon jazz for other, more accessible forms of popular music?

Chapter 6

Cool School

Musicians in the fifties were the very epitome of everything cool. Just the presence of
Miles Davis and John Coltrane lowered the earth's average temperature by 2.4 degrees . . .

Genius Guide to Jazz
April 2001

\mathcal{T}he cool school movement in jazz is really a collection of closely related styles,
drawing inspiration from musical genres as diverse as bebop, swing, classical, and
even Latin music. To make things easier for you, **cool school** music can simply
be defined as a somewhat relaxed, more listenable offshoot of bebop. There were
practitioners of this new "cool" style on both the East and West Coasts. In fact,
earlier jazz historians often separated West Coast and cool school as two different
styles. While there can be some minor differences in the two perceived styles, the
basic goals of the various musicians were similar. Many "West Coast" musicians
took part in the most famous early cool school recording, *Birth of the Cool*, on
Capital Records. This album, which featured a group led by trumpet player Miles
Davis, placed more emphasis on written charts and mellower sounds than was
common in the bebop style. The recording still carries many of the marks of mod-
ern jazz, however, with a bebop-style rhythm section and a focus on improvisation
along with the written material. Historically, this album is very important as it rep-
resents the first time in jazz history that an artist (or group of artists) created a new
style of music and named it. The cool school attitude was sometimes associated
with lifestyle as well as musical performance. In his book *Writings in Jazz* Nathan
Davis (no relation) considers Miles Davis' cool approach to life.

cool school

More than any other musician, Miles Davis typified the cool school. The way he walked, his cool, relaxed manner, and self-assurance made him the symbol of what cool was all about. Bebop was "cool" because it projected an intellectualism, but cool gave the impression that nothing mattered. If you didn't like the music, that was okay. Davis became a folk hero. Among jazz musicians and fans he was high priest, with a following equaled only by that of certain spiritual leaders of the 1970s. Every note that he played was revered.[1]

To some extent, the cool recordings and performances of artists such as Miles Davis and Dave Brubeck found more acceptance with the general public when compared to bebop. In the 1950s and 60s, however, jazz was no longer America's most popular music. Older people were listening to pop singers, and younger people were into rock-and-roll. Jazz still had its fans, but the dominance it had enjoyed as America's popular music in the 1930s and 40s was over.

The People Who Made It Happen

Miles Davis

Born and raised near St. Louis, Miles Davis moved to New York City in 1944 to study trumpet at the Julliard School of Music. One of the reasons he chose this particular music school was so that he could be near the new bebop movement and its main players, Charlie Parker and Dizzy Gillespie. Before long, Davis dropped out of school and started playing in a quintet with Charlie Parker. Miles followed Parker to the West Coast, but when Bird was put away in the Camarillo State Hospital (due to his drug abuse) for several months, Miles was forced to find other work. He played in big bands led by Billy Eckstine and Dizzy Gillespie. When Parker reappeared on the New York music scene in 1947, Davis rejoined the quintet. After playing with Parker for a while, Miles Davis became somewhat disenchanted with bebop. He liked the concepts, but found the frantic pace of bebop and the constant focus on one style of improvisation a bit limiting. Working with pianist and composer **Gil Evans**, Davis joined a group of like-minded musicians in a collaboration that would eventually be called the Miles Davis Nonet or the Miles Davis Tuba Band. The "nonet," or group of nine players, featured a rather interesting collection of instruments: Davis on trumpet, Lee Konitz on alto saxophone, Gerry Mulligan on baritone saxophone, and J.J. Johnson or Kai Winding on trombone. In addition to those standard, frontline instruments, the band also used studio musicians Junior Collins, Sandy Siegelstein, or Gunther Schuller on French horn, and Bill Barber on tuba. These six instruments were scored in tightly woven harmony with intricate moving lines. The use of lower-pitched instruments including trombone and baritone sax, coupled with the warm, rich sounds of the French horn and tuba, gave the group a unique and "cool" sound. The group was rounded out by a bebop-style rhythm section that on various tracks featured John Lewis or Al Haig on piano and Max Roach or Kenny Clarke on drums. Three different bass players were used in the *Birth of the Cool* sessions including Al McKibbon, Nelson Boyd, and Joe Shulman.[2]

Gil Evans

Dig Deeper

RECORDING

The Complete Birth of the Cool

BOOK

Miles: The Autobiography by Miles Davis with Quincy Troupe

WEBSITE

www.milesdavis.com

MOVIE

Miles Ahead

The Birth of the Cool by Miles Davis

Birth of the Cool became a collector's item, I think, out of a reaction to Bird and Dizzy's music. Bird and Diz played this hip, real fast thing, and if you weren't a fast listener, you couldn't catch the humor or the feeling in their music. Their musical sound wasn't sweet, and it didn't have harmonic lines that you could easily hum out on the street with your girlfriend trying to get over with a kiss. Bebop didn't have the humanity of Duke Ellington. It didn't even have that recognizable thing. Bird and Diz were great, fantastic, challenging—but they weren't sweet. But *Birth of the Cool* was different because you could hear everything and hum it also.

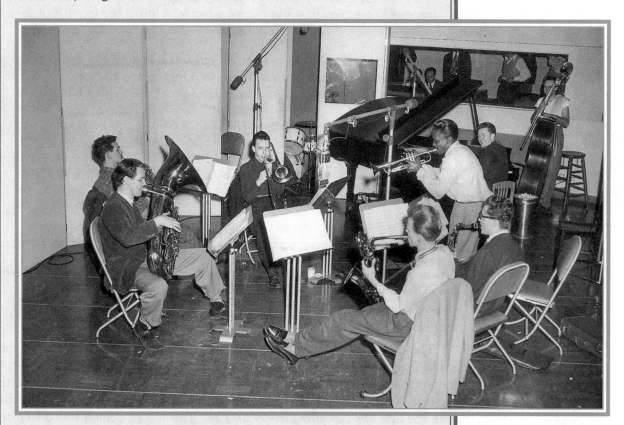

Gil and I had already started doing things together and everything was going real well for us. I was looking for a vehicle where I could solo more in the style that I was hearing. My music was a little slower and not as intense as Bird's. My conversations with Gil about experimenting with more subtle voicing and s--t were exciting to me. Gerry Mulligan, Gil, and I started talking about forming this group. We thought nine pieces would be the right amount of musicians to be in the band. Gil and Gerry had decided what the instruments in the band would be before I really came into the discussions. But the theory, the musical interpretation and what the band would play, was my idea.

Miles Davis and the nonet recording music for the album Birth of the Cool. *Left to right: Bill Barber, tuba; Junior Collins, horn; Kai Winding, trombone; Max Roach, drums (behind sound baffle); Al Haig, piano; Joe Shulman, bass; Miles Davis, trumpet; Lee Konitz, alto sax; and Gerry Mulligan, baritone sax.* Courtesy of Frank Driggs

See, this whole idea started out just as an experiment, a collaborative experiment. Then a lot of black musicians came down on my case about their not having work, and here I was hiring white guys in my band. So I just told them that if a guy could play as good as Lee Konitz played—that's who they were mad about most, because there were a lot of black alto players around—I would hire him every time, and I wouldn't give a damn if he was green with red breath. I'm hiring a motherf---r to play, not for what color he is. When I told them that, a lot of them got off my case. But a few of them stayed mad with me.

We played the Royal Roost for two weeks in late August and September of 1948, taking second billing to Count Basie's orchestra. A lot of people thought the s--t we were playing was strange. I remember Barry Ulanov of *Metronome* magazine being a little confused about the music we played. Count Basie used to listen every night that we were there opposite him, and he liked it. He told me that it was "slow and strange, but good, real good."

So that's what we did in *Birth*. And that's why I think it got over like it did. White people back then liked music they could understand, that they could hear without straining. Bebop didn't come out of them and so it was hard for many of them to hear what was going on in the music. It was an all-black thing. But *Birth* was not only hummable but it had white people playing the music and serving in prominent roles. The white critics liked that. They liked the fact that *they* seemed to have something to do with what was going on. It was just like somebody shaking your hand just a little extra. We shook people's ears a little softer than Bird or Diz did, took the music more mainstream. That's all it was.

Reprinted with the permission of Simon & Schuster, Inc., from *MILES: The Autobiography* by Miles Davis with Quincy Troupe. Copyright © 1989 by Miles Davis. All rights reserved.

Dig Deeper

RECORDINGS

*Porgy and Bess;
Sketches of Spain*
Gil Evans: *New
Bottle, Old Wine*

The nonet only played a few gigs in public, but in 1949 and 1950 they made a series of 78-rpm records that were later collected onto one 33 1/3-rpm long-play album. When Capitol Records released the album, Miles Davis selected the title *Birth of the Cool*. Occasionally, you will also see versions of this album with the title *The Complete Birth of the Cool*. This album demonstrated to many jazz musicians and fans that there were modern jazz outlets that didn't necessarily require complete devotion to the bebop style. It also formed a long-lasting bond between Miles Davis and Gil Evans. Together, they created a series of albums using various large collections of instruments that showcased Miles as a gifted soloist. His playing was intelligent and slightly reserved but always had a deep undercurrent of emotional content. The Davis/Evans collaborations produced several successful recordings for Capitol Records including *Sketches of Spain*, *Porgy and Bess*, and *Miles Ahead*. Listen to the tune *Summertime*, taken from the album *Porgy and Bess*, which you will find on Spotify.

Listening Guide

Summertime (G. Gershwin, arr. G. Evans)

Example of Gil Evans' work with Miles Davis in the cool school style

Recorded August 18, 1958

Performed by Miles Davis with the Gil Evans Orchestra. Miles Davis, solo trumpet with Harmon mute; Phil Bodner and Romeo Penque, flute; Julian "Cannonball" Adderley, alto sax; Danny Bank, bass clarinet; Johnny Coles, Bernie Glow, Ernie Royal, and Louis Mucci, trumpet; Willie Ruff, Julius Watkins, and Gunther Schuller, French horn; Joe Bennett, Frank Rehak, and Jimmy Cleveland, trombone; Dick Hixon, bass trombone; Bill Barber, tuba; Paul Chambers, bass; "Philly Joe" Jones, drums; and Gil Evans, conductor

This selection is a wonderful example of the unique collaboration between Miles Davis and Gil Evans. After the success of *Birth of the Cool*, Davis and Evans went on to create several famous jazz albums together. This particular tune comes from the album *Porgy and Bess*, which features jazz arrangements of many of the big songs from Gershwin's opera. As he frequently did, Davis uses a metal mute called a Harmon mute to alter the sound of his trumpet. Pay close attention throughout to Gil Evans' creative use of unusual tone colors. *Summertime* features a simple 16-bar chorus. Notice that this piece begins with one count of pick-up notes before the first full measure starts.

Total time: 3:17

:00	Head. Davis plays melody with full group accompaniment.
:35	1st solo chorus.
1:11	2nd solo chorus.
1:46	3rd solo chorus.
2:22	Out chorus. Return to the original melodic shape, but Davis plays the tune with some significant embellishments. Performance ends with a brief tag.

In addition to working with Gil Evans, Miles Davis often ran a quintet or sextet that played bebop-formatted tunes performed in a cooler jazz style. For the most part the band used no written arrangements but rather played in the "head-solos-out chorus" format made so common in the bebop style. Because these groups were able to record in the 33 1/3-rpm format, they were not constrained by the short time limits in the studio that had been imposed on earlier musicians. Miles and his associates could allow their improvisations to unfold more slowly; they had more freedom to experiment and explore each nuance in the music. Albums such as *'Round About Midnight*, *Relaxin' with the Miles Davis Quintet*, and *Milestones* are great examples of the cool school style. It should be noted, however, that many of the groups Miles Davis fronted in the 1950s actually employed musicians with a wide range of contrasting styles. While many of these recordings are now considered outstanding expressions of the cool school in jazz, saxophonists John Coltrane and Julian "Cannonball" Adderley, for example, are both more closely associated with various hard bop styles we'll study in Chapter 7. Throughout his career, Davis seemed to have a unique ability as a bandleader to bring together musicians with wildly different style approaches and form them into a cohesive group of performers.

Dig Deeper

RECORDINGS

'Round About Midnight; Relaxin' with the Miles Davis Quintet; Milestones; '58 Miles Featuring Stella by Starlight

modal

Dig Deeper

RECORDING

🎺

Kind of Blue: 50th Anniversary Legacy Edition with DVD

BOOK

🎺

Kind of Blue: The Making of the Miles Davis Masterpiece
by Ashley Kahn

Toward the end of the 1950s, Miles began to conceive a new approach to improvisation. Rather than craft each passage of music to coincide exactly with the chords that would accompany it, Davis and the other players in his group began to experiment with selecting one set of notes or a scale pattern that would, at least to a certain extent, work with all the chords in a given piece of music. This technique is called **modal** improvisation. Don't worry if you don't understand all the technical musical information here. Just know that this new approach to improvisation freed the soloists musically, giving them the potential for even more creativity in their improvisations. Recorded in 1959, the album *Kind of Blue* became the first public exploration of this new improvisational style. Jazz historian and author Gary Giddins made the following comments about the album *Kind of Blue*: "This opened up the world for improvisers because they could get away from the . . . gymnastics of popping through all of these complicated harmonic labyrinths and just concentrate on inventing melody because the harmony didn't change. The guys who had been bebopping through all those chords for all those years were naturally falling into certain clichés, certain easy kinds of phrases. Miles forced them out of it."[3] The music continued to be cool-sounding for the most part, but like *Birth of the Cool* before it, this new recording had a huge impact on many jazz musicians and fans alike. In fact, although jazz critics, historians, and fans can agree on almost nothing, *Kind of Blue* is universally accepted as one of the greatest artistic expressions the world of jazz has ever created. You can hear the tune *So What* from this album on Spotify, and study the entire album as well.

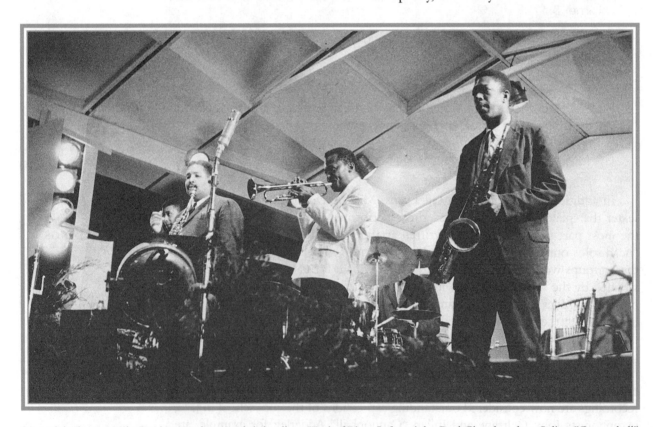

Most of the famous Miles Davis sextet that recorded the album Kind of Blue. *Left to right: Paul Chambers, bass; Julian "Cannonball" Adderley, alto sax; Miles Davis, trumpet; and John Coltrane, tenor sax.*
Courtesy of Frank Driggs

Listening Guide

So What (Miles Davis)

Example of modal jazz from the album *Kind of Blue*

Recorded February 3, 1959

Performed by Miles Davis, trumpet; Julian "Cannonball" Adderley, alto sax; John Coltrane, tenor sax; Bill Evans, piano; Paul Chambers, bass; and Jimmy Cobb, drums

The tune *So What*, from the ground-breaking album *Kind of Blue*, has become a modern jazz standard. In terms of counting measures, it actually follows the standard 32-bar song form (A-A-B-A). The similarities, however, end there. The entire tune consists of two chords, one used for all of the letter A material and a similar chord one half-step higher for the bridge. This limited and relaxed harmonic structure allowed the musicians much more room to explore different melodic and harmonic ideas without the constraints of the constantly shifting chord structures of standard bebop. Notice that this tune begins with three counts of pick-up notes before the first full measure starts.

Total time: 9:22

:00	Free-form introduction played by Bill Evans and Paul Chambers.
:33	Head. Melody is played on the bass with answers from the front-line instruments.

 :33 1st 8 bars, letter A.

 :49 2nd 8 bars, repeat of letter A.

 1:03 Bridge.

 1:17 Last 8 bars, return to letter A.

1:31 1st chorus of trumpet solo.

 1:31 1st 8 bars, letter A.

 1:46 2nd 8 bars, repeat of letter A.

 2:00 Bridge.

 2:14 Last 8 bars, return to letter A.

2:28 2nd chorus. Trumpet solo continues.

3:25 1st chorus of tenor sax solo.

4:20 2nd chorus. Tenor sax solo continues.

5:16 1st chorus of alto sax solo.

6:11 2nd chorus. Alto sax solo continues.

7:05 Bill Evans' piano solo. One chorus only. Horns play riff behind his improvisation.

8:02 Out chorus. Bass melody returns on 2nd 8 bar phrase at 8:16. Tune ends by fading out.

PERENNIAL POLL WINNER

MILES DAVIS

PLAYS

MARTIN

A PRODUCT OF

RICHARDS MUSIC CORP.

Elkhart, Ind.

In later chapters, we will see that Miles Davis went on to explore hard bop and free jazz, and he pioneered the concept of jazz-rock fusion as well. Throughout his life, Miles Davis was constantly breaking down barriers, exploring new musical territory, and opening musical doors that many jazz musicians would follow him through.

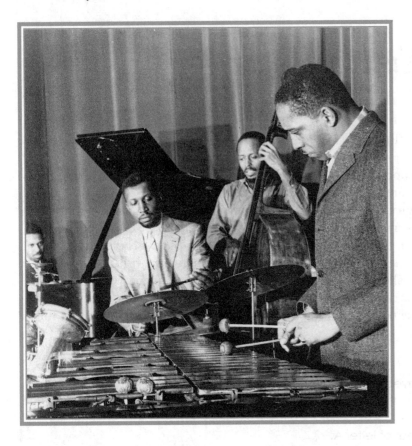

Press photo of the Modern
Jazz Quartet. Left to right:
John Lewis, Connie Kay,
Percy Heath, and Milt
Jackson.
Courtesy of the Institute
of Jazz Studies, Rutgers
University

Modern Jazz Quartet

For most of its extended career the Modern Jazz Quartet was made up of the following players: John Lewis, piano; Milt Jackson, vibes; Percy Heath, bass; and Connie Kay, drums. As an ensemble, the group got its start performing as the rhythm section in the Dizzy Gillespie big band. The only difference was that in the earliest days of the group noted bebop drummer Kenny Clarke held down the drum chair. One of the longest-running and most consistent bands in the history of jazz, the quartet was together from 1952 to 1974. The members went their separate ways for a few years but reunited in 1980 for a concert at Budokan Hall in Tokyo. Soon the band began to tour and record again on a regular basis until the death of drummer Connie Kay in 1994. From your Spotify playlist you can listen to MJQ perform the original version of their signature tune, *Django*.

Dig Deeper
RECORDINGS

🎺

MJQ: 40 Years
(Atlantic box set);
Place Vendôme
(with the Swingle
Singers); *Blues
on Bach; The Last
Concert; Reunion
at Budokan*

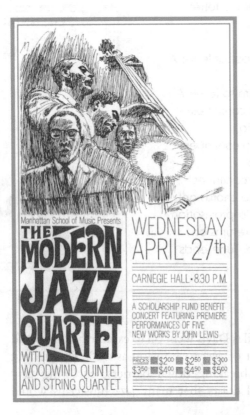

1966 concert program that featured the Modern Jazz
Quartet performing with classical chamber ensembles.

Listening Guide

Django (John Lewis)

Example of The Modern Jazz Quartet

Recorded January 1955

Performed by The Modern Jazz Quartet. Milt Jackson, vibraphone; John Lewis, piano; Percy Heath, bass; and Kenny Clarke, drums

For many, The Modern Jazz Quartet represents the ultimate expression of the cool school style. While maintaining a relentlessly high standard of musical performance, this band offers the listener the ultimate in a laid-back approach to jazz improvisation. It is a testament to the musicians' high skill level that they made everything they played, regardless of tempo, sound so relaxed and effortless. The thematic structure is a bit unusual here, so don't worry too much about counting measures. Just be aware that the theme presents itself in three basic recurring sections. The entire performance is built around most of the material you hear at the very beginning of the piece.

Extra musician's info: For those who are interested, here is a more specific breakdown of the musical structure of this performance. The first melody of the tune is 20 measures long, but once the solos start, the structure is AABA'C, and the sections are not completely symmetrical. The first two letter A sections are 6 bars each, then the letter B section (played over a static pedal point) is 8 measures long. Then we hear a shortened version of the letter A material, this time marked A' because it only lasts for 4 bars, and finally a new rhythmic groove for 8 bars that we call letter C. This format happens twice for the vibraphone solo, and then there is an odd little connecter section, which is indicated clearly in the listening guide below, before the piano plays two choruses over this same format. The song concludes with the same 20-bar melody heard at the very beginning of the recording.

Total time: 7:03

:00	There is no introduction. The tune begins right away, performed in a rhythmically free style.
1:06	After a statement of the thematic material in a relatively free tempo, the rhythm section firms up the groove as Milt Jackson's vibraphone solo begins on a more complex multiple-section format.
1:59	As the vibe solo continues, the band introduces a new rhythmic gesture that will return again several more times throughout the performance.
2:16	A second solo chorus for vibraphone begins.
3:25	Depending on how you count the following few measures (which you aren't supposed to be worried about for this particular track), the band doubles the tempo for a few bars, or they play a double-time feel in the original tempo. Either way, this little section connects the end of the vibraphone solo with the beginning of the piano solo that follows.
3:34	John Lewis' piano solo begins.
4:43	A second solo piano chorus begins.
5:53	The original melody, again played in a rhythmically free style, returns. The band repeats all of the material heard at the beginning of the track and simply slows to a gentle stop for the conclusion of the tune.

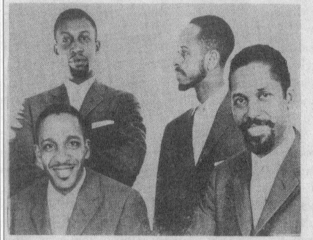

Concert flyer for a series of Modern Jazz Quartet performances in The Netherlands. This flyer was printed on the reverse side of the Sidney Bechet flyer found in Chapter 3.
Courtesy of Tad Hershorn at the Institute of Jazz Studies, Rutgers University

Unlike most jazz performers who spent much of their practice time alone, MJQ often practiced improvisation as a band. The result was a very cohesive but flexible style of improvisation, similar to an intimate conversation between old friends. MJQ performed so tightly as a unit that many accused them of using too much written or prearranged material. In reality, other than the standard musical "lead sheets," almost nothing the band performed was ever committed to paper. Unlike some other jazz musicians of the day, the members of the Modern Jazz Quartet acted in a very professional manner. They always dressed well, showed up on time, and avoided drug and serious alcohol abuse. The band approached jazz more as a type of classical chamber music, often playing concerts in formal auditoriums rather than traditional jazz nightclubs. The band is particularly noted for the consistently high quality of their recordings. Over the band's career, MJQ explored a very interesting range of music, all presented in the language of the cool school. In addition to their own recording projects, the group often invited guest artists such as Sonny Rollins, Jimmy Giuffre, the Beaux-Arts String Quartet, and the Swingle Singers to join them in the studio or for recordings made live in concert.

Dave Brubeck

Perhaps more than any other musician, pianist and composer Dave Brubeck was very closely associated with music from the West Coast. He grew up in California, where he attended the University of the Pacific and Mills College. He studied composition with noted French classical composer Darius Milhaud. Brubeck had already been playing jazz, but as he related in the book *Hear Me Talkin' To Ya*: "It was Milhaud who encouraged me in my playing jazz. He felt that playing jazz was an expression of American culture. He felt a musician born in America should be influenced by jazz."[4] In the late 1940s Brubeck led a series of small to medium-size jazz groups in California. Like the Miles Davis Nonet, Brubeck's groups experimented with mixing complex written arrangements and cool improvisations. He frequently worked with noted alto saxophonist Paul Desmond. Between 1951 and 1967

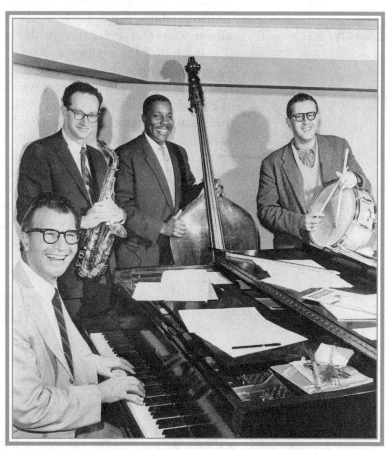

The Dave Brubeck Quartet in a 1950s press photo. Left to right: Dave Brubeck, Paul Desmond, Eugene Wright, and Joe Morello. Courtesy of the Institute of Jazz Studies, Rutgers University

the two of them fronted one of the most successful quartets in the world of jazz. Dave Brubeck frequently mixed classical music ideas with his approach to jazz, and his compositions reflect a harmonic sensibility that was clearly influenced by European classical music. In his book *Jazz Styles* historian Mark Gridley makes the point that part of Brubeck's public appeal was due to his more "classical" approach to jazz.

That Brubeck's work sounds classical may explain part of his popularity. By comparison with the jumpy, erratic character of bop style, his compositions and improvisations are much easier to follow. They possess a simple and tuneful quality. His creations are orderly, and they project a freshness and clarity that make the listener's job easy. In addition, most of Brubeck's pieces are pretty, and they convey a light and pleasant mood.[5]

Time Out

Dave Brubeck also enjoyed exploring complex rhythms drawn from various world music sources. In using these complex polyrhythms, Brubeck and his quartet pushed jazz beyond its simple, basic beat of 4/4 time. Even the most complex music of Thelonious Monk used rhythms that intentionally contradicted the basic four-beat pattern of popular music. Brubeck used unsquare rhythmic patterns such as 5/4 time (an extra beat in every measure of the music), 7/4 time (which usually sounds like alternating measures of 3/4 and 4/4 time), and even more complex rhythms based on African and Indian rhythmic patterns. On Brubeck's most popular album, *Time Out*, every tune made use of odd meters. The big hit off the album was a song called *Take Five*. Recorded in 1959, the tune became a hit song at a time when jazz in general was not very popular. Its popularity is even more amazing when you consider that it has no vocal, has a long drum solo in the middle (on the album version), and perhaps most amazingly, is entirely in 5/4 time. Nonetheless, fueled by sales to college students and other "hip" young Americans, *Take Five* climbed to the top of the charts. Take some time out now to study the album version of *Take Five* in the following listening guide. You'll find this version of the track on your Spotify playlist.

Dig Deeper

RECORDINGS

Time Out: 50th Anniversary Legacy Edition with DVD; Jazz Impressions of Eurasia; The Real Ambassadors (with Louis Armstrong); *Dave Brubeck: Time Signatures: A Career Retrospective; Paul Desmond with the Modern Jazz Quartet: Live at Town Hall*

BOOKS

It's About Time: The Dave Brubeck Story by Fred M. Hall; *Take Five: The Public and Private Lives of Paul Desmond* by Doug Ramsey

Listening Guide

Take Five (Paul Desmond)

Example of the Dave Brubeck Quartet's approach to cool school music, coupled with the band's exploration of nonstandard meter

Recorded July 1, 1959

Performed by Dave Brubeck, piano; Paul Desmond, alto sax; Eugene Wright, bass; and Joe Morello, drums

This tune, and in fact the entire *Time Out* album, represents a new level of rhythmic exploration that had never really been seen before in the world of jazz. Please note that this listening guide is written for the album version of this tune. The typical popular radio version of this track is several minutes shorter and omits the drum solo. The tune follows a 24-measure structure made up of three 8-bar patterns. The melody has two parts, we'll call them letter A and letter B, and they present themselves in a typical A-B-A format.

Total time: 5:24

:00	The performance begins with a 12-bar introduction that vamps over the 5/4 time signature. As you listen, note that the way the musicians emphasize certain beats makes the groove actually feel like 3+2 throughout.
:21	Paul Desmond enters on alto sax, playing the 8 bars of the letter A melody.
:35	Letter B, again 8 measures long.
:50	The letter A material returns for another 8 measures.
1:04	As the band begins a simple vamp over the tonic chord, Paul Desmond begins his improvised solo. It runs for 26 measures.
1:50	The same tonic chord vamp continues in the piano and bass as Joe Morello's drum solo begins. Again, this material was cut from the radio version of the tune. Notice how the piano and bass continue a very steady 3+2 vamp while Morello takes ever more daring rhythmic chances as his solo develops. His solo follows a dramatic arc though 88 measures, first building in intensity before dying away and leading back to the restatement of the original melody.
4:21	The main melody returns, again featuring Paul Desmond. This section is another full 24-bar statement of the melodic material (A-B-A).
5:04	The musicians tag the tune with 8 final measures using repeats of the last melodic figure.

Similar to the Modern Jazz Quartet, Brubeck found a great deal of success by taking jazz out of the nightclub and placing it on the concert stage. The Dave Brubeck Quartet was in great demand on college campuses around the country. In fact, several of Brubeck's most successful albums were made from live college shows.

In his later life, Dave Brubeck continued to tour and record on a regular basis. His four sons all play music, and Brubeck frequently performed with them on tours and in the recording studio. Over the years, he explored fusion (even using electronic instruments) and other forms of music that mix classical music with jazz, but Brubeck always seemed to return to the cool jazz styles that made him so successful.

Gerry Mulligan. Courtesy of the Institute of Jazz Studies, Rutgers University

Gerry Mulligan and Chet Baker

Gerry Mulligan took part in the *Birth of the Cool* recording sessions as both baritone sax player and composer/arranger. Trumpet player Chet Baker was very popular as both a cool trumpet player and singer. Together, they formed a group in the mid-1950s called the Gerry Mulligan "Pianoless" Quartet. This unusual group became quite popular in Los Angeles. Because the group had no piano, the sound texture was quite thin. To fill in for the lack of a comping instrument, Baker and Mulligan would improvise contrapuntal accompanying lines behind one another as each took his improvised solo. You can hear this unique ensemble playing the jazz standard *Line for Lyons* on Spotify.

Listening Guide

Line For Lyons (Gerry Mulligan)

Example of the cool school sound and a "pianoless" quartet

Recorded September 2, 1952

Performed by Gerry Mulligan, baritone sax; Chet Baker, trumpet; Carson Smith, bass; and Chico Hamilton, drums

The Mulligan-Baker "pianoless" quartet was the epitome of the cool school "West Coast" sound. Because the group had no piano or guitar to fill in the notes of the chords, both of the front-line players frequently improvised little counterpoint lines and fills to help accompany what the main soloist was improvising. Notice the sense of interplay and musical conversation between the trumpet and baritone sax throughout this performance. This tune was dedicated to disc jockey and festival promoter Jimmy Lyons. The tune follows a standard 32-bar song form (A-A-B-A).

Total time: 2:33

:00	Head.
:47	2nd chorus. 1st half features baritone sax solo.
1:11	2nd chorus. 2nd half (bridge and last 8) features trumpet solo.
1:35	3rd chorus. 1st half features collective improvisation, 2nd half offers a return to the original melody, followed by a brief tag line to end the piece.

Dig Deeper

MOVIES/ SOUNDTRACKS

Chet Baker: Let's Get Lost; Born to Be Blue

RECORDINGS

The Best of the Gerry Mulligan Quartet with Chet Baker; The Best of Chet Baker Sings; Chet Baker: *My Favourite Songs Vol. 1 & 2, The Last Great Concert* [*sic*] Gerry Mulligan: *Re-Birth of the Cool; Lonesome Boulevard*

In addition to playing, Chet Baker would also sing from time to time. His boyish voice and dashing good looks made him an instant success. He was on track to become a major Hollywood star, but unfortunately Baker was already addicted to heroin. Even though the "bad-boy" image of James Dean was popular at this time, Baker went too far, and Hollywood would have nothing to do with him. The pianoless quartet only remained together for about eleven months, but both Mulligan and Baker went on to have major careers in the world of jazz. Both men played and recorded into the 1990s, each leaving behind a significant body of work.

Chet Baker.
Courtesy of the Institute of Jazz Studies, Rutgers University

Stan Getz

Another gifted innovator in the cool school/West Coast style was tenor saxophone player Stan Getz. He is often closely associated with the bebop of Chapter 5 or the hard bop of chapter 7, but Getz sometimes played with a more melodic approach than many of the bebop players. His improvisational style has been said to reflect both classical music lines and the jazz lines of Charlie Parker and Dizzy Gillespie. Most importantly, Stan Getz was one of the early modern musicians to incorporate Latin rhythms and tunes in his performances. After an encounter with Brazilian composer and musician **Antonio Carlos Jobim**, Getz began to regularly feature new Brazilian tunes in his sets. Many of these tunes came to be known as **bossa novas**. Songs including *Desafinado*, recorded with guitarist and singer João Gilberto; *Corocovado*, recorded with Jobim; and *Girl from Ipanema*, which featured Brazilian singer Astrud Gilberto, all became hit recordings. Like many musicians of this period, Stan Getz battled narcotics addiction, even serving time in jail, but he continued to record and perform successfully into the early 1990s. Check out the classic recording *Desafinado* on Spotify.

Antonio Carlos Jobim

bossa novas

RECORDINGS

Getz/Gilberto; Stan Getz and Bill Evans; Captain Marvel

DOCUMENTARY

Stan Getz: In Copenhagen 1987

BOOKS
Stan Getz: A Life in Jazz by Donald L. Maggin; *Stan Getz: Nobody Else But Me* by Dave Gelly

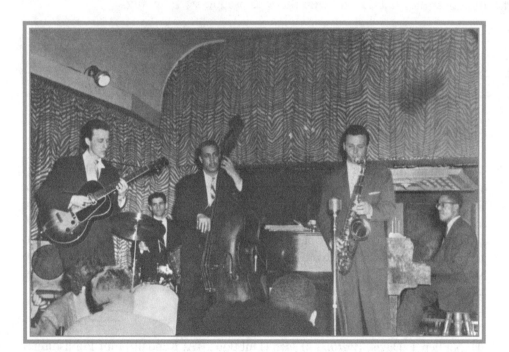

Stan Getz performing with Charles Mingus in 1956. L-R: Jimmy Raney, guitar; Phil Brown, drums; Charles Mingus, bass; Stan Getz, tenor sax; and Duke Jordan, piano.
Courtesy of the Institute of Jazz Studies, Rutgers University

Listening Guide

Desafinado (Antonio Carlos Jobim)
Example of Latin influences on jazz and cool saxophone sound of Stan Getz
Recorded March 18-19, 1963
Performed by Stan Getz, tenor sax; João Gilberto, guitar and vocal; Antonio Carlos Jobim, piano; Ketter Betts, bass; and Milton Banana, drums

When Stan Getz was introduced to Antonio Carlos Jobim, their association opened many new doors in the world of jazz. As you saw with the Dizzy Gillespie recording in Chapter 5, there was a growing interest in some jazz circles for adding more Latin elements to jazz. Working independently of the American jazz scene (although he did listen to a lot of American jazz recordings), Jobim created a style of jazz that came to be known as the bossa nova, the samba, or just Brazilian Jazz. Stan Getz was one of the first American jazz players to work and record with these talented Brazilian musicians. The formal structure of this tune is quite complex. The tune begins with a short, 2-measure introduction, followed by Gilberto's vocal. The end of his vocal marks the end of the first chorus. Stan Getz plays a full improvised chorus, and the tune ends with a brief fade out.

Extra musician's info: As mentioned above, the form here is rather complex. It is actually a 68-measure A-A-B-A' format, with two letter A statements of 16 bars each, followed by a contrasting letter B statement of 16 bars. When we return to the letter A material, it extends out by an extra 4 bars toward the end of the structure, making it last 20 bars this time around. Again, as stated above, the tune starts with a little 2-bar guitar vamp for an introduction, followed by one full chorus of the format as a vocal and one full solo chorus improvised by Stan Getz on saxophone. The tune ends with both the sax and the singer gently performing over the same 2- bar vamp that was used to start the tune.

Total time: 4:13

:00 1st chorus (with a 2-bar introduction) begins.
1:56 Stan Getz's sax solo begins.

The Cool School Today

For many musicians today, the lessons learned from the cool school recordings of the 1950s and 60s are just one more set of ideas to draw upon for inspiration. There are musicians who focus exclusively on cool style performances, but more common today is to play with as wide a variety of musical ideas as possible. A few great examples of modern cool style expression include pianist Ted Gioia, two great recordings from the Ross Traut/Steve Rodby duo, and even all the way to Norway for the group Siri's Svale Band. Apparently, from the original Norwegian, "Svale" can actually be translated as "cool."

Notes

1. Nathen T. Davis, *Writings in Jazz* (Dubuque, IA: Kendall/Hunt Publishing Co., 1998), p. 179.

2. *Birth of the Cool*, liner notes, (Hollywood, CA: Capitol Jazz) CDP 7 92862 2.

3. *Jazz: A Film by Ken Burns*, Episode 9 (Washington, DC: PBS, 2001), videocassette.

4. Nat Shapiro and Nat Hentoff, *Hear Me Talkin' To Ya* (New York: Dover Publications, 1955), p. 392.

5. Mark Gridley, *Jazz Styles*, 7th ed. (Upper Saddle River, NJ: Prentice Hall, 2000), p. 200.

Study Guide

Chapter 6 Review Questions

True or False

___ 1. Cool jazz, like bebop, focuses on improvisation.

___ 2. The Modern Jazz Quartet embraced the drug culture yet managed to perform well together.

___ 3. Cool school jazz was often performed in more formal venues than the traditional nightclubs and dance halls of swing and bebop.

___ 4. Dave Brubeck was popular among college students.

___ 5. Cool style jazz is still a type of music actively performed today.

___ 6. Stan Getz, though often associated with bebop, performed in a cool style.

___ 7. Cool school jazz was performed exclusively on the West Coast, whereas the East Coast heard only bebop.

Multiple Choice

8. Cool school jazz is:
 a. a faster, more intense bebop.
 b. a swing-style jazz performed with a small combo.
 c. performed only in Los Angeles.
 d. a more relaxed offshoot of bebop.
 e. bebop that has been influenced by rock.

9. Miles Davis' playing style in *Summertime* is different from Dizzy Gillespie's style in *Manteca*. Miles Davis generally:
 a. is more reserved.
 b. is more flamboyant.
 c. uses more complex harmonies.
 d. plays in an even higher register.
 e. plays a different instrument.

10. What is the title of the first album that used modal improvisation?
 a. *The Birth of the Cool*
 b. *Milestones*
 c. *Kind of Blue*
 d. *Miles Ahead*
 e. *Modal Blues*

11. Which cool school musician was influenced by classical music, having studied composition with Darius Milhaud?
 a. Gil Evans d. Gerry Mulligan
 b. Dave Brubeck e. Chet Baker
 c. Milt Jackson

12. What is the unique feature of the tune *Take Five*?
 a. It features five alto saxophonists.
 b. It uses modal harmonies.
 c. It features classical musician Darius Milhaud.
 d. It is performed with a harmonica.
 e. It uses an unusual rhythmic pattern.

Fill in the Blank

13. Milt Jackson performed with the _____ Quartet and played the _____.

14. _____ is the title of the album in which cool jazz was created and named.

15. Miles Davis worked with pianist and composer _____ to form a group that played in the cool school style.

16. In addition to performing frequently with bebop musicians, drummers _____ and_____ also recorded with the Miles Davis Nonet.

17. The technique of improvising over a set of agreed-upon pitches rather than a series of chords is called _____ improvisation.

18. In addition to singing, Chet Baker played the _____.

19. Gerry Mulligan and Chet Baker formed a _____ Quartet.

20. Stan Getz incorporated Brazilian tunes into jazz. This style is called the

 _____.

21. Miles Davis had his first big break with bebop saxophonist _____.

22. _____ by _____ is the album viewed by most jazz historians, critics, and fans as the greatest jazz album.

Short Answer

23. List three reasons why Dave Brubeck's music enjoyed more popularity than bebop.

24. What is unusual about the instrumentation on your recording of *Line for Lyons*?

25. Why was the MJQ accused of using prearranged and written-out material?

Essay Questions

1. Using the Internet, explore the life and times of the Modern Jazz Quartet. What interesting musical avenues did MJQ travel? Do you think the group's approach to jazz performance helped change the opinions of some "serious" music fans? What is the legacy of MJQ's music?

2. Discuss the impact of the Latin-influenced jazz composed by Antonio Carlos Jobim and recorded by Stan Getz. Using the Internet, investigate the legacy of Jobim's music.

Chapter 7

Hard Bop

Making the simple complicated is commonplace; making the complicated simple, awesomely simple, that's creativity.

Charles Mingus

Like the term cool jazz, **hard bop** serves both historians and music fans as a simple catch-all term for easily identifying a number of closely related musical styles. At its core, hard bop expanded on the bebop ideas of the 1940s and early 1950s. Musicians who performed in the hard bop style, however, tended to play with even more aggressive tones, extreme tempos, and extended harmonies. Melodies were made more complex, and improvised solos tended to get longer and longer. Some hard bop tunes could last up to fifteen or twenty minutes.

In addition to the "pure" hard bop style, some musicians began to bring more blues and gospel music elements into their performances. This side of the hard bop style was sometimes referred to as **funky jazz** or **soul jazz**, and it was able to find more audience appeal, particularly in the 1960s and early 1970s. A good example of early funky jazz is the tune *Killer Joe* found on your Spotify playlist. Performed by The Jazztet, this recording displays the shuffling rhythm and catchy, motive-driven style that became a hallmark of this side of the hard bop world.

hard bop

funky jazz
soul jazz

Listening Guide

Killer Joe (Benny Golson)

Example of the hard bop style with light, shuffling rhythms
Recorded February 6-10, 1960
Performed by The Jazztet. Art Farmer, trumpet; Benny Golson, tenor sax; Curtis Fuller, trombone; McCoy Tyner, piano; Addison Farmer, bass; and Lex Humphries, drums

This performance is a relatively early example of the hard bop style. The harmonies have a touch of gospel quality, and the gentle shuffle rhythm used throughout the performance became one common approach to the funky or soul side of hard bop. The piece begins with a descriptive narration delivered by sax player Benny Golson. You will also hear his voice saying "Killer Joe" right at the end of the tune. The tune itself follows a 32-bar song form (A-A-B-A), but the chord progression is unusual when compared to a song based on the standard "Rhythm" changes.

Total time: 4:58

:00	Narration.
:47	4-measure introduction.
:55	Head.
1:30	Bridge.
1:48	Last 8 bars of head.
2:06	2nd chorus. 1st half played by trumpet, 2nd half played by sax.
3:15	3rd chorus. 1st half played by trombone, 2nd half played by piano.
4:25	8-bar tag. Return to the original melody, followed by a slow fade and a final bit of narration.

Some musicians and jazz critics alike thought this new, soul-oriented approach was something of a commercial sellout. While there is nothing wrong with making money, in some cases the critics were actually right for a change. A few artists did go too far in attempting to pander their music to the lowest common denominator. These recordings were usually simple instrumental knock-offs of popular tunes of the day. The downside for us as modern jazz fans is that we must exercise extra caution when buying recordings that feature some of these artists. Some of their recordings can easily be considered masterpieces, but others were purely commercial ventures attempting to cash in on a quick, catchy pop tune with little or no real creativity.

The People Who Made It Happen

Clifford Brown

The life of trumpet player Clifford Brown is perhaps one of the most frustrating and tragic stories in the history of jazz. Considered a master of the jazz trumpet by the time he was 22 years old, Brown was killed in a car accident less than four years later. Unlike many of his contemporaries, he neither drank nor took drugs. He had a strong work ethic and was apparently just an all-around good guy. Brown brought a more aggressive improvisational style to jazz, with even faster

tempos and extremely complex, original tunes including *Joy Spring*. At the same time, however, his tone was warm and rich, and even at the blazing tempos he often played, his musical lines were always lyrical, flowing expressions. His most important recordings were made in a group he co-led with noted bebop drummer Max Roach. Like Charlie Parker and Dizzy Gillespie before him, musicians looked up to Clifford Brown and followed his groundbreaking improvisational style. His impact on many jazz musicians is still felt to this day. You can hear the Clifford Brown-Max Roach Quintet with tenor saxophonist Sonny Rollins playing *What Is This Thing Called Love* on Spotify.

Dig Deeper
RECORDINGS

Clifford Brown: The Complete Blue Note & Pacific Jazz Recordings; Brownie: The Complete EmArcy Recordings of Clifford Brown; Clifford Brown with Strings

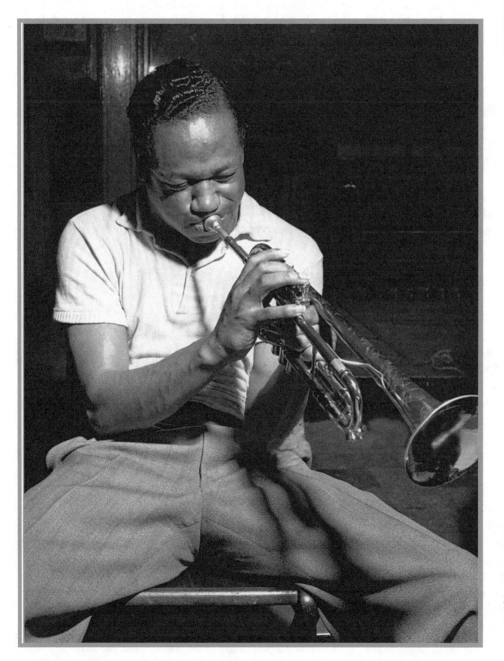

Trumpet player Clifford Brown during a rehearsal with his sextet. This Francis Wolff photo was later used on several album covers and posters.
Michael Cuscuna/Corbis Premium Historical/ Getty Images

Listening Guide

What Is This Thing Called Love (Cole Porter)

Example of Clifford Brown's approach to hard bop and an early recorded example of tenor sax titan Sonny Rollins

Recorded February 16, 1956

Performed by the Clifford Brown-Max Roach Quintet. Clifford Brown, trumpet; Max Roach, drums; Sonny Rollins, tenor sax; Richie Powell, piano; and George Morrow, bass

When Cole Porter wrote the ballad *What Is This Thing Called Love*, this performance was definitely not what he had in mind. Both bebop and hard bop players often increased the tempo of classic ballads, sometimes adding radical rhythmic variations as well. Note the use of a prearranged unison line that was created by this band for added effect. Pay close attention to drummer Max Roach's lyrical drum solo. The concept of gentle lyricism and the word drummer rarely go together, but Max Roach has always been one of the few exceptions. Roach does tend to rush (or push the beat ahead) during his solo, however, making the counting very difficult. This tune follows the standard 32-bar song form (A-A-B-A).

Total time: 7:38

:00		Long introduction. Piano and bass play a pedal point while Brown and Rollins improvise little riffs and other melodies.
:59		Head, played by trumpet only. Sax (only) takes over on the bridge.
	:59	1st 8 bars, letter A.
	1:06	2nd 8 bars, repeat of letter A.
	1:13	Bridge, sax takes over.
	1:20	Last 8 bars, return to letter A. Brown starts his improvised solo on the last 2 bars of this section.
1:27		1st chorus of trumpet solo.
	1:27	1st 8 bars, letter A.
	1:34	2nd 8 bars, repeat of letter A.
	1:41	Bridge.
	1:48	Last 8 bars, return to letter A.
1:54		2nd chorus of trumpet solo.
2:21		1st chorus of sax solo.
2:49		2nd chorus of sax solo.
3:16		1st chorus of piano solo. Count with care in these next two choruses as pianist Richie Powell goes way outside the standard chord changes and really plays with the time as well. You might focus on improvisation the first couple of times you listen and later go back and focus on the rhythm section to help you keep up with the form.
3:43		2nd chorus of piano solo.
4:10		Bass plays one full solo chorus.
4:37		Full band plays one shout chorus. Only the rhythm section plays the bridge.
5:04		Drum solo begins. Roach plays two full choruses. Counting along is very difficult here as Roach rushes quite a bit. When you hear Clifford Brown come back in on trumpet you will be back at the top of the 32-bar form.

5:52 Brown and Rollins improvise over a full chorus by trading 8-bar solos.

6:18 Brown and Rollins improvise over a full chorus by trading 4-bar solos.

6:43 New shout chorus melody is used as an out chorus, with a drum solo on the bridge beginning at 6:56.

7:03 Brown returns to the original melody for the last 8 bars of the form. The tune ends with a tag using material similar to that found in the introduction.

Art Blakey and the Jazz Messengers

Bands led by drummer Art Blakey became training grounds for several generations of players who went on to be major jazz figures in their own right. Blakey was a very aggressive drummer who played with lots of strong accents and hard "fills" that encouraged the other members of his band to improvise with great intensity. Mark Gridley describes the band this way: "Their music was

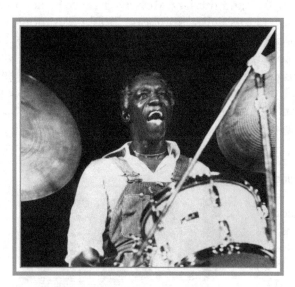

Drummer and band leader Art Blakey.
Courtesy of the Institute of Jazz Studies, Rutgers University

extremely intense, hard driving, and uncompromising. Their swing feeling was unrelenting and possessed a weightiness that distinguished it from those 'cool jazz' styles that also swung persistently."[1] Over the space of nearly 45 years, the many different bands called Art Blakey and the Jazz Messengers released more than 100 recordings. Almost all of them are considered solid expressions of the hard bop style. Listen to an early 60s version of the Jazz Messengers playing *Alamode* on Spotify. Some of the great musicians who passed through the ranks of the Jazz Messengers include trumpet players Lee Morgan, Freddie Hubbard, Chuck Mangione, Wynton Marsalis, and Terence Blanchard; sax players Jackie McLean, Wayne Shorter, Branford Marsalis, and Donald Harrison; and pianists Horace Silver, Keith Jarrett, and Joanne Brackeen. In an interview for the Ken Burns documentary *Jazz*, Wynton Marsalis said this about playing with Art Blakey:

> Yeah, the Messengers were the training ground for a lot of great musicians because he gave you a chance to play, and to *learn* how to play. He would put his swing up underneath you so that you could learn how to play . . . And he would tell you that you were sad, and when I first sat in with him, I knew I wasn't playing nothing. He said "Man you sad, but that's all right. . . . " and when you were around him you were around the essence of jazz music. So he put that in us. If you want to play this music, you have to play it with soul, with intensity, and every time you touch your horn, you *play* your horn. You know, this is not a game.[2]

Listening Guide

Alamode (Curtis Fuller)

Example of hard bop as played by the Jazz Messengers
Recorded June 13-14, 1961
Performed by Art Blakey and the Jazz Messengers. Art Blakey, drums; Lee Morgan, trumpet; Wayne Shorter, tenor sax; Curtis Fuller, trombone; Bobby Timmons, piano; and Jymie Merrit, bass

This recording represents a more straight-ahead style of hard bop. Pay close attention to Blakey's aggressive style of drumming. Notice how he sometimes reacts to what the soloist is playing and at other times seems to be attempting to drive the soloist on to even greater feats of improvisation. This tune is played in a double-time feel, which means that the basic beat is going to feel like it is twice as fast as it actually is. If you find yourself counting 16-bar phrases instead of 8-bar phrases, you are counting twice as fast as the basic beat.

Total time: 6:50

:00	8-bar introduction played by the rhythm section.
:16	Head begins with letter A melody, played for 16 bars (repeat at :31).
:47	Letter B melody is played for 8 bars.
1:03	Return to letter A melody, again played for 8 bars.
1:18	Sax solo begins.
2:19	Trumpet solo begins.
3:18	Trombone solo begins.
4:17	Piano solo begins.
5:15	Out chorus begins.
5:44	Tune ends with a long fade over letter B material.

A performance of Art Blakey and the Jazz Messengers at Sweet Basil is announced in this 1990 ad.

Horace Silver

Pianist Horace Silver is often considered the perfect example of a hard bop musician. Silver was a triple threat—a solid composer and arranger, a good band leader, and a wonderful improvisor. Silver got his first big break playing with an early version of the Jazz Messengers. Unlike the longer lines of earlier bebop musicians, Silver used shorter, more percussive lines full of crisp, catchy melodies. He frequently used shuffling accompaniments that were reminiscent of big band riffs to back up the other soloists in his band. Some of his most famous compositions include *Cookin' at the Continental, Sister Sadie, Strollin', Señor Blues*, and *Song for My Father*. You can also hear ten new Horace Silver compositions on a 1996

Impulse release titled *The Hard Bop Grandpop* and nine more new pieces on the 1999 release *Jazz…Has…a Sense of Humor*. The following listening guide is for the original 1959 version of *Cookin' at the Continental*.

Horace Silver.
Courtesy of the Institute of Jazz Studies, Rutgers University

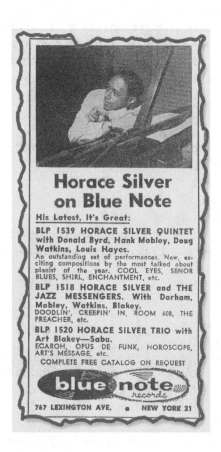

Dig Deeper

RECORDINGS

Horace Silver and the Jazz Messengers; Song for My Father; Horace Silver: Retrospective; The Hard Bop Grandpop

BOOK

Let's Get to the Nitty Gritty: The Autobiography of Horace Silver by Horace Silver with Phil Pastras

Listening Guide

Cookin' At the Continental (Horace Silver)

Example of Horace Silver's arranging and performing styles
Recorded January 31, 1959
Performed by Horace Silver, piano; Junior Cook, tenor sax; Blue Mitchell, trumpet; Gene Taylor, bass; and Louis Hayes, drums

This band lineup was one of Silver's most cohesive groups, and that success really shines through on this track and its tight yet spontaneous playing. Compared to many jazz projects of the period, which were often little more than a single statement of the melody followed by a series of seemingly unrelated solo choruses, this track has more arranged material that lends a strong sense of unity to the performance. The tune is a simple 12-bar blues structure, but Silver's writing style makes each of those twelve measures something very special. Count with care, as the tune is quite fast. Each chorus is going by in about eleven seconds.

Total time: 4:54

:00	8-bar introduction.
:07	Head. Trumpet and sax double the melody.
:18	Repeat of the head with the same format.
:30	Shout chorus. Rhythm section drops out while the trumpet and sax play a new, creatively harmonized line for 4 measures. Then the rhythm section joins back in, and the horns return to the melody until the last measure of this chorus when they play a new lick that leads into the sax solo.
:41	1st sax chorus.
:52	2nd sax chorus.
1:04	3rd sax chorus.
1:15	4th sax chorus. Note that the sax overlaps just a bit into the start of the next chorus.
1:26	1st trumpet chorus.
1:37	2nd trumpet chorus.
1:49	3rd trumpet chorus.
2:00	4th trumpet chorus.
2:11	1st piano chorus. Note that Horace Silver chooses to begin his solo with almost 4 bars of silence. Regardless, the 12-bar format remains the same.
2:22	2nd piano chorus.
2:33	3rd piano chorus.
2:44	4th piano chorus.
2:55	5th piano chorus.
3:06	6th piano chorus.
3:16	7th piano chorus.
3:27	Horns trade 4-bar solo licks with the drums through two 12-bar choruses. The order of solos is (1st) sax, drums, trumpet; (2nd) drums, sax, drums.
3:50	Out chorus.
4:01	Repeat of the out chorus.
4:13	Repeat of shout material used back at 0:30. Again, the horns return to the original melody after this 4-bar shout. This time, however, once they reach the end of the 12-bar structure they add a few extra measures of prearranged material that will take them to the end of the performance.

Charles Mingus

Over the course of his career, bass player and composer Charles Mingus covered a great deal of musical ground. He started out as a swing musician, played bebop with all of the major innovators of that style, and went on to lead some of the most adventuresome musical ensembles of the twentieth century. Along the way he performed with musicians as diverse as Louis Armstrong, Duke Ellington, Charlie Parker, Thelonious Monk, and most of the major hard bop players of the day, ending his career by creating a collaborative project with folk-rock singer Joni Mitchell. Mingus was one of the most fiercely original composer/performers of all time. Like his performing career, his music brought together many different influences including swing, bebop, and more funky jazz, blues, and gospel music. From the late 1950s on, Mingus often used the recording studio as a kind of "workshop" to create densely textured performances that pushed all of his musicians to and beyond their preconceived limits. Some of his major recordings include *Pithecanthropus Erectus* (which represents the rise and fall of humankind), *Mingus at Antibes* (perhaps one of the finest live jazz recordings ever made), and *Let My Children Hear Music* (Mingus' personal response to the Beatles' late studio work and one of his favorite albums). Your Spotify playlist contains a 1959 Mingus band performance of the tune *Better Git It In Your Soul*, a work Mingus would revisit often over the rest of his career.

Dig Deeper

RECORDINGS

Pithecanthropus Erectus; Mingus Ah Um; Mingus at Antibes; Mingus, Mingus, Mingus, Mingus, Mingus; Let My Children Hear Music; Mingus (by Joni Mitchell)

DOCUMENTARY

Triumph of the Underdog

El Paso musician Bob Foskett made the following four photos of Charles Mingus and his group during a concert at the McKelligon Canyon Amphitheater on October 16, 1977. This show was one of the artist's last public performances.
Courtesy of Bob Foskett

Listening Guide

Better Git It In Your Soul *(Charles Mingus)*

also known as *Better Git Hit In Yo' Soul*

Example of Mingus recording in the loose, "workshop" style that became a trademark of his later work

Recorded May 5, 1959

Performed by Charles Mingus, bass; John Handy III, Booker T. Ervin and Shafi Hadi, saxophones; Willie Dennis and Jimmy Knepper, trombone; Horace Parlan, piano; and Dannie Richmond, drums

This is a work that Mingus revisited many times during his career. This particular recording comes from the album *Mingus Ah Um*. If you need a category to put this performance in, call it "soul jazz" or "gospel bop." The truth is it's just Mingus at his very best. This piece uses an A-A-B-A structure (not a 32-bar song form) for both the head and out chorus, but the improvised solos and the middle ensemble sections are played over 6/8 versions of the blues. (With 6/8 you can count 6 really fast beats in each measure, or you can count large beats **1**, 2; **2**, 2; kind of like a two-sided waltz, which would be **1**, 2, 3; **2**, 2, 3; etc . . .) Counting out the full form is very difficult, so don't worry too much about it. Throughout, pay attention to how Mingus keeps singing, yelling, and creating a general ruckus, spurring his musicians on to ever greater feats of improvisation.

Total time: 7:20

:00	Introduction.	
:16	Head.	
1:09	Alto sax solo begins.	
1:58	Loose section of collective improvisation begins.	
	1:58	Piano plays basic riff groove with rhythm section.
	2:14	Rest of band enters.
	2:32	Alto sax "floats" over rest of band.
	3:02	Band clearly joins with piano riff.

L-R: *Charles Mingus, bass; Ricky Ford, tenor sax; Dannie Richmond, drums; and Jack Walrath, trumpet; performing at McKelligon Canyon in El Paso, Texas, Oct. 16, 1977.*

Courtesy of Bob Foskett

3:35	Tenor sax solo begins. All rhythm drops out except hand claps and high-hat cymbals.
4:06	Rhythm section re-enters as tenor sax solo continues.
4:38	Drum solo begins.
4:53	Band re-enters for more loose collective improvisation.
5:25	Return to drum solo.
5:40	Return to loose collective improvisation.
5:57	Return to drum solo.
6:11	Out chorus. Return to main original melody. Tune ends with long "Amen" chords played by the entire band.

Charles Mingus and his music don't really fit perfectly in any pigeonhole like bebop, cool school, or hard bop, but his overall musical output fits better in the hard bop arena than it does anywhere else. Noted jazz historian, critic, and sometime record producer Leonard Feather wrote a wonderful feature piece about the life and music of Charles Mingus for the *Los Angeles Times*. This short article should give you at least some sense of this very complex man and his music.

*C*harles Mingus by Leonard Feather

"I never wanted to pin myself down so that anyone could say 'This is Mingus.' I don't ever want to be caught in any one groove. Everything I do is Mingus."

This declaration, made many years ago, probably came closer than any other to summing up the essence of the mercurial, indefinable, probing, intense man who was Charles Mingus. During his lifetime too many of us tried in vain to analyze his music, aware though we were that it resisted categorization.

When he died January 5, 1979, in Cuernavaca, Mexico, at the age of 56, an end was put to the ordeal through which he had suffered for more than a year: Those great hands that had produced so much vital, raw and earthy music had been immobilized by paralysis.

The headlines, of course, read "Jazz Bassist Dies," and inevitably his virtuosity as an instrumentalist, which became Mingus's original identification, overshadowed an even more significant role as a composer, leader and catalyst.

Mingus was at once a kindly, sensitive man and an angry, quarrelsome figure whose career was hampered by his inability to deal with the problems of growing up black in an obstacle-ridden society. He knew what he wanted—recognition, acceptance of his music, and a broad canvas on which to make his statements—but could never summon the patience to handle the frustrations he encountered.

I shall never forget the trauma of trying to organize an album I was assigned to produce in 1960. The record company consented to a session with Mingus's quintet. Mingus later asked whether he could add a couple of horns. This change was agreed to.

One afternoon I walked into a rehearsal to find that not one or two, but four men had been added. Mingus also mentioned some old arrangements he had long wanted to try out—material that dated back to his days in the Lionel Hampton orchestra in the 1940s. Since this music was already available and paid for, he suggested, it would be a shame not to use it. He proposed some sort of compromise that would make it possible to add a few more musicians on some tracks.

Before long the band had expanded to 14 pieces. The record company balked. Mingus screamed. He sent long, threatening telegrams to the musicians' union and to me, insisting on the larger band.

Pianist Bob Neloms performing with Charles Mingus at McKelligon Canyon in El Paso, Texas, Oct. 16, 1977.
Courtesy of Bob Foskett

At one point he called me when I was out and left a long message with my wife, informing her that he was dying of cancer, had only a few months to live, and that for this reason alone the records would have a special historic value.

To cut a long and painful story short, after two days of crises during which it seemed the album would never be made, we wound up with a 22-piece orchestra conducted by Gunther Schuller. The album, entitled "Pre-Bird," was reissued several times. Mingus eventually sent the record company a bill for thousands of dollars to cover the arrangements which he had said were already paid for. He was paid, and in today's perspective you realize how right he was in bringing this music and these musicians together for a record. Eric Dolphy, Clark Terry, Slide Hampton, Jimmy Knepper, Joe Farrell, Booker Ervin, Yusef Lateef and Paul Bley were just a few of the participants.

"Mingus's intensity killed him," said Red Callender, the bassist who was among his earliest friends in Los Angeles. "He never did find out how to relax."

Callender was 20 when he met Mingus, four years his junior. "At that time I was playing melodies on the bass, which was very unusual in those days. Mingus was fascinated, and although I had never claimed to be a teacher, he insisted on studying with me. He had been playing cello and the bass was almost new to him, but he was very fast, picking up things by ear. After me, he studied for five years with a man named Reinschagen who had played with the New York Philharmonic."

Mingus had great discipline for playing and practicing, Callender recalled, but not for coping with the difficulties of the world in which he was growing up. "He would come for a lesson and we'd sit around for a long time talking about racial injustice. He was living in Watts, and in the early 1940s Los Angeles in general was a hopeless place for black people, especially black musicians who wanted to get into studio work."

Mingus in any case was not temperamentally equipped for the movie session life; as Callender says, he wanted to accomplish more than the studios could offer him. Eventually he would describe some of the experiences of those early years in his autobiography, *Beneath the Underdog*. The book, which Mingus carried around for years before he could find a publisher, dwelt too little on music and excessively on his sexual exploits, yet it served a valuable purpose as a catharsis for his emotions.

For all his sensitivity, Mingus during the early years was apparently content to live the life of a sideman. Public awareness of his potential role as a composer began when he played his own "Mingus Fingus" on a 1947 record with Lionel Hampton.

"At one time," Red Callender recalls, "I had a group in San Francisco and Mingus played with me. The idea of two bass players in a small combo was unusual, and we enjoyed splitting the chores—we'd alternate playing rhythm and melody parts. During that time I never heard a harsh word from him.

"Later he went to work for Red Norvo, whom he really loved—a very kind man. But during that period I think there were some experiences that led to a more bitter attitude. One time when I was in Honolulu, Mingus tracked me down somehow and called me from New York. I was like his father confessor; we talked for an hour."

In 1951 Mingus began recording a series of New York sessions for his own label, Debut Records. The company was short-lived, but these were significant early outlets for self-expression. For several years he seemed to be groping for a direction; he flirted with European concert music and the avant-garde. His personality came into sharper focus with a series of works that reflects his social consciousness ("Fables of Faubus," sarcastically dedicated to a white Southern governor) and his debt to the church ("Better Git It in Your Soul").

Mingus was quoted at the time as remembering that all the music he heard as a child came out of the church. "My family went to the Methodist church; in addition, my mother would take me to the Holiness church. The blues was in the church—moaning and riffs, exchanges between the preacher and the congregation."

For the last 20 years of his life Mingus's music reflected these influences, along with his perennial admiration for Duke Ellington. "The first time I heard Duke," he said, "it was a revelation—like nothing I had heard in the churches. I screamed and almost jumped out of the bleachers."

Once established as a writer, nourisher of talents and regular recording artist, Mingus might have been expected to attain a measure of security, with substantial royalties from many original compositions in his albums. But as Callender observed, he was too disorganized to achieve either the kind of continuous success or the material rewards he deserved. He abused his body, eating enormous quantities, sleeping too little, putting on too much weight, worrying to the verge of paranoia.

Dr. Edmund Pollock, a clinical psychologist whom Mingus invited to contribute the notes for one of his albums, wrote, "Mr. Mingus has never given up. From every experience such as a conviction for assault or as an inmate of a Bellevue locked ward, Mr. Mingus has learned something and has stated it will not happen again to him. He is painfully aware of his feelings and wants desperately to heal them. He is cognizant of . . . segregated society's impact upon the underdog."

Mingus never lived to achieve the self-assurance he needed. Callender remembered: "One of the last times I saw him he took me to see the documentary film, 'Mingus,' which showed how he had been evicted from his home in New York.

"Mingus had a chaotic life, but what's amazing is that he left us as much as he did—so many great performances, so much beauty.

"He lived longer than Charlie Parker; like Bird, he accomplished a great deal in a short time. For that at least, we should all be thankful."

Charles Mingus, McKelligon Canyon, El Paso Texas, October 16, 1977, in one of his last public performances.
Courtesy of Bob Foskett

From *The Passion of Jazz*, by Leonard Feather, originally from *Los Angeles Times*. Reprinted by permission of the author's heirs.

Organist Jimmy Smith. The Hammond Organ came in a number of different versions, with the B-3 model being the most famous.
© David Redfern/Redferns Getty Images

Wes Montgomery

Self-taught guitarist Wes Montgomery was often grouped with musicians under the hard bop banner. Montgomery was a fan of Charlie Christian and in the beginning worked hard to imitate his style. Eventually Montgomery would surpass even Christian's amazing technique, mastering both bebop and cool school styles before moving on to explore the many facets of hard bop. One of his major early recordings, *The Incredible Jazz Guitar of Wes Montgomery*, includes his most important original tune, *West Coast Blues*. This album, like many of his recordings in the 1950s and early 1960s, looks back on bebop but also looks forward to more blues- and gospel-influenced hard bop. As Wes Montgomery went farther into the world of "soul jazz," his later albums leaned heavily toward a more pop-oriented audience. He even recorded jazz versions of many popular 60's tunes including those of the Beatles. Like Charlie Christian before him, Wes Montgomery had a large impact on guitar players in many different styles of music. Blues musicians, rock players, and even country stars including Chet Atkins and Roy Clark all acknowledged a debt to his artistry. You can explore Montgomery's playing style in the listening guide for *O.G.D.* found at the end of the next section about jazz organist Jimmy Smith.

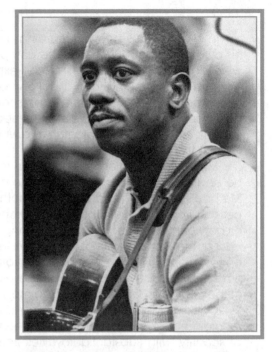

Press photo of guitarist Wes Montgomery.
Courtesy of the Institute of Jazz Studies, Rutgers University

Jimmy Smith

The Hammond B-3 organ (and various other permutations of this instrument model) became very popular with some hard bop ensembles, particularly those that

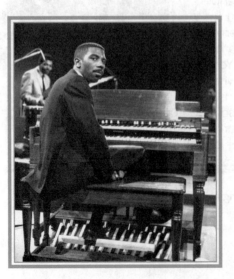

tended to focus on what we are calling funky or soul jazz, which often included more of a black gospel music influence. Both Fats Waller and Count Basie experimented with playing jazz on various types of electronic organs, but neither ever used the instrument on a regular basis (though both produced several very interesting recordings using the instrument over the years). The Hammond B-3 was a real breakthrough in instrument design. Its (relatively) small size, portability, and affordable price made it very popular in smaller churches and funeral homes. Then and now, Black gospel music in particular often

makes heavy use of this instrument. Jazz musicians prized the Hammond B-3 both for its wide range of sounds and the fact that one player could play both the chords required from the piano and, by using a large set of foot pedals, the bass lines as well. Having one guy do two jobs meant that you could split the money three ways instead of four! More seriously, while not all Hammond B-3 players chose to play the bass lines, those who did found that it allowed more harmonic freedom, as any chord substitutions or harmonic additions the keyboard player chose to add could also be immediately reflected in the bass line as well, again because the same guy was doing both jobs.

Without a doubt, the father of this new instrumental style was Jimmy Smith. This artist focused heavily on funkier blues-oriented sounds, which became his trademark. Over his long career, he recorded with everything from a duo to an extra-large big band. Smith was quite prolific in the recording studio, with well over 60 titles in his catalog. Some of his finest recordings include *Cool Blues*, *Back at the Chicken Shack*, *The Dynamic Duo* (with Wes Montgomery), and the recent *Angel Eyes: Ballads & Slow Jams*. Smith also created one of the most exciting more and enjoyable Christmas albums of all time, *Christmas Cookin'*. Listen now to Jimmy Smith and Wes Montgomery performing together as they stretch out on an original Montgomery composition titled *O.G.D.*, which was also known by the title *Road Song*.

Listening Guide

O.G.D. (aka Road Song) (Wes Montgomery)

Example of the funky/soul jazz side of the hard bop style
Recorded September 21-28, 1966
Performed by Wes Montgomery, guitar; Jimmy Smith, Hammond organ with pedal bass; Grady Tate, drums; and Ray Barretto, percussion

With this listening guide we get two amazing artists for the price of one. In September of 1966 Wes Montgomery and Jimmy Smith teamed up for a series of recording sessions that led to two album releases on the Verve label, *Jimmy and Wes: The Dynamic Duo* and *Further Adventures of Jimmy and Wes*. Both albums are excellent recordings that feature both big band charts arranged by the great Oliver Nelson and quartet performances such as the one in this listening guide. The tune is in a typical 32-bar song format of A-A-B-A, but it does not follow George Gershwin's chord changes for the tune *I've Got Rhythm*. All improvised solos are played over the full 32-bar structure. Throughout the performance, and in the solo choruses in particular, listen carefully to the intricate musical interplay between Wes Montgomery and Jimmy Smith. This is a spontaneous musical conversation between two very talented artists. "O.G.D." is an acronym used in the jazz world to describe the trio of organ, guitar, and drums.

Total time: 5:13

:00	Letter A material is played by guitarist Wes Montgomery.
:13	Letter A material is repeated.
:26	Letter B (bridge) material is presented, still featuring Montgomery.
:39	The final opening statement of letter A material.
:52	1st solo guitar chorus.
1:41	2nd solo guitar chorus.
2:31	1st Hammond organ solo chorus.
3:20	2nd Hammond organ solo chorus.
4:09	Out chorus. The tune comes to a conclusion with a simple repeat of the last 4 bars of thematic material.

Miles Davis, Again

Over the course of his career, Miles Davis made deep excursions into the hard bop arena. Critics often sell Miles' technique short, saying that the real reason he did not stick with Charlie Parker was that he just didn't have the chops to keep up. While it is true he didn't always play with the same velocity or aggression as Charlie Parker, Miles Davis' extensive recorded output more than proves he could play in a very aggressive manner whenever he took a notion to do so. For a good example of the aggressive Miles, listen to the tune *Walkin'* from *The Complete Concert: 1964*.

Many players who passed through the Miles Davis band became notable figures in the hard bop style, including John Coltrane and Sonny Rollins. Davis' second famous quintet included Herbie Hancock, piano; Ron Carter, bass; Tony Williams, drums; and Wayne Shorter, sax. A few of this group's major recordings that delve into the hard bop style include *The Complete Concert: 1964* (George Coleman in place of Shorter), *Miles Smiles*, *Sorcerer*, and *Nefertiti*. Taken from the 1967 album *Sorcerer*, you can listen to this great hard bop quintet play *Masqualero*.

Listening Guide

Masqualero (Wayne Shorter)

Example of the second Miles Davis Quintet playing hard bop in the late 1960s

Recorded May 17, 1967

Performed by Miles Davis, trumpet; Wayne Shorter, tenor sax; Herbie Hancock, piano; Ron Carter, bass; and Tony Williams, drums

Taken from the album *Sorcerer*, this recording demonstrates the second great Miles Davis Quintet playing at the height of its hard bop powers. As with the upcoming Coltrane quartet recording of *The Promise*, notice the amazing sense of interplay between the musicians. This performance is just another form of communication between a very gifted group of players. Although there is a stricter underlying structure here when compared to many of the works of Ornette Coleman (see Chapter 8), this performance is created in a manner similar to free jazz. The formal structure of this work is quite complex. Its basic format is A-B-A, with the letter A statements being 8 measures each and the letter B material being 6 measures long. Be aware, however, that the band does not stay strictly within that format. Just clear your mind and let the emotions of these skillful improvisers take you where they may. There is a lot to take in on this particular recording, and it will require several careful listenings before you can really begin to grasp all of the nuances it contains. Relax and enjoy the ride.

Total time: 8:51

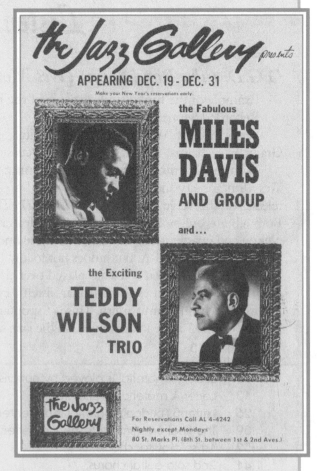

Flyer sent to regular Jazz Gallery customers announcing a Miles Davis engagement that was going to include a New Year's Eve performance.

Courtesy of Tad Hershorn at the Institute of Jazz Studies, Rutgers University

:00 Introduction.
:14 Head.
 :14 A.
 :28 B.
 :39 A.
:54 Miles Davis' trumpet solo begins.
3:20 Wayne Shorter's sax solo begins.
6:18 Ron Carter, Herbie Hancock, and Tony Williams explore collective improvisation. At various times, however, you will notice that the piano tends to dominate, almost turning portions of the section into a piano solo. As a listener, it's a bit of a tough call here.
7:56 Out chorus. Return to some of the original material used at the beginning, but the formal structure has been altered. The horns are omitted on the last letter A statement in favor of a loose rhythm section improvisation that simply allows the tune to drift away.

John Coltrane

From 1955 until his death in 1967, tenor and soprano saxophone player John Coltrane explored many different jazz styles including traditional ballad playing, modal jazz, hard bop, and free jazz. Coltrane came to national prominence playing in groups led by Miles Davis. In 1959, the same year that he recorded Kind of Blue with Davis, Coltrane was featured in a solo recording titled Giant Steps. His solos from recordings such as this one were dubbed "sheets of sound" by one jazz critic. The term refers to the relentless flurry of notes that Coltrane played as he explored each complex chord structure from every possible direction. Three examples from your Spotify playlists, *Giant Steps*, *The Promise*, and *Jupiter* (featured in Chapter 8) clearly display Coltrane's "sheets of sound" style of improvisation.

John Coltrane during one of the recording sessions for his Blue Train *album. Shaded in the color blue, this Francis Wolff image became the album cover.*
Michael Cuscuna/ Corbis Premium/ Histoarical/Getty Images

Dig Deeper

RECORDINGS

Blue Train; Giant Steps; My Favorite Things; Live at the Village Vanguard; John Coltrane and Johnny Hartman; Live at Birdland; A Love Supreme

BOOKS

John Coltrane: His Life and Music by Lewis Porter; *Coltrane: The Story of a Sound* by Ben Ratliff; *A Love Supreme: The Story of John Coltrane's Signature Album* by Ashley Kahn

WEBSITE

www.john coltrane.com

Listening Guide

Giant Steps (John Coltrane)

Example of an aggressive hard bop style and Coltrane's "sheets of sound" approach to improvisation

Recorded May 4-5, 1959

Performed by John Coltrane, tenor sax; Tommy Flanagan, piano; Paul Chambers, bass; and Art Taylor, drums

This 16-measure tune has been frustrating jazz musicians since its creation in 1959. It is one of the most difficult standard tunes in the entire jazz songbook, but the melody could not be simpler. What makes this tune so challenging is the fast tempo at which it is usually performed, coupled with a complex and rapidly evolving series of chords. Basically, each note you hear in the opening melody is supported by a different chord. By the time you get through the entire 16-measure structure, you've passed through 52 different chords—some repeated at various times, but always a different chord every two or four beats depending on the pattern—all in about twelve seconds. Whew! It's exhausting just talking about it.

Total time: 4:43

:00	Head. 16 measures.
:14	Repeat of the head. 16 measures. Coltrane launches his improvised solo during the last 2 bars of this chorus.
:28	1st solo chorus, featuring John Coltrane on tenor saxophone. This extended solo is a perfect example of Coltrane's "sheets of sound" approach to solo improvisation.
:41	2nd sax chorus.
:54	3rd sax chorus.
1:07	4th sax chorus.
1:20	5th sax chorus.
1:34	6th sax chorus.
1:47	7th sax chorus.
2:00	8th sax chorus.
2:14	9th sax chorus.
2:27	10th sax chorus.
2:40	11th sax chorus.
2:53	Tommy Flanagan's piano solo begins. Unlike Coltrane, who had been practicing this material for months before the recording date, Flanagan got the music just a few minutes before the recording session began. While he tries valiantly to play this difficult new material at a breakneck tempo, you can clearly hear that he scuffles through his choruses from beginning to end.
3:06	2nd piano chorus.
3:19	3rd piano chorus.
3:32	4th piano chorus. For his final solo chorus, Flanagan mostly abandons single-line improvisation in favor of safer block chord statements.
3:44	Coltrane returns with the first of two more solo choruses.
3:57	2nd solo chorus for Coltrane after the piano solo.
4:10	Coltrane returns to the original melody of the tune for two full statements, followed by one final improvised flourish on sax down to a low note to conclude the performance.

Listening Guide

The Promise (John Coltrane)

Example of hard bop leaning toward aggressive modal improvisation and free jazz
Recorded October 8, 1963
Performed by John Coltrane, soprano sax; McCoy Tyner, piano; Jimmy Garrison, bass; and Elvin Jones, drums

Here is the classic John Coltrane Quartet playing an excellent example of the straight-ahead hard bop style. The band members are comfortable with each other's playing styles, and that familiarity is evident in the spontaneous interplay between Coltrane and the other musicians. As Coltrane goes more "outside" of the planned chord structure, the other musicians have no problem going with him. Coltrane is playing the soprano sax, an instrument he helped return to the forefront of jazz. This recording was made during a live show at the famous New York City nightclub Birdland. The head and out chorus of this tune follow the format A-B-A-B-C, played in alternating 8-bar phrases. The improvised solos are all played over the standard 32-bar song form (A-A-B-A), and the chord changes are similar to the tune *So What* discussed in Chapter 6.

Total time: 8:07

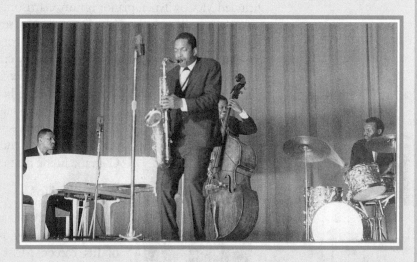

The ground-breaking John Coltrane Quartet. This 1962 photograph shows McCoy Tyner, piano; John Coltrane, tenor sax; Jimmy Garrison, bass; and Elvin Jones, drums.
Photo courtesy of Duncan Schiedt

:00	Head.	
	:00	A.
	:14	B.
	:25	A.
	:37	B.
	:48	C.

1:00 McCoy Tyner begins piano solo. Plays five full choruses. Listen to how he comps for himself and particularly how he and the other rhythm section players change their accompaniment styles as his improvisation shifts moods.

	1:00	1st solo chorus.
	1:49	2nd solo chorus.
	2:39	3rd solo chorus.
	3:29	4th solo chorus.
	4:20	5th solo chorus.

5:09	John Coltrane begins soprano sax solo. Plays two full choruses. Pay careful attention to the interplay between the soloist and all the members of the rhythm section, especially drummer Elvin Jones.
	5:09 1st solo chorus.
	6:00 2nd solo chorus.
6:51	Out chorus. Follows same form as opening head. Tune ends with a long piano chord, along with brief improvisations on cymbals and bass.

Following the *Giant Steps* album, Coltrane ventured deeper into modal jazz with recordings including *My Favorite Things* and *A Love Supreme*. These recordings featured one of the greatest and most cohesive recording ensembles of all time, which included McCoy Tyner, piano; Jimmy Garrison, bass; and Elvin Jones, drums. Unlike Coltrane's work with the Miles Davis quintet/sextet, however, there is nothing "cool" about this quartet's performances. Coltrane's tone is edgy and aggressive, and his solos can almost be overwhelming at times. Oddly enough, *My Favorite Things* went on to become one of John Coltrane's most commercially successful albums. Performances from this time period in Coltrane's life have been endlessly studied and imitated by music students and professional jazz players alike. Perhaps even more than Charlie Parker, the current style of jazz saxophone playing is most directly related to the work of John Coltrane. We'll revisit Coltrane in the next chapter as we discuss free jazz.

Sonny Rollins

Sonny Rollins.
Courtesy of the Institute of Jazz Studies, Rutgers University

Like John Coltrane, tenor saxophonist Sonny Rollins has explored many different styles of jazz over the course of his career. Most of Rollins' important recordings, however, are closely associated with the hard bop style. Rollins first came to prominence in the early 1950s, performing with such bebop luminaries as Clifford Brown, Miles Davis, and Thelonious Monk. He went on to lead a series of small groups throughout the 1950s and 60s. Rollins has had a somewhat erratic career, however, often taking long breaks from performing and recording. One of the great jazz legends is that when Rollins would become disenchanted with his performances, he would take time off to regroup and explore new musical styles. A native New Yorker, he would spend long periods of time practicing in the middle of the Williamsburg bridge, which links lower Manhattan to Brooklyn. In addition to performing standard bebop-style tunes, Rollins has been known to take pop tunes such as *I'm An Old Cowhand* and *Softly As A Morning Sunrise* and transform them into blazing hard bop masterpieces. He has also taken a turn at composition, and some of his more creative original compositions, including *Oleo, Doxy, Airegin* (backward spelling of Nigeria), and *Pent-up House,* have become jazz standards. Over the years, Rollins has often been singled out by musicians for his use of silence and space in live performances and on record. In fact, he has often performed and recorded in a trio with bass and drums (no piano) and even as an individual soloist with no accompaniment of any kind. Just past the age of 87 years young as of

this writing, Rollins shows no signs of letting up. He continues to compose, record, and tour on a regular basis. From your Spotify playlist for this chapter, you can hear Sonny Rollins play with the Clifford Brown-Max Roach Quintet on *What Is This Thing Called Love* and with his own band on *The Bridge*. Dig even deeper into Spotify and you'll find another 100 or so recordings that feature this amazing musician.

Dig Deeper

RECORDINGS

Way Out West; A Night at the Village Vanguard; The Bridge; Sonny Rollins +3; Without a Song: The 9/11 Concert

BOOK

Saxophone Colossus: A Portrait of Sonny Rollins by Bob Blumenthal

DOCUMENTARIES

Sonny Rollins: Saxophone Colossus; Jazz Icons: Sonny Rollins Live in '65 & '68

Listening Guide

The Bridge (Sonny Rollins)

Example of Sonny Rollins playing in a hard bop style
Recorded January 30 – February 14, 1962
Performed by Sonny Rollins, tenor sax; Jim Hall, guitar; Bob Cranshaw, bass; and Ben Riley, drums

This particular recording was the first project Sonny Rollins undertook after a three-year hiatus from public performance. The title of this tune and the album, *The Bridge*, is a direct reference to where Rollins would go to practice during his time away from the public. While many critics point out that his style of improvisation here does not mark a major departure from his earlier approach, this is still a masterful recording. The title track, *The Bridge*, is a typical 32-bar A-A-B-A song form with one major rhythmic exception. Each time the material from letter A is presented in the headand out chorus, you will notice there is a dramatic rhythmic difference between the first 4 bars and the second 4 bars of the 8-measure structure. The first 4 measures are always presented in 4/4 time, i.e., four beats per measure with the quarter note providing the basic beat, but the second 4 measures of each letter A statement shift to 6/8 time, which means you will now hear six beats per measure with the eighth note becoming the basic beat. At first you may find this rhythmically challenging to count, particularly because it goes by so fast, but you'll soon get the hang of it because the same pattern continues to repeat itself throughout most of the performance. This pattern is also used in some of the solo choruses, but others shift to straight 4/4 time for a completely standard 32-bar A-A-B-A song form based on the chord progression from the Gershwin tune *I've Got Rhythm*, known simply to musicians as "Rhythm changes." The letter B material, or the bridge of *The Bridge* (pun intended), is always presented in a clear 8-measure pattern in 4/4 time. This guide will break down the 1st chorus for you in a very detailed timeline, but since the same pattern continues throughout most of the performance, for the rest of the listening guide we will simply point out the major events and places where the time shifts in the various solo choruses.

Total time: 5:59

:00	First 4 bars of the letter A melody in 4/4 time.
:05	Second 4 bars of the letter A melody in 6/8 time.
:08	Repeat of the first 4 bars of the letter A melody in 4/4 time.
:11	Repeat of the second 4 bars of the letter A melody in 6/8 time.
:14	Letter B (bridge). 8 measures with a new melody (actually just improvisation) and accompanying chord changes, all presented in standard 4/4 time.
:20	Final statement of the first 4 bars of the letter A melody in 4/4 time.
:23	Final statement of the second 4 bars of the letter A melody in 6/8 time.

:26	Sonny Rollins' tenor sax solo begins. He'll play three choruses over the alternating 4/4 to 6/8 rhythmic pattern.
:50	2nd sax chorus.
1:13	3rd sax chorus.
1:37	4th sax chorus. Here the band shifts to straight 4/4 time for the entire 32-bar structure.
2:01	5th sax chorus. The straight 4/4 time continues.
2:24	6th sax chorus. The straight 4/4 time continues.
2:47	1st guitar chorus. The rhythm now shifts back to the alternating 4/4 to 6/8 time.
3:11	2nd guitar chorus. The band shifts back to straight 4/4 time for the entire 32-bar structure.
3:36	3rd guitar chorus in straight 4/4 time.
4:00	1st bass chorus. Straight 4/4 time continues.
4:23	2nd bass chorus. Straight 4/4 time continues.
4:47	1st drum chorus. Straight 4/4 time continues. Notice how the bass and guitar use simple chord statements to clearly outline the A-A-B-A structure of the tune.
5:09	2nd drum chorus. Straight 4/4 time and the bass and guitar outline of the structure continue.
5:32	Out chorus. Sonny Rollins returns with the melody, again presented with the alternating 4/4 to 6/8 rhythmic structure as presented at the beginning of the tune.

Saxophone colossus Sonny Rollins performing in New Haven, Connecticut, in 2000.
Photograph by Tad Hershorn

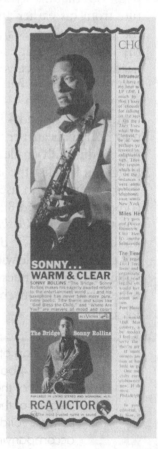

Hard Bop Today

Back in the late 1980s and early 1990s, a number of very talented young musicians came to prominence in the jazz world playing in the hard bop style. Players including Branford and Wynton Marsalis, Joshua Redman, Terence Blanchard, and Nicholas Peyton were referred to as the "young lions." Lately their style has been classified as "post bop" or even "mainstream" modern jazz. Regardless of what you call it, these younger players spent many hours studying the recordings and transcribing the solos of jazz masters including Clifford Brown, John Coltrane, and Sonny Rollins. In addition, many of these younger players enjoyed some of their earliest public success as members of the Jazz Messengers. Unlike some of their predecessors, however, these young players are well versed in a wide variety of musical styles, and they move freely between forms of pop music into older styles of jazz and back to hard bop again without giving the transitions a second thought. The hard bop styles of the late 1950s and 1960s are just one more trick in their musical bag.

Notes

1. Mark Gridley, *Jazz Styles*, 7th ed. (Upper Saddle River, NJ: Prentice Hall, 2000), p. 213.

2. *Jazz: A Film by Ken Burns*, Episode 9 (Washington, DC: PBS, 2001), videocassette.

Study Guide

Chapter 7 Review Questions

True or False

___ 1. Some soul-oriented hard boppers have been accused of using blues and gospel styles to sell more records.

___ 2. Economic considerations can explain some of the popularity of the Hammond B-3 organ among musicians.

___ 3. Wes Montgomery was influenced by Charlie Christian.

___ 4. Miles Davis did not have the technical facility to perform in the hard bop style.

___ 5. The Jazz Messengers acted as a training ground for many young musicians.

___ 6. The hard bop style of jazz is actively performed today.

___ 7. Hard bop tends to use the small combo format instead of the larger big band format.

Multiple Choice

8. Elements of Clifford Brown's playing style include:
 a. a rich tone combined with very fast tempos.
 b. the incorporation of gospel tunes.
 c. aggressive, biting tones combined with medium tempos.
 d. the use of strong accents and hard fills.
 e. extremely fast stride style.

9. Horace Silver's main instrument was the:
 a. bass. d. alto sax.
 b. drums. e. trumpet.
 c. piano.

10. Who was the musician that often experimented with new musical ideas in the recording studio?
 a. Horace Silver
 b. Jimmy Smith
 c. Charles Mingus
 d. Wes Montgomery
 e. Sonny Rollins

11. "Sheets of sound" describes the improvisation style of which musician?
 a. Sonny Rollins d. Clifford Brown
 b. John Coltrane e. Charles Mingus
 c. Horace Silver

12. Herbie Hancock recorded with the quintet of which artist?
 a. Miles Davis d. Ron Carter
 b. Wes Montgomery e. Elvin Jones
 c. Horace Silver

13. _____ is one of the most well-known hard bop guitarists to ever record.
 a. Sonny Rollins
 b. Miles Davis
 c. John Coltrane
 d. Clifford Brown
 e. Wes Montgomery

14. Which instrument did Jimmy Smith pioneer the use of in jazz?
 a. electric guitar
 b. electric keyboard
 c. Hammond B-3 organ
 d. electric bass
 e. harmonica

Fill in the Blank

15. Hard bop jazz that integrates blues and gospel music is called _____ or _____.

16. _____ is a drummer who led a series of hard bop bands.

17. Saxophonist _____ performed cool jazz, modal jazz, hard bop, and free jazz.

18. For many musicians, the current jazz saxophone model is based on the playing style of _____.

19. One of John Coltrane's most commercially successful albums was _____, even though it was modal jazz with very aggressive playing.

20. _____ is known for performing pop tunes in the hard bop style.

21. Hard bop pianist _____ was a good composer/arranger, a good band leader and a wonderful improviser.

Short Answer

22. List four ways hard bop differs from bebop.

23. List the John Coltrane Quartet members and their instruments as you hear them on the recording of *The Promise*.

24. How many solo choruses do you hear in the tune *What Is This Thing Called Love*?

25. List the players featured on your recording of *Masqualero*.

Essay Questions

1. Art Blakey's band, the Jazz Messengers, became a training ground for young jazz musicians. Using the Internet and other media sources, discuss the legacy of the Jazz Messengers. Why do you think Blakey was such an influential band leader?

2. Considering the more "commercial" side of hard bop, do you think it is okay for musicians and other artists to alter or "water down" their creations in an attempt to reach a wider audience? Support your yes or no answer with an explanation and relevant examples.

Chapter 8
Free Jazz and the Avant-Garde

When people believe in boundaries, they become part of them.

Don Cherry

The entire avant-garde movement in jazz, and free jazz in particular, was a direct outgrowth of the continued experimentation with both the bebop of Chapter 5 and the hard bop of Chapter 7. Players in the **free jazz** style often abandoned much of the preplanned structure that had been present in jazz. Pre-set chord progressions in particular were frequently completely abandoned. Some groups, especially those led by Ornette Coleman, avoided using piano or guitar because of their potential for playing chords and implying tonal progression.

Horn players in the free jazz style frequently played with very harsh tones, often exploring the extreme limits of their instruments. They also made use of many nontraditional sounds by screaming into their instruments, making screeching noises, and just generally causing a big ruckus. Drummers focused on playing random patterns meant to inspire, contradict, and sometimes complement what the other musicians were doing. Bass players often listened carefully to the soloist and then decided whether to go with what they were hearing or simply go off in their own musical direction.

Musicians in the general **avant-garde** movement tended to use all of the various techniques listed above but also made use of more conventional musical styles when they felt it would suit their artistic purposes. Collective improvisation became a very important part of the free jazz and avant-garde styles. For many free and avant-garde players, a growing social consciousness also played a big role in the music they were creating. In an attempt to have more control over their material, musicians and composers formed various cooperative groups including the Jazz Composers Guild, the Black Artists Group, and the Association for the Advancement of Creative Musicians.[1]

free jazz

Dig Deeper
BOOKS

Free Jazz by Ekkehard Jost; *This Is Our Music: Free Jazz, the Sixties, and American Culture* by Iain Anderson; *A Power Stronger Than Itself: The AACM and American Experimental Music* by George E. Lewis

avant-garde

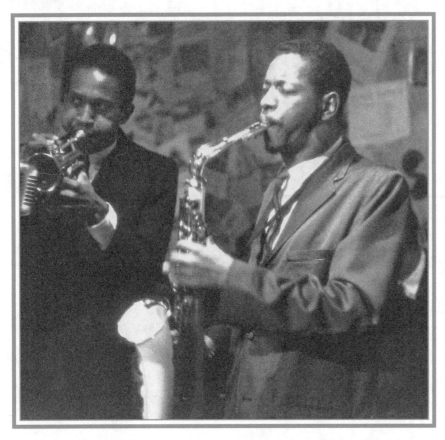

Don Cherry, trumpet, and Ornette Coleman, alto sax, in a 1959 photograph.
Courtesy Bob Parent Archive

The People Who Made It Happen

Ornette Coleman

By far the most important voice in the free jazz movement, saxophonist Ornette Coleman is often credited with almost single-handedly creating this controversial style of jazz. The creation of what we now know as free jazz was very much an evolutionary process. Coleman began his musical career playing rhythm and blues in and around his native Fort Worth, Texas. He later relocated to the West Coast, where he started taking part in jam sessions, playing mostly in the bebop and hard bop styles. His first record features a standard rhythm section, but Coleman quickly abandoned the use of a piano in order to break away from the constraints of formal chord structures.[2] In 1959, he moved to New York City and opened with his quartet at a club called the Five Spot. His quartet at the time consisted of Don Cherry, trumpet; Charlie Haden, bass; and Billy Higgins, drums. Higgins was replaced in 1960 by drummer Ed Blackwell. The group signed with the noted jazz and soul label Atlantic Records and recorded the albums *The Shape of Jazz to Come* and *Change of the Century*.

In the fall of 1960 Coleman released *Free Jazz: A Collective Improvisation*, one of the most controversial jazz recordings ever put on the market. For this particular recording, Coleman added another quartet to his own and called the group a double quartet. There was still no piano player, but the other group did include noted jazz musicians Eric Dolphy, bass clarinet; Scott LaFaro, bass; Freddie Hubbard, trumpet; and the aforementioned Billy Higgins on drums. The entire album was one long free jazz improvisation with a few preselected themes that were used between solos. While one player is the lead soloist, the other musicians were free to improvise behind him, often creating riffs, but nothing like what you heard from Count Basie's band in Chapter 4. The actual term *free jazz* really didn't come into wide use until after the release of this album. This album was so divisive in the jazz community *Down Beat* magazine felt compelled to publish its first double review. The two wildly divergent opinions you will read here accurately reflect the divided feelings of jazz fans and artists toward this new approach.

Dig Deeper

WEBSITE

www.ornettecoleman.com

RECORDINGS

The Shape of Jazz to Come; Free Jazz: A Collective Improvisation; Song X (with Pat Metheny)

BOOK

Miles, Ornette, Cecil: Jazz Beyond Jazz by Howard Mandel

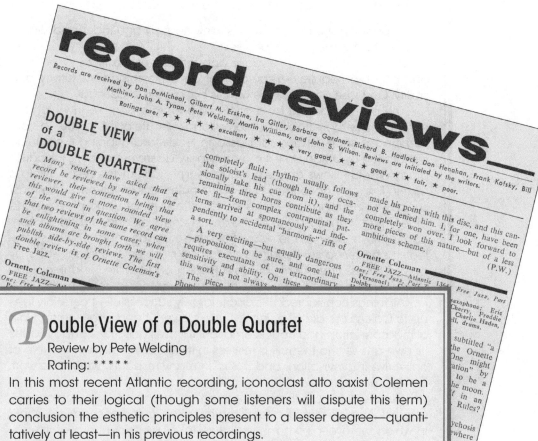

record reviews

Records are received by Don DeMicheal, Gilbert M. Erskine, Ira Gitler, Barbara Gardner, Richard B. Hadlock, Don Henahan, Frank Kofsky, Bill Mathieu, John A. Tynan, Pete Welding, Martin Williams, and John S. Wilson. Reviews are initialed by the writers.

Ratings are: ★ ★ ★ ★ ★ excellent, ★ ★ ★ ★ very good, ★ ★ ★ good, ★ ★ fair, ★ poor.

DOUBLE VIEW of a DOUBLE QUARTET

Many readers have asked that a record be reviewed by more than one reviewer, their contention being that this would give a more rounded view of the record in question. We agree that two reviews of the same record can be enlightening in some cases; when such albums are brought forth we will publish side-by-side reviews. The first double review is of Ornette Coleman's *Free Jazz*.

Ornette Coleman
FREE JAZZ—At...
One: Free JAZZ...

completely fluid; rhythm usually follows the soloist's lead (though he may occasionally take his cue from it), and the remaining three horns contribute as they see fit—from complex contrapuntal patterns arrived at spontaneously and independently to accidental "harmonic" riffs of a sort.

A very exciting—but equally dangerous —proposition, to be sure, and one that requires executants of an extraordinary sensitivity and ability. On these ... this work is not always ...
The piece ...
phoni...

made his point with this disc, and this cannot be denied him. I, for one, have been completely won over. I look forward to more pieces of this nature—but of a less ambitious scheme.

(P.W.)

Ornette Coleman
FREE JAZZ—Atlantic 1364
One: Free Jazz, Part ...
Personnel: ...
Dolphy ...

Double View of a Double Quartet

Review by Pete Welding
Rating: ★★★★★

In this most recent Atlantic recording, iconoclast alto saxist Colemen carries to their logical (though some listeners will dispute this term) conclusion the esthetic principles present to a lesser degree—quantitatively at least—in his previous recordings.

The entire LP—both sides—is given over to a collective improvisation by a double quartet (Dolphy, Hubbard, LaFaro, and Higgins make up the second quartet) that lasts 36 1/2 minutes. Using only the sketchiest of outlines to guide them, the players have fashioned a forceful, impassioned work that might stand as the ultimate manifesto of the new wave of young jazz expressionists. The results are never dull.

In first hearing, *Free Jazz* strikes one as a sprawling, discursive, chaotic jumble of jagged rhythms and pointless cacophonies, among which however are interlarded a number of striking solo segments (particularly those of the two bassists). The force, intensity, and biting passion that motivate it also come across.

On repeated listening, however, the form of the work gradually reveals itself, and it is seen that the piece is far less unconventional than it might at first appear. It does not break with jazz tradition; rather it restores to currency an element that has been absent in most jazz since the onset of the swing orchestra—spontaneous group improvisation. Yet Coleman has restored it with a vengeance; here we have better than half an hour's worth, with only a minimal amount of it predetermined to any degree.

In *Free Jazz* the soloist is free to explore any area in his improvisation that his musical esthetic takes him to; he is not bound by a harmonic, tonal, or rhythmic framework to which he must adhere rigidly. The performance (and his role in it) is completely fluid: rhythm usually follows the soloist's lead (though he may occasionally take his cue from it), and the remaining three horns contribute as they see fit—from complex

contrapuntal patterns arrived at spontaneously and independently to accidental "harmonic" riffs of a sort.

A very exciting—but equally dangerous—proposition, to be sure, and one that requires executants of an extraordinary sensitivity and ability. On these grounds, this work is not always successful.

The piece is begun by a brief polyphonic ensemble in which the horn men seek to establish the emotional climate of the piece. This determined, a short "arranged" passage leads to a gripping five minute exploration by Dolphy in his most waspish, acerbic manner; Hubbard's graceful solo follows and is of equal length; Coleman's searing solo is next in line and consumes a full 10 minutes. It is by all odds the most successful improvisation of the lot, despite its length, and provokes the other three horns to some of their most complex and interesting contrapuntal interplay on the disc. After a terse unison figure, Cherry's flatulent, meandering solo sputters on for five minutes. It is succeeded by powerful bass statements by both Haden and LaFaro, and finally the drummers have the field before all come together for the close.

All things considered, the disc is largely successful—it certainly lives up to Coleman's dieta, at least. It *is* a powerful and challenging work of real conviction and honest emotion: it poses questions and provides its own answers to them; it is restless in its re-examination of the role of collective improvisation, and this is, in many respects, where the work is most successful.

Needless to say, there is nothing of smugness or complacency about it. And it is almost a total improvisation, a sort of seamless whole in which the over-all organic structure takes precedence over its constituent elements (selection of notes, etc.). As a result, Cherry's faltering solo makes little real difference in terms of the larger work—enough momentum has been established by this time to carry it right through.

Some salient points:

It seems to me that experiments ought to be presented as such—and not as finished works. This piece does have more than its share of inevitable rough spots; but how much of this results from this group having been brought together in the studio just for the purposes of recording this piece? A much fuller rapport would appear to be necessary before the maximum results could be achieved from this method and approach. Still, Coleman has made his point with this disc, and this cannot be denied him. I, for one, have been completely won over. I look forward to more pieces of this nature—but of a less ambitious scheme.

Review by John A. Tynan
Rating: No Stars
This friendly get-together is subtitled "a collective improvisation by the Ornette Coleman Double Quartet." One might expect a "collective improvisation" by Coleman's usual crew of four to be a merry event. But here we shoot the moon. It's every man-jack for himself in an eight-man emotional regurgitation. Rules? Forget 'em.

Where does neurosis and psychosis begin? The answer must lie somewhere within this maelstrom.

If nothing else, this witch's brew is the logical end product of a bankrupt philosophy of ultraindividualism in music. "Collective improvisation"? Nonsense. The only semblance of collectivity lies in the fact

that these eight nihilists were collected together in one studio at one time and with one common cause: to destroy the music that gave them birth. Give them top marks for the attempt.

From *Down Beat*, January 18, 1962, by Pete Welding and John A. Tynan. Copyright © 1962 by Maher Publications. Reprinted by permission.

Ornette Coleman's radical new approach to jazz had a big impact on the world of music. All of the players mentioned in the rest of this chapter were following in Coleman's musical footsteps as they branched out into the more avant-garde side of jazz. You can hear a reunited version of the original Ornette Coleman band on a 1971 recording titled *Civilization Day* from the album *Science Fiction* on Spotify.

Listening Guide

Civilization Day (Ornette Coleman)

Example of free jazz as performed by the style's founding fathers
Recorded September 9, 1971
Performed by Ornette Coleman, alto sax; Don Cherry, trumpet; Charlie Haden, bass; and Billy Higgins, drums

Well, here it is. Nothing in the entire history of jazz has polarized the community as much as the creation of free jazz. This recording represents an early 70s reunion of the original 1958-59 Ornette Coleman Quartet, and it demonstrates all of these fine musicians at their absolute best. Some feel this music is fraudulent and lacks focus. Others believe it is the logical continuation of the bebop and hard bop styles, with some avant-garde twentieth-century classical techniques thrown in as well. There are no prearranged chord changes here and very little precomposed material of any kind for the musicians to work with other than the opening material. This is truly jazz without a net. Give the recording your honest attention and reflection; then decide for yourself.

Total time: 6:06

:00	Head. As you listen to this very complex melody, notice that the instruments seem to be intentionally playing slightly out of phase. This is not a mistake but, rather, a very precise execution of a very difficult musical gesture. You'll hear this same difficult melodic shape come back at the end of the performance.
:14	Collective improvisation between Coleman and Cherry (rhythm out).
:27	Trumpet solo (begins with a brief collective flourish).
2:54	Sax solo (drums drop out until 3:08).
5:18	Drum solo.
5:48	Out chorus. Full restatement of the opening material.

Later in his career Coleman again sparked controversy when he began to play trumpet and violin in his live performances and on record. Unlike the saxophone, on which he was a trained and gifted performer, Coleman had no formal training on these other instruments. He seemed to feel that his lack of training actually allowed him to play even more freely, but trained instrumentalists begged to differ. They branded Coleman as self-indulgent and a musical fraud.

In more recent years Ornette Coleman embraced a broader array of musical styles, including adding electronic sounds and synthesizer loops to his music. One of the terms sometimes used to describe his newer style was "free funk." He played with a wide variety of musicians including guitarist Pat Metheny and groups as diverse as the London Symphony Orchestra and the Grateful Dead. The Dead's guitarist Jerry Garcia also joined Coleman on the album *Virgin Beauty*. As far back as the mid-1970s Coleman began fronting a new, electric double quartet, which would eventually include his son Denardo on drums and synthesizers. Some of his best recent recordings include *Sound Grammar*, *Colors: Live from Leipzig*, *Tone Dialing*, *Virgin Beauty*, *Soapsuds, Soapsuds, Soapsuds, Soapsuds*, and *Song X* (with guitarist Pat Metheny).

John Coltrane, Again

In recordings such as *My Favorite Things* and *A Love Supreme*, John Coltrane and his quartet were already becoming more musically aggressive. Long solos and wide melodic and harmonic diversions were the order of the day. In the last few years of his life, Coltrane moved more and more toward a totally free jazz style. Unlike Ornette Coleman and others, however, Coltrane sometimes continued to use a piano in his groups. Like many jazz players of his time, Coltrane had battled both drug and alcohol addiction. After he overcame his problems, he became a very spiritual man, and he viewed this freer style of playing as a pure expression of his spirituality. Some of his last albums are solid explorations of the free jazz style. Albums including *Ascension*, *Meditations*, and *Stellar Regions* can be very difficult listening for beginning jazz fans, but they are masterpieces in their own right. You can explore a very pure expression of Coltrane's free jazz style on the track *Jupiter* from *Interstellar Space*, one of his last recording projects.

Dig Deeper

RECORDINGS

Ascension; Meditations; Stellar Regions; Expressions; Interstellar Space

Listening Guide

Jupiter (John Coltrane)

Example of free jazz as performed by John Coltrane
Recorded February 22, 1967
Performed by John Coltrane, tenor sax and bells; and Rashied Ali, drums
This selection is taken from the album *Interstellar Space*, which was one of the last projects Coltrane recorded and is representative of him at the height of his free jazz explorations. This particular project was an extended duet suite for sax and drums, and each movement is based on the name of a planet (though a bonus track titled *Leo* was later added). It was recorded around the same time as both the *Stellar Regions* and *Expressions* albums, and all three releases share some stylistic and thematic ideas.
Total time: 5:25

:00 There is no need for a specific timeline here. The track opens with a brief ringing of bells, joined a few seconds later by some innovative drumming by Rashied Ali. At 0:25 Coltrane begins a statement of the important melodic material, joined by a clear rhythmic drive provided by Ali on drums. This brief section flows seamlessly into several minutes of thematic and rhythmic exploration in the free jazz style. The work concludes with an altered, but identifiable, statement of the important thematic material beginning around 4:29 (or perhaps a little earlier depending on how you hear it). This final melodic statement is followed by another ringing of the bells as the track quickly fades away.

Cecil Taylor

Classically-trained pianist Cecil Taylor is considered one of the freest of the free jazz performers. In fact, he is one of the most aggressive musicians to ever take the stage on any instrument in any musical genre. Taylor has been known to challenge audiences with extremely long performances that offer little or no relaxation in style throughout. Many of his extended improvisations make use of extreme twentieth-century classical piano techniques. Some of Taylor's diverse piano styles include techniques developed by the likes of John Cage, Karlheinz Stockhausen, and Harry Partch, the most radical of twentieth-century classical musicians. Cecil Taylor performances have been preserved on record, but most people feel that you must see him perform live to really "get it." In addition to his solo performances, he has collaborated over the years with other avant-garde artists, including sax players Jimmy Lyons and Sam Rivers, the Art Ensemble of Chicago, and with his own trio and big band.

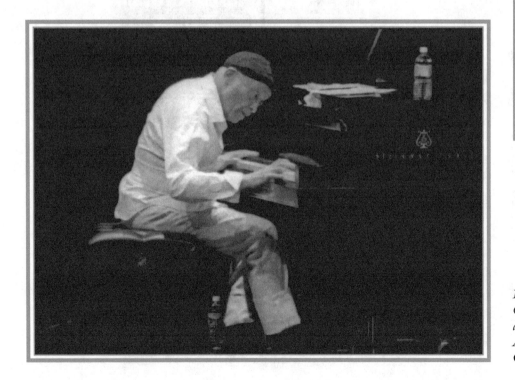

Dig Deeper
RECORDINGS

Unit Structures; Conquistador; Air Above Mountains; Double Holy House; The Willisau Concert

BOOK

Miles, Ornette, Cecil: Jazz Beyond Jazz by Howard Mandel

DOCUMENTARY

Cecil Taylor: All the Notes

Noted free jazz pianist Cecil Taylor photographed at a recent performance in Albuquerque, New Mexico.
Courtesy of James Gale

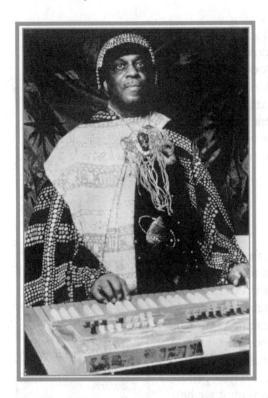

Sun Ra and his duct-taped keyboard in an undated press photo.
Courtesy of the Institute of Jazz Studies, Rutgers University

Dig Deeper

RECORDINGS

Heliocentric Worlds of Sun Ra (box set); *Atlantis; Space is the Place; Strange Celestial Road*

BOOK

Space is the Place: The Lives and Times of Sun Ra by John F. Szwed

DOCUMENTARY

Sun Ra: A Joyful Noise

MOVIE

Space is the Place

Sun Ra

The artist known as Sun Ra inhabited a musical planet all his own. Born Herman Blount, the pianist and arranger worked in various typical musical jobs at the beginning of his career. He also worked in the theater and even played piano in Fletcher Henderson's band for a time. After changing his name to Sun Ra and adapting a persona from outer space, he began leading collections of musicians under band names such as "Sun Ra and the Myth-Science Solar Arkestra."[3] These bands' performances were wild mixtures of free jazz, hard bop, and world music, with just a touch of Duke Ellington thrown in for good measure. The band wore outrageous African and spaceman-inspired costumes. They made use of lots of percussion instruments in addition to the typical saxophones, trumpets, and trombones. In the 1970s the band began using electronic instruments to even further expand their bold array of sounds. As with Cecil Taylor, you really had to see and hear Sun Ra's band to believe it, but there are recordings available. To check out music from another planet, listen to *Atlantis, Space is the Place,* or *Strange Celestial Road.* May the Force be with you.

Ad for a 1990 Town Hall concert featuring Sun Ra and his Arkestra. Notice some of the concerts listed on the left that were going on around the same time at other New York venues.

Art Ensemble of Chicago

The Art Ensemble of Chicago got its start as part of the Chicago-based Association for the Advancement of Creative Musicians. The group played in a wide variety of musical styles, moving from free jazz to New Orleans street grooves to bebop to world music and back again without blinking an eye. In addition to traditional jazz instruments, the group used a vast array of percussion instruments. The band also made use of some instruments not normally associated with jazz including the zither, the celesta, conch shells, and even toy instruments. Like the Sun Ra Arkestra, Art Ensemble of Chicago members often wore wild costumes and incorporated theatrics into their shows. They sometimes wore African-inspired clothing and used tribal face paint to enhance their stage appearance. Like many American jazz musicians of the 1960s and 70s, this band spent a great deal of their time working in Europe. Alan Axelrod describes the band this way:

> The Art Ensemble is one of the most important avant-garde jazz groups and certainly among the most delightfully inventive. Live performances are as much a treat for the eyes as for the ears, with displays of miscellaneous instruments ranging from beautiful African percussion pieces to bicycle horns, gongs, sirens, and various toys. Jazz purists may protest the group's theatricality, but let them stay home. . . . Groups like the Art Ensemble are not for purists or for anyone who wants their music *either* this way *or* that. "Free jazz" is not merely free of tonal and rhythmic restrictions, it is about freedom to choose whatever direction offers itself as the most creative at the moment.[4]

In later years, the band members began to pursue individual projects, but they still came together from time to time to tour and record. The band's strong ties to Africa are reflected in recordings including *Art Ensemble of Soweto* and *America South Africa*. Sadly, trumpet player and founding member Lester Bowie passed away in 1999. The group has continued on in various permutations after Bowie's death, releasing several new recordings, including *Non-Cognitive Aspects of the City,* which is a two-CD set recorded live at the Iridium jazz club in New York City in 2004 and released in 2006. Even as recently as 2018 original

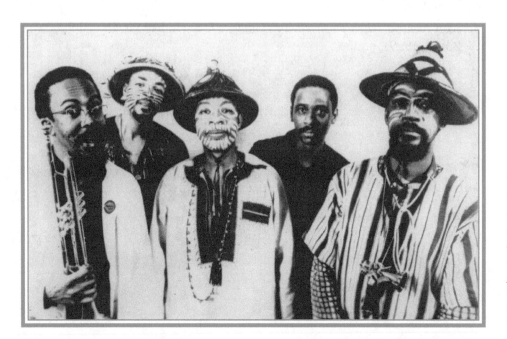

The Art Ensemble of Chicago in an undated ECM Records press photo. L-R: Lester Bowie, Don Moye, Malachi Favors, Roscoe Mitchell, and Joseph Jarman.
Courtesy of the Institute of Jazz Studies, Rutgers University

band founder and woodwind specialist Roscoe Mitchell and drummer Don Moye continued to perform under the Art Ensemble of Chicago banner. Most recently they have released a two-CD project titled *We Are On The Edge: A 50th Anniversary Celebration* that features both studio tracks and live recordings.

Free Jazz and the Avant-Garde Today

Cecil Taylor and members of the Art Ensemble of Chicago are still active performers today. In addition, solo performers such as Anthony Braxton, Pharoah Sanders, Bill Frisell, Keith Jarrett, and bassist Barre Phillips, along with groups such as The Bad Plus and Medeski, Martin, and Wood (MMW) all continue to explore the avant-garde side of jazz. Beyond these previously mentioned musicians, we will meet the artists John Zorn, Django Bates, Don Byron, and Jane Ira Bloom at the end of Chapter 11, all of whom utilize elements of free jazz and the avant-garde in their music and are all outstanding examples of how these techniques are being applied to many diverse styles of music today. Furthermore, many current groups that are essentially hard bop oriented often play music with heavy leanings toward free jazz and the avant-garde. Today, the more experimental forms of jazz are much more popular in Europe than they are in the United States. Many expatriate American avant-garde musicians are currently living and working throughout Europe. European jazz musicians also seem more willing to perform in these very challenging, but uncommercial, styles. Like all of the styles we have already examined, many current students of jazz have studied free jazz techniques. For many artists performing in the world of jazz, free jazz is just one more dialect of a multifaceted language they can choose to use or ignore at will.

Notes

1. *Jazz: A Film by Ken Burns*, Episode 9 (Washington, DC: PBS, 2001), videocassette.

2. Henry Martin and Keith Waters, *Jazz: The First 100 Years* (Belmont, CA: Wadsworth/Thomson Learning, 2002), pp. 245-47.

3. Ibid, p. 266.

4. Alan Axelrod, *The Complete Idiot's Guide to Jazz* (Indiapolis, IN: Alpha Books, 1999), p. 256.

Study Guide

Chapter 8 Review Questions

True or False

___ 1. Free jazz performances rely on a great deal of spontaneous interplay between the musicians.

___ 2. Ornette Coleman believed that he could improvise more freely playing instruments on which he had little or no training.

___ 3. John Coltrane viewed the free jazz style of playing as a more pure expression of his spirituality.

___ 4. Cecil Taylor was influenced mostly by rhythm and blues and early rock.

___ 5. Cecil Taylor makes use of 20th-century classical piano techniques.

___ 6. For many avant-garde musicians, their stage appearance was an integral part of the performance.

___ 7. Jazz musicians choose to perform in the free jazz format because they lack improvisational skills.

___ 8. European audiences are generally more receptive to free jazz than American audiences.

___ 9. Free jazz is usually very well organized and is often prearranged.

Multiple Choice

10. Avant-garde:
 a. refers to conventional artistic styles.
 b. refers to very bad artistic styles.
 c. is enjoyed only in New York.
 d. refers to new and unconventional trends in the arts.
 e. is the title most 1960s and 70s band leaders sought.

11. Who is considered the first pioneer of the free jazz movement?
 a. Ornette Coleman d. Duke Ellington
 b. Tom Clary e. Lester Bowie
 c. Greg Lisemby

12. In free jazz, instrumentalists tend to:
 a. play in a very sweet manner.
 b. play in a very harsh and aggressive manner.
 c. play the piano.
 d. have a large fan base.

13. Ornette Coleman:
 a. couldn't improvise well.
 b. was a maladjusted adult.
 c. really wanted to be a rock star.
 d. began his career playing rhythm and blues.
 e. first recorded in the cool jazz style.

14. What is Cecil Taylor's instrument?
 a. piano d. guitar
 b. trumpet e. alto saxophone
 c. tuba

15. Which ensemble mixes traditional jazz instruments with many types of percussion instruments in addition to other unusual instruments?
 a. The World Saxophone Quartet
 b. Horace Silver and His Hot Five
 c. The Stellar Regions Group
 d. The Quintet of Free
 e. Art Ensemble of Chicago

Fill in the Blank

16. _____ is Sun Ra's birth name.

17. _____ improvisation was an important part of free jazz and avant-garde styles.

18. _____ is one of the most controversial jazz recordings ever released.

19. _____ is another style pioneered by Coleman that employs synthesizer loops and electronic sounds.

20. Pianist _____ is known for his extremely long performances with little or no relaxation in his very aggressive style.

21. _____ is a band leader who mixed many styles of music and performed in outrageous costumes.

22. _____ and _____ are albums that reflect the Art Ensemble of Chicago's strong ties to Africa.

23. Ornette Coleman recorded the album *Virgin Beauty* with guitarist _____ _____.

Short Answer

24. Explain why some free jazz groups avoided using the piano and/or the guitar in their ensembles.

25. The Association for the Advancement of Creative Musicians was based in which U.S. city?

Essay Questions

1. After studying the career of Ornette Coleman and experiencing his music, do you think he was a genius or a fraud? Why?

2. Using the Internet, explore the state of jazz in Europe today. Offer some examples of what you find.

Chapter 9
Fusion: The 70s and 80s

I'll play it first and tell you what it is later.

Miles Davis

When Miles Davis recorded the albums *In A Silent Way* and *Bitches Brew*, he used the term "jazz-rock" fusion. His recordings set off a firestorm in the music industry, the effects of which we are experiencing to this day. In the late 1960s jazz was at its lowest point, as it had become almost completely eclipsed by other popular music styles. The large multi-day festivals including Monterey Pop Festival and Woodstock, which were followed up by ever-growing rock tours, helped expand the world of popular music at an unprecedented rate. With all the money that was coming in from non-jazz artists, large-scale commercial success became much more important to jazz record producers as well. The *Billboard* chart recorded the top 200 albums in terms of sales each week, and it was rare for jazz albums to appear anywhere on it. Jazz-rock fusion, which was later shortened to just **fusion**, was viewed by many jazz musicians—and by producers and promoters alike—as a way to bring a new audience into the world of jazz. In time, the term fusion became a rather generic way of saying that an artist mixed jazz with any other musical style. Currently, it is one of the most dominant formats in the jazz industry. Also, like many of the previously discussed styles, fusion is simply one more musical dialect the best jazz musicians today are capable of speaking.

fusion

One More Time, Miles Davis

In the late 1960s, Miles Davis' second famous quintet (Herbie Hancock, piano; Ron Carter, bass; Tony Williams, drums; and Wayne Shorter, sax) was in transition. The first thing to happen was that on the albums *E.S.P.* and *Miles Smiles*, among others, the group began to take more of a free approach to improvisation—nothing as far out as Ornette Coleman or the late recordings of John Coltrane—but they were clearly moving in that direction. Then Miles started to

incorporate more electric instruments on his recordings. On the recording *Miles in the Sky* Herbie Hancock played electric piano as well as the traditional acoustic piano, and on one track electric guitarist George Benson joined in as well.[1] By the next album, *Filles de Kilimanjaro*, the group's lean toward fusion was unmistakable. The *All Music Guide to Jazz* describes the album this way:

> The sixth and final studio album by Miles Davis' second classic quintet finds the group looking towards early fusion. . . . The music is less esoteric than his music of a year or two earlier, with funky rhythms and hints at pop and rock music becoming more prevalent although not dominant yet. To many of the jazz purists, this was Miles Davis' final jazz album, but to those with open ears towards electronics and danceable rhythms, this set was the predecessor of his next great innovation.[2]

The next two albums that Miles Davis made, *In A Silent Way* and *Bitches Brew*, changed the face of jazz forever. Miles had become a big fan of both Sly and the Family Stone and guitarist Jimi Hendrix. Davis particularly liked the open improvisations on Hendrix's studio jams, including tracks from the album *Electric Ladyland* such as *Voodoo Chile*. You can hear the results of Miles' early experiments with fusion on the tune *Shh/Peaceful* from the 1969 album *In a Silent Way*.

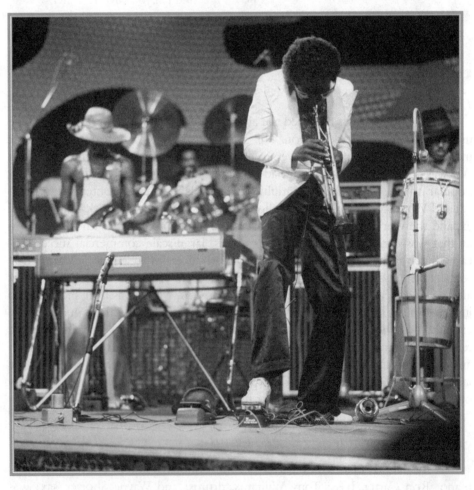

Miles Davis performing with his fusion band at the 1973 Montreux Jazz Festival in Switzerland. Notice how he is using an effects box with his right foot to alter the basic sound of his trumpet. Left-to-right: Michael Henderson, bass; Miles Davis, trumpet; and Reggie Lucas, guitar.
David Warner Ellis/Redferns/Getty images

Listening Guide

Shh/Peaceful (Miles Davis)

Example from the first major fusion recording

Album: *In A Silent Way*, recorded July 30, 1969

Performed by Miles Davis, trumpet; Wayne Shorter, soprano and tenor sax; Herbie Hancock and Chick Corea, electric pianos; Josef Zawinul, electric piano and organ; John McLaughlin, electric guitar; Dave Holland, bass; and Tony Williams, drums

Before he made *Bitches Brew*, Miles Davis tested the deep end of the jazz-rock fusion waters with the albums *Miles in the Sky*, *Filles de Kilimanjaro*, and, most importantly, *In a Silent Way*. For many, *In a Silent Way* represents the first serious exploration of fusion, and it resulted in a more coherent musical presentation than much of the material included in the more famous *Bitches Brew* project that would follow a few months later. As presented on the original LP, the entire album *In a Silent Way* consists of two performances. One side of the album was taken up by the title track coupled with the tune *It's About That Time*. The other side contained an eighteen-minute performance of *Shh/Peaceful*. The material for this album was recorded in long, freely improvised sessions and later edited down to the final album version. *Shh/Peaceful* was edited in such a way that the first material you hear was actually reused at the end of the track, giving the performance a standard A-B-A formal structure. In 2004, Columbia issued *The Complete In a Silent Way Sessions*, a three-CD set that is now available on Spotify. On this set you can hear rehearsals, outtakes, and the original, unedited sessions. The final album versions of each edited performance are also there, and it is that version of *Shh/Peaceful* we will explore in this listening guide.

Total time: 18:16

:00	Introduction and establishment of the basic groove.
1:42	Miles Davis states the principal thematic idea for *Shh* and then embarks on an extended improvisation based on that material. Notice throughout the high level of musical interplay between Davis and the other musicians. In some ways, this almost borders on collective improvisation, but Davis is clearly in the lead.
5:16	Trumpet solo concludes, followed by an interlude section featuring interplay between the guitar and keyboards.
5:55	Drums drop out and the groove shifts for a bit as the interplay between guitar and keyboards continues.
6:14	Drums return. Call and response passages and other bits of collective improvisation continue between guitar and keyboards. This marks the actual beginning of the *Peaceful* section.
9:13	Wayne Shorter enters on soprano sax. His solo is accompanied by extended interplay with the keyboard players.
10:43	The sax solo comes to an end at one of the rougher edit points on the recording, and the guitar/keyboard interplay becomes the focal point of the recording once again.
11:57	At this point, the recording returns to the *Shh* material heard at the very beginning of the track, giving the final edited performance a clear A-B-A structure. Credit here is due to producer Teo Macero, who took an active role in helping create the edit of the final product.
13:41	Through the magic of tape editing, Miles Davis returns with the same melodic material presented at his first entrance on the track back at 1:42.
17:14	As the trumpet solo comes to an end, the groove continues. Improvisation and musical interplay continue between the other musicians as the track drifts toward a rather abrupt fadeout.

In two excerpts from his book *Miles: The Autobiography*, Miles Davis discusses how his then wife, Betty Mabry, introduced him to new black music sounds, and later he goes on to discuss the development of the material that became the seminal double album *Bitches Brew*.

RECORDINGS

🎺

In A Silent Way;
Bitches Brew

BOOK

🎺

Miles: The
Autobiography by
Miles Davis with
Quincy Troupe

Jimi Hendrix, *In A Silent Way* and *Bitches Brew* by Miles Davis

The music I was really listening to in 1968 was James Brown, the great guitar player Jimi Hendrix, and a new group who had just come out with the hit record "Dance to the Music," Sly and the Family Stone, led by Sly Stewart, from San Francisco. The s--t he was doing was badder than a motherf----r, had all kinds of funky s--t up in it. But it was Jimi Hendrix that I first got into when Betty Mabry turned me on to him.

I first met Jimi when his manager called up and wanted me to introduce him to the way I was playing and putting my music together. Jimi liked what I had done on *Kind of Blue* and some other stuff and wanted to add more jazz elements to what he was doing. He liked the way Coltrane played with all those sheets of sound, and he played the guitar in a similar way. Plus, he said he had heard the guitar voicing that I used in the way I played the trumpet. So we started getting together. Betty really liked this music—and later, I found out, she liked him physically, too—and so he started to come around.

He was a real nice guy, quiet but intense, and was nothing like people thought he was. He was just the opposite of the wild and crazy image he presented on the stage. When we started getting together and talking about music, I found out that he couldn't read music. Betty had a party for him sometime in 1969 at my house on West 77th. I couldn't be there because I had to be in the studio that night recording, so I left some music for him to read and then we'd talk about it later. (Some people wrote some s--t that I didn't come to the party for him because I didn't like having a party for a man in my house. That's a lot of bulls--t.)

When I called back home from the studio to speak to Jimi about the music I had left him, I found out he didn't read music. There are a lot of great musicians who don't read music—black and white—that I have known and respected and played with. So I didn't think less of Jimi because of that. Jimi was just a great, natural musician—self-taught. He would pick up things from whoever he was around, and he picked up things quick. Once he heard it he really had it down. We would be talking, and I would be telling him technical s--t like, "Jimi, you know, when you play the diminished chord. . . ." I would see this lost look come into his face and I would say, "Okay, okay, I forgot." I would just play it for him on the piano or on the horn, and he would get it faster than a motherf----r. He had a natural ear for hearing music. So I'd play different s--t for him, show him that way. Or I'd play him a record of mine or Trane's and explain to him what we were doing. Then he started incorporating things I told him into his albums. It was great. He influenced me, and I influenced him, and that's the way great music is always made. Everybody showing everybody else something and then moving on from there.

But Jimi was also close to hillbilly, country music played by them mountain white people. That's why he had those two English guys in his band, because a lot of white English musicians liked that American

hillbilly music. The best he sounded to me was when he had Buddy Miles on drums and Billy Cox on bass. Jimi was playing that Indian kind of s--t, or he'd play those funny little melodies he doubled up on his guitar. I loved it when he doubled up s--t like that. He used to play 6/8 all the time when he was with them white English guys and that's what made him sound like a hillbilly to me. Just that concept he was doing with that. But when he started playing with Buddy and Billy in the Band of Gypsies, I think he brought what he was doing all the way out. But the record companies and white people liked him better when he had the white guys in his band. Just like a lot of white people like to talk about me when I was doing the nonet thing—the *Birth of the Cool* thing—or when I did those other albums with Gil Evans or Bill Evans because they always like to see white people up in black s--t, so that they can say they had something to do with it. But Jimi Hendrix came from the blues, like me. We understood each other right away because of that. He was a great blues guitarist. Both him and Sly were great natural musicians; they played what they heard.

So, that's the way my head was as far as music was going. First, I had to be comfortable with what I was going to be playing. Then, I had to find the right musicians. It was a process of playing with different people and picking my way forward. I spent time listening to and feeling what certain people could play and give, and what they couldn't, and picking and choosing the ones who would fit, and eliminating the ones who wouldn't. People eliminate themselves when there's nothing happening—or they should.

■ ■ ■

Nineteen sixty-nine was the year rock and funk were selling like hotcakes and all this was put on display at Woodstock. There were over 400,000 people at the concert. That many people at a concert makes everybody go crazy, and especially people who make records. The only thing on their minds is, How can we sell records to that many people all the time? If we haven't been doing that, then how can we do it?

That was the atmosphere all around the record companies. At the same time, people were packing stadiums to hear and see stars in person. And jazz music seemed to be withering on the vine, in record sales and live performances. It was the first time in a long time that I didn't sell out crowds everywhere I played. In Europe I always had sellouts, but in the United States, we played to a lot of half-empty clubs in 1969. That told me something. Compared to what my records used to sell, when you put them beside what Bob Dylan or Sly Stone sold, it was no contest. Their sales had gone through the roof. Clive Davis was the president of Columbia Records and he signed Blood, Sweat and Tears in 1968 and a group called Chicago in 1969. He was trying to take Columbia into the future and pull in all those young record buyers. After a rough start he and I got along well, because he thinks like an artist instead of a straight businessman. He had a good sense for what was happening; I thought he was a great man.

He started talking to me about trying to reach this younger market and about changing. He suggested that the way for me to reach this new audience was to play my music where they went, places like the Fillmore. The first time we had a conversation I got mad with him because I thought he was putting down me and all the things I had done for Columbia. I hung up on him after telling him I was going to find another record company to record for. But they wouldn't give

me a release. After we went back and forth in these arguments for a while, everything finally cooled down and we got all right again. For a while, I was thinking about going over to Motown Records, because I liked what they were doing and figured that they could understand what I was trying to do better.

What Clive really didn't like was that the agreement I had with Columbia allowed me to get advances against royalties earned, so whenever I needed money, I would call up and get an advance. Clive felt that I wasn't making enough money for the company to be giving me this type of treatment. Maybe he was right, now that I'm looking back on all of it, but right from a strictly business position, not an artistic one. I felt that Columbia should live up to what they had agreed to. They thought that since I sold around 60,000 albums every time I put out a record—which was enough for them before the new thing came around—that wasn't enough to keep on giving me money.

So this was the climate with Columbia and me just before I went into the studio to record *Bitches Brew*. What they didn't understand was that I wasn't prepared to be a memory yet, wasn't prepared to be listed only on Columbia's so-called classical list. I had seen the way to the future with my music, and I was going for it like I had always done. Not for Columbia and their record sales, and not for trying to get to some young white record buyers. I was going for it for myself, for what I wanted and needed in my own music. *I* wanted to change course, *had* to change course for me to continue to believe in and love what I was playing.

When I went into the studio in August 1969, besides listening to rock music and funk, I had been listening to Joe Zawinul and Cannonball playing s--t like "Country Joe and the Preacher." And I had met another English guy, named Paul Buckmaster, in London. I asked him to come over sometime and help me put an album together. I liked what he was doing then. I had been experimenting with writing a few simple chord changes for three pianos. Simple s--t, and it was funny because I used to think when I was doing them how Stravinsky went back to simple forms. So I had been writing these things down, like one beat chord and a bass line, and I found out that the more we played it, it was always different. I would write a chord, a rest, maybe another chord, and it turned out that the more it was played, the more it just kept getting different. This started happening in 1968 when I had Chick, Joe, and Herbie for those studio dates. It went on into the sessions we had for *In A Silent Way*. Then I started thinking about something larger, a skeleton of

A NOVEL BY MILES DAVIS

Bitches Brew is an incredible journey of pain, joy, sorrow, hate, passion, and love. Bitches Brew is a new direction in music by Miles Davis. Bitches Brew is a novel without words.

Bitches Brew is a specially priced 2-record set.
ON COLUMBIA RECORDS

Magazine advertisement announcing the groundbreaking new recording by Miles Davis titled Bitches Brew. *Courtesy of Tad Hershorn at the Institute of Jazz Studies, Rutgers University*

a piece. I would write a chord on two beats and they'd have two beats out. So they would do one, two, three, da-dum, right? Then I put the accent on the fourth beat. Maybe I had three chords on the first bar. Anyway, I told the musicians that they could do anything they wanted, play anything they heard but that I had to have this, what they did, as a chord. Then they knew what they could do, so that's what they did. Played off that chord, and it made it sound like a whole lot of stuff.

I told them that at rehearsals and then I brought in these musical sketches that nobody had seen, just like I did on *Kind of Blue* and *In A Silent Way*. We started early in the day in Columbia's studio on 52nd Street and recorded all day for three days in August. I had told Teo Macero, who was producing the record, to just let the tapes run and get everything we played, told him to get *everything* and not to be coming in interrupting, asking questions. "Just stay in the booth and worry about getting down the sound," is what I told him. And he did, didn't f--k with us once and got down everything, got it down real good.

So I would direct, like a conductor, once we started to play, and I would either write down some music for somebody or I would tell him to play different things I was hearing, as the music was growing, coming together. It was loose and tight at the same time. It was casual but alert, everybody was alert to different possibilities that were coming up in the music. While the music was developing I would hear something that I thought could be extended or cut back. So that recording was a development of the creative process, a living composition. It was like a fugue, or motif, that we all bounced off of. After it had developed to a certain point, I would tell a certain musician to come in and play something else, like Benny Maupin on bass clarinet. I wish I had thought of video taping that whole session because it must have been something and I would have liked to have been able to see just what went down, like a football or basketball instant replay. Sometimes, instead of just letting the tape run, I would tell Teo to back it up so I could hear what we had done. If I wanted something else in a certain spot, I would just bring the musician in, and we would just do it.

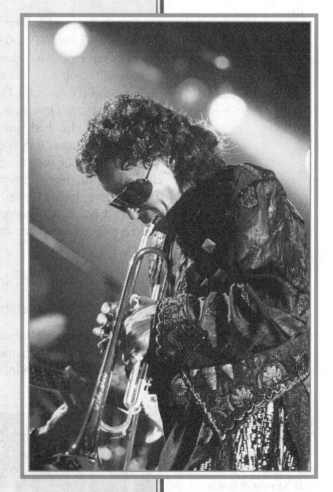

Late in his career, Miles Davis began playing a trumpet with a distinctive red lacquer finish and a microphone system that was easily attached to the horn for freedom of movement. This photo is from the late 1980s or possibly the early 1990s.
David Redferns/Redferns/ Getty images

That was a great recording session, man, and we didn't have any problems as I can remember. It was just like one of them old-time jam sessions we used to have up at Minton's back in the old bebop days. Everybody was excited when we all left there each day.

Some people have written that doing *Bitches Brew* was Clive Davis's or Teo Macero's idea. That's a lie, because they didn't have nothing to do with none of it. Again, it was white people trying to give some credit to other white people where it wasn't deserved because the record became a break-through concept, very innovative. They were going to rewrite history after the fact like they always do.

What we did on *Bitches Brew* you couldn't ever write down for an orchestra to play. That's why I didn't write it all out, not because I didn't know what I wanted; I knew that what I wanted would come out of a process and not some prearranged s--t. This session was about improvisation, and that's what makes jazz so fabulous. Any time the weather changes it's going to change your whole attitude about something, and so a musician will play differently, especially if everything is not put in front of him. A musician's attitude is the music he plays.

Reprinted with the permission of Simon & Schuster, Inc., from *MILES: The Autobiography* by Miles Davis with Quincy Troupe. Copyright © 1989 by Miles Davis. All rights reserved.

The album *Bitches Brew* eventually reached number 35 on the *Billboard* pop chart and sold over 400,000 copies in 1970 alone. The album would go on to sell well over a million copies and remains in print on CD today. Miles began performing as the opening act for large rock shows including Blood, Sweat & Tears, Santana, and the Grateful Dead.[3] "Deadheads" in particular seemed very open to the extended jams Davis was exploring at this point in his career. Around this time, Miles and Hendrix had jammed together in private on several occasions. In fact, some sources suggest they had planned to record together, but due to Jimi Hendrix's untimely death the recording never materialized. Miles Davis continued to explore different approaches to fusion until his death in 1991. Some of his most important late recordings include the albums *Tutu* and *Amandla*. Like several other previously mentioned bands, the various groups Miles Davis fronted in the 1970s and 80s became training camps for an entire generation of fusion musicians.

Miles Davis Alumni

John McLaughlin and the Mahavishnu Orchestra

One of the first breakthrough fusion groups after Miles Davis, the Mahavishnu Orchestra was an international collection of creative artists including British guitarist John McLaughlin, American Billy Cobham on drums, Czech keyboard

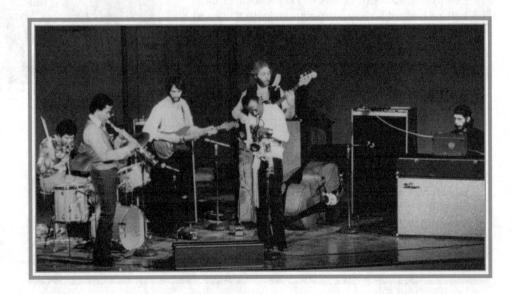

Younger musicians performing with Miles Davis, ca. 1970. After working with Davis, each of these men went on to have major careers in jazz, and they are all still very active performers today. Left to right: Jack DeJohnette, drums; Wayne Shorter, soprano sax; John McLaughlin, guitar; Miles Davis, trumpet; Dave Holland, bass; and Chick Corea, keyboards. Courtesy of John McLaughlin

player Jan Hammer, Irish bassist Rick Laird, and rock violinist Jerry Goodman (later replaced by French avant-garde player Jean-Luc Ponty). Their first two albums, *The Inner Mounting Flame* and *Birds of Fire*, both made it into the top 100 on the *Billboard* chart, with *Birds of Fire* eventually climbing all the way to number 15.[4] The recent book *Jazz: The First 100 Years* describes the band this way:

> In contrast to the loose, often ethereal jazz-rock improvisations played by Miles Davis . . . the Mahavishnu Orchestra was tightly rehearsed. The group played dazzling unison figures, complex meters (such as 7/8 or 5/16), ostinato figures—sometimes indebted to Indian music—and rock rhythms pounded out at a ferocious velocity by drummer Billy Cobham, who used a drum set with double bass drums, one played by each foot. On doublenecked guitar, using wah-wah pedal and other electronic devices, McLaughlin tore through rapid-fire sixteenth-note solo passages, bending notes and using distortion at deafening volume. . . . Not all of the compositions played by the Mahavishnu Orchestra relied on high-octane, blisteringly fast playing. [Tunes such as] *A Lotus on Irish Streams* . . . and *Open Country Joy* . . . are pastoral, acoustic reveries. Much of the band's impact derived from the dramatic juxtaposition of acoustic works such as these with high-energy electric compositions.[5]

Guitarist John McLaughlin remains an active performer today, playing a wide array of musical styles, including an extended tour in the Fall of 2017 that revisits the music of the Mahavishnu Orchestra, which he will perform with his current band, The 4th Dimension. Recent solo projects include the 2015 release *Black Light* and the related 2006 release *Industrial Zen*, among a number of other fine recordings from the past 40 plus years. Some notable earlier releases include a 1996 recording titled *The Guitar Trio* with fellow guitarists Al Di Meola and the late Paco De Lucia, and the 1993 recording *Time Remembered: John McLaughlin plays Bill Evans*. Visit McLaughlin's extensive website to explore his impressive and diverse musical career.

Weather Report

Made up of several musicians who worked on both *In A Silent Way* and *Bitches Brew*, the band Weather Report went through several personnel changes before it arrived at its most successful lineup of musicians. The most popular version of Weather Report featured Joe Zawinul, keyboards; Wayne Shorter, saxes; Peter Erskine, drums; and Jaco Pastorius, bass. In 1977, largely on the strength of their hit song *Birdland*, the album *Heavy Weather* climbed to number 30 on the *Billboard* chart and sold over 500,000 copies.[6] The song *Birdland* became an instant jazz classic. It was later recorded in a big band version by Maynard Ferguson, in a vocalese version by Manhattan Transfer, and even with elements of hip-hop by Quincy Jones and friends. You will find Weather Report's hit version of *Birdland* on your Spotify playlist for this chapter.

With the exception of Jaco Pastorius (who died tragically in 1987), the members of Weather Report continued to record and perform both individually and in various collaborations for many years. Drummer Peter Erskine is well known for being a versatile musician, and his playing style is still in great demand by a wide array of artists. Saxophonist Wayne Shorter, already a jazz legend before he joined Weather Report, has become a true elder statesman in the world of jazz. He still performs and records on a regular basis as of this writing. Finally, until his death in 2007, keyboard player Joe Zawinul also remained an active performer, often blending elements of world music and jazz in his recordings and live shows.

Dig Deeper
RECORDINGS

The Inner Mounting Flame; Birds of Fire

Dig Deeper
RECORDINGS

Black Market; Heavy Weather
Jaco Pastorius: *The Birthday Concert*

DOCUMENTARY

Weather Report: Live at Montreux 1976

BOOKS

Jaco: The Extraordinary and Tragic Life of Jaco Pastorius by Bill Milkowski
Footprints: The Life and Work of Wayne Shorter by Michelle Mercer
In a Silent Way: A Portrait of Joe Zawinul by Brian Glasser

Listening Guide

Birdland (Josef Zawinul)

Example of fusion in the 1970s as recorded by alumni of the Miles Davis band
Album: *Heavy Weather*, released 1977
Performed by Weather Report. Josef Zawinul, synthesizers, acoustic piano, melodica, and vocal; Wayne Shorter, soprano and tenor saxes; Jaco Pastorious, electric bass, mandocello, and vocal; Alex Acuna, drums; and Manolo Badrena, percussion

Weather Report was one of the hottest fusion bands of the 70s and early 80s, and this tune was their biggest hit. Compared to material released by Miles Davis, this is a much more pop-oriented style of fusion. It still contains an excellent improvised solo by Wayne Shorter and some very creative playing by everyone in the band, but the overall performance is definitely more accessible to a larger (even non-jazz fan) audience. The format here is a series of brief melodic statements connected by a relentless, driving rhythmic groove.

Total time: 5:58

:00	Opening bass groove is established.
:18	1st melody.
:43	2nd melody.
:55	Brief interlude with little melodic action.
1:02	3rd melody.
1:31	4th melody.
1:45	Brief collective improvisation between bass and acoustic piano.
1:59	5th melody. Simple 4-bar riff that is used to build up to full-band shout sound, not unlike that in a swing era big band.
2:36	Longer interlude designed to release some of the tension created by the previous section.
2:48	Brief improvisation on synthesizer.
3:07	Brief improvisation on tenor sax.
3:36	Return of 1st melody, heavily modified andaccompanied by a return to the original bass groove at 3:46.
3:59	Return of 2nd melody.
4:12	Return of 3rd melody.
4:23	Return of 5th melody. Builds up again until the final fadeout at 5:54.

The band Weather Report performing live at the Hammersmith Odeon, a famous music venue in west London, England. Left-to-right: Joe Zawinul, keyboards; Wayne Shorter, saxophone; and Jaco Pastorius, fretless electric bass.
Mike Prior/Redferns/Getty images

Herbie Hancock

After several commercially unsuccessful attempts at fusion, Herbie Hancock and his band reached number 13 on the *Billboard* pop chart in 1973 and eventually sold over one million copies with their album titled *Head hunters*. The hit tune from the album, *Chameleon*, is considered by many to be the ultimate statement of funk brought into the jazz-rock or fusion arena.[7] The following listening guide will take you through the entire album version of *Chameleon*.

Keyboard legends Herbie Hancock (left) and Chick Corea (right) performing together at The Kennedy Center in Washington, D.C. in 2015.
The Washington Post/Getty Images

Hancock would later have one of the first fusion hits on MTV with a tune called *Rockit*. Released in 1983, the tune itself was a catchy little number with a nice funk groove. What really set the tune apart, however, was that it was accompanied by a very creative video that found itself in heavy rotation on the fledgling MTV. Following the success of *Rockit*, Hancock has gone back and forth between different styles of fusion and classic acoustic jazz. He has even undertaken some acting, portraying musicians in several films including *Round Midnight*. In 2008, Hancock won a Grammy Award for Album of the Year for the recording *River: The Joni Letters*, which is an amazing achievement for a jazz recording in the twenty-first century. He followed that up with *The Imagine Project in 2010*. Both recordings feature collaborations with a wide array of artists from many different musical styles. For a further look into the life of Herbie Hancock, read the article in Chapter 11 that features a discussion between Wynton Marsalis and Hancock taken from *Musician* magazine.

Dig Deeper

RECORDINGS

Return to Forever: *Light as a Feather* and *The Romantic Warrior*
Chick Corea: *Trilogy; Live at the Blue Note; Hot House* (with Gary Burton); *The Mozart Sessions* and *Play* (with Bobby McFerrin); *Two* and *Enchantment* (with Béla Fleck); *Originals-Part One* and *Standards-Part Two* (solo piano)

DOCUMENTARY

Chick Corea: Rendezvous in New York

Village Voice *ad featuring the Chick Corea Elektric Band and the Branford Marsalis Quartet (see Chapter 11) in a double bill.*

Chick Corea

When Herbie Hancock got food poisoning on his honeymoon, Miles Davis hired keyboard player Chick Corea to take Hancock's place in his band. Eventually Corea, Hancock, and Joe Zawinul all played electric keyboards on fusion recordings made by Davis. After leaving Miles' band in the early 70s, Chick Corea formed a band called Return to Forever. As first organized, the band focused on Latin jazz fusions and featured Brazilian singer Flora Purim. Later, Corea altered the band's personnel and musical direction, embracing the same kind of electric fusion being played by the Mahavishnu Orchestra. If anything, Return to Forever went even deeper into rock grooves. You can experience the orchestral and rock mix of this band on the track *The Romantic Warrior* found on Spotify.

Listening Guide

Dig Deeper
WEBSITE

www.chickcorea.com

The Romantic Warrior (Chick Corea)

Example of more rock-oriented fusion with many classical elements as well

Album: *The Romantic Warrior*, released 1976

Performed by Return to Forever. Chick Corea, acoustic piano and electronic keyboards; Al Di Meola, acoustic and electric guitars; Stanley Clarke, acoustic and electric basses; and Lenny White, drums and percussion. NOTE: Instruments listed are used on entire album. Some are not found on this track.

This band covered a vast musical territory, exploring jazz, rock, Latin styles, and even elements of classical music.

Total time: 10:51

:00	Long, rather ethereal introduction.
1:44	Piano establishes the beginning of the main theme group, quickly joined by the bass and guitar entrances.
3:18	Bass solo begins. This particular solo was most likely created in two parts over one continuous accompaniment.
3:18	1st part of bass solo is played on an acoustic bass using a bow in the classical tradition.
3:45	2nd part of bass solo seamlessly switches to pizzicato bass played in the standard manner.
4:11	Bass solo continues. Note Corea's establishment of a riff played on acoustic piano. This riff will appear later in both the guitar solo and Corea's own piano solo.
4:52	Piano returns to a brief statement from the main theme group, followed quickly by the rest of the band.
5:19	Acoustic guitar solo begins.
5:58	Piano riff returns as guitar solo continues.
6:46	Bass returns to a brief statement from the main theme group, followed quickly by the rest of the band.
7:20	Piano solo begins.
8:28	Corea hints at earlier piano riff again and also quotes a short part of the main theme.
8:52	Main theme group returns, played by entire band, with melodic extensions toward the end.
9:58	Tune ends with material reminiscent of the sounds used in the introduction, followed by one last technical flourish played by the entire band.

In recent years Corea has undertaken a number of diverse musical projects, recording and touring with both his Elektric Band and his Acoustic Band. He has also made a number of recordings with other major jazz figures including singer Bobby McFerrin, vibe player Gary Burton, and banjo virtuoso Béla Fleck. As of this writing in 2017, Corea has won 22 Grammy awards, including awards for recent projects that include *Trilogy* (a three-disc set with his current acoustic trio with bassist Christian McBride and drummer Brian Blade), *Hot House* (with Gary Burton), *Forever* (with former Return to Forever band members bassist Stanley Clarke and drummer Lenny White), *Five Peace Band* (with guitarist John McLaughlin), and *Corea Concerto* (which features Corea performing his composition *Concerto No. 1* with the London Philharmonic Orchestra). Chick Corea's recorded output is quite prolific, and you can find over 70 current releases in a wide array of musical styles on Spotify, among many other resources for recorded music. You can also view a number of excellent live concerts featuring Corea in performance on YouTube.

Some Other Representative Examples of Fusion

Chuck Mangione

Flugelhorn player, composer, and band leader Chuck Mangione was one of the first fusion musicians in the 1970s to explore a more pop-oriented approach to jazz. Long before Kenny G made playing music geared toward a pop audience a crime in the jazz world, Mangione was filling the radio airwaves with the tune *Feels So Good*. At the height of his success, Mangione was fronting a big band and an excellent fusion quintet. His concerts were major events that were frequently sold out. Albums such as *Live at the Hollywood Bowl* and the film soundtrack *Children of Sanchez* display a gifted composer/arranger who had the ability to organize a very talented group of musicians to perform his music. The often overlooked *Tarantella*, which has yet to be released on CD, added guest artists Chick Corea and Dizzy Gillespie to the regular band for one of the best live big band fusion albums made in the 1980s. In recent years, Mangione has continued to compose and record, but he has scaled back his schedule a great deal. Members of his band, including woodwind player Chris Vadala and guitarist Grant Geissman, have gone on to careers as solo performers and music educators. The following listening guide is for the extended album version of the tune *Feels So Good*.

Dig Deeper

RECORDINGS

Feels So Good; Children of Sanchez; Live at the Hollywood Bowl; Tarantella (LP only)

Saxophone player Chris Vadala (left) performing with flugelhorn player and bandleader Chuck Mangione.
Photo by Kerry Decker.
Courtesy of Chris Vadala and Kerry Decker

Listening Guide

Feels So Good (Chuck Mangione)

Example of a lighter style of fusion as played by Chuck Mangione and his small band
Album: *Feels So Good*, released in 1977
Performed by Chuck Mangione, flugelhorn and electric piano; Chris Vadala, all woodwinds; Grant Geissman, all guitars; Charles Meeks, bass; and James Bradley Jr., drums

The nine-minute-plus version of this tune presented here is the full track from the *Feels So Good* album. This same material was edited down to a pop-friendly radio performance of under four minutes, and in that version the tune climbed to number four on the pop charts and was nominated for a Grammy Award for Record of the Year. The sustained airplay on pop radio was one of the reasons this tune became such a hit. To accommodate the pop radio format, the entire slow introduction was cut, and much of the improvisation was shortened or eliminated altogether. In live concerts, however, Mangione and his group never compromised, always playing extended, newly improvised solos, presenting the music in a fresh light at every show. Regarding the making of the album *Feels So Good*, saxophonist Chris Vadala states: "Chuck Mangione didn't like to rehearse his new material before a recording session, so these tracks were quite spontaneous and often first takes with the exception of the overdubs."

Total time: 9:38

:00	The track begins with a long, rhythmically free introduction that explores elements of the tune's main melody and harmonic progression, along with some nice improvisation by Mangione on flugelhorn.
1:35	The rhythmic groove and tempo that will be used for the rest of the track are established by Grant Geissman on guitar, who is quickly joined by the rest of the rhythm section and more layers of overdubbed guitar licks.
2:09	The main melody of the tune begins, played by Chuck Mangione on flugelhorn. The tune has three parts, one of which is used as a refrain that sometimes functions as a sound bed for improvisation. It works like a modern version of a swing riff.
3:14	The melody of the tune is stated again, this time featuring guitar.
4:17	Chris Vadala begins an extended improvised sax solo. Notice that you will also hear more sax sounds in the background licks. Again, the improvised solo came first, and the overdubbed background parts were added later.
5:20	Improvised guitar solo begins.
6:21	Mangione returns with another statement of the melody played on flugelhorn.
7:26	A vamp section begins that features improvised call and response between sax and flugelhorn. In a radio edit of this tune, and indeed many tunes created for pop radio, this sort of section would be used as a place to fade into the next tune or announcement. In this particular album recording, however, the fade actually happens a couple of minutes later.
8:39	The vamp groove continues as the band returns to a portion of the melody and begins a long fadeout. As the fade continues, you will notice more improvisation on tenor sax from Chris Vadala.

Source: Chris Vadala, personal interview, March 21, 2011.

Recent Press photograph of the band Spyro Gyra. Left-to-right: Lionel Cordew (drums), Julio Fernandez (guitar), Jay Beckenstein (saxophone), Scott Ambush (bass), and Tom Schuman (keyboards).
Spyro Gyra.com/ Industry

Spyro Gyra

Appearing on the international music scene at roughly the same time as Chuck Mangione, Spyro Gyra is today one of the longest lived fusion bands in existence. With numerous recordings to its credit, the band has continuously turned out high-quality, audience-friendly jazz fusion. Some critics call their music predictable, but it seems to be what their fans enjoy. All the members of the band are gifted jazz improvisers who have made a very conscious decision to play in their chosen style. To get a good sense of that style, look for albums such as *Morning Dance*, *Catching the Sun*, or *Dreams Beyond Control*, and, most recently, *Down the Wire*, *A Foreign Affair*, and *The Rhinebeck Sessions*.

Grover Wasington, Jr.

Saxophonist Grover Washington, Jr. is best remembered today for his creative and commercially successful fusion jazz style. Along with artists such as George Benson, Bob James, and Al Jarreau, among others, Washington is frequently credited with the creation of a style that would eventually be known as "smooth jazz." A gifted improviser and composer, Washington created a series of very successful albums in the 1970s and early 80s that reached a tremendous audience. Albums such as *Mister Magic*, *Winelight*, and *The Best Is Yet To Come* all enjoyed long chart runs, with some of his collaborations with vocalists becoming chart-toppers that can still be heard in rotation today on various streaming and local commercial radio stations. Particularly memorable are the tunes *Just the Two of Us* with singer Bill Withers (from the album *Winelight*) in 1981 and the title track from *The Best is Yet To Come* with singer Patti LaBelle in 1983. Never one to rest on his laurels, however, Washington continued to push himself musically, releasing albums that explored a number of different jazz styles and undertaking collaborations with diverse artists including opera star Kathleen Battle, guitarist Kenny Burrell, pianists Mal Waldron and Randy Weston, cool school saxophonist Gerry Mulligan, hard

Saxophonist Grover Washington, Jr. rehearsing with guitarist Kenny Burrell and bass player Reggie Workman in 1985 as they prepare for a show titled One Night With Blue Note *that took place at Town Hall in New York City.*
Anthony Barboza/Archive Photo/Getty Images

bop saxophonist Dexter Gordon, and hard bop/fusion trumpet player Eddie Henderson. Long before there was a Kenny G, there was Grover Washington, Jr., making accessible music in a fusion jazz style. And, quite frankly, at this point in the history of jazz, while the "Kenny G phenomenon" has largely passed away, the recordings of Grover Washington, Jr. remain a strong testimony to a gifted artist who made a concise choice to create accessible music. For more information on this issue, see our discussion on Smooth Jazz in Chapter 11.

The Brecker Brothers

Trumpet player Randy Brecker and saxophonist Michael Brecker covered a great deal of musical territory during their time together. Recording as the Brecker Brothers, they put down some of the strongest fusion ever recorded. They explored the use of a number of electronic effects on their respective horns and were also early adopters of various wind synthesizer technologies. Their albums *Heavy Metal Bebop* (long out of print in America but now available in an eight disc box set titled *Brecker Brothers: The Complete Arista Album Collection*) or the more recent GRP release *Return of the Brecker Brothers* are both good introductions to the Brecker Brothers band. Both singularly and together these men were "first call" musicians, prominently featured with artists such as Joni Mitchell, Paul Simon, James Taylor, Blood, Sweat & Tears, and the Saturday Night Live band. They both appeared regularly as sidemen in all kinds of musical situations and seemed to fit right in no matter what style of music they were playing. Michael Brecker passed away in 2007, but his brother Randy continues working in a number of different musical situations. Most recently, he released a CD titled *RandyPOP!* that celebrates some of the most famous popular music recordings he took part in throughout his extensive career as a studio musician. Among his many other notable recordings, check out *34th n Lex, Paris By Night*, and *Trumpet Summit Prague: The Mendoza Arrangements* (with fellow trumpet players Bobby Shew and Jan Hassenöhrl). You can also check out Randy Brecker's straight-ahead jazz style on the album *Paris By Night*.

The following listening guide is for a track titled *Escher Sketch (A Tale of Two Rhythms)* from the Michael Brecker album *Now You See It . . . Now You Don't*. In addition to playing the saxophone, Michael Brecker was a pioneer in the use of the **EWI**, or Electronic Wind Instrument, a wind-controlled synthesizer. You will hear both instruments prominently displayed on this tune.

Dig Deeper
RECORDINGS

*Heavy Metal Bebop;
Return of the
Brecker Brothers*

Saxophonist Michael Brecker during a performance at the Outpost Performance Space in Albuquerque, New Mexico. Photographer Jim Gale has become a regular fixture on the Albuquerque jazz scene and has captured a number of excellent jazz artists in performance.
Courtesy of James Gale

Listening Guide

What Is Hip (S. Kupka, E. Castillo, and D. Garibaldi)

Example of the Tower of Power horn band sound
Album: *Tower of Power*, released in 1973
Performed by Tower of Power. Lenny Williams, lead vocals; Lenny Pickett and Emilio Castillo, tenor sax and vocals; Stephen Kupka, baritone sax and vocals; Mic Gillette and Greg Adams, trumpet and vocals; Bruce Conte, guitar and vocals; Chester Thompson, organ and vocals; Francis Prestia, bass; David Garibaldi, drums; and Brent Byars, congas and bongos

This tune uses a standard verse/chorus format found in almost all popular vocal music. The improvised horn solos take place over rhythmic vamps and/or the chord progressions used in the vocal chorus. In live versions of this tune the instrumentalists tend to stretch out the improvisation more than is evident on this original track, and the band has revisited this material several times on record and in videos. This, however, is the version that started it all for a band that has been together now for over 40 years!

Total time: 5:04

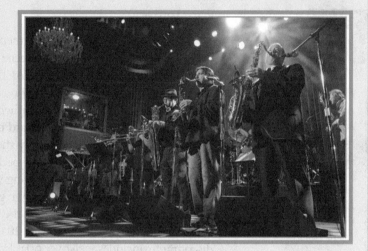

The Tower of Power horn section in action.
Photo by Frank Anazalone Photography

:00	Tune begins with a vamp featuring an improvised guitar solo.
:19	Vocal verse begins.
:37	Vocal chorus. As the vocal ends the chorus concludes with a trumpet improvisation, followed by a return to the guitar vamp.
1:01	Vamp with solo guitar returns.
1:10	2nd vocal verse begins.
1:29	2nd vocal chorus begins, which again closes with an improvised trumpet solo.
1:52	Band and lead vocalist introduce a repeated new melody built over the line "hipness is, what it is (3x), and sometimes hipness is what it ain't!"
2:12	Vamp with solo guitar solo returns.

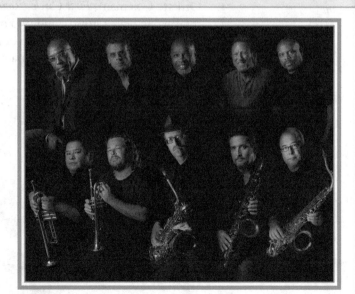

Recent Tower of Power press photo.
Courtesy of Tower of Power

2:21 3rd vocal verse begins.

2:39 3rd vocal chorus begins. Again, as the vocal comes to an end the chorus extends with more improvised trumpet, this time with a much longer section that is coupled with complex horn and rhythm section background licks.

3:22 This section begins with a Hammond B-3 organ solo that leads to a return of the vocal chorus, which is now used as a vamp featuring more keyboard improvisation, horn licks, and vocal call and response between the lead vocalist and other band members.

4:44 Tune comes to a conclusion with a final statement of a horn gesture that was heard earlier in the chart.

Dig Deeper

RECORDINGS

Pat Metheny Group; As Wichita Falls, So Falls Wichita Falls; First Circle; Song X (with Ornette Coleman); *Road to You: Live in Europe; Secret Story; Orchestrion; What's It All About*

WEBSITE

www.patmetheny. com

Pat Metheny

Electric guitar virtuoso Pat Metheny is frequently mentioned as the most influential guitarist to appear on the jazz scene in the past 30 or 40 years. When you consider that this scene includes guitarists Al Di Meola, John Scofield, Larry Coryell, Mike Stern, and John McLaughlin, among others, this is high praise indeed. After getting his start performing with Weather Report bassist Jaco Pastorius and vibe player Gary Burton, Metheny met keyboard player Lyle Mays and formed the first of many groups that would be called simply the Pat Metheny Group. Over the course of his diverse career, Metheny has gone back and forth between performing challenging music on the fringes of jazz to playing very relaxed and immediately accessible fusion. In addition to recording with his own groups, he has made recordings with musicians as diverse as Ornette Coleman and the London Symphony Orchestra.

As of 2017, Metheny has won 20 Grammy Awards in various categories, and his discography includes well over 60 releases as soloist, in various duo and trio settings, with his band The Pat Metheny Group, and as guest artist on a wide array of recording projects and soundtracks. A sampling of some of his most interesting recordings includes *As Wichita Falls, So Falls Wichita Falls* (with Lyle Mays), *Song X* (with Ornette Coleman), *First Circle, Road to You: Live in Europe*, and *This Way Up* (with the Pat Metheny Group), and two more meditative solo projects titled *What's It All About* and *One Quiet Night*. Also of particular note are his recent collaborations with pianist Brad Mehldau, among many, many other side projects. One unique project

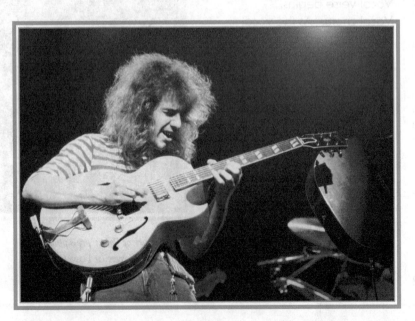

Guitarist Pat Metheny.
Derick Thomas/Corbis
Historical/Getty Images

from 2010 was titled *Orchestrion*, which featured Metheny as a solo artist onstage (and on record) but performing with a number of different instruments that were all controlled by his guitar or through pre-arranged composition over which he could then improvise. This incredible collection of instruments included various pitched and non-pitched percussion instruments, pianos, a set of blown bottles, and various other instruments created specifically for the project. In many ways, it was basically an attempt to create a twenty-first century version of an extended player piano with added instrumental effects from the late nineteenth and early twentieth centuries, also called an "orchestrion." You can find some very interesting video and discussion of the project on Metheny's extensive website and on YouTube.

Pat Metheny has a loyal group of fans who follow his career very closely, buying each of his new recordings as they come out and making it a point to see him regularly in live concerts. The following listening guide is for the tune *Third Wind* as it was performed on the recording *Road to You: Live in Europe*.

Listening Guide

Third Wind (P. Metheny and L. Mays)

Example of more relaxed fusion style sometimes used by guitarist Pat Metheny
Album: *Road To You: Live In Europe*, released 1993

Performed by Pat Metheny, guitars and guitar synthesizers; Lyle Mays, acoustic piano and electronic keyboards; Paul Wertico, drums and percussion; Armando Marcal, percussion, timbales, congas and vocal; Pedro Aznar, percussion, steel drums, vibes, marimba, melodica, and vocal; and Steve Rodby, bass

The structure of Pat Metheny's music is often very complex, although he manages to make it look and sound very easy. This tune is no exception.

Total time: 8:41 (but note that Spotify track extends out to 9:45 and includes extensive applause and the crowd singing the main theme back to the band)

:00	Following a few percussion hits, if you start counting when you hear the guitar, the introduction to this tune lasts a symmetrical 8 measures.
:19	Letter A material begins, played twice for a total of 16 measures. The first 8 bars feature guitar lead, which is joined by voice the second time through at :32.
:44	Letter B material is presented for 8 measures by both guitar and voice.
:57	Letter A' material is presented. It is an altered version of the first material presented, again featuring both guitar and voice.
1:09	Letter C material for 8 bars, then the music is extended over a pedal point for 10 more bars that take Metheny to the launch of his improvised solo.
1:38	Guitar solo begins with a 4-measure solo break.
3:12	Group jam with pre-arranged solo statements from keyboards and some voices.
5:14	Drums featured. Rest of group's playing slowly grows in intensity. Note that the groove evolves to a modified shuffle groove during this section of the piece. This new rhythmic feel will continue until the end of the performance.
6:01	New, extended pre-arranged melody for various guitar sounds and voices is introduced.
6:48	Final section of melodic content is repeated as a closing vamp before more improvisation from Metheny on synthesized guitar starting at 7:09.
7:57	Pre-arranged melody for guitar and voices returns and repeats until the final chords of the tune.

Notes

1. Michael Erlewine et al., eds., *All Music Guide to Jazz*, 3rd ed. (San Francisco: Miller Freeman Books, 1998), pp. 280–81.

2. Ibid., pp. 281–82.

3. Henry Martin and Keith Waters, Jazz: *The First 100 Years* (Belmont, CA: Wadsworth/Thomson Learning, 2002), pp. 298–300. Also Mark Gridley, *Jazz Styles* 7th ed. (Upper Saddle River, NJ: Prentice Hall, 2000), pp. 342–43.

4. Ibid., p. 303.

5. Ibid.

6. Ibid., p. 316.

7. Gridley, *Jazz Styles*, p. 321.

Study Guide

Chapter 9 Review Questions

True or False

___ 1. Today, fusion refers to a mixture of jazz and any other musical style.

___ 2. Jaco Pastorius played bass with the band Weather Report.

___ 3. Miles Davis broke up his fusion bands in the mid-1980s and returned to performing cool jazz.

___ 4. Fusion uses jazz-sounding melodies, harmonies, and rhythms but no improvisation.

___ 5. Tower of Power has a strong horn section, and all the members of the group have good improvisation skills.

___ 6. Guitarist Grant Geissman has been associated with Chuck Mangione.

___ 7. The Pat Metheny Group often features keyboard player Lyle Mays.

___ 8. In the late 1960s jazz was just as popular as rock-and-roll.

___ 9. Miles Davis and Jimi Hendrix collaborated in the studio on the album *Bitches Brew*.

Multiple Choice

10. With which group was John McLaughlin associated?
 a. Weather Report
 b. Mahavishnu Orchestra
 c. Art Ensemble of Chicago
 d. Tower of Power
 e. The Brecker Brothers

11. Chick Corea's album *Return to Forever*:
 a. explores the use of art-rock and classical music styles in jazz.
 b. was recorded in 1986.
 c. uses the EWI.
 d. uses acoustic instruments only.
 e. features the singer Bobby McFerrin.

12. *Birdland* on your Spotify playlist was recorded by:
 a. the Miles Davis Quintet.
 b. Chuck Mangione.
 c. Chick Corea.
 d. the Tower of Power.
 e. none of the above.

13. Which fusion artist had a hit video on MTV?
 a. Herbie Hancock
 b. Pat Metheny
 c. Chick Corea
 d. Chuck Mangione
 e. Miles Davis

14. *Heavy Metal Bebop* is a fusion album by which artist(s)?
 a. Spryo Gyra
 b. Tower of Power
 c. Chick Corea
 d. The Brecker Brothers
 e. Pat Metheny

15. The tune *Third Wind* comes from which album?
 a. *Song X*
 b. *Road to You: Live in Europe*
 c. *Morning Dance*
 d. *In the Idiom*
 e. *'Round Midnight*

16. Jazz-rock fusion is:
 a. the ultimate music for self-expression.
 b. the best format in which to use non-traditional sounds.
 c. a trend started at Woodstock.
 d. a type of music made popular by the Modern Jazz Quartet.
 e. a type of music made popular by Miles Davis.

Fill in the Blank

17. Pianist _____ plays both electric and acoustic piano on Miles Davis' album *Miles in the Sky*.

18. Weather Report's album *Heavy Weather* made it to number _____ on the Billboard chart.

19. Some critics consider the musical style of the band _____ to be predictable.

20. EWI is short for _____.

21. _____ is Chick Corea's main instrument.

Short Answer

22. List the two Miles Davis albums that introduced jazz-rock fusion to the public.

23. List the three pianists who played electric keyboard on Miles Davis' early fusion albums.

24. Which style of jazz is commercially more successful, free jazz or fusion?

25. What style of jazz do you hear on your recording of *Escher Sketch*?

Essay Questions

1. Using the Internet, look into the careers of artists such as Joni Mitchell, Sly and the Family Stone, and Blood, Sweat & Tears. Discuss the relationship between these artists and Miles Davis. (Hint: the influence goes both ways.)

2. Discuss the impact of Miles Davis on the world of jazz. Consider information in previous chapters as well as this chapter.

Chapter 10

Mainstream Jazz: 1950~Present

It bugs me when people try to analyze jazz as an intellectual theorem. It's not. It's feeling.

Bill Evans

This chapter focuses on a wide variety of artists who derive their styles from the swing era of the 1930s and 40s and the bebop styles of the late 40s and 50s. Their music, however, is full of adaptations and additions. It often brings together some of the newer innovations in jazz while still maintaining a style that tends to be more accessible to the general public.

There are so many great and worthy jazz artists in the world that it is very difficult to pick and choose a few to serve as representative examples in a book of this nature. Furthermore, in addition to the musicians who are the focus of this chapter, be aware that many of the artists mentioned in previous chapters could have at least a portion of their musical output discussed in this chapter as well.

Listening Guide

Come Fly With Me (S. Kahn and J. Van Heusen)

Example of Frank Sinatra performing with the Count Basie Big Band
Album: *Sinatra At the Sands with the Count Basie Orchestra*, recorded in January and February of 1966 and originally released in July 1966

Performance by Frank Sinatra, vocals; Quincy Jones, arranger & conductor; William "Count" Basie, piano (note, also Bill Miller on some album tracks); Marshal Royal and Bobby Plater, alto saxophone; Eric Dixon and Eddie "Lockjaw" Davis, tenor saxophone; Charlie Fowlkes, baritone saxophone; Harry "Sweets" Edison, Al Aarons, Sonny Cohn, Wallace Davenport, and Phil Guilbeau, trumpet; Al Gray, Henderson Chambers, Grover Mitchell, and Bill Hughes, trombone; Freddie Green, guitar; Norman Keenan, bass; Sonny Payne, drums

This classic live recording is a perfect example of how Frank Sinatra and many other solo singers who came out of the swing era continued to back themselves with great jazz musicians. Jazz styles continued to be the backbone of most everything they did as performing artists. As discussed in Chapter 4, Count Basie's band became one of the favored groups for backing up successful mainstream singers throughout the 1950s and beyond. As you listen to this recording, notice Sinatra's amazing style as a singer, of course, but also listen to the great interplay he has with the band. The "Basie style" is firmly established here, and all of the nuances of that style are in full effect, including a driving, but relaxed, rhythm section; a horn section that really swings with a tremendous sense of time; and perfect, subtle little improvised solo fills from various players that enhance but never overshadow Sinatra as the featured performer.

Total time: 3:45

:00 Long introduction, complete with emcee voiceover and band vamp as Frank Sinatra greets the crowd with his first joke of the evening.

:59 Letter A material, 12 measures long ending on a dominant chord so the song can return to the top of the structure.

1:17 Letter A material repeated, also 12 measures long but with changes to the last few bars so the tune ends on a full consonance this time around. (This is typically written in a format that uses something musicians call a first and second ending.)

1:35 Letter B material; two contrasting eight-bar phrases for a total of 16 measures in this section.

2:00 Letter A'. This time around we hear the same 12-measure structure presented at the start of the main tune, but at the end of the normal 12 bar structure the tune extends for an additional 4 measures to reach the final musical climax.

2:24 Band shout chorus. Arranger Quincy Jones writes 12 dramatic measures of music over the second time through the original letter A material.

2:42 Sinatra rejoins the band with a second time through the 16 measures of letter B material.

Count Basie and Frank Sinatra during a 1950s recording session. Their kind of mainstream jazz remained popular even as bebop became the language of choice among many jazz musicians.
Courtesy of the Institute of Jazz Studies, Rutgers University

3:08 Sinatra continues to the end of the tune with a final statement of the letter A' material. At the end of the closing 16-bar structure notice that arranger Quincy Jones adds 4 more measures of dramatic big band writing to close out the tune.

Sources: Erlewine, Stephen Thomas. "Review: Sinatra At The Sands." http://www.allmusic.com/album/sinatra-at-the-sands-mw0000650777 (March 19, 2017)

"Sinatra At The Sands." https://en.wikipedia.org/wiki/Sinatra_at_the_Sands (March 19, 2017)

(A Few of) the People Who Made (and Make) It Happen

Tony Bennett

Singer Tony Bennett is one of the hottest properties in the world of jazz today. Unlike most of his contemporaries, Bennett has managed to "cross over," connecting with an entirely new (and much younger) audience. In 1996, he did a set on the television show *MTV Unplugged*. The show was a surprise hit, and the music was later released on CD to both critical and popular acclaim. The media said things like "Tony Bennett is back," to which Bennett essentially replied, "I never went anywhere!" In 2001, he released an album of duets with artists including Ray Charles, Natalie Cole, Sheryl Crow, Billy Joel, Diana Krall, k.d. lang, Bonnie Raitt, and Stevie Wonder. On the record company website promoting the release of the album *Playin' With My Friends: Bennett Sings the Blues*, they offer a brief overview of Bennett's extraordinary career.

> His initial successes came via a string of Columbia singles in the early 1950s including such chart-toppers as "Because of You," "Rags to Riches" and a remake of Hank Williams' "Cold, Cold Heart" and [he] has ten Grammy Awards to his credit, including a Grammy Lifetime Achievement Award. He had 24 songs in the Top 40, including "I Wanna Be Around," "The Good Life," "Who Can I Turn To" and his signature song, "I Left My Heart In San Francisco," which garnered him two Grammy Awards. Tony Bennett is one of a handful of artists to have new albums charting in the 50s, 60s, 70s, 80s, and 90s [and now in the 2000s and 2010s]. . . . In the 1950s, thousands of screaming bobbysoxers surrounded the Paramount Theatre in New York, held back only by police barricades, to see their singing idol Tony Bennett. Today the children and grandchildren of those fans are enjoying the same experience. As the *New York Times* pointed out, "Tony Bennett has not just bridged the generation gap, he has demolished it. He has solidly connected with a younger crowd weaned on rock. And there have been no compromises."[1]

In more recent years, Bennett's music has remained uncompromising, but he has also continued to reach out to a younger generation of performing artists and audience members. A second *Duets II* recording followed in 2011 featuring such diverse artists as John Mayer, Michael Bublé, Willie Nelson, Queen Latifah, Andrea Bocelli, Lady Gaga, and the late Amy Winehouse. This first association with Lady Gaga led to two follow-up recordings in 2014 titled *Tony Bennett and Lady Gaga: Cheek to Cheek* and also a live television performance (which was also released as an audio and DVD recording) simply titled *Cheek to Cheek Live!*. Other important recent recordings include *The Art of Romance, A Swingin' Christmas* (with the Count Basie Big Band), and *The Silver Lining: The Songs of Jerome Kern* (with pianist Bill Charlap).

The following listening guide is for the song *It Had to Be You*, recorded live during Tony Bennett's performance on *MTV Unplugged*. Beyond this song, you can also listen to the entire performance on Spotify.

Dig Deeper
RECORDING

Tony Bennett: MTV Unplugged

Lady Gaga and Tony Bennett perform onstage during the Cheek to Cheek *tour at Radio City Music Hall in New York City on June 19, 2015.*
Kevin Mazur/Getty Images Entertainment/Getty Images

Listening Guide

It Had To Be You (I. Jones and G. Kahn)

Example of Tony Bennett's performance on MTV's *Unplugged*
Recorded April 15, 1994
Performed by Tony Bennett, vocals; Ralph Sharon, piano; Doug Richeson, bass; and Clayton Cameron, drums

This is a very straight-ahead vocal performance of a standard from the Great American Songbook. After a spoken introduction, with some very tasteful piano playing by Ralph Sharon in the background, you'll hear one full statement of the verse lyrics, followed by one full statement of the chorus. While the instrumentalists don't get individual solo space in this particular performance, listen carefully to their skills as jazz improvisers while they back up this gifted vocalist. There is a great deal of call and response as Bennett sings the tune while the other musicians fill the spaces he leaves for them.

Total time: 3:12

:00	Spoken introduction with improvised piano background.
:22	16-measure verse.
1:02	32-measure chorus, presented as two contrasting groups of 16-bar phrases with alternating first and second endings. The end of the tune simply slows and is taken straight out by Bennett, who extends the last note while the band plays a brief concluding fill.

Sarah Vaughan

Like Ella Fitzgerald before her, vocalist Sarah Vaughan was a favorite among instrumental jazz musicians. She had an amazing ear, impeccable phrasing, and a flawless sense of time. She was able to do with her voice what Dizzy Gillespie and Charlie Parker were able to do with their horns. Vaughan came to prominence singing with the big bands of Earl Hines and Billy Eckstine, where she met both Dizzy and Bird. Her vocal style was firmly rooted in the bebop style, but she was also able to deliver convincing performances of jazz standards and pop tunes as well. Some of her best recordings over the years were done for Mercury Records. Working for Mercury was a good situation for Vaughan because in addition to the more pop-oriented albums she released with them, she was able to concurrently release serious jazz albums on their sister label, EmArcy. She was happy singing jazz, and she was making money singing pop music. Over her long career, some of her most famous tunes included *Lover Man*, *Misty*, *Tenderly*, and *Broken Hearted Melody*, her most successful commercial hit.

Vocalist Sarah Vaughan.
Courtesy of the Institute of Jazz Studies, Rutgers University

Nat "King" Cole

It is largely forgotten today, but singer Nat "King" Cole was a pioneering piano player on a par with Count Basie, Duke Ellington, and even Earl "Fatha" Hines. Like Basie, Nat Cole began comping with his left hand while his right hand played light, swinging melodies. Cole's first big break came with recordings he made in the King Cole Trio with guitarist Oscar Moore and bass player Wesley Prince, who was later replaced by Johnny Miller. This trio was a commercial success on both radio and record during the swing era. The group recorded numerous instrumental sides, but some of their biggest hits featured Nat Cole's singing along with his relaxed style of piano playing. The tunes *Sweet Lorraine*, *Paper Moon*, and *Straighten Up and Fly Right* became big hits for the trio during the 1940s.

In 1950, Cole shot to the top of the pop charts with a ballad titled *Mona Lisa*. Introduced to a much larger, mostly non-jazz audience, he often found himself singing in front of a big band or even a full orchestra. By the late 1950s he hardly ever played piano in public, instead focusing his career on beautiful, but safe, commercial material. Perhaps his best-known hit today is a recording of Mel Tormé's *The Christmas Song*. Depending on which Nat "King" Cole sound you like, there are many great recordings available. A heavy smoker, he

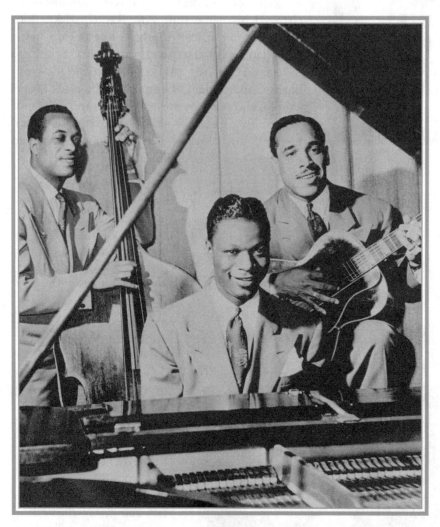

Nat Cole and the King Cole Trio in a late 1930s/early 1940s press photo. Left to right:
Johnny Miller, bass; Nat Cole, piano; and Oscar Moore, guitar.
Courtesy of the Institute of Jazz Studies, Rutgers University

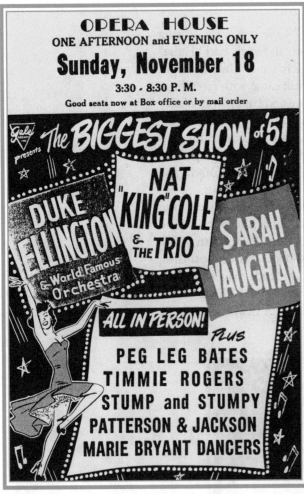

This ad announcing "The Biggest Show of '51" is one of those rare instances when ad copy didn't lie. Even for its day, this was quite a lineup of talent.

Press photo of Ray Charles during a recording session. Courtesy of the Institute of Jazz Studies, Rutgers University

died of lung cancer in 1965 at the age of 47.[2] His daughter, singer Natalie Cole, has continued in the family tradition. Using "studio magic," she was even able to create several recordings that featured her singing duets with her late father.

Ray Charles

Over the course of his long career, Ray Charles had numerous hits on the rhythm and blues chart, the jazz chart, the country chart, and all of the pop charts. In fact, just looking at his three number one hits on the pop charts—*Georgia on My Mind, Hit the Road Jack,* and *I Can't Stop Loving You*—should give you some idea of the diverse musical elements that made up his music.[3] *Georgia* is a classic jazz ballad, *Hit the Road Jack* is a hard-driving rhythm and blues tune, and *I Can't Stop Loving You* is the quintessential country tear-jerker. The artist was born Ray Charles Robinson, but in deference to boxer "Sugar Ray" Robinson, he changed his name simply to Ray Charles.[4] Born and raised in the deep South, he lost an early battle with glaucoma and was completely blind by the age of seven. His music was deeply rooted in the Delta blues, country blues, the music of the black gospel church, and even the music of the Grand Ole Opry. Frequently outspoken on a wide range of topics, his 2002 official website offered some insight into his views on jazz in America today:

I cannot understand how we as Americans, possessing such a rich heritage of music and the artists who play it, don't recognize all those talented people. It's a shame that so many of today's young people don't know the work of Art Tatum or Dizzy Gillespie or Charlie Parker or Clifford Brown, to name a few. They are the creators; they are the artists who helped form the backbone of our country's popular music. . . . When you talk about, say, classical music, you're talking about a form that came

from Europe and European composers and musicians from an earlier time. But we basically created jazz in this country, we own that form of music. And it's sad that we all don't have more extensive knowledge of that fact. . . . In Europe, though, you find people who know all about our music. I'm talking about the average person. I've been to Europe and talked to people who have records of mine that I forgot I ever made! And I find that incredible.[5]

Ray Charles performed in small-combo settings, fronted a big band, and even recorded with full symphony orchestras. Over the years, he was honored with just about every music award available. He was featured on radio, television, and in the movies. In 1980, he played the role of a music store owner in the *Blues Brothers*, a movie that featured cameo roles for many famous older rhythm and blues, soul, and jazz musicians. In more recent years, Charles continued to record and tour extensively and was a spokesman for several prominent companies, including Pepsi.

Around the time of his death in 2004, a biopic simply titled *Ray* enjoyed great success in theatres around the country and won a number of film awards. In addition, at this same time Concord Records released a final studio project with guest artists including Norah Jones, B. B. King, Diana Krall, Willie Nelson, and James Taylor, among others, performing duets with Ray Charles on a CD titled *Genius Loves Company*. While Charles is not at his absolute best, this triple-platinum album is still full of emotion and great musicianship, and it serves as a fitting final tribute to a man who cut a wide swath across the world of popular music.

Another fascinating recording released a few years after Ray Charles' death is the album *Ray Sings, Basie Swings*. Released by Concord records, this studio project was created by writing new charts for the "ghost" Count Basie band, recording them in the studio, and marrying those new tracks with live Ray Charles vocals recorded on a 1970s European tour that was never released. In addition to the standard Count Basie band musicians, the project also features the work of Hammond B-3 organist Joey DeFrancesco and singer Patti Austin, among other special guests. The results of this "greatest concert that never was" are simply amazing. As

Ray Charles performing at the North Sea Jazz Festival in 1990.
Photograph by Tad Hershorn

Dig Deeper

RECORDINGS

Genius & Soul: The 50th Anniversary Collection; Anthology; Ray Sings, Basie Swings

BOOK

Brother Ray: Ray Charles' Own Story by Ray Charles with David Ritz

MOVIE

Ray

Dig Deeper

OTHER MAINSTREAM SINGERS

Betty Carter
Rosemary Clooney
Sammy Davis, Jr.
Johnny Hartman
Shirley Horn
Peggy Lee
Abbey Lincoln
Julie London
Dean Martin
Carmen McRae
Anita O'Day
Nina Simone
Mel Tormé
Dinah Washington

mentioned elsewhere in this textbook, this is another fantastic example of using "studio magic" for good instead of evil.

Erroll Garner

Pianists Erroll Garner and Art Tatum were contemporaries. They both spent

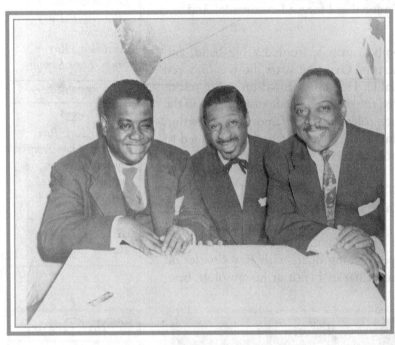

much of their careers playing solo piano shows and making highly individual recordings. Both were major influences on the generations of jazz pianists who would follow them. Their personal approaches to the instrument, however, were very different. Where Tatum was energetic and almost frantic at times, Garner was lyrical and relaxed. Completely self-taught, Erroll Garner developed a unique sense of rhythm in which his two hands played very independently of one another. He would frequently lay down a steady beat with his left hand, only to have his right hand play intentionally behind that beat. He took advantage of being a solo artist, often improvising elaborate and fanciful introductions to the tunes he enjoyed performing. Sometimes he'd be over a minute into a tune before the audience would even know what song he was playing. There are many great Erroll Garner recordings available on CD. If you want to discover his highly original playing style, the 1955 recording titled *Concert by the Sea* is a good place to start.

Rare photo of three piano greats. Left to right: Art Tatum, Erroll Garner, and Count Basie.
Courtesy of the Institute of Jazz Studies, Rutgers University

Oscar Peterson

Inspired by pianists Art Tatum and Nat Cole, Oscar Peterson enjoyed a very successful career in jazz. A master of many different playing styles, he managed to mix them all together in a light, swinging manner. His recordings are always of the highest quality, and yet they remain accessible, even to the casual listener. Peterson was very active in the recording studio over the years. He frequently recorded with a trio made up of piano-bass-guitar or piano-bass-drums, and he was also a frequent collaborative artist, accompanying such singers

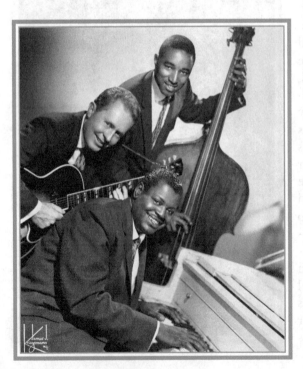

The Oscar Peterson Trio, with Herb Ellis, guitar and Ray Brown, bass.
Courtesy of the Institute of Jazz Studies, Rutgers University

as Louis Armstrong and Ella Fitzgerald. Many instrumentalists also joined Peterson in concert and on record including Milt Jackson, Clark Terry, Stephanne Grappelli, and Joe Pass, along with younger artists such as Jon Faddis and Roy Hargrove. His catalog of both studio and live recordings numbers more than 100 releases, many of which have been put out on compact disc. Some of his best recordings include *The Gershwin Songbooks*, *The Best of the Verve Songbooks* (both collections of earlier work), *Porgy and Bess,* and *At Zardis'*. For more recent work, check out *The Trio*, *Live at the North Sea Jazz Festival,* and *The Legendary Oscar Peterson Trio Live at the Blue Note*. Peterson suffered a very serious stroke in 1993, but he continued to record and perform until he passed away in 2007.[6]

Bill Evans

Pianist Bill Evans was an extremely sensitive musician who was able to convey great emotional depth in almost everything he played. Evans was a member of the famous Miles Davis sextet that made the 1959 album *Kind of Blue*, which went a long way toward establishing the concepts of modal improvisation. Also in 1959, Evans formed a trio with bass player Scott LaFaro and drummer Paul Motian. The group's recordings made in the next few years are universally considered some of the best piano trio recordings ever made. Unlike most trios of this type, which place most of the emphasis on the improvisational skills of the pianist, this group really played as a very tight-knit improvising unit. Sadly, Scott LaFaro was killed in a car accident in 1961. Evans went into seclusion for some time but later formed a new trio with Motian and bassist Chuck Israels. Evans also recorded frequently with guitarist Jim Hall. Some of Bill Evans' best recordings include *Sunday at the Village Vanguard*, *Waltz for Debby*, *Interplay*, and the unusual *Conversations with Myself* (recorded by overdubbing three piano parts all played by Evans). You can hear the classic Evans-LaFaro-Motian trio on Spotify performing the song *Gloria's Step*.

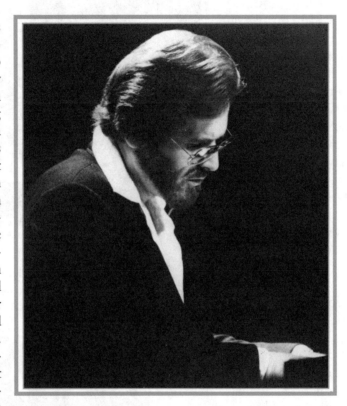

Dig Deeper
RECORDINGS

Sunday at the Village Vanguard; Waltz for Debby; The Complete Riverside Recordings; Conversations with Myself

Pianist Bill Evans. Courtesy of the Institute of Jazz Studies, Rutgers University

Dig Deeper
OTHER MAINSTREAM PIANISTS

*Monty Alexander
Kenny Barron
Ray Bryant
Johnny Costa
John Eaton
Red Garland
Sir Roland Hanna
Dick Hyman
Ahmad Jamal
Hank Jones
Marian McPartland
Phineas Newborn, Jr.
Michael Petrucciani
Jimmy Rowles
Hazel Scott
Billy Taylor
Randy Weston
Mary Lou Williams*

Listening Guide

Gloria's Step (Scott LaFaro)

Example of piano trio performing with a mix of bebop, cool school, and hard bop styles
Recorded June 25, 1961
Performed by Bill Evans, piano; Scott LaFaro, bass; and Paul Motian, drums

Most classic piano trios focus on the improvisational skills of the pianist, but this group (which many consider to be Bill Evans' best trio) creates a great deal of subtle interplay throughout their performances. Notice that bassist Scott LaFaro often improvises melodic countermelodies under Evans' solo. Later, when it's time for the bass solo, LaFaro demonstrates his command of the instrument by playing a very beautiful improvisation, utilizing mostly the upper register of the string bass—a place many bass players will not dare to go. This recording was made during a live show at the Village Vanguard less than two weeks before LaFaro's untimely death in a car accident. The formal structure is very unusual, so don't worry about trying to figure it out. Instead, focus all of your attention on discovering how the three musicians interact throughout the piece. For an exercise in contrast, search on Spotify for alternate takes of this recording that were also made during the Village Vanguard recording sessions. You'll be amazed at the differences.

Extra musician's info: As mentioned above, the form here is rather complex. The melody to *Gloria's Step* is 20 measures long, and it is broken down into two parts, which are 10 bars each and are simply called "letter A" and "letter B." Harmonically, the tune is also quite complex, making use of a number of "altered" chords that add extra depth and color to the musical sound and increase the level of difficulty for the improvising musicians. For the head of this performance, the full 20-measure structure is stated twice.

Total time: 6:09

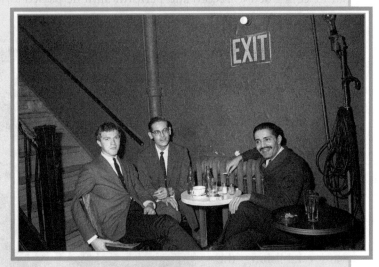

Scott LaFaro, Bill Evans, and Paul Motian sitting at the foot of the stairs at the Village Vanguard in New York City.
© Steve Schapiro/Corbis Premium Historical/Getty Images

This is the entrance to the Village Vanguard jazz club in New York City. Some of the most famous live jazz recordings ever made were captured in this cramped basement nightspot.
Photo by Author

:00	Head. Two full statements of the melody. The full structure is 20 measures long, and is made up of two contrasting 10-bar sections that are normally called "letter A" and "letter B."
1:00	Piano solo begins. Pianist Bill Evans plays a total of four 20-measure solo choruses.
3:01	Bass solo begins. Bassist Scott LaFaro also plays a total of four 20-measure solo choruses. As his solo continues, notice how he intentionally plays "across" the contrasting letter A and B sections of this tune, as well as blurring the junctures of the end of one improvised chorus and the start of the next chorus. Bill Evans' return to the main melody of the tune almost seems to come from out of nowhere.
5:01	Out chorus. Like the opening of this selection, Evans plays two full statements of the melody, which he concludes with a simple extended chord at the end of the performance.

George Shearing

Long before the Beatles started the "British Invasion" in the world of rock and roll, English pianist George Shearing had become a household name in America. Already a popular musician in England, Shearing moved to the United States in 1947 and spent a great deal of his time here until his death in 2011. Playing with a style that falls somewhere between the cool school and bebop, he had a big hit with the tune *September in the Rain* in 1949. Shearing frequently improvised in the "locked hands" style that became his trademark. Historian Henry Martin describes the locked hands style as "a mode of performance in which the pianist plays a four-note chord in the right hand and doubles the top note with the left hand an octave below. The hands move together in a 'locked' rhythmic pattern as they follow the same rhythm."[7] In the 1960s, Shearing made a series of lush-sounding recordings using large groups of strings, brass instruments, and other more unusual instrumental collections. The albums *The Shearing Spell, Black Satin, White Satin, Latin Escapade, Latin Affair, Shearing Bossa Nova,* and *Burnished Brass* were very popular "mood music" during the swinging 60s. In particular, Shearing's Latin albums reflected the growing popularity of Latin music. In recent years, these albums have enjoyed a resurgence in popularity with the "exotica," or lounge lover, crowd.[8] For his part, Shearing continued to be active in the studio and on the road as well. In the 1980s and early 1990s he frequently performed with singer Mel Tormé, with whom he won a Grammy, and he made an excellent series of straight-ahead jazz recordings for both the Concord and Telarc record labels well into the new millenium.

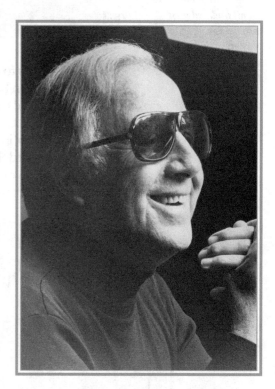

Press photo of pianist and composer George Shearing. Courtesy Bennett Morgan and Associates Inc.

Stan Kenton

Pianist Stan Kenton came to musical prominence leading an innovative big band in the late 1940s. He started as a band leader fronting a typical big band in 1941, but by 1947 his band had grown in both size and complexity. Kenton's arrangements used dense harmonies and extended ranges. The Kenton band was always known for being one of the loudest-blowing and highest-note-playing groups in the world

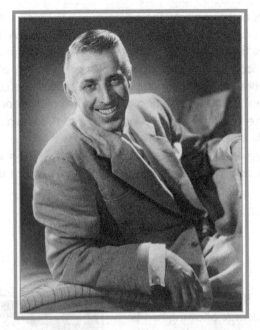

Composer, pianist, and bandleader Stan Kenton in an undated press photograph.
Courtesy of the Institute of Jazz Studies, Rutgers University

of jazz. Kenton also began incorporating Latin rhythms in tunes such as *The Peanut Vendor, Malaguena, and La Suerte de los Tontos*. He began calling his music "progressive jazz," and his groups in the 1950s carried bold names such as the Innovations in Modern Music Orchestra. Like Art Blakey in the hard bop style on the East Coast, Kenton's band became a training ground for many of the best West Coast players. In his later groups he made unusual additions to the basic big band set-up including adding a complete section of French horns or mellophoniums, using extra woodwinds, and sometimes even a full string section. Kenton was constantly pushing the envelope of what a big band could do, even going so far as to create jazz transcriptions of the music of opera composer Richard Wagner. The Kenton band was the original "heavy metal" band in the world of jazz, the first group that could turn it all the way up to "11." To have more control over his personal musical destiny, Kenton formed his own record label, Creative World, in the 1970s. Stan Kenton passed away in 1979, but his legacy lives on, as many of his most famous musical charts were published. High school and college jazz bands continue to study his music on a regular basis. You can hear the unique Kenton sound when you explore the following listening guide for the original recording of his theme song, *Artistry In Rhythm*.

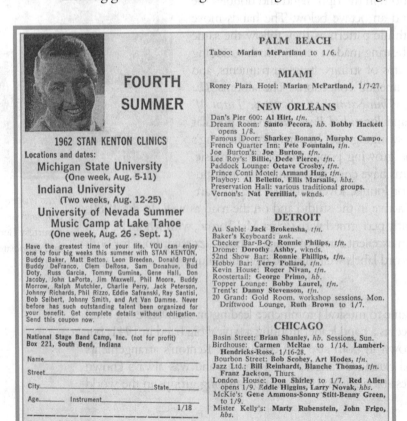

Stan Kenton's dedication to music education can be seen in this advertisement for a series of summer music camps. Note the list of musicians taking part in the camps, as well as the random club listings to the right of the ad.

Listening Guide

Artistry in Rhythm (Production on Theme) (Stan Kenton)

Example of the innovative Stan Kenton Orchestra
Recorded November 19, 1943
Performed by Stan Kenton and His
Orchestra. Stan Kenton, piano, composer/arranger, and leader; Eddie Meyers
and Art Pepper, alto sax; Red Dorris and
Maurice Beeson, tenor sax; Bob Gioga,
baritone sax; Ray Borden, John Carroll,
Buddy Childers, Karl George, and Dick
Morse, trumpet; Harry Forbes, George
Faye, and Bart Varsalona, trombone; Bob
Ahern, guitar; Clyde Singleton, bass; and
Joe Vernon, drums

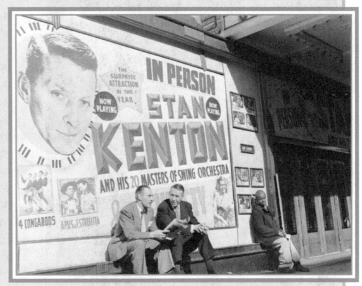

Artistry in Rhythm was one of Stan
Kenton's early successes, and this performance is based on the melody that was his
band's theme song. This listening guide
is for the original 1943 Capitol recording of the tune, but Kenton revisited this
material many times throughout his long
career, always with creative new arrangements that featured the unique aspects of

*Stan Kenton, right, talks with baritone sax player Bob Gioga as a
young friend looks on, ca. 1947.*
©William P. Gottlieb. From the Library of Congress Collection.

the particular band he was fronting at the time. The tune has one principal theme, but it is presented in a number of different styles in this short version, which was recorded for a 78 rpm disc.

 The piece also inspired a series of follow-up numbers, some of which made use of melodic, harmonic, and/or rhythmic content found in the original tune. Other tunes in the *Artistry* series simply drew from the original title. It should also be noted that some of the subsequent works and arrangements were written by composers other than Stan Kenton. These works include *Artistry Jumps*, *Artistry in Boogie*, *Artistry in Bolero*, *Artistry in Blues*, *Artistry in Tango*, *Artistry in Sounds*, *Artistry in Percussion*, *Artistry in Gillespie*, and *Safranski (Artistry in Bass)*.

Total time: 3:20

:00 Introduction begins, built around some of the main thematic material and played in a rhythmically free style.

:25 Drummer establishes a fast tempo, followed by two full statements of the theme.

:58 The tempo shifts while the band plays a brief interlude that leads to a rhythmically free Kenton piano solo based on the same thematic material.

1:47 As Kenton comes to the end of his piano solo, he establishes a new tempo that is taken over by the rest of the band. We hear one statement of the theme played by muted trumpets, followed by another transition section that takes us to yet another tempo shift.

2:19	Saxes play a creative line in a slower, driving swing style based on the original melody.
2:39	Brass return with their own licks in this new swing tempo.
3:02	The tune comes to a dramatic end with a series of arranged lines that feature the entire band.

Maynard Ferguson

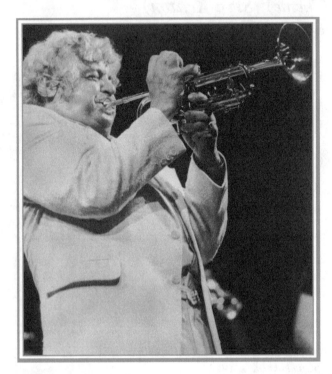

Trumpet player Maynard Ferguson got his start playing in bands led by Stan Kenton. His incredible mastery of the extreme high range of the trumpet and his impressive endurance while playing the instrument made him a natural for the Kenton style. After leaving Kenton, Ferguson became a regular on the Hollywood studio scene, playing trumpet on many of the most famous film soundtracks of the mid-1950s. Next, Ferguson formed his own big band, and for the following 12 years enjoyed a good bit of success. As rock music really began to dominate the charts, Ferguson backed away from the world of jazz, moving with his family first to India and later to England. In the late 60s, Ferguson began designing musical instruments and fronting a variety of groups that toured all over Europe, where jazz was still somewhat popular. A relatively recent article in *Contemporary Musicians* tells the story of how this middle-aged jazz trumpet player broke into the world of pop music.

Maynard Ferguson.
Courtesy of the Institute of Jazz Studies, Rutgers University

In 1969 Ferguson signed with CBS Records in England and created a repertoire for his new British band in which pop and rock songs were rearranged into a big band format, with electronic amplification. This was Ferguson's response to the psychedelic sixties. He produced contemporary arrangements of late 1960s and early 1970s hits like "MacArthur Park" and the Beatles' "Hey Jude." Ferguson's recording of "Gonna Fly Now"—the theme from the hit film Rocky—catapulted Maynard into mainstream popularity with a Top-10 single, a gold album, and a grammy nomination in 1978. His album *Conquistador*, from which "Gonna Fly Now" sprang, earned Ferguson an unusual place in the history of music; with *Conquistador*, he alone was able to crack the pop charts in 1977. Ferguson's efforts helped rekindle the public's interest in big bands; his fanfare solos, along with his expertise on several brass instruments—often demonstrated in a single performance—set a dazzling example of sheer technical virtuosity.[9]

Clark Terry

If for nothing else, trumpet player Clark Terry gets an "A" for effort and a mention here for longevity. After a stint in the U.S. Navy during the 1940s, Terry worked in several of the finest big bands, including groups led by Count Basie and Duke Ellington. A featured soloist with Duke's band throughout most

of the 1950s, Terry became a recognized jazz entity. In a recent biography page on Jim Cullum's *Riverwalk* website, musician and writer Chuck Berg described Terry's life after Ellington: "Now an international star, Clark was courted by the National Broadcasting Company in New York to join its musical staff. Accepting the challenge of becoming the first black musician on the NBC payroll, Clark soon became a television star as one of the spotlighted players in *The Tonight Show* Band. It was during this period that Clark scored a smash hit as a singer with his irrepressible *Mumbles*."[10]

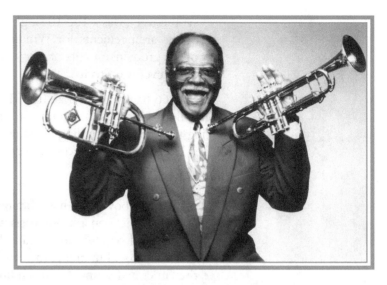

When *The Tonight Show* moved to the West Coast Clark Terry stayed in New York City, where he began fronting a series of successful groups. He made numerous recordings for various labels, both large and small, and was in great demand for public appearances around the world. Among other distinctions, Terry fronted the last band to do an official Jazz Ambassadors tour for the U.S. Department of State, and he was awarded a NEA Jazz Masters fellowship in 1991. Beyond being an active performer, Clark Terry was also noted for his deep commitment to music education. He was actively involved with the International Association for Jazz Education for many years, and he even started his own jazz camp. Clark Terry endured a long battle with diabetes, though he continued to perform and record well into his late 80s, and he continued to teach students even into his early 90s. He passed away on February 21, 2015.

J.J. Johnson and Kai Winding

Trombonists J.J. Johnson and Kai Winding took part in the recording sessions that led to the release of the previously discussed *Birth of the Cool* album. They were also among the first group of trombonists to master playing their sometimes cumbersome instruments in the challenging bebop genres. Both went on to have significant careers that spanned a wide range of musical styles. Look on the credits of a modern jazz album with a great trombone player and the chances are pretty good that it is one of these two men behind the horn. Together, however, they made some of the most innovative mainstream jazz albums of the 1950s and 60s. Usually referred to as "Jay and Kai," these two men fronted a quintet for a number of recordings and sometimes expanded the group with as many as eight trombones in the front line. Like many of the other artists mentioned in this chapter, some of these recordings featured the finest jazz players and arrangers dealing with more commercial material.

Kai Winding in particular serves as a good example of how the desire to be commercially successful could alter the course of a serious jazz player's career. An article on the website *Space Age Pop Music* explains:

> Looking for more of a good thing [after the success of some Jay and Kai recordings], Winding then formed a four-trombone sextet which recorded on impulse from 1956 to 1961. Winding then became the musical director for Hugh Hefner's chain of Playboy Clubs and was enticed by producer Creed Taylor to the Verve label. For the rest of the 1960s, Winding cranked out a steady flow of middle-of-the-road popular jazz that latched onto every popular trend—bossa nova, countrypolitan, Beatles. Winding's cover of *More*, featuring the spooky sounds of the ondioline [an early

Clark Terry.
Photo courtesy of Clark Terry's Private Collection

Dig Deeper

OTHER MAINSTREAM INSTRUMENTALISTS

Dan Barrett, trombone and trumpet
Bob Brookmeyer, valve trombone
Benny Carter, multi-instrumentalist
Buddy DeFranco, clarinet
Eddie "Lockjaw" Davis, saxophone
Carl Fontana, trombone
Urbie Green, trombone
Freddie Hubbard, trumpet
Illinois Jacquet, saxophone
James Morrison, multi-instrumentalist
Ken Peplowski, clarinet and saxophone
Houston Person, saxophone
Doc Severinsen, trumpet
Bobby Shew, trumpet
Stanley Turrentine, saxophone
Frank Wess, flute and saxophone

synthesizer], was a Top 10 single in 1963. Claus Ogerman provided most
of the arrangements for Winding's Verve albums, which include some
of the groovin'-est cuts of *now sounds* [the hot new thing in the 60s] you
could ever want to frug to.[11]

A 1966 handwritten note from Kai Winding to band leader Maynard Fergu-
son confirms his musical attempts to be more commercially successful. It is inter-
esting to note that Winding is using the term "jazz-rock" over three years *before*
Miles Davis created the recordings *In A Silent Way* and *Bitches Brew*.

Maynard:

As the Playboy Club has obtained its cabaret license (Dec. 29th) I'm
appearing there on a steady basis with my group (5 men). I have Sundays
off and will be interested in any lucrative Sunday engagements (prefer-
ably concerts). I'm billing my music now as "jazz rock" which [connotes]
the "in crowd sound." Am sending you my latest "Verve" release under
separate cover. I hope to be able to accept Fri and/or Sat dates in March-
April-May as things should have settled down here by then.

Regards
Kai Winding[12]

Joe Pass

Guitarist Joe Pass is one of the most imitated guitar players of the past few
decades. Pass was inspired by a number of jazz guitarists including Django
Reinhardt and Charlie Christian and is now recognized as one of the most
technically proficient musicians to ever pick up the instrument. He was able to
borrow from others yet create a style of playing that was uniquely his own. Pass
got his first start in the jazz world playing in swing bands during the 1940s. He
served for a time in the military, but when he got out he became a serious drug
addict, even serving time in jail. Rehabilitated by the early 1960s, he began to
gain notoriety for his fluid style and seemingly effortless improvisations. In the
1970s Pass made a series of records for producer Norman Granz' Pablo label.
These recordings have become something of a "New Testament" for guitarists

Dig Deeper
RECORDINGS

*For Django;
Virtuoso, Vol. 1-4;
Roy Clark &
Joe Pass Play
Hank Williams
[Seriously!]*

DOCUMENTARY

*Norman Granz'
Jazz in Montreux:
Joe Pass '75*

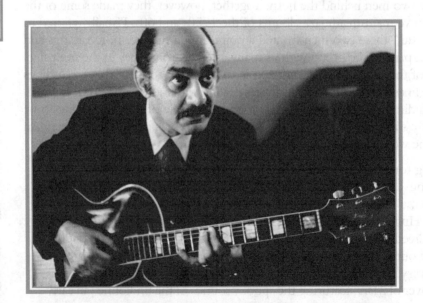

Joe Pass.
Photograph by Tad
Hershorn

everywhere. Pass was also a willing and able accompanist, particularly noted for his long-term collaboration with singer Ella Fitzgerald. Though he passed away in 1994 after battling cancer, he remained quite active until his death. Recordings he made for both Pablo and Telarc record companies in the 1980s and 1990s are solid, accessible jazz performances and clinics on how to play the jazz guitar.

Latin Jazz

You could write an entire book on the subject of Latin jazz. In fact, several people have. As you may recall from Jelly Roll Morton's discussion in Chapter 3, the concept of Latin rhythms being used in jazz has been around almost as long as jazz itself. During the swing era, a number of bands played tunes that made use of Latin dance rhythms, and bands such as the one led by Xavier Cugat focused on them. In the late 40s and throughout the 50s, two men, Chano Pozo (who died in 1948) and Machito, brought the idea of Afro-Cuban rhythms to beboppers including Dizzy Gillespie and to big bands including the one led by Stan Kenton. In the 1950s a new dance craze called the mambo swept the nation. One of the greatest bands of all time for this style of music was led by the great Latin percussionist **Tito Puente**. Over the years, Puente led a series of the hottest Latin bands in America, which always featured wonderful, fresh material and some of the finest Latin jazz improvisers available. The following listening guide is for a well-known live version of Tito Puente and his band performing *Oye Como Va*. In addition to its inclusion on your Spotify playlist, you'll find this same recording on a number of Latin jazz compilation CDs.

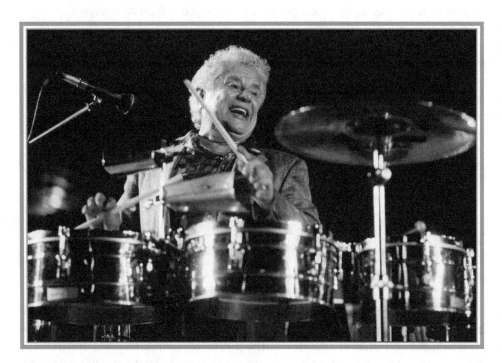

Latin jazz pioneer Tito Puente.
Leon morris/Redferns/Getty images

Dig Deeper
OTHER MAINSTREAM GUITARISTS

Howard Alden
George Benson
Gene Bertoncini
Kenny Burrell
Charlie Byrd
Herb Ellis
Tal Farlow
Grant Green
Jim Hall
Barney Kessel
Pat Martino
Les Paul
Bucky Pizzarelli
George Van Eps
Frank Vignola

Tito Puente

Dig Deeper
DOCUMENTARIES/ RECORDINGS

Buena Vista Social Club; Calle 54; Antonio Carlos Jobim & Friends

BOOKS

Latin Jazz: The Perfect Combination by Raul A. Fernandez; *Latin Jazz: The First of the Fusions, 1880s to Today* by John Storm Roberts; *Cubano Be, Cubano Bop: One Hundred Years of Jazz in Cuba* by Leonardo Acosta; *Cuban Fire: The Story of Salsa and Latin Jazz* by Isabelle Leymarie

WEBSITE

www.latinjazz net.com

Listening Guide

Oye Como Va (Tito Puente)

Example of a Latin jazz master and his band

Album: *Party with Puente:*, released July 11, 2000

Performed by Tito Puente and His Orchestra. Tito Puente, timbales, vocal, and leader; Mario Rivera, flute; Ray Gonzalez, trumpet; Jimmy Frisaura, valve trombone; Jorge Dalto, piano; Bobby Rodriguez, bass; Johnny Rodriguez, bongos and vocal; and Jose Madera, congas

Tito Puente wrote this Latin jazz classic in 1963. It was later made even more famous by noted rock artist Carlos Santana when the guitarist featured it on his 1970 album *Abraxas*. For both artists, the song became an important part of their respective live shows. Puente recorded the number live on several notable occasions, and this particular version (originally released on the Concord album *Party with Puente:*, released July 11, 2000) has been featured on a number of compilation CDs that focus on Latin jazz.

Many Latin jazz tunes feature multiple repeated sections, and while the charts are usually clearly organized, the number of times an individual section will be played can vary greatly from performance to performance. Often a leader or other musician will simply signal the band when it is time to move ahead to the next section, so if a musician is developing a particularly interesting solo, that improvisation might be extended for several more sectional repeats. Various vocal and instrumental sections often return again and again throughout a given performance, mixed together with simple vamp or refrain sections and improvised solos. This music always has a very strict rhythmic organization but is normally played with great freedom in all other musical respects.

Total time: 5:48

:00	Performance opens with a series of vamped grooves that feature a flute solo floating over the top of the structure.
:46	The introduction concludes with an iconic 4-measure refrain that you will hear at various points throughout the performance.
:53	Main vocal melody is stated for 8 measures, followed by 16 bars of instrumental playing, which is actually two different 8-bar sections.
1:36	The main vocal melody is repeated, followed by another 16 bars of instrumental playing, including an improved flute solo.
2:21	Flute solo continues, supported by various riffs in the band as the sections go by.
3:03	4-measure refrain returns, bridging the end of the flute solo with the bass solo that follows.
3:11	Bass solo.
4:50	Full band enters with two new 8-measure sections of music, accompanied by more flute improvisation.
5:19	Vocal melody returns.
5:33	Performance comes to an end with a final statement of the 4-bar refrain.

Puente became a symbol of Latin jazz around the world, and his consistently fine recordings (well over 100) reflect his amazing and extensive body of work. As you read in Chapter 6, the 1950s also witnessed the birth of the bossa nova craze, as documented in the recordings of Stan Getz with Antonio Carlos Jobim. A native of Brazil, Jobim's many compositions have become jazz standards today and are frequently used by jazz groups of many different styles.

Other fine Brazilian musicians to check out include singer Flora Purim, percussionist Naná Vasconcelos, bandleader and pianist Sérgio Mendes, guitarist and composer Luiz Bonfá, trumpet player Cláudio Roditi, and pianist and vocalist Eliane Elias.

In recent years, the Latin jazz scene has exploded in popularity. Crossover bands including Gloria Estefan and the Miami Sound Machine have reached a large mainstream audience around the world. In turn, these bands have opened the doors for more traditional Afro-Cuban acts including the Buena Vista Social Club, Cubanismo, and Cuban Masters "Los Originales." There are also a number of fine mainstream jazz musicians who have come out of the Latin jazz tradition. Pianist Eddie Palmieri and percussionist Poncho

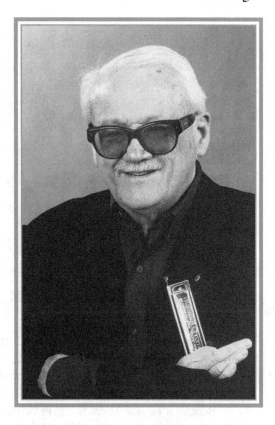

Jazz harmonica and guitar player Toots Thielemans. Over the years, Thielemans, who was born in Belgium, played everything from swing to bebop to Latin jazz. His Brazil Project *recordings featured many of the best Brazilian musicians working with some of the world's finest jazz players. These recordings make a very strong case for music being a truly universal language.*
Photo by Dirk Hermans
Courtesy of Reggie Marshall

Sanchez have both led outstanding Latin jazz bands, and they have been featured on more mainstream projects as well. Both Gonzalo Rubalcaba and Aturo Sandoval left Cuba with the help of Dizzy Gillespie, and both have gone on to major careers in the mainstream jazz world. Saxophonist Paquito D'Rivera frequently performs with his own outstanding quintet, but he as also joined artists as diverse as the Turtle Island String Quartet, classical cellist Yo-Yo Ma, and composer/arranger Lalo Schifrin. Furthermore, there are also a number of Latin jazz musicians who have passed away but whose body of recorded work remains an important part of the greater world of jazz, including vibraphone player and percussionist Cal Tjader, bandleader and percussionist Mongo Santamaria, and saxophonist Gato Barbieri, among many, many others. To get started in listening to Latin jazz, try recordings made by any of the musicians mentioned above. In particular, check out the album *Reencarnación* by the group Cubanismo, *Papa Gato* by Poncho Sanchez, or *Putumayo presents Latin Jazz the compilation CD*. To explore the softer side of Latin jazz, listen to the *Greatest Hits* album of Antonio Carlos Jobim or *The Brazil Project*, *Vols. 1 & 2*, by the late Toots Thielemans.

Not So Mainstream but Very Cool: The Cult Vocalists

Following in the footsteps of Eddie Jefferson and Lambert, Hendricks & Ross, a group of singers began appearing on the scene in the 1950s and 60s that have collectively been referred to as **cult vocalists**. While there are a wide variety of singers usually included under the cult vocalist banner, they are all jazz-based singers with a strong underground following. The "big three" in this genre are Bob Dorough, Blossom Dearie, and Dave Frishberg. Both Dorough and Dearie

Cult Vocalists

Pianist, composer, and cult vocalist Dave Frishberg.
Courtesy of Dave Frishberg

Dig Deeper
CARTOON SERIES

School House Rock!

got their start playing piano and singing quirky original tunes, bebop tunes, and unusual arrangements of jazz standards. In addition, both Dorough and Dearie were big hits in Paris, where they spent a great deal of their time in the 1950s and early 60s, and Dorough created a minor sensation when he recorded a tune called *Blue XMas* with Miles Davis in 1962.

A bit younger, Dave Frishberg came to prominence as a songwriter when Blossom Dearie recorded his original composition *Peel Me a Grape*. An excellent pianist, Frishberg began playing gigs and pitching his new songs to singers around the country. It took a little while, but over the years many singers have recorded Frishberg's material. No one, however, sings Frishberg better than Frishberg. His unique voice and his unerring sense of timing, both in playing and singing, allow him to deliver his material in a most engaging way.

Believe it or not, there is a good chance that you have experienced all of these great artists. In the early 1970s Bob Dorough was hired by ABC Television to be music director for a series of Saturday morning cartoon shorts called *School House Rock*. Dorough in turn hired all of his friends including Blossom Dearie, Frishberg, and singer/instrumentalists Jack Sheldon and Grady Tate. The tunes

Composer, singer, and Hammond B-3 virtuoso Charlie Wood is one of a new crop of musicians blending the traditions of jazz, blues, soul, and rock. Long a regular at Kings Palace on historic Beale Street in Memphis, Wood has recently taken more time for recording projects and international touring. As with many successful American jazz musicians, Wood has found more mainstream acceptance working in Europe than in his homeland. His most recent CDs include Tomorrow Night, New Souvenirs, *and* Just You, Just Me *(with vocalist Jacqui Dankworth). Other notable releases include* Southbound, Who I Am, R & B-3, Somethin' Else, Lucky, Flutter and Wow, Lush Life *and* Charlie Wood and the New Memphis Underground. *Charlie Wood and his music can be found at* www.charliewood.us.
Courtesy of Charlie Wood

I'm Just a Bill, Conjunction Junction, Lolly, Lolly, Lolly Get Your Adverbs Here, $7.50 Once a Week, Three Is a Magic Number, Figure Eight, and *Naughty Number Nine* all feature the writing and singing abilities of these outstanding performers.

Until recently, many of these artists continued to perform and record on a regular basis. In the early 2000s, Blue Note released two new CDs featuring Dorough and Frishberg as a duo performing both their original music and jazz standards. Blossom Dearie owned an independent record label, Daffodil Records, and she was a regular on the New York nightclub scene until her death in 2009. For some other interesting cult vocalists, you might also check out the late Mose Allison, Holly Cole, Tom Waits, Jay Leonhart, and Memphis' own Charlie Wood.

Notes

1. "Tony Bennett, Playin' With My Friends: Bennett Sings the Blues," http://www.tonybennett.net/bio.html (May 20, 2002).

2. Michael Erlewine et al., eds., *All Music Guide to Jazz*, 3rd ed. (San Francisco: Miller Freeman Books, 1998), p. 218.

3. "Ray Charles, Performer," *Rock and Roll Hall of Fame and Museum*. http://www.rockhall.com/hof/inductee.asp?id=76 (May 20, 2002).

4. "Ray Charles, Biography," *Ray Charles Offical Website*. http://www.raycharles.com/bio.htm (May 20, 2002).

5. Ibid.

6. Erlewine et al., eds., *All Music Guide to Jazz*, 3rd ed., pp. 897 - 903.

7. Martin and Waters, *Jazz, The First 100 Years* (Belmont, CA.: Wadsworth/Thomson Learning, 2002), p. 217.

8. "Space Age Musicmaker, George Shearing," *Space Age Pop Music*. http://www.spaceagepop.com/shearing.htm (May 20, 2002)

9. "Maynard Ferguson, Trumpet Player, bandleader," *Contemporary Musicians*, vol. 7. www.maynard.ferguson.net/bio2.html (May 20, 2002).

10. Chuck Berg, "Clark Terry," *Riverwalk*. http://www.riverwalk.org/profiles/terry.htm (May 20, 2002).

11. "Space Age Musicmaker, Kai Winding," *Space Age Pop Music*. http://www.spaceagepop.com/winding.htm (May 20, 2002)

12. Kai Winding, "Letter to Maynard Ferguson," www.store6.yimg.com/l/jukejoint 1668 19914822 (April 3, 2002).

Study Guide

Chapter 10 Review Questions

True or False

___ 1. Nat "King" Cole was a pianist as well as a vocalist.

___ 2. Ray Charles found that Europeans often knew more about jazz than Americans.

___ 3. Over the course of his career, Oscar Peterson has played both sax and trumpet in his ensembles.

___ 4. Oscar Peterson won a Grammy for his album *The Gershwin Songbooks*.

___ 5. Like Duke Ellington, Stan Kenton was a composer/arranger, pianist, and band leader.

___ 6. Early in his career, Clark Terry worked with Louis Armstrong.

___ 7. Kai Winding is known for making sure that his musical ventures were commercially successful.

___ 8. Cult vocalists usually record pop tunes but limit their audience appeal by their notorious style of dress.

___ 9. In addition to being involved in the fusion movement in jazz, Bill Evans was an important figure in the jazz avant-garde.

Multiple Choice

10. Which artist is best known for playing the Mambo?
 a. Tito Puente
 b. Xavier Cugat
 c. Chano Pozo
 d. Stan Getz
 e. Antonio Carlos Jobim

11. Frank Sinatra recorded the 1966 album *Live At The Sands* with a big band led by pianist:
 a. Nat "King" Cole d. Oscar Peterson
 b. Ray Charles e. George Shearing
 c. Count Basie

12. Which musician made use of diverse blues, country, gospel, and rhythm and blues sources?
 a. Ray Charles d. Sarah Vaughan
 b. Tony Bennett e. Natalie Cole
 c. Nat "King" Cole

13. Which pianist played on the album *Kind of Blue*?
 a. George Shearing d. Oscar Peterson
 b. Nat "King" Cole e. Bill Evans
 c. Stan Kenton

14. On the album *Black Satin*, which pianist performed with large ensembles that had a full, lush sound?
 a. George Shearing
 b. Erroll Garner
 c. Natalie Cole
 d. Stan Kenton
 e. none of the above

15. Which composer/arranger added instruments to the typical big band to create a much thicker texture?
 a. Bill Evans d. George Shearing
 b. Stan Kenton e. Clark Terry
 c. Oscar Peterson

Fill in the Blank

16. Pianist _____ was associated with the "locked hands" style.

17. _____ performed on *MTV Unplugged* in 1996.

18. Vocalist _____ had a style rooted in bebop, but he/she also performed pop tunes.

19. Pianist _____, a contemporary of Art Tatum, had a playing style that is much more relaxed.

20. _____ performed with the *Tonight Show* Band.

21. _____ recorded *Gonna Fly Now*, the theme from the movie *Rocky*.

22. In order to have more control over his own releases, Stan Kenton formed his own record label called _____.

23. Modern jazz guitarist _____ serves as a model for current players.

24. Trumpet player and jazz educator _____ worked with Count Basie and Duke Ellington.

Short Answer

25. List the three main cult vocalists.

Essay Questions

1. Using the Internet and other current media resources, explore the recent popularity of jazz artists including Tony Bennett. Why do you think these artists have connected with new audiences when other jazz artists have failed?

2. Think about recent films or television programs you have seen. Have any styles of jazz played a role in the soundtrack? As we come to the end of this material, do you find yourself noticing jazz styles in places you previously overlooked?

Chapter 11

Recent Trends

*. . . Got a little chunk of soul that I promised not to part with,
but make me an offer and I probably will.*

Charlie Wood

\mathcal{B}eginning in the late 1980s and picking up steam in the 1990s, jazz made something of a comeback in the world of music. During that time, musicians including Wynton and Branford Marsalis, Harry Connick, Jr., and Diana Krall became fairly well known names in the music industry. Perhaps beginning with the soundtrack for the film *When Harry Met Sally . . .*, swing music from an artist such as Harry Connick, Jr. was clearly becoming more mainstream. In the following years, swing dancing became a fad in many larger American cities. Cigars, martinis, and cosmopolitans grew popular as some members of Generation X explored a more "sophisticated" lifestyle. When singer Tony Bennett made an appearance on *MTV Unplugged*, a live performance show, a younger generation of music fans were amazed that he performed without big amps, explosions, or a megawatt light show. With a simple rhythm section of piano, bass, and drums, Mr. Bennett just sang great songs with tremendous emotion. Swing music and the classic jazz standards were the hot new thing. Of course, what this new audience didn't realize was that jazz musicians had been performing like this for nearly 100 years. Regardless, new musical doors were opened. As we move deeper into the twenty-first century, enthusiasm for jazz has cooled a bit as other pop music fads continue to come and go. If you listen to singers including Alicia Keys, Erykah Badu, Norah Jones, Esperanza Spalding, and Jamie Cullum, as well as groups such as Barenaked Ladies, Us3, the Dave Matthews Band, and Lake Street Dive, however, you can hear that elements of jazz are still alive in the world of pop music.

Jazz in all of its various styles is still a viable art form in the new century. As we've seen, there are still traditional jazz bands, swing musicians, bebop players, cool school devotees, hard boppers, and practitioners of free jazz working in the music industry. In addition, there are many current jazz artists who bring together

JAZZ MAGAZINE
WEBSITES

www.downbeat.com
www.jazztimes.com
www.jazziz.com
*www.jazzinside
magazine.com*
*www.allabout
jazz.com*
www.allmusic.com

one or more of these styles, creating their own unique musical fusion. This chapter features a few of the most recent musical trends and some of the artists that are making these styles happen.

A Return to Older Traditions

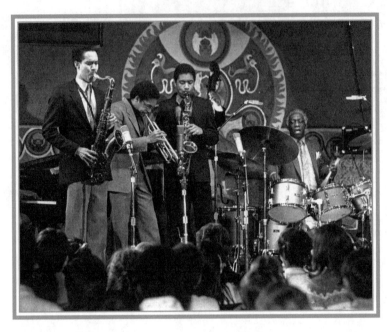

Like a number of the musicians grouped together as "young lions" during the 1980s and early 1990s, both Wynton and Branford Marsalis spent time playing with Art Blakey and the Jazz Messengers. As you learned in Chapter 7, this band became something of a training ground for many younger musicians over the years. Left-to-right: Billy Pierce, tenor saxophone; Wynton Marsalis, trumpet; Branford Marsalis, alto saxophone; and Art Blakey, drums.
© Tom Copi/Michael Ochs Archives/Getty Images

In the 1980s and 90s a number of very serious younger musicians appeared on the jazz scene who were skilled in the bebop and hard bop styles. Collectively called the "young lions," musicians including Wynton and Branford Marsalis, Joshua Redman, Marcus Roberts, Terence Blanchard, Kenny Kirkland, and Jeff Watts all revisited older musical traditions with some success. In the jazz world, the often outspoken Wynton Marsalis in particular created some controversy as he tried to develop a rather narrow definition of what was and, perhaps more importantly, what was not jazz. In a discussion recorded in the March 1985 issue of *Musician* magazine, Marsalis and master musician Herbie Hancock squared off on the topic of jazz today. Many of the complex issues raised in both Chapter 9 and this chapter are given consideration in this discussion.

Wynton vs. Herbie: The Purist and the Crossbreeder Duke It Out

MUSICIAN: We don't want to get you guys into an argument.
HANCOCK: Oh, we won't, we never argue.
MARSALIS: I would never argue with Herbie.
MUSICIAN: I'll tell what we want to start with. Is there a necessity for any young player, no matter how brilliant he is, to work his way through a tradition?
MARSALIS: That's a hard question to answer. When we deal with anything that's European, the definitions are clear cut. But with our stuff it all comes from blues, so "it's all the same." So that'll imply that if I write an arrangement, then my arrangement is on the same level as Duke Ellington. But to me it's *not* the same. So what I'm trying to determine is this terminology. What is rock 'n' roll? What does jazz mean, or R&B? Used to be R&B was just somebody who was black, in pop music they are white. Now we know the whole development of American music is so steeped in racist tradition that it defines what we're talking about.
MUSICIAN: Well there's the Berklee School of Music approach, where you learn technique. And some people would say, "Well, as long as it's coming from the heart, it doesn't matter about technique."

MARSALIS: This is the biggest crock of bulls--t in the history of music, that stuff about coming from the heart. If you are trying to create art, the *first thing* is to look around and find out what's meaningful to you. Art tries to make life meaningful, so automatically that implies a certain amount of emotion. Anybody can say "I have emotion." I mean, a thousand trumpet players had soul and emotion when they picked up trumpets. But they weren't all Louis Armstrong. Why?

HANCOCK: He was a better human being.

MARSALIS: Because Louis Armstrong's technique was better.

MUSICIAN: Is that the only thing, though?

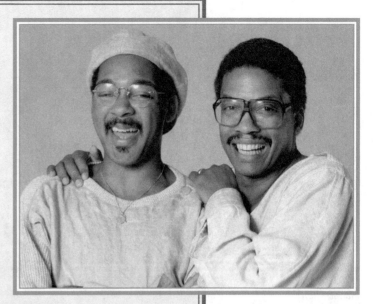

MARSALIS: Who's to say that his soul was greater than anybody else's? How can you measure soul? Have any women left him, did he eat some chicken on Saturday night? That's a whole social viewpoint of what payin' dues is. So Duke Ellington shouldn't have been great because by definition of dues he didn't really go through as much as Louis Armstrong, so naturally his piano playing didn't have the same level of soul. Or Herbie wasn't soulful, either. Because when he was coming up, black people didn't have to eat out of frying pans on Friday nights.

MUSICIAN: Well, one of the ways of judging soulfulness, as you say, is suffering. But it's not the only way.

MARSALIS: I read a book [by James Lincoln Collier] where a cat said that "in 1920-something we notice that Louis Armstrong's playing took on a deeper depth of emotion. Maybe that's because his mother died." What brings about soulfulness is realization. That's *all*. You can realize it and be the richest man in the world. You can be someone living in the heart of Harlem in the most deprived situation with no soul at all. But the social scientists . . . oh, soul. That's all they can hear, you know. Soul is part of technique. Emotion is part of technique. Music is a craft, man.

HANCOCK: External environment brings fortune or misfortune. Both of them are means to grow. And that's what soul is about: the growth or, as Wynton said, realization. To realize how to take that experience and to find the depth of that experience in your life. If you're able to do that, then everything becomes fortune.

MARSALIS: The thing that makes me most disgusted is that a lot of guys who write about the music don't understand the musicians. People have the feeling that jazz is an expression of depression. What about Louis Armstrong? To me, his thing is an expression of joy. A celebration of the human condition.

HANCOCK: Or the other concept is somebody who, out of his ignorance and stupidity, dances and slaps his sides. No concept of intelligence, focus, concentration . . . and the study, the concern. Even the self-doubt and conflict that goes into the art of playing jazz.

Herbie Hancock.
Getty Images
Entertainment/ David
Becker/ Getty Images

Look, I didn't start off playing jazz. I hated jazz when I first heard it. It sounded like noise to me. I was studying classical music, and at the same time, going to an all-black grammar school. I heard groups like the Ravens. But I really didn't have many R&B records. I was like a little nerd in school.

MARSALIS: Well, I don't know about *that.*

HANCOCK: Jazz finally made an impression on me when I saw a guy who was my age improvising. I thought that would be impossible for somebody my age, thirteen or fourteen, to be able to create some music out of his head.

I was a classical player, so I had to learn jazz the way any classical player would. When it came to learning what one feels and hears as soulful nuances in the music, I actually had to learn that technically.

MARSALIS: That's interesting, because I did it the opposite way. When you put out *Headhunters* and *Thrust*, Branford and I listened to those albums, but we didn't think it was jazz. My daddy would play jazz, but I was like, hey, man, I don't want to hear this s--t. I grew up in New Orleans—Kenner, Louisiana, actually, a country town. All I ever did was play "When the Saints" and stuff. I couldn't really play, I had no technique. So when I came to high school, everybody else could play the trumpet and I was the saddest one. The first record I heard was [John Coltrane's] *Giant Steps.* My daddy had all those records, but I never would listen to them. Why listen to jazz, man?

HANCOCK: None of your friends were playing it?

MARSALIS: None of the people I knew. You couldn't get no women playing jazz! Nobody had a philosophy about what life was supposed to be about. We didn't have a continuum. I never listened to Miles or Herbie. I didn't even know you played with Miles, until I was sixteen. Then when I started listening to jazz, I would only listen to a certain type. Only bebop. So I can relate to starting from a fan-type approach. But when you play music, you're going to play the way you are.

MUSICIAN: What about your statement at the Grammy's?

MARSALIS: It was very obvious what I was saying.

HANCOCK: I have to congratulate you on that. You implied that there was good music and music that was in bad taste. Everybody wondered, "What music is he referring to?"

MARSALIS: Listen, the only statement I made was that we're trying to elevate pop music to the level of art. Not just in music. Pop culture. Pop anything. I have nothing against pop music. I listen to the radio. I'm not saying people should listen to jazz or buy jazz records, or even know the music. Just *understand* what the music is about, because the purpose and the function of pop music is totally different from jazz.

HANCOCK: A few people that have interviewed me have asked me if the statement that he made was directed against what I was doing. That never dawned on me.

MARSALIS: I wasn't even thinking about that.

MUSICIAN: A lot of people do think that.

MARSALIS: People think I'm trying to say jazz is greater than pop music. I don't have to say that, that's *obvious*. But I don't even think about it that way. The two musics say totally different things. Jazz is *not* pop music, that's all. Not that it's greater. . . . I didn't mean it was obvious.

HANCOCK: That's your opinion, which is fine. Now you're making a statement of fact.

MUSICIAN: So is classical music "greater" than jazz?

MARSALIS: Hell no, classical music is a European idiom. America has a new cultural identity. And the ultimate achievement for any culture is the creation of an art form. Now, the basic element of our art form is the blues, because an art form makes life meaningful. Incidentally, I would like to say—and I hope you will print this—classical music is *not* white music. When Beethoven was writing music, he wasn't thinking white or black. Those terms became necessary in America when they had to take white artists and make them number one because they couldn't accept black artists. We constantly have historical redefinitions to take the artistic contributions out of the hands of people who were designated black. The root of the colloquial stuff throughout the whole world now comes out of the U.S. Negro's lifestyle.

MUSICIAN: Is there something in some of the root forms of this music that has a certain inner strength?

MARSALIS: People don't know what I'm doing basically, because they don't understand music. All they're doing is reacting to what they think it remotely sounds like.

We don't have to go *back* to the sixties. Beethoven didn't have to go *back* to Haydn. We never hear that. What they say is, well, Beethoven is an extension of Haydn. Everybody has to do that—Stravinsky, Bartok. But in European music people have a cultural continuum. And our music is just, "Well, what is the next new Negro gonna think up out of the blue sky that's gonna be innovative?" Ornette Coleman sounds like Bird; he was playing rhythm changes on "The Shape of Jazz to Come." Have I ever read that by anybody reviewing those albums? No. Why? Because they don't know what rhythm changes sound like. So they're gonna write a review on what I'm doing and I'm supposed to say, "That's cool."

HANCOCK: When you first asked the question, I heard it as sensitively as he heard it. 'Cause I said to myself, "He's saying Wynton is going back to play the sixties-style of music in 1984."

MUSICIAN: We all agreed apparently at one point that jazz was more meaningful, in some sense, than pop music. Since you work in the two idioms, what do you feel is different?

HANCOCK: Wait a minute. I *don't* agree. Let me address myself to that. When we have life, we have music. Music can be manifest in many different forms, and as long as they all have purpose, they shouldn't be pitted against each other as one being more important than the other. That's stupid. That's like apples and oranges.

MUSICIAN: All right, you're doing both. What's the difference in the quality of the experience with each kind of music?

HANCOCK: Let me tell you how I started getting my feet wet with pop music. When I got into high school and started getting into jazz, I didn't want to hear anything else but classical music and jazz. No

R&B, nothing, until I heard James Brown's "Papa's Got a Brand New Bag." Later on, when I heard (Sly and the Family Stone's) "Thank You Falettinme Be Mice Elf Agin," it just went to my core. I didn't know *what* he was doing, I mean, I heard the chorus but, how could he *think* of that? I was afraid that that was something I couldn't do. And here I am, I call myself a musician. It bothered me. Then at a certain point I decided to try my hand at funk, when I did *Headhunters.* I was not trying to make a jazz record. And it came out sounding different from anything I could think of at the time. But I still wasn't satisfied because in the back of my head I wanted to make a funk record.

I had gotten to the point where I was so directed toward always playing something different that I was ignoring the validity of playing something that was familiar. Visually I symbolize it as: There's the space from the earth up to somewhere in the sky, then I was going from the sky up to somewhere further up in the sky. And this other thing from the earth up to the sky I was kind of ignoring. And so one thing about pop music that I've discovered is that playing something that's familiar or playing the same solo you played before has no negative connotations whatsoever. What's negative is if it doesn't sound, each time, like it's the first time you played it. Now, that's really difficult for me to do. Take Wah Wah Watson, for example. He's not a solo player, he's a rhythm player. But he used to play a little solo on one tune and it would be the same solo every night. And every night he would get a bigger hand than I would. And every night it was the same notes but it sounded fresh. So my lesson was to try to learn to play something without change, and have it sound fresh and meaningful.

Wynton Marsalis.
Courtesy of James Gale

MARSALIS: I look at music different from Herbie. I played in a funk band. I played the same horn parts every night all through high school. We played real funk tunes like Parliament Funkadelic, authentic funk. It wasn't this junk they're trying to do now to get their music played on white radio stations. Now, to play the Haydn Trumpet Concerto is a lot different from playing "Give Up the Funk" or "Mothership Connection." I dig "Mothership Connection," but to me what pop music is trying to do is totally different. It's really geared to a whole base type of sexual thing. I listen to the radio. I know tunes that they have out now: here's people squirming on the ground, fingering themselves. It's low-level realizations of sex. Now, to me, music to stimulate you is the music that has all the root in the world in it, but is trying to elevate that, to elevate the people to a certain level rather than go down.

HANCOCK: It's not like that, Wynton. If it were, it would just stay the same. Why would music change?

MARSALIS: Because they get new computers. You tell me, what's the newest thing out that you've heard?

HANCOCK: Okay, Prince, let's take that.

MARSALIS: What is the tune "Purple Rain"? Part of it is like a little blues. I've got the record, I listen to it all the time. The guitar solo is a rehash of some white rock.

MUSICIAN: It's a rehash of Hendrix, too.

MARSALIS: Well, I'm not gonna put that on his head because he can do stuff Hendrix never thought of doing, which a lot of people want to overlook just to cut him down and say he sounds like Hendrix. You can print that if you talk about him. But there's no way you can get new in that type of music because the message will always be the same.

HANCOCK: There are songs that have a lot of musical episodes. I saw Rick Springfield's video. I don't care if he's got a bad reputation. I heard some harmonic things that were really nice.

MARSALIS: You can get the newest synthesizers, but that music'll only go to a certain level. I'm not saying that's negative.

MUSICIAN: In a sense you're describing what Herbie's doing.

MARSALIS: He knows what he's doing, right? (laughs)

HANCOCK: It's *not* true because I know. You mention drum machines. There are examples of pop music today using drum machines specifically in a very automated way. Automation doesn't imply sex to me at all. It's the opposite of sex.

MARSALIS: But that's not what we're talking about.

HANCOCK: You said the music is about one thing, and it's about sex. And I'm saying it's not just about that.

MARSALIS: We don't even want to waste our time discussing that because we *know* that that's what it's about.

HANCOCK: If you name specific things, I would certainly agree with you. If you say dancing is about sex, I would agree with you, too. But I think you're using same false ammunition.

MUSICIAN: In most of the world's traditions sex is both connected with the highest creative aspects and then can be taken to the lowest basic—

MARSALIS: That's what I'm saying. What direction you want to go with it and which level it's marketed on. When I see stuff like videos with women looking like tigers roaming through the jungle, you know, women playing with themselves, which is cool, man, but to me that's the high school point of view. The problem I have is when people look at that and start using terms like "new video art with such daring concepts."

A lot of stuff in our society is racially oriented, too. I read a quote from Herbie. He said, "I heard that people from MTV were racist oriented and I didn't want to take any chances, so when I did my video I made sure they didn't focus on me and that some of the robots' faces were white." That somebody like him would have to make a statement like that. . . .

MUSICIAN: That is a heavy statement.

MARSALIS: But what he's saying is true. Maybe they wouldn't have played his video. And what pisses me off is the arrogance of people whose whole thing is just a blatant imitation of the negroidial tradition. Blatant. And even the major exponents of this type of music have said that themselves. And they'll have the arrogance and the audacity to say, "Well, we just gonna play white people's videos." How am I supposed to relate to that?

MUSICIAN: On the other hand, "Rockit" won five video awards. It partly broke open MTV; there are now more black acts on. And now kids in the heartland who have never heard black music are beginning to hear it. It's probably because of what you did.

MARSALIS: They're still not hearing it. Black music is being broken down. It's no longer black music. This is not a discussion or argument. You get the Parliament records and the EW&F [Earth, Wind & Fire] and the James Brown, the Marvin Gaye, and you listen. What I hear now is just obvious rock 'n' roll elements like Led Zeppelin. If people want to do that, fine. If they want to sell more records, great. What I'm saying is, that's reaffirmation of prejudice to me. If bending over is what's happening, I'm going to bend over.

MUSICIAN: Is there another side? What do you think, Herbie?

HANCOCK: Well, Wynton is not an exponent of the idea that blending of musical cultures is a good thing.

MARSALIS: Because it's an *imitation* of the root. It loses roots because it's *not* a blending. It's like having sex with your daughter.

HANCOCK: Okay, let me say this because this is something that I know. Up until recently a black artist, even if he felt rock 'n' roll like Mick Jagger, couldn't make a rock 'n' roll record. Because the media actually has set up these compartments that the racists fit things into. You can hear elements of rock from black artists.

MARSALIS: You don't just hear elements. What I hear in them is blatant, to the point of cynicism.

HANCOCK: Okay, okay. I'm not disagreeing. I know that there have been black artists that have wanted to do different kinds of music than what the R&B stations would play. That to me is more important, the fact that we can't do what we want to.

MARSALIS: I'm agreeing with you, everybody should do what they want to do. But what's happening is, our vibe is being lost. I see that in movies. I see it on television. What you have now is white guys standing up imitating black guys, and black guys sitting back and looking at an imitation of us saying, "Ohhh . . ." with awe in their faces. You have black children growing up with Jehri curls trying to wear dresses, thinking about playing music that doesn't sound like our culture.

MUSICIAN: Does Herbie "hear" what he's doing?

MARSALIS: Herbie hears what Herbie plays. But a lot of that music Herbie is not writing. And when Herbie is playing, he's gonna make the stuff sound like Herbie playin' it.

HANCOCK: Let me explain something about "Rockit." If you're a black artist doing some forms of pop music, which "Rockit" is, you have to get on black radio and become a hit. And if you get in the top twenty in black radio—or urban contemporary they call it now (laughter)—anyway, if it's considered crossover material, then at that point the record company will try to get the rock stations to play it. And so I said to myself, "How can I get this record exposed as quickly to the white kids as to the black kids?" So the video was a means to an end.

MUSICIAN: Did it bother you, having to make that decision?

HANCOCK: I didn't care about being in the video. I don't care about being on the album cover of my record. It's not important to me. Why should I have to be in my own video? (Marsalis winces)

MUSICIAN: But why *shouldn't* you? I mean, it's your video.

HANCOCK: That was not an issue with me. I'm not on the cover of most of my records. What I care about is whether the cover looks good or not. I wanted the video to be good. That's the first thing. The second thing I said: Now, how am I gonna get on there, because I want to get my record heard by these kids?

MUSICIAN: Can't you see this strategy is a way of breaking something in?

MARSALIS: If you cheese enough, they'll make you President.

HANCOCK: I wasn't cheesing. I was trying to get heard.

MUSICIAN: He broke open the medium, partially.

MARSALIS: Michael Jackson broke the medium open. Let's get that straight. What's amazing to me is that [Herbie's] thing was used by all the cats that were doing break dancing.

HANCOCK: There were three things against it. First of all, no vocals. Secondly, that kind of music wasn't even getting any airplay at that time. Third thing is my name.

MARSALIS: Right. But the only thing that I hate, the only thing that disgusts me about that is I've seen Herbie's thing on *Solid Gold* as "New Electronic" type of jazz or something. I mean, it's a *pop* tune, man. Our whole music is just going to continue to be misunderstood. You have to understand that people who hear about me, they don't listen to the music I play. If I have girlfriends, they don't listen to what I'm playing. They don't care. They only know Wynton as an image. Or Wynton, he's on the Grammys, he has a suit on. So their whole thing is media oriented. I'm not around a lot of people who listen to jazz or classical music, forget that! I did a concert and people gave me a standing ovation before I walked onto the stage. But in the middle of the first piece they were like (nods off) . . . so that lets you know right there what's happening.

MUSICIAN: Is that a black audience?

MARSALIS: Black people. Yeah, this is a media thing, you understand. I'm talking to people who are in the street.

HANCOCK: I understand what you're talking about, about black artists with Jehri curls and now with the long hair. And I don't mean the Rastas, either. . . .

MARSALIS: Well, check it out. Even deeper than that, Herbie, is when I see brothers and sisters on the TV. I see black athletes, straining to conform to a type of personality that will allow them to get some more endorsements. What disturbs me is it's the best people. When somebody is good, they don't have to do that. I was so happy when Stevie's album came out. I said, Damn, finally we got a groove and not somebody just trying to cross over into some rock 'n' roll.

HANCOCK: I understand what you mean about a certain type of groove, like this is the real R&B, and so forth. But I can't agree that there's only one way we're supposed to be playing. I have faith in the strength of the black contribution to music, and that strength is always

going back to the groove, anyway. After a while certain things get weeded out. And the music begins to evolve again.

MARSALIS: Now, check out what I'm saying—

HANCOCK: No, 'cause you've talked a lot—

MARSALIS: Okay, I'm sorry. I'm sorry, man.

HANCOCK: (laughter) Give me a break! I've never been on an interview with you, so I didn't know how it was. Wowww! I understand what you're saying, but I have faith that whatever's happening now is not a waste of time. It's a part of growth. It may be a transition, but transition is part of growth, too. And it doesn't bother me one bit that you hear more rock 'n' roll in black players, unless it's just not good. The idea of doing rock 'n' roll that comes out of Led Zeppelin doesn't bother me. I understand it's third-hand information that came from black people to begin with, but if a guy likes it, play it. When Tony Williams and I first left Miles, we did two different things. My orientation was from a funk thing. What Tony responded to was rock 'n' roll. That's why his sound had more of a rock influence than *Headhunters*. I can't say that's negative.

MARSALIS: I agree with what Herb has said. If somebody wants to go out with a dress on, a skirt, panties—that's their business. But what happens is not that one or two people do that. Everybody has to do that. It doesn't bother me that [black] comedians can be in film, I think that's great. And the films are funny. What bothers me is that *only* comedians can be in films.

I think since the sixties, with people on TV always cursing white people but not presenting any intellectual viewpoint, that any black person who tries to exhibit any kind of intellect is considered as trying not to be black. We have allowed social scientists to redefine what type of people we are. I play some European [music] to pay respect to a great, great music which had nothing to do with racial situations. Beethoven wasn't thinking about the social conditions in America when he wrote something, he was thinking about why did he have to get off the street for the princes. So his music has the same type of freedom and struggle for abolition of the class system, as Louis Armstrong's music is a celebration of that abolition. See, Beethoven's music has that struggle in it. Louis Armstrong is the resolution of that. This gigantic cultural achievement is just going to be redefined unless I take an active part in saying what I think is correct.

HANCOCK: Now that you've voiced all—not all, but *many* of your objections—what do you do about it? How do we make it better? If all we do is complain. . . .

MARSALIS: We're not complaining. We're providing people with information.

HANCOCK: Well, there's two ways to provide people with information. One way is to point your finger at them or intimidate them by pulling at their collars. But many times what that does is it makes the person feel uncomfortable, and then if he starts to get on the defensive, you've lost more ground than you've gained. So I've found from my own life that I can get more accomplished by getting a person inspired to do something. Inspiration, not intimidation.

MARSALIS: 'Cept intimidation is good, too.

HANCOCK: This is where you and I differ. I haven't said much before because I'm not like that.

MUSICIAN: You've really defined your point of view in terms of this interview, and Herbie hasn't yet.

MARSALIS: I was talking too much. Sorry I was being uncool.

HANCOCK: No, no, no. it was cool. It's all right. I'll come back another day when you're not here. . . . (general laughter)

MARSALIS: The problem is in the educational system. I've had conversations with people about you. Musicians have no idea who you are. They have no understanding or respect for being able to play. It's just like they think they're you or something. The first question I hear everywhere is, "How do you get over? How did you get your break with Herbie?" I said, "When I was with Herbie and them, I was just fortunate to be on the bandstand. Just to be learning from Herbie. . . ." No, seriously, man, I'm not saying it to kiss your ass. You know it's true.

HANCOCK: That's what I feel about him. He came in with one trumpet, nineteen years old playing with me, Ron [Carter], and Tony [Williams].

MARSALIS: I was scared.

HANCOCK: When I heard him play, then I had to call up Ron and Tony and say—

MARSALIS: Hey, this mother is sad. (laughs)

HANCOCK: Look, it's gonna work. What he did was so phenomenal. You remember that tour. That tour was bad.

MARSALIS: I learned so much on that tour, man.

HANCOCK: So did I, man. You taught me a lot. You made me play. Plus you made me get some new clothes. (laughs)

MARSALIS: I can get publicity until I'm a hundred. That's not gonna make me be on the level with cats like Miles or Clifford, or know the stuff that you know. Even "Rockit" has elements that I can relate to. But in general you made funk cats musicians. And that has been overlooked.

MUSICIAN: In the end, were the compromises involved in doing the video worth it?

HANCOCK: I had a choice. And I'm proud of the choice that I made. But as a result, what happened? Between Michael Jackson's video and my video, the impact opened the thing up. Now, I'm sure Michael can take more credit for that. Anyway, if it was true that MTV was racist—

MARSALIS: It was true. You don't have to say "if."

HANCOCK: I have never claimed that to be true.

MARSALIS: I'll say it.

HANCOCK: I've only claimed that this is what I observe. But now you see plenty of videos with black artists. It doesn't even look like there's any difference anymore. Even though I wasn't even looking for that as a solution, if this additional thing was accomplished, I feel really good about that. And I feel good about getting five awards on MTV. They were trying to copy something before. Now they realize they have something that's more powerful than what they were trying to copy.

MARSALIS: The sound of Michael Jackson's music, the sound of Prince's music, the sound of "Rockit"—that sound is *not* black. People are consciously trying to be crossovers. I've read interviews where people say, "We take this type of music and we try to get this type of sound to appeal to this type of market to sell these many records."

MUSICIAN: Do you think Michael did that?

MARSALIS: Of course he did. But the thing that separates Michael Jackson from all other pop artists is the level of sincerity in his music.

MUSICIAN: You're saying he's got sincerity, and yet at the same time he contoured his sound?

MARSALIS: He's a special person. He's not contrived. What I don't understand is why he did that cut with Mick Jagger.

HANCOCK: I'll tell ya, I just did a record with Mick Jagger and, man, Mick Jagger's *bad*.

MARSALIS: Yeah, well. . . .

HANCOCK: I didn't know that. And you don't know that, either.

MARSALIS: I'm not doubting that he's bad. . . .

HANCOCK: Wynton, you *don't* know that.

MARSALIS: I'm not doubting that he's bad, Herbie. Check it out. But a lot of pop music is geared toward children. It's not something that I can really have a serious discussion about.

HANCOCK: You're right. It's geared toward teens and the pre-teens. So what it's doing is stimulating my own youth and allowing me to express my own youth. Because it's not like I'm doing my daughter's music. This is *my* music. And we both happen to like it because we both feel that youthful element. People tell me I look younger now than I did five years ago. And I do . . . except in the morning. (laughs) I would venture to say that a lot of it has to do with the music I'm playing now. Electric music, you know. I'm finding a door that hasn't been opened. That's exciting me, and I'm given the opportunity to use some elements from the "farthest out" jazz stuff in this music, and have it be unique.

MUSICIAN: How do you get human feeling in automated, computerized music like that?

HANCOCK: First we create the music. Afterwards I sit back and listen, and sometimes I discover things that I wasn't really thinking about when I was doing them. I hear the elements that have warmth. Sometimes it's a particular synthesizer sound. But it could be how it's played.

MARSALIS: I'm coming off negative and that's not what I'm intending. . . . The purpose of pop music is to sell records that appeal to people on a level that they want to accept it on. If you put out a record and it doesn't sell, then your next response is, Why didn't the record sell? Let's try to do this or that to make the record sell.

MUSICIAN: That's terribly condescending toward pop. . . .

HANCOCK: Why are we asking him about pop music? What does *he* know about pop music?

MARSALIS: I know a lot about pop music.

HANCOCK: No, you don't.

MARSALIS: I played in pop—

HANCOCK: Wynton, you don't. You *think* you know.

MARSALIS: I don't want to mess with you.

HANCOCK: The very statement that you just made makes it obvious that you don't know.

MARSALIS: That's cool. I'm not going to get into it. I've had conversations with you, where you told me, "Man we're trying to get this kind of market." It's not like I don't know pop musicians. It's not like I don't listen to music.

HANCOCK: Then there's some things you misunderstand about it. Because I *never* use the word *sell*.

MARSALIS: I don't know. Remember what you told me before? "Yeah, man, my record just went gold, man. I need to get me some more records like that." We had long conversations about that. We shouldn't be arguing about this in the press, man. We have to be cool. We've talked about this already.

HANCOCK: Do you think I'd object if my records sold millions?

MARSALIS: Don't say you don't think about that.

HANCOCK: Of course I would.

MARSALIS: Because you do. You *do* think about that.

MUSICIAN: To think about it and have it as your aim are two different things.

HANCOCK: Thank you.

MARSALIS: I'm getting tired now. You said the opposite of what I wanted to hear.

HANCOCK: Look, I'd like to have a Rolls-Royce, too. But I'm not purposefully trying to set myself up to get a Rolls-Royce.

MARSALIS: Pop music is something that you don't really have to know too much to know about.

HANCOCK: (long silence) . . . Okay, next!

MUSICIAN: When you play pop music, do you feel as musically fulfilled as when you're playing jazz?

MARSALIS: Don't lie, Herbie.

HANCOCK: Okay, I only feel musically fulfilled when I can do both. If I don't play any jazz this year or half of next year, I'm gonna still be doing fine. But at a certain point, I'm gonna want to play some. Now, what I wanted to say was when I did "Rockit," when I did *Light Me Up* . . . I'm not sitting down and saying, "What can I put in this music to make it sell?" That's what I *don't* do. When I'm sitting and actually making the music, I know my frame of mind. And you can't tell me—

MARSALIS: I can't tell you anything. . . .

HANCOCK: No, I'm being honest. Let's say you want to do cartoons, or make a comic book, and you're Gauguin. If Gauguin were to do a comic book, I would respect him if he had the same kind of attitude of trying to make something happen with the cartoon, and learn from dealing with a medium that's more popular than the one he's accustomed to.

MUSICIAN: What he's also saying is there's this evolutionary sweep that takes all these things in its stride. . . .

HANCOCK: I'm not looking at these things that you're objecting to as the end. I look at them more as an interim.

Wynton Marsalis speaks at the opening of the new home for Jazz at Lincoln Center. Marsalis directs the Lincoln Center Jazz Orchestra and serves as Artistic Director for the organization. Located in the Time Warner building on Columbus Circle in New York City, Jazz at Lincoln Center is the first performance, education, and broadcasting facility custom-built for jazz.
Ramin Talaie/Corbis Entertainment/
Getty images

> MARSALIS: It's just ignorance being celebrated to the highest level. If somebody wants to say anything that has any kernel of intellect, immediately the word elitist is brought out and brandished across the page to whip them back down into ignorance. Especially black artists and athletes. We are constantly called upon to have nothing to say. I'm just trying to stimulate . . . some kind of intellectual realization. I'm just trying to raise questions about why we as musicians have to constantly take into account some bulls--t to produce what we want to produce as music, what Herbie is saying about evolution. Frankly, I never thought about it that way. But he brought out something interesting. All I can say is, I hope he's right.

From *Musician 77* (March 1985) by Rafi Zabor and Vic Garbarini, "Wynton vs Herbie: The Purist and the Crossbreeder Duke it Out."

Branford Marsalis at a recent performance in Albuquerque. Courtesy of James Gale

Compared to Wynton Marsalis, many other mainstream artists are more willing to explore different kinds of music. For example, his brother, Branford, and many other young jazz musicians toured with rock musician Sting (himself a jazz player at one point), and later went on to be members of the *Tonight Show* band when comedian Jay Leno took over the show. Both Wynton and Branford Marsalis have performed classical music, and Branford has also done some acting in films including *Throw Mamma from the Train*.

Branford Marsalis' extensive recorded output includes mainstream productions (*Loved Ones*, a duo recording made with his father, Ellis Marsalis), complex hard bop/post-hard bop bordering on free jazz (*Crazy People Music, Contemporary Jazz, Braggtown*), movie soundtracks (*Mo' Better Blues*), and music with elements of hip-hop with his band Buckshot LeFonque (*Buckshot LeFonque, Music Evolution*). Most recently he has been deeply exploring the music of John Coltrane, performing and recording music from Coltrane's groundbreaking 1965 album *A Love Supreme*, among many other diverse musical assignments as both a bandleader and as a sideman or special guest with other artists.

In 1987, Wynton Marsalis co-founded Jazz At Lincoln Center, and he currently serves as Artistic Director, running the resident Lincoln Center Jazz Orchestra. He has taken part in yearlong tributes to both Duke Ellington and Louis Armstrong, and the artist continues to be in great demand as one of the major spokesmen for the world of jazz. In particular, Wynton Marsalis was prominently featured in the nine-part Ken Burns documentary simply titled *Jazz*, which first premiered on PBS in 2001, and he has also been featured in several other PBS and NPR productions. Popular as a commercial television personality as well, Marsalis has been a regular on

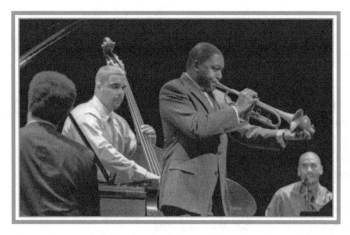

Wynton Marsalis performs with his group in Albuquerque's Popejoy Hall during a recent visit to New Mexico.
Courtesy of James Gale

the show *CBS Sunday Morning*, for which he submits reports and recorded the latest version of the show's iconic theme song, and he has also made contributions to the revamped *CBS This Morning* weekday program. Among other firsts, Wynton Marsalis won the first Pulitzer Prize in music awarded to a jazz performance for his composition and recording of an extended work titled *Blood on the Fields*, and in 2011 he was named a National Endowment for the Arts Jazz Master. In celebration of his 50th birthday, Columbia Records and Sony Classical released a deluxe 11-CD box set titled *Swinging into the 21st*. Other notable recent releases include a series of projects with the Lincoln Center Jazz Orchestra, which includes a project featuring pianist Jon Batiste titled *The Music of John Lewis*. Your Spotify playlist includes a somewhat rare track from a 1990 film titled *Tune In Tomorrow*. Marsalis' band was featured in the film, and the following detailed listening guide explores the tune *Double Rondo on the River* (*Pedro's Getaway*), which appeared on the film's CD soundtrack and was later also released on the 2001 CD *Popular Songs: The Best of Wynton Marsalis*.

Dig Deeper
WEBSITES

www.wynton
marsalis.org
www.jalc.org

Listening Guide

DOUBLE RONDO ON THE RIVER *(Wynton Marsalis)*

Example of younger players' return to older styles of jazz

Album: *Tune In Tomorrow: Soundtrack*, recorded, 1990. (also on *Popular Songs*: *The Best of Wynton Marsalis*)

Performed by Wynton Marsalis, trumpet; Dr. Michael White, clarinet; Wes Anderson, alto sax; Todd Williams, soprano and tenor sax, clarinet; Herb Harris, tenor sax; Joe Temperley, baritone sax; Wycliffe Gordon, trombone; Marcus Roberts, piano; Reginald Veal, bass; and Herlin Riley, drums

In many ways, this recording represents jazz having come almost full circle. The musical language of this tune falls somewhere between traditional jazz and the swing style of Duke Ellington, with a little Charles Mingus thrown in for good measure. The big difference here is that as you listen carefully to the playing of these fine musicians, little nuances from bebop, hard bop, free jazz, and even fusion begin to make themselves evident. These younger musicians have personal experiences with all of the newer jazz styles—as well as funk, soul, rock, hip-hop, and so on—and all of these styles are part of their musical language. The *rondo* is a classical music form, with standard layouts of A-B-A-C-A (five-part) and A-B-A-C-A-B-A (seven-part). This loose treatment of the rondo concept doesn't fit neatly into the classical mold, but it does make use of the alternating A and B melodies, with the improvised solos taking on the function of the letter C material.

Total time: 9:24

:00 This peice begins with a long improvised piano solo that introduces both rhythmic structures and chord progressions that will be used throughout the performance.

1:28 Band enters playing letter A material. This Mingus-like passage always occurs in groups of three full statements. The first 4 bars of the melody are grouped in beat patterns of 3+3+2, followed by 2 measures of regular 4/4 time. The third statement of the theme is presented in exactly the same way except that it has an extra 2 measures of 4/4 time at the end of the phrase.

1:54 Letter B-1 material is presented in an 8-bar phrase. The first 4 bars are played by sax and trombone, followed by 4 bars of clarinet. The entire 8-bar structure is then repeated.

2:13 Letter B-2 material is played one time. It follows the same structure as the B-1 material except that the melody line has been inverted.

2:23 Letter A material returns with the addition of more solo trumpet licks.

2:49 Soprano sax solo begins. Soloist plays six 8-bar choruses total. In the typical rondo structure, this section of the piece would function as letter C.

3:48 Letter A returns.

4:13 B-1, played twice.

4:33 B-2, played once.

4:43 Trumpet solo begins. Soloist plays nine 8-bar choruses total.

6:10 Letter A.

6:35 B-1.

6:45 B-2.

6:54 B-1.

7:04 Letter A.

7:29 Soprano sax solo begins. Soloist plays six 8-bar choruses total.

8:27 Letter A.

8:52 Letter B material returns, this time presented as a piano solo. The tune ends with a slow fadeout on this piano solo.

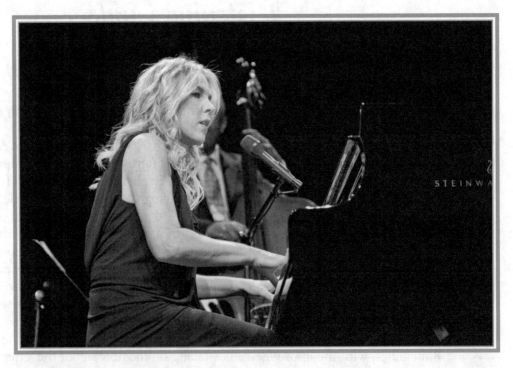

Pianist and singer Diana Krall.
Photoshot/Hulton Archive/Getty Images

Guitarist and swing vocalist John Pizzarelli.
Courtesy Bennett Morgan & Associates, Inc.

Singer Nancy Wilson helps keep the jazz tradition alive, singing everything from swing to bebop to the blues and even fusion. In addition to fronting her own groups, she has sung with the group Echos of an Era, which also featured pianist Chick Corea.
Courtesy Bennett Morgan & Associates, Inc.

Swing music's return to popularity helped bring a number of singers to prominence. Harry Connick, Jr. has fronted both a big band and a small jazz ensemble. A gifted composer and pianist as well as singer, Connick is often viewed as America's modern version of Frank Sinatra. In truth, Connick is considerably more talented. He writes many of his own tunes, arranges the charts for his big band, and displays a real gift for improvisation as well. Guitarist and singer John Pizzarelli has followed in his father Bucky's footsteps as a very skilled mainstream jazz guitarist. John Pizzarelli, however, has also added singing to his act, performing many tunes from the Great American Songbook by composers including George Gershwin, Cole Porter, and Irving Berlin. Pianist and singer Diana Krall has made inroads to the pop music market with a dark, sultry voice and a true gift for conveying deep emotional content in a song. Like Connick, she is a talented improviser on piano as well. In addition, singers such as Cassandra Wilson, Dee Dee Bridgewater, Dianne Reeves, Nancy Wilson, Karrin Allyson, René Marie, and Kevin Mahogany are keeping a wide variety of vocal jazz styles alive. These singers perform everything from the blues to jazz standards to vocalese and scat singing. Look for them all at a jazz festival near you.

More traditional jazz singers who are gaining widespread popularity today include Jane Monheit, Michael Bublé, and Peter Cincotti. Most recently, Bublé has received the most public attention and has been heralded as the next Frank Sinatra or Tony Bennett. He has appeared on all of the morning talk shows, as well as many of the major late night network television programs. Born in Vancouver, Bublé includes Sinatra, Ella Fitzgerald, Sarah Vaughan, Elvis Presley, Bobby Darin, and Stevie Wonder among his major influences. Jane Monheit grew up on Long Island in a musical family, studied voice at the Manhattan School of Music and, at age 20 in 1998, placed second among vocalists at the Thelonious Monk International Jazz Competition. A few years later, she released her first album working with jazz legends including Kenny Barron, Ron Carter, and David "Fathead" Newman, and she has been popular in the jazz world ever since. Her voice is pure, and her style reflects her deep knowledge of recorded jazz history. Finally, it has been suggested that Peter Cincotti is going to be the next Harry Connick, Jr. Smooth in style, pleasant of voice, he has the dashing good looks that are sure to help him transition easily to both the small and large screens. His 2004 album *On The Moon* offered creative versions of diverse standards including *The St. Louis Blues, I Love Paris,* and the Ray Charles hit *You Don't Know Me*. Cincotti's most recent EP release, *Exit 105,* features all original compositions and arrangements by the artist.

Norah Jones is perhaps the best known of this younger generation of jazz-oriented singers. Her style creates subtle fusions of jazz with blues, country, pop/rock, and world music elements. She has two major CDs that can both be found on the historic Blue Note label and are titled *Come Away With Me* and *Feels Like Home*. In 2006, she released a pared down recording of her band performing with a sound they perfected in their smaller club shows. Both the name of the band and the title of the album are *The Little Willies*. This group explores a variety of music, including band originals, along with tunes by Willie Nelson, Kris Kristofferson, and Townes Van Zandt. In 2009, Jones released another solo CD, *The Fall*, and in 2010, a series of collaborations titled *. . . Featuring Norah Jones*. In 2012, along with Willie Nelson and Wynton Marsalis, she recorded a new celebration of the music of Ray Charles titled *Here We Go Again*. Her two most recent solo efforts are titled *Little Broken Hearts* (2012) and *Day Breaks* (2016).

Similar to Norah Jones, though more energetic at times, is a young British singer named Jamie Cullum. His major CD releases include *Twentysomething*, *Catching Tales*, *The Pursuit*, *Momentum*, *Interlude*, and *Taller*. Cullum's live shows and his recordings blend creative improvisation with covers of diverse material and original tunes. His eclectic tastes include the music of Jimi Hendrix, Broadway show tunes, modern jazz, and angst-ridden Generation X melancholia. In 2004 he performed a brilliant set on the acclaimed PBS live music show *Austin City Limits*. Watch for it in reruns or look for it on DVD. Cullum also has an extensive website that offers news, tour blogs, various recordings, DVD material, sheet music, and tour merchandise. The following listening guide is for the title track to his first major CD release, *Twentysomething*.

Jamie Cullum.
Courtesy of
Rachel Coomber

Listening Guide

Twentysomething (Jamie Cullum)

Example of Jamie Cullum performing original material with jazz elements
Album: *Twentysomething*, released May 11, 2004 (U.S.A.)
Performed by Jamie Cullum, vocals and piano; Alan Barnes, alto sax; Ben Castle, tenor sax; Martin Shaw, trumpet and flugelhorn; Geoff Gascoyne, acoustic bass; Sebastiaan de Krom, drums; and Francis Fuster, percussion

This is the title track from Jamie Cullum's first major American CD release. The song clearly sums up a great deal of what Cullum's music is all about. He is a young jazz musician who also likes many other styles of modern music and is willing to bridge the gap between them. While the album track is fairly compact, in live performances he often opens the tune up for more improvised solos, gets the audience involved in singing the horn riffs, and sometimes even morphs the performance into other jazz tunes on the fly. He and the musicians he surrounds himself with are fearless live performers.

This tune uses a fairly typical repeated chorus, but here the chorus is 13 measures long. In addition, the tune has an extended, freely delivered verse, not unlike many of the great show tunes of Cole Porter, George Gershwin, and many others, which jazz singers often perform at the very beginning of the tune only. The same holds true here. Later in the track, Cullum goes much further, however, creating a nice little vamp that keeps coming back and an entirely new Latin section that shows up just once.

Total time: 3:37

:00	Verse. Sung freely by Jamie Cullum while he accompanies himself on solo piano.
:34	Repeated 4-bar vamp, played twice. Piano is joined by bass and drums.
:45	1st vocal chorus, 13 measures.
1:02	2nd vocal chorus, 13 measures.
1:19	3rd vocal chorus, 13 measures.
1:37	Trumpet and sax trade 2-measure improvised licks over the vamp, 8 bars total.
1:47	Piano solo, 16 bars total with horn riffs added for the second 8 bars.
2:08	5-bar vocal interlude that connects to the next section.
2:14	16-measure Latin jazz section built around new lyrics and melodic material.
2:36	Vamp returns with added horn hits and a long vocal note that gradually shifts pitches, 8 measures.
2:47	Final vocal chorus, 13 measures.
3:04	Vamp returns, this time with vocals only, 8 measures.
3:15	Band joins the vamp as the background vocals continue and Cullum returns to the main theme. This section runs to an abrupt ending that adds a strong final punctuation to the tune.

Perhaps the hottest new artist to break on the jazz scene in the past few years is composer, bassist, and vocalist Esperanza Spalding. This talented young musician is winning fans within both the jazz world and the pop mainstream. Jazz players respect her for her deep knowledge of the art form and her amazing instrumental skills, whereas general pop audiences are blown away by her talents as a singer and her versatility with so many different musical styles. As testament to her unique position in music today, she won the 2011 Grammy Award for Best

Dig Deeper
WEBSITE
www.esperanza spalding.com

Esperanza Spalding.
Photo by Sandrine Lee
Courtesy of Montuno
Productions

New Artist, the first jazz performer ever to be so honored. Her major CD releases include *Junjo* (2006), *Esperanza* (2008), *Chamber Music Society* (2010), *Radio Music Society* (2012), and, most recently, the innovative and highly personal *Emily's D+Evolution* (2016), *Exposure* (2017), and *12 Little spells* (2018).

Smooth Jazz

In his highly opinionated book *Jazz Rock: A History*, author Stuart Nicholson makes a case for keeping the term *jazz rock* alive for describing what he considers to be "credible" jazz-oriented performances that make use of rock elements while reserving the term *fusion* for musical styles he deems less worthy. While the use of these terms in the way described below is very much a minority view, the underlying attitude expressed is quite common.

Jazz-rock has been with us for a period roughly equivalent to that between Louis Armstrong's solo on "Weather Bird" to Ornette Coleman's album *The Shape of Jazz to Come*. Thirty years is a long time in the history of jazz, yet jazz-rock still remains an enormously controversial subject, not least because it has become increasingly perceived in terms of the commercial excesses of fusion. Indeed, the specter of fusion has grown so large, primarily through commercial FM radio, that today it fills the viewfinder, blotting out jazz-rock and distorting its achievements. In responding to commercial logic, fusion all but turned an art form back into a commodity by allowing itself to be shaped by the requirements of the marketplace. And as we all know, commercial radio gravitates to where the money is and the money is generated by whatever sells advertising. Fusion happened to click with the right money demographic, the 25 to 52-year-olds, and now there are almost two hundred New Adult Contemporary radio stations across the country specializing in formatting fusion with high rotation playlists often put together by market research firms specializing in "audience testing" to ensure recordings are "selected on the basis of the broadest possible appeal" (i.e., the lowest common denominator).[1]

Many jazz critics seem to think it is a cardinal sin to make money, and Heaven forbid if you play a style of music that someone who is not considered a *worthy* jazz fan might enjoy (i.e., John Coltrane never played a solo that went on a bit too long in his entire life). In recent years, mixing jazz styles together with pop music has opened up a large commercial market that many jazz performers—some very talented, some not so much—have embraced. Critics have used labels including *smooth jazz, quiet storm, lite-jazz, hot-tub jazz, yuppie jazz,* and *fuzak* (a combination of fusion and Muzak) to describe these more commercial forms of jazz.[2] The industry has particularly embraced the term *smooth jazz,* but for the musicians, radio stations, and record companies that support it, being called a smooth jazz artist is not an insult.

Kenny G

One of the most popular smooth jazz performers today is saxophonist Kenny G. Given the rather opinionated quote at the beginning of this section, Stuart Nicholson actually paints an accurate portrait of the pop saxophone player. Instead of focusing on the artist, Nicholson seems to blame the "Kenny G problem," as it is sometimes known in the jazz world, on music fans.

> Perhaps the biggest-selling crossover artist was the saxophonist Kenny Gorelick, who debuted on the Arista label in 1982 with *Kenny G*, followed by *G Force*, which sold over 200,000 album copies. An uncomplicated R&B-based fusion aimed at FM airplay, both albums and the subsequent *Gravity* were not served well by the inclusion of vocal tracks. With *Duotones*, the vocals were dropped and, with the success of the single taken from the album, "Songbird," Kenny G hit the big time. Subsequent best-selling albums and sellout tours seemed to suggest that an awful lot of people enjoyed his middle-of-the-road, no-surprises, easy-listening style, which had become omnipresent on FM radio.[3]

In truth, there is a bit of a problem with Kenny G, but it's not his music. If you like it, go ahead—it's okay to enjoy it. Think of it as one of life's little guilty pleasures. Be aware, however, that this is a performer who has made a very good living billing himself as a jazz musician, but he rarely lends his support to the larger community of jazz. Regardless of how pop-oriented their music became, performers including Chuck Mangione, Grover Washington, Jr., and Herbie Hancock, as well as players in bands such as Spyro Gyra and Tower of Power have always been quick to direct their fans toward the past masters of jazz. For Kenny G there seems to be no other music in the world besides his own.

In 2000, guitarist Pat Metheny posted (and subsequently deleted) a now infamous post on his website taking Kenny G to task mostly for a track he created where he overdubbed his playing over the top of Louis Armstrong's last vocal hit, *What A Wonderful World*. In the jazz world, Kenny G's actions created a firestorm, and Metheny's comments were seen by many as a worthy defense of the jazz art form. In a column published in the July 16, 2000 *New York Times*, music critic Ben Ratliff offered a more balanced opinion of the specific recording, Pat Metheny's response to both Kenny G in general as an artist and, again, the recording in question, as well as a broader opinion of the "smooth jazz" world of Kenny G and its listeners. As with the previous discussion from historian Stuart Nicholson, Ratliff basically points out that this style of music wouldn't exist if people were not buying it. As you read the following article, do keep in mind that it was written almost 20 years ago now, and that it was written in specific response to events of the day.

*J*azz Can Take Itself Too Seriously

By Ben Ratliff July 16, 2000

The most widely read piece of writing on jazz in the last few months, I would imagine, has been by the guitarist Pat Metheny. In early June, Mr. Metheny outlined his views on the smooth-jazz million-seller Kenny G within the discussion section of his own Web site, patmetheny-group.com. (It's no longer posted there.) Mr. Metheny's letter (intended

only for the fans who visit his site and written in heat-of-the-moment e-mailese) has been forwarded around the world; there was a day last month when I received it a dozen times.

The letter is impressively honest and rather thoughtful. It proceeds from evenhanded assessment—a rare response where smooth jazz is concerned—to persecutory rage, setting up Kenny G as a defiler in the temple of jazz. "I first heard him a number of years ago," Mr. Metheny wrote of Kenny G, "playing as a sideman. . . . My impression was that he was someone who had spent a fair amount of time listening to the more pop-oriented sax players of that time, like Grover Washington or David Sanborn, but was not really an advanced player, even in that style. He had major rhythmic problems and his harmonic and melodic vocabulary was extremely limited, mostly to pentatonic-based and blues-lick derived patterns."

But Kenny G (his last name is Gorelick) had other resources. "He did show a knack for connecting to the basest impulses of the large crowd," Mr. Metheny wrote, "by deploying his most effective licks (holding long notes and playing fast runs—never mind that there were lots of harmonic clams in them) at the key moments. . . . The other main thing I noticed was that he also, as he does to this day, plays horribly out of tune—consistently sharp."

Mr. Metheny believes that Kenny G's music should be assessed as jazz, not as instrumental pop. "He SHOULD be compared to John Coltrane or Wayne Shorter," he contended, "on his abilities (or lack thereof) to play the soprano saxophone."

But it was what followed that got people excited. The subject was Kenny G's 1999 recording of the song "What a Wonderful World," in which the voice of Louis Armstrong is embedded within the new recording by Kenny G's quartet. "With this single move," Mr. Metheny wrote, "Kenny G became one of the few people on earth I can say that I really can't use at all—as a man, for his incredible arrogance to even consider such a thing, and as a musician, for presuming to share the stage with the single most important figure in our music." And then he adds a hint of personal retribution: "Everything I said here is exactly the same as what I would say to Gorelick if I ever saw him in person. And if I ever DO see him anywhere, at any function—he WILL get a piece of my mind."

Taking a cue from Mr. Metheny's challenge ("I am also amazed that there HASN'T already been an outcry against this among music critics—where ARE they on this?????!?!?!?!"), I bought "Classics in the Key of G" to hear the offending song and listened to a Kenny G album for the first time in my life. Like Mr. Metheny, I never felt one way or the other about Mr. Gorelick; his music is ambient dandelion-fluff that I knew plenty about from being put on hold by telephone receptionists. He sells millions, yet doesn't measure up to Coltrane? I'd sooner get riled about why I can't shoot my tax returns at the moon and get them back an hour later, fully executed.

When I heard "What a Wonderful World," I experienced another first: I felt something from a Kenny G song. This mostly came from Armstrong. His singing is the only life in the track. But it came from the juxtaposition, too. For anyone to use Armstrong this way is horrid; the jolt you feel, whether you like the song or not, is caused by the arrogance it takes to make that hop into the land of the dead.

But sometimes pop culture is horrid, and Kenny G, Louis Armstrong and Pat Metheny all belong to pop culture. Armstrong's public persona

was marked by generosity; he was the least rarefied of geniuses. And "What a Wonderful World" itself is not sacred. It's perfect within itself, but it's merely pleasant, a big, dewy Barney smile.

In selecting "What a Wonderful World," Mr. Gorelick made a good choice for his own purposes. I'm afraid that it works. The last 20 years of intelligent writing about Armstrong has established that he was capable of both the freshest, freest pieces of improvisation as well as cheery schlock; and to understand him is to understand that American pop culture is nothing without both impulses. I think I'd be more upset if Kenny G sampled a really lively, rhythmic Armstrong performance. But he wouldn't. It wouldn't work. Pop may be opportunistic, but above all it's practical.

If Kenny G belongs to a tradition, it isn't jazz so much as advertising, in which music has a specific function: to provoke passivity. His use of an Armstrong tune is just giving way to the flow of commerce; it has no other meaning.

There's a new ad for Pop-Tarts that uses Jimi Hendrix's version of "The Star-Spangled Banner." I haven't seen people get hot about that. Where would they start? The crime of appropriating a moment from Woodstock? Or of appropriating Hendrix for the sake of a Pop-Tart? Or of the equating of Hendrix with a Pop-Tart? You realize, after a while, that Hendrix isn't the point. The point is, are you hungry?

A few years ago, Kenny G briefly changed musical directions a bit and signed with the Concord jazz label. His 2008 release, *Rhythm and Romance*, explored Latin jazz. To his credit, in some of the press surrounding that project Kenny G actually acknowledged his musical debt to earlier jazz artists such as Stan Getz, who was a pioneer in Latin jazz styles. Unfortunately, his 2010 release *Heart and Soul*, also on the Concord label, marked a clear return to the style of music that made Kenny G famous. The music is polished, slickly packaged, and, at least from an improvised jazz point of view, not at all engaging in any meaningful way. That said, it climbed to the top of the jazz charts in 2010 and even reached number 33 on the *Billboard* pop chart. In 2015, he released a second album of bossa nova tracks titled *Brazilian Nights*, which was also a very elaborately produced commercial success. The artist continues to tour and record on a regular basis.

Some Other Smooth Jazz Artists

It is hard to place a finger on exactly when the smooth jazz movement began. In theory, you could go all the way back to some cool school artists, but most of them would not appreciate being included in that theory! In the 1980s, fusion musicians including Grover Washington, Jr., George Benson, and Al Jarreau brought more of a relaxed, soul music sensibility to their music. The style grew in popularity as radio stations began programing this music to a much larger audience. In the years that followed, the smooth jazz format was extended to include more new age artists such as Yanni and John Tesh. Like many other forms of jazz, the category of smooth jazz is really a collection of closely related styles. Some artists feature a great deal of improvisation in more of a pop format, whereas others bypass true improvisation in favor of a really nice groove and a very accessible melody. Many hardcore jazz fans and musicians alike speak in very negative tones about smooth jazz, but these crossover artists are crying all the way to the bank. Furthermore, in the final analysis, there are those who would argue that any new fans coming to any sector of the greater jazz world is a good thing, regardless of how they get there.

Hip-Hop Influences On Jazz

Some rap artists have explored elements of jazz in their music. The groups A Tribe Called Quest, Arrested Development, and Digable Planets have all used jazz samples or live jazz as a part of their music. Furthermore, solo artists Erykah Badu and Jamiroquai have both incorporated jazz styles in their performances. In fact, some critics have called Badu the next Billie Holiday. In an attempt to blend jazz and hip-hop culture, artists including Quincy Jones brought hardcore rappers such as Ice T, Big Daddy Kane, and Melle Mel into their projects. Whether they know it or not, some of the best freestyle rappers are continuing the tradition of improvisation that has always been an integral part of jazz.

acid jazz Another catch-all category that has grown in popularity recently is **acid jazz**. Ask ten different people and you will get ten different definitions of what acid jazz is. Well, it is really just another approach to musical fusion. A recent series of albums titled *The Roots of Acid Jazz* feature artists such as Jimmy Smith and Wes Montgomery, as well as more modern players such as Herbie Hancock. Modern groups who fall into the acid jazz category include Buckshot LeFonque and Us3. The latter group is particularly interesting as they developed a relationship with a flagship jazz record label, Blue Note. A song called *Cantaloop* from the album *Hand on the Torch* went on to break into the top 20 on the pop charts. At the time, the album became the biggest seller ever for a label that has recorded just about every jazz artist mentioned in this book. The following listening guide explores the group in more depth and offers a detailed exploration of their biggest hit, *Cantaloop (Flip Fantasia)*.

Listening Guide

Cantaloop (Flip Fantasia) (R. Kelly, M. Simpson, G. Wilkinson, and H. Hancock)

Example of rap and hip-hop styles blended with jazz samples and live jazz

Album: *Hand on the Torch*, released November 16, 1993

Performed by Rahsaan Kelly, lead rap vocal; Gerard Presencer, trumpet; Geoff Wilkinson, producer, programming, samples, and scratches; and Mel Simpson, producer, keyboards, and programming

Even today, over twenty years after the CD *Hand on the Torch* was first released, this track and this group remain controversial in the world of jazz. Some folks in the record industry and elsewhere viewed this recording as the salvation of jazz in the late twentieth century when it was first released. Meanwhile, many jazz purists said this was not real jazz, and some were particularly offended by the sampling of classic jazz tracks. In a recent discussion about the creation of the material for *Hand on the Torch*, Us3 mastermind Geoff Wilkinson wrote: "I was trying to make something that was 50% jazz and 50% hip hop. . . . We did get criticized several times for 'tearing pages out of the Bible', but my answer was that we'd been sanctioned by God (in the shape of Blue Note Records)."

Like it or not, the time has come for everyone involved with jazz to acknowledge that this group played a positive role in changing the public face of jazz. Instead of dismissing groups such as Us3, "serious" jazz musicians, critics, and educators alike need to embrace such acts as a good way to access an entirely new group of potential fans. Furthermore, as the people who are involved with the group are clearly very knowledgeable jazz fans themselves, a little more respect for their craft seems in order. A simple examination of the samples used in the track we are considering reveals that these people really know their stuff.

The main sample used on *Cantaloop (Flip Fantasia)* is a brief portion of Herbie Hancock's tune *Cantaloupe Island* from his *Empyrean Isles* album released in 1964 on Blue Note Records. The other musicians on Hancock's recording include Freddie Hubbard, Ron Carter, and Tony Williams. Other samples on the Us3 track include some minor spoken dialogue, e.g., "yeah" and "what's that?" taken from a Lou Donaldson recording titled *Everything I Do Gonna Be Funky (From Now On)*. Finally, the Us3 track opens with the voice of Pee Wee Marquette, the man who served as emcee at the New York jazz club Birdland in the 1950s, taken from an Art Blakey recording titled *A Night at Birdland, Vol. 1*. Other samples of Marquette's voice are also heard later in the Us3 track. For the most part, these are not recordings a casual jazz fan would know well, let alone people who work outside the world of jazz.

So, jazz fans, please approach with an open mind. And for those of you who aren't fans just yet, keep an open mind as you explore exactly what jazz can be. To really grasp the depth of nuance in this track, including stereo panning and the intricate layers of the samples used, consider listening with headphones. I know most people simply consider this a dance track, and it does have a strong groove, but there really is a great deal of artistry here. No, it's not all straight-ahead improvisation like groups led by Charlie Parker or John Coltrane, but it is still art.

Total time: 4:37

:00	The track opens with Pee Wee Marquette making an announcement at Birdland, followed by the sample of Hancock's original recording. Quickly, other samples and live playing are overdubbed. In particular, notice trumpet player Gerard Presencer's re-creation of a portion of Freddie Hubbard's line from the original Hancock recording. (18 bars)
:47	The main rap begins. Without going too deeply into structural analysis, the track uses something of a verse/chorus format, but here the "chorus" functions through most of the track as an instrumental interlude with some spoken overdubs. (12 bars)
1:12	Instrumental chorus begins. (8 bars)
1:29	2nd rap verse, this time extended in length with added horn riffs later in the section. (16 bars)
2:02	2nd instrumental chorus, this time played twice. (16 bars)
2:35	3rd rap verse. (12 bars)

Recent press photo of Us3 in performance.
Courtesy Us3 (www.Us3.com)

3:00 Instrumental solo. Trumpet player Gerard Presencer returns with the same theme heard in the introduction, but after a few bars he branches out into his own improvisation. (16 bars)

3:33 Trumpet solo continues, joined by arranged horn riffs. This section continues to a fade out as the track draws to a conclusion. (32 bars, but most of the last bar is buried in the fade.)

Source: Geoff Wilkinson, e-mail discussion, March 28-31, 2011.

CD cover of Us3's recent release, stop. think. run. Courtesy Us3 (www.Us3.com)

M-base

Dig Deeper
WEBSITES

www.us3.com
www.m-base.com

Saxophonist and M-base creator Steve Coleman. © Mephisto

One interesting development that started in the 1980s is saxophonist Steve Coleman's creation of a style he calls **M-base**. Short for "Macro-Basic Array of Structured Extemporization," M-base is a mixture of rap, funk, rock, and jazz styles. Other musicians skilled in the more traditional styles of jazz have also explored M-base as a style. Former Miles Davis keyboard player Geri Allen, for example, and singer Cassandra Wilson have both experimented with this new fusion of jazz styles.[4] Both women are skilled jazz performers with a wide array of musical styles at their disposal. These are gifted artists who may be seeking a more accessible form of communication without having to compromise their art. Only time will tell.

The Country Connection

Although most people miss it completely, there has always been a strong connection between country music and jazz. Many of the best "pickers" in country music are masters of improvisation. Older artists including Bill Monroe, Bob Wills, and Chet Atkins made heavy use of jazz styles in their music. Modern

groups such as New Grass Revival, and the subsequent groups its members have taken part in, have all had a strong leaning toward very creative improvisation. Nashville artists Sam Bush, Edgar Myer, Jerry Douglas, Matt Rollings, Howard Levy, and Béla Fleck have all created music that often bounces between many different musical styles, including jazz. Furthermore, the playing of noted studio musicians such as Vassar Clements, Johnny Gimble, and John Jorgenson all reflected the direct influence of Gypsy jazz guitarist Django Reinhardt and his music. Béla Fleck in particular has broken a lot of new musical ground with his group Béla Fleck and the Flecktones. The following listening guide covers the band in more detail and offers an exploration of the tune *The Sinister Minister*, which was an early hit for the band.

A recent press photo of the Béla Fleck and the Flecktones with the original band lineup. Left-to-right: Roy "Futureman" Wooten (percussion/SynthAx drumitar), Howard Levy (keyboards and harmonica), Béla Fleck (banjo), and Victor Wooten (bass).
Courtesy of Jim McGuire

Dig Deeper
WEBSITES

www.flecktones.com
www.belafleck.com

Listening Guide

The Sinister Minister (Béla Fleck)

Early example of Béla Fleck and the Flecktones
Album: *Béla Fleck and the Flecktones*, released March 6, 1990
Performed by Béla Fleck, acoustic and electric banjos; Howard Levy, harmonica, keyboards, and güiro; Victor Wooten, bass; and Roy "Futureman" Wooten, SynthAxe drumitar

In many ways, the first version of the band Béla Fleck and the Flecktones represented a modern reincarnation of the original Benny Goodman quartet: The musicians came from different cultural and musical backgrounds, they blended those cultures into one cohesive group, and no one else on the planet could have done what those particular artists were doing together as a unit at that time. Both groups were truly unique. Howard Levy left the Flecktones a few years after this recording was made, and the band toured and recorded as a trio for a while, later adding innovative woodwind player Jeff Coffin (who also works with the Dave Matthews Band) to the group. Levy rejoined the band on tours beginning in 2009, and he and Coffin now alternate performance time with the group as their respective schedules allow. In any configuration, this is a band you need to see perform live.

In terms of formal structure, *The Sinister Minister* presents itself in a number of fairly symmetrical 4- and 8-measure phrases. There are three distinct 8-bar melodies that we will simply call letters A, B, and C.

Total time: 4:37

:00	Introduction. A repeated 4-bar figure is played four times, adding more instruments each time. In the last measure of the last statement the band plays a different chord pattern that leads to another 4-bar figure.
:31	Introduction continues. This new 4-bar chord pattern will later be used to support the letter B material. Here it is played twice, for a total of 8 bars.
:46	Harmonica enters with the letter A melody, 8 measures.
1:01	Harmonica continues with the letter B melody, 8 measures.
1:16	Harmonica continues with the letter C melody, which in many ways really functions as a melodic extension of the letter B material, 8 measures.
1:31	Letter A material returns for another 8-bar statement, still with the harmonica in the lead.
1:46	Banjo solo over letter A and letter B chord progressions, 16 bars total.
2:16	Harmonica returns with another 8-bar statement of letter A material.
2:32	4-measure interlude that sets up the bass solo.
2:39	Bass solo begins, utilizing harmonic and thematic material from letters A, B, and C. Victor Wooten has developed a unique style of playing the electric bass, and his amazing technique is legendary among bass players around the world. This is what most electric bass players would do if they could! You'll feel the groove jump a little at the end of this solo as Wooten leads the band back to the vamp. He throws in a 3/4 measure just to make things a little more interesting.
3:31	As the bass solo comes to a conclusion, the introductory vamp returns, 4 measures.
3:39	Harmonica returns with an 8-bar statement of letter B.
3:54	Harmonica continues with an 8-bar statement of letter C.
4:09	Letter A melody returns for a few bars and leads into a prearranged series of closing licks that bring the tune to its conclusion.

A Few Artists Who Just Defy Category

John Zorn

Composer and saxophonist John Zorn has used his music to amuse, confuse, and just generally shock his audiences for years now. His music has been described as "eclecticism gone haywire," which is about as good a description as you will find.[5] Any sound Zorn has ever heard, any noise from the street, and even sound effects from cartoons show up in Zorn's music at the most unpredictable of times. For many years, Zorn was a regular at the experimental Manhattan club the Knitting Factory. You can still catch him around New York City on a somewhat regular basis performing with a wide range of musicians. Some of Zorn's best efforts in the recording studio include *Big Gundown*, *Spillane*, *Spy Vs. Spy: The Music of Ornette Coleman*, and *Naked City*. Don't ask why, just go there and enjoy the wild ride.

Django Bates

In many ways, English pianist and composer Django Bates is the British equivalent of John Zorn. The biggest difference in their respective approaches is that Bates has a more overt sense of humor. In some ways, he is a modern, skinny, white version of Thelonious Monk. His recordings can be difficult to get in America, but they are well worth the search. On the CD *Winter Truce (and homes blaze)*, his band's take on the classic *New York, New York* is reason enough to buy the entire disc. He has also made some very fine solo piano recordings including *Autumn Fires*. More recent projects include *You Live and Learn …. (Apparently)*, *Spring Is Here (Shall We Dance?)*, and *Beloved Bird*, a 2010 release that celebrates the music

of Charlie Parker. In addition to fronting his own bands, Bates is also noted for his work with a number of other groups, including a band called the Loose Tubes, a big band that was active in England in the 1980s and that has recently reunited for a series of concerts and recordings including the 2015 release *Arriving*. In addition, he is an active music educator, teaching at various music conservatories and other institutions in England, Denmark, and Switzerland.

Don Byron

Clarinet player Don Byron is yet another performer who could be found from time to time on one of the stages at the Knitting Factory. Byron has played in recent versions of the Duke Ellington Orchestra and has also sat in with the rock band Living Colour. His playing mixes together a wide array of jazz styles with twentieth-century classical music and Jewish klezmer. As a band leader he has made several very important jazz albums in the past few years including *Tuskegee Experiments*, *Bug Music* (a tribute to the cartoon-like music of Raymond Scott, among others), and *Music for Six Musicians*. Byron's music is at various turns hilarious and tragic, but it is always thought provoking. His most recent project, which he calls the Don Byron New Gospel Quintet, is exploring the intersection of black gospel music and jazz.

Clarinetist Don Byron performing at the Outpost Performance Space in Albuquerque, New Mexico.
Courtesy of James Gale

Sex Mob

One of the hottest new groups on the "alternative" jazz scene is a band run by trumpet player Steven Bernstein called Sex Mob. Their 2001 CD, *Sex Mob Does Bond*, features wild jazz performances of soundtrack music taken from various James Bond films. Like John Zorn, this is a band that was featured regularly at the Knitting Factory and is very much on the cutting edge of the jazz world today. The band's website describes a Sex Mob performance as follows:

> Perhaps the most fascinating thing about the Sex Mob sound is its precarious balance of red-faced, wobbly musical acrobatics and crystal-clear, sober playing. Akin to the "Drunken Style" famed in Kung Fu legend, Bernstein & Co. swagger through tracks, almost falling off stage right before bringing the music back from its stumbling point. It owes as much to Buster Keaton and the Little Rascals as it does to King Oliver, New Orleans second-line brass band lineage, Louis Armstrong, Duke Ellington and [free jazz saxophonist] Albert Ayler. Only after seasoned listening do you realize that they don't need a stage net to prevent injuries to band members and audience alike.[6]

Dig Deeper

WEBSITE

*www.patricia
barber.com*

Sex Mob has now been together over 20 years, and the band is run by slide trumpet player Steven Bernstein. The band's latest release, *Cultural Capital*, features the first band recording that will focus exclusively on original compositions by Bernstein. In addition to his work with Sex Mob, Bernstein is an active New York City musician, performing with a wide array of musicians and with other bands including the Millennial Territory Orchestra, the Universal Melody Brass Band, and Butler/Bernstein & The Hot 9, which is a band he fronts with legendary pianist and vocalist Henry Butler.[7]

Patricia Barber

Chicago-based singer, pianist, and composer Patricia Barber is another artist who can be very difficult to place in a single musical category. One the one hand she writes complex, fusion-driven "post-modern" bop, but she also has a dark side that helps her create elegantly depressing meditations on various aspects of life today. In addition, Barber has been known to perform creative covers of popular tunes including the Doors' *Light My Fire*, which she sings in a slow, sultry jazz style. She is also a gifted improviser on piano, playing intricate extended passages reminiscent of diverse influences including Art Tatum, Bill Evans, Chick Corea, and Herbie Hancock. A few of her best earlier CDs include *A Distortion of Love*, *Modern Cool*, *Verse*, and *Live: A Fortnight in France*. More recent projects include the amazing original jazz song cycle *Metamorphoses*, which Barber created as part of a Guggenheim Fellowship she won in 2003. The recording was released in 2006 on Blue Note Records. In 2008 she shifted directions completely and released an outstanding collection of jazz standards titled *The Cole Porter Mix*. In 2013, Barber changed record labels, joining Concord Jazz, and she released *Smash*, yet another strong set of originals with innovative playing and singing throughout. When she's not on the road, you can find her playing a regular Monday night gig at the Green Mill in Chicago, and it is worth the trip to attend a live performance. If you can't make it, however, the artist has also released a series of *Monday Night Live at the Green Mill* recordings over the past few years that are the next best thing.[8]

*Composer, pianist, and
singer Patricia Barber.*
Courtesy of Mike Friedman
at Premonition Records

Jane Ira Bloom

Soprano saxophone player Jane Ira Bloom may be the most important performer on that instrument since John Coltrane. In addition to being a great player, Bloom has incorporated movement on stage as part of her improvisations. She sometimes uses a variety of electronic effects on stage, and the changing timbres of her tone as she moves around the stage become part of her improvisations. Bloom has gained the attention of both critics and music fans alike. In 2001 she was the winner of the Jazz Journalists Award for soprano sax player of the year and the Down Beat International Critics Poll for soprano saxophone, awards she has won a number of other times since then. In 2007 she

Photo by Kristen Larsen,
Courtesy of Jane Ira Bloom.

was awarded a Guggenheim Fellowship for music composition, and she has also enjoyed several Doris Duke/Chamber Music America awards over the years. In addition, she was the first musician ever commissioned by the NASA Art Program and was also honored by having an asteroid named in her honor by the International Astronomical Union (asteroid 6083 Janeirabloom). Along with her extensive performing and composing schedule, Bloom serves as a professor at The New School for Jazz and Contemporary Music in New York City.[9] Bloom frequently mixes her music with both the visual arts and dance. She has created original music for dance ensembles and has also used the paintings of artists including Jackson Pollock as launching points for her musical creations. You can hear her tune *Jackson Pollock* on Spotify.

Dig Deeper
WEBSITE

www.janeira bloom.com

Listening Guide

Jackson Pollock (Jane Ira Bloom)

Example of modern fusion
Album: *Chasing Paint: Jane Ira Bloom Meets Jackson Pollock*, recorded April 14 and May 3, 2002
Performed by Jane Ira Bloom, soprano sax and live electronics; Fred Hersch, piano; Mark Dresser, bass; and Bobby Previte, drums

All of the tracks on this CD were inspired by paintings created by Jackson Pollock. Compared to most musicians who take general inspiration from the other arts, however, Jane Ira Bloom literally looks at a Pollock image and reads the canvas as if it were printed music, molding the shapes found in the painting into sound.

Total time: 2:54

:00	Principal theme is stated by Bloom on soprano sax.
:17	Rhythm section joins in as Bloom begins to explore and expand on the original theme.
1:16	As her improvisation continues, Bloom begins to alter the sound of her horn with the addition of live electronic effects. "Live"

means that she is using the effects as she performs her improvisation and not adding them later in a post-performance process. She uses the same techniques in both live performance and the studio setting.

2:09 Main theme returns. Notice that the electronic effects have been removed.

This painting was originally titled No. 11, 1952, *but the artist later added the descriptive title* Blue Poles, 1952. *This image has become one of Jackson Pollock's most famous paintings, and it offers the viewer a good perspective of the artist's innovative technique. Saxophone player Jane Ira Bloom projects images similar to this one on a wall, and then her band "reads" it like music, interpreting the painting in the language of music.* Blue Poles, 1952 (oil, enamel, aluminium paint & glass on canvas) pollock, jackson (1912–56)/National Gallery of Australia, Canberra/ Purchase 1973/Bridgeman Images

Snarky Puppy

The band Snarky Puppy was originally conceived by students in the jazz program at the University of North Texas, which also produced such jazz luminaries as Jeff Coffin (Béla Fleck and the Flectones, Dave Matthews), Bob Belden (noted jazz composer and arranger), Lyle Mays (Pat Metheny), and Norah Jones, among many others. Led by bassist and composer Michael League, the band features a core group of musicians who appear on most projects and in live performances, but the band is frequently augmented by a wide array of guests and other part-time band members. The band is particularly noted for their high energy, live music performances that explore and blend an eclectic mix of different musical styles. Many of the bands most successful recordings were actually recorded in live performance and simultaneously filmed for video release as well. The band's website features a video links page that includes a number of outstanding live performances, including a recent show that was filmed in 360 degree perspective to be viewed in the Google Chrome domain.[10] In a discussion of how different music critics and fans try to categorize the band, the group's website offers the following discussion: ". . . Snarky Puppy isn't exactly a jazz band. It's not a fusion band, and it's definitely not a jam band. It's probably best to take Nate Chinen of the *New York Times*' advice, as stated in an online discussion about the group, to 'take them for what they are, rather than judge them for what they're not.'"[11] The group won their first Grammy Award in 2014 for Best R & B Performance, followed by two Best Contemporary Instrumental Album awards in 2016 (*Sylva*) and 2017 (*Culcha Vulcha*). In addition to an extensive performance schedule, the band frequently makes time to offer workshops and other educational outreach opportunities for music students of all ages.

Brad Mehldau

Pianist and composer Brad Mehldau is an absolutely fearless improviser who is widely respected for his abilities in a solo setting, with his outstanding trio, and as a willing collaborative artist. After work as a sideman, most notably with saxophonists Christopher Hollyday and Joshua Redman, Mehldau arrived on the international jazz scene in the mid-1990s with a series of impressive trio recordings for the Warner Brothers record label, several of which were recorded live at the famous Village Vanguard Jazz Club in New York City. The *Art of the Trio* series eventually extended to five recordings with that title, as well as many other fine trio (and a few quartet) projects. The entire *Art of the Trio* recordings are now available as a box set (or MP3 download) from Nonsuch, Mehldau's current record label. Other collaborations include separate projects with the opera singers Renée Fleming (*Love Sublime*) and Anne Sofie von Otter (*Love Songs*), where Mehldau composed some of the music and performed as pianist. Other interesting collaborative projects include live performances and recordings with guitarist Pat Metheny and, most recently, a new recording and tour with Chris Thile, noted mandolin player, vocalist, and host of the National Public Radio Show *Live From Here*.

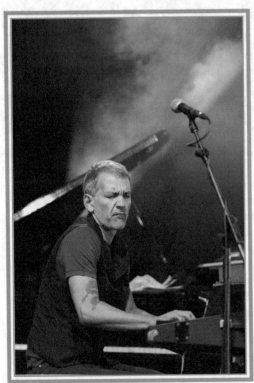

Pianist Brad Mehldau.
Michael Putland/Hulton
Archive/Getty Images

Mehldau's wide-ranging improvisation skills take the artist from meditative, accessible performances, through classically-influenced modern jazz expressions, right up through outright moments of totally free jazz. Perhaps the most important thing to note about Mehldau's style, however, is that no matter how far outside he takes you as a listener, he will always bring you back to a safe musical space. For a brief sampling of Brad Mehldau's skills, listen to a live performance of the famous Beatles' tune *Blackbird* (which was really performed as a Paul McCartney solo on *The Beatles*, aka *The White Album*) as recorded for the Nonsuch album *10 Years Solo Live*, which features a collection of live solo tracks recorded between 2004 and 2014.

Dig Deeper
WEBSITE

www.bradmehldau. com

Listening Guide

Blackbird (Paul McCartney, but often listed as Lennon and McCartney)

Example of pianist Brad Mehldau in a live solo setting
Album: *10 Years Solo Live*, recorded September 18, 2011
Performance by Brad Mehldau, piano

The formal structure of this Paul McCartney tune is actually quite tricky, though the tune remains an engaging and accessible expression of popular music. The song is actually created in two parts that can be labeled letter A and B, though in the pop world the letter B part is often called a "refrain." The tune also features mixed meter, meaning the basic beat groupings are shifting throughout the piece, with groupings in three, four, six (also sometimes written as 3/2 time, which actually changes the basic beat), and two. Like a number of songs created later in the Beatles output, this song features an elision between the two contrasting sections, meaning as you come to the end of the refrain (or letter B) the main melody accompaniment starts again, overlapping the end of the second part of the song. Pianist Brad Mehldau, of course, handles all of this complexity with effortless ease, and then spins out creative and extensive improvisations over the top of the structure while always managing to reference the original tune. This performance is a perfect musical example of the Charles Mingus quote that appears at the top of Chapter 7: "Making the simple complicated is commonplace; making the complicated simple, awesomely simple, that's creativity."[12]

Total time: 6:30

:00	Tune begins with a simple two-bar introduction (one measure of four beats and one measure of three beats) that mimics what McCartney played on the original recording.
:07	Letter A material begins.
:39	Letter A Material repeats.
1:01	Letter B, or refrain.
1:15	Shorted statement of letter A and letter B material, imitating the instrumental interlude and vocal refrain return as played and sung on the original recording.
2:02	More extensive improvisation begins, though elements of the original melody clearly remain. Of particular interest is Mehldau's brief quote from another famous Beatles' tune at 2:50, *Golden Slumbers* from *Abby Road*. Mehldau quotes the melody for the line " . . . and I will sing a lullaby." This event happens just before a return to the letter B material.
3:10	The next few minutes of improvisation display Mehldau extending his melodic ideas over sectional elements of the tune, though he continues to reference the original melodies and identifiable chord progressions at times throughout this more complex improvisation.
5:26	Clear statement of the original letter A melody returns, played twice with a gradual slowing of rhythmic texture and two repeats of the final line, "you were only waiting for this moment to arrive," to conclude the performance. Again, Mehldau's performance directly mirrors the original recording.

Some Final Thoughts on the Future of Jazz

In the final summary of their book *Jazz Issues*, authors David Megill and Paul Tanner point out that jazz today is at something of a crossroads. They note that jazz has the potential to go the way of classical music. The cultural mixing that brought us jazz in the first place, however, also offers the potential for continued growth in this art form.

There are many scenarios that can play themselves out as jazz matures as an art form. It may find, like classical music today, that it spends most of its time looking back as it searches for continued authentication. The fact that jazz is still a performer and improvisationally centered art form may prevent that from happening. We should remember that classical music also once had an exciting improvisational component but lost it to compositional intent. Jazz, as it looks for its own repertory, may suffer a similar loss. Also by looking back, jazz may respond more slowly to current cultural issues. For now, jazz still offers us a relatively quick response to social and cultural change. It still works as a mirror of the struggle for diversity prevalent in American culture and best reflects the dialectic posed when cultures merge. Most of all, jazz has offered us an example of how things we value gain status in our society. The uniqueness of the jazz art form reflects the unique balance of influences at work in our culture as they are played out by the individual artists who have defined the jazz tradition.[8]

That assessment is a thoughtful consideration of the future of jazz. The only thing missing is the audience. Many classical musicians are notorious for almost daring their potential audience to like their music, and I'm afraid that in some instances jazz musicians aren't far behind. The main purpose of creating a book of this nature is to bring a larger audience to the world of jazz. I would encourage jazz musicians to do everything in their power to make themselves more accessible to their audience. In no way do I mean that they should compromise the music they choose to play, but they should strive to develop a better rapport with their listeners. Conversely, I would encourage all jazz fans, and especially those new to the art form, to be a little patient with jazz musicians. Sometimes musicians aren't comfortable trying to put into words what they are doing. In fact, some musicians firmly believe that the music should always speak for itself. Given the lack of general music education over the last 30 or 40 years, my personal feeling is that many people no longer have the basic skills to even begin a journey in the world of jazz. This is an indictment of the general education system in America, not potential jazz fans as individuals. These problems are further compounded by a mainstream music industry that consistently panders to the lowest common denominator and turns its back on any artist who can't sell a million units right out of the starting gate.

Exploring the world of jazz is a fascinating, complex, sometimes frustrating, but always rewarding experience. It is one of the purest forms of communication humans have ever created. Sometimes it takes a little work to really understand the language, but at its best, jazz can be a window into a person's soul. Perhaps the most amazing thing is that unlike other forms of art, you don't just examine the finished product. Read a book and you are experiencing the final edit. A painter may struggle for years to capture just the right shades of light before he or she allows the public to experience their work. Even most classical music is at least in part a re-creation. When you hear a Beethoven piano sonata, you are experiencing

one performer's interpretation of another artist's creation. Most drama functions exactly the same way. Of all of these art forms, jazz is one of the few that involves an element of spontaneous creation offered before the general public on a regular basis. It never happens the same way twice, and is—at its best—a direct reflection of the moment in which it was created. In the end, perhaps that is jazz's greatest reward to its listeners and performers alike. We are all part of that unique moment of creation. It never happened exactly that way before, and it will never be performed exactly that way again. Is that cool or what?

Notes

1. Stuart Nicholson, *Jazz Rock: A History* (New York: Schirmer Books, 1998), p. xiv.

2. Ibid, p. xiii. Henry Martin and Keith Waters, *Jazz, The 100 Years* (Belmont, CA: Wadsworth/Thomson Learning, 2002), p. 296.

3. Nicholson, *Jazz Rock*, p. 219.

4. Martin and Waters, *Jazz*, p. 348.

5. Michael Erlewine et al., eds., *All Music Guide to Jazz*, 3rd ed. (San Francisco: Miller Freeman Books, 1998), p. 1209.

6. Brian Coleman, "Read the Bio.," *Official Sex Mob Website*. http://www.sexmob.com/mob.html# (May 20, 2002).

7. "About" and "+Projects." *Official Steven Bernstein Website*. http://www.stevenbernstein.net/ (March 21, 2017).

8. "Patricia Barber: Discography." *Official Patricia Barber Website*. http://patriciabarber.com/music (March 21, 2017).

9. "Jane Ira Bloom, Soprano Saxophonist/Composer," *Official Jane Ira Bloom Website*. http://www.janeirabloom.com/retrospectiveawards.html (March 21, 2017).

10. "Snarky Puppy." *Official Snarky Puppy website*. http://snarkypuppy.com/video (March 21, 2017).

11. "Snarky Puppy." *Official Snarky Puppy website*. http://snarkypuppy.com/about. (March 20, 2017).

12. Mingus, Charles. https://en.wikiquote.org/wiki/Charles_Mingus (accessed March 21, 2017).

Study Guide

Chapter 11 Review Questions

True or False

___ 1. Some current jazz artists have begun performing music that has been "audience tested" by radio stations.

___ 2. One current trend in jazz is to fuse pop and jazz.

___ 3. Real fusion music only mixes jazz and rock styles.

___ 4. Smooth jazz refers to uncomplicated, pleasant, easy-listening jazz that may or may not feature improvisation.

___ 5. Band leader Steven Bernstein released the album *Bug Music*.

___ 6. Jazz music can reflect social and cultural changes quickly.

___ 7. Jazz involves spontaneous creation.

___ 8. Guitarist Django Reinhardt influenced modern country musicians.

___ 9. Many country musicians are skilled improvisers.

___10. Swing music became popular again during the 1980s and 90s.

Multiple Choice

11. In addition to playing the guitar, John Pizzarelli:
 a. sings.
 b. plays the piano.
 c. tap dances.
 d. plays the drums.
 e. plays the banjo.

12. Acid jazz is defined as:
 a. jazz that has been influenced by the drug culture.
 b. jazz that was recorded in the late 1960s.
 c. jazz that is performed exactly like traditional jazz except that it is amplified.
 d. jazz played on solo guitar.
 e. there is no agreed-upon definition of acid jazz.

13. What type of music is a mixture of rap, funk, rock, and jazz?
 a. new age d. M-base
 b. smooth jazz e. lite-jazz
 c. fuzak

14. Who recorded the album *Winter Truce*?
 a. John Zorn d. Django Bates
 b. Steven Bernstein e. Al Jarreau
 c. Don Byron

15. Which modern jazz artist's performances include a combination of jazz, dance, and visual arts?
 a. Jane Ira Bloom d. Raymond Scott
 b. Kenny G e. Don Byron
 c. Albert Ayler

16. The creator of M-base is:
 a. Geri Allen. d. Steve Coleman.
 b. Jane Ira Bloom. e. Miles Davis.
 c. Jamiroquai.

Fill in the Blank

17. Pianist, vocalist, and composer _____ _____ is viewed as a young Frank Sinatra, but he is a better improviser.

18. The "young lions" are skilled improvisers in _____ and _____ styles.

19. A modern spokesman for jazz, _____ _____ has a fairly conservative definition of jazz.

20. Some critics consider the solo artist _____ to be the next Billie Holiday.

21. Saxophonist _____ is known for using every sound possible to shock and entertain his/her audience.

22. Sex Mob, as well as John Zorn's bands, performed at Manhattan's _____.

23. _____ is a jazz artist who has had an asteroid named in his/her honor.

Short Answer

24. List two groups who fall into the acid jazz category.

25. List some of the "young lions" in the current jazz world.

Essay Questions

1. Make your own predictions about the future of jazz. What do you think jazz musicians could do to make their music more accessible to a wider audience?

2. Reread the Dr. Billy Taylor article found in Chapter 1. Have your views on jazz changed during this course?

Appendix A

Jazz Clubs

Restaurants, nightclubs, and bars around the world feature live jazz entertainment from time to time. Check the local event listings of almost any newspaper in America, and you will find places that offer jazz as part or all of their live programing. Listed below are just a few of the major jazz clubs currently in operation. Most of these clubs have their own websites, and many cities also offer general club listings as part of a community service website. Again, check the local newspaper sites, as they almost always offer some type of arts and music page. Clubs open, close, and change locations frequently, so it is always a good idea to check the latest local listings and call ahead before you go out.

New York City

The Blue Note - This is one of the finest jazz clubs in the world. The acts are always first-rate, and the sound quality is quite good throughout the club. Prices are high, but you get what you pay for. 131 West 3rd Street, New York, NY 10012. (212) 475-8592. NOTE: Club is close to the 6th Ave./MacDougal St. subway stop. www.bluenote.net.

Village Vanguard - Even more historic than the Blue Note, the Village Vanguard has been offering the finest in jazz performances since 1935. This downstairs (basement) club is small and intimate (claustrophobic) but the music is always good. If you start looking at some of the best live jazz recordings ever made, you will notice that the "Live at the Village Vanguard" title is common to many different artists. 178 7th Ave. South, New York, NY 10014. (212) 255-4037. www.villagevanguard.com.

Iradium - Right down the street from the Ed Sullivan Theatre where Stephen Colbert does his show, this club offers internationally-known jazz acts at typical big club prices. The food is good, but it also is not cheap. If they have an act you know you want to see, this will be money well spent. If you don't know the artists, however, try to listen to their music somewhere before you drop $50 to $100 in the club. 1650 Broadway (51st Street), New York, NY 10019. (212) 582-2121. www.theiridium.com.

Birdland - This is a relatively new club that is related in name only to the original Birdland of bebop fame. Like the other clubs listed above, it offers major jazz acts on a regular basis at typical big club prices. If you go early, however, you can often experience talented younger New York jazz musicians for little or no cover charge. Birdland is located at 315 West 44th Street, between 8th and 9th Avenues in Midtown Manhattan, just a few blocks off of Times Square. (212) 581-3080. www.Birdlandjazz.com.

Smalls & Mezzrow Jazz Clubs. – Smalls closed for a while, reopened in a new location, and has now returned to its original (but renovated) space at 183 W. 10th St. at 7th Ave. They've also developed a great website that offers live video streaming most nights, as well as a video archive. Tune in at www.smallsjazzclub.com. In 2014, Smalls opened a sister club across the road, also on a corner of 10th St. and 7th Ave. The Mezzrow venue is a smaller

"listening room" that focuses on solo piano artists and some duos and trios. Like Smalls, they often offer live video streaming, which can be found on their website, www.mezzrow.com. Both video links take you to a new viewing page that will require you to sign up. You can stream live video for free, but to view the archived material (which is well worth it!) you have to pay a fee. When you go there live, however, the best news is that one cover charge usually gets you in to both clubs all night, and they often have a special student ticket price with a valid student I.D. The contact number for both clubs is (646) 476-4346.

Fat Cat – This club used to have a direct association with Smalls Jazz Club listed above. That association seems to have changed now, but Fat Cat remains a funky basement space in the heart of Greenwich Village at 75 Christopher St. at 7th Ave. The club still features a great deal of local talent, often with little or no cover charge, and the music can go on until 4:00 a.m. many nights with wide open jam sessions. (212) 675-6056. www.fatcatmusic.org.

55 Bar & Grill - This is my favorite club in New York City. Like Smalls, this is a loose, intimate space that makes you feel very comfortable. Artists are always world-class, and surprisingly famous jazz musicians perform here on a regular basis when they are not on the road. 55 Christopher St. (7th Ave. S. & Waverly Pl.) (212) 929-9883. www.55bar.com.

Jazz at Lincoln Center - This incredible space opened in 2004 inside the Time-Warner building on Columbus Circle, just down the street from the actual Lincoln Center. There are three performance spaces (including a bar) and a number of interesting educational projects all connected with the new location. For the most part, tickets are not cheap, but it's an amazing place to hear (and see) jazz. One hall features a large glass backdrop behind the stage that overlooks Central Park and Columbus Circle. Truly breathtaking. Broadway at 60th St. (212) 258-9800. They have an extensive website: www.jalc.org.

Smoke: Jazz & Supper Club-Lounge - This club replaced Augie's Jazz Club in the late 90s and has been going strong ever since. They offer a wide mix of local talent and nationally recognized jazz artists. They also have a house band led by Vincent Herring that tears it up every Monday night with an open jam session starting at 10.30 p.m. 2751 Broadway, New York, NY 10025. (212) 864-6662. www.smokejazz.com.

New Orleans

Snug Harbor - Located just outside the French Quarter proper, this is one of the best jazz spots in the city. Ellis Marsalis, patriarch of the great Marsalis jazz family, often performs here, along with many of New Orleans' best players. The club also features national touring jazz acts from time to time. 626 Frenchmen St., New Orleans, LA 70119. (504) 949-0696. www.snugjazz.com.

The Spotted Cat - Directly across the street from Snug Harbor is The Spotted Cat, one of the best clubs in the Frenchmen St. area, which has enjoyed an amazing resurgence over the past few years. Where Snug Harbor used to be something of an oasis in a sketchy part of town, now the Faubourg Marigny District (which is just outside the French Quarter proper) has become a mecca for many of the better music clubs in NOLA. Among many great music venues, The Spotted Cat has become a favorite, featuring multiple sets by many of the cities' hottest local bands throughout the afternoon into the late evening. The best thing to do is catch the early set at Snug Harbor, and then just slip right across the street for the rest of the evening. You won't be disappointed, no matter who is playing! NOTE: It's cash only! 623 Frenchmen St., New Orleans LA 70116. (504) 943-3887. www.spottedcatmusicclub.com.

Fritzel's - This little hideaway close to the end of the commercial portion of Bourbon Street is a favorite hangout for local jazz musicians who often come to sit-in with the hired band after their respective shows are over for the night. They don't charge a cover, and they serve great German beer and schnapps. You might not find this club listed in some of the "main-stream" directories, but trust me, it's there, and it is a real treat when the place gets rockin' late at night. A good last stop before you crash. 733 Bourbon St., New Orleans, LA 70117. (504) 586-4800. www.fritzelsjazz.net.

Court of Two Sisters - This restaurant hosts a great jazz brunch. Well worth going to the trouble of making a reservation and dressing up a little to go. 613 Royal St., New Orleans, LA 70130. (504) 522-7261. www.courtoftwosisters.com.

Preservation Hall - This historic music venue has no bar and little in the way of amenities. If you want to see old New Orleans music legends practicing their craft, this is the place. 726 Saint Peter Street, New Orleans, LA 70116. (504) 522-2841. www.preservationhall.com.

Tipitina's - This New Orleans legend of a club has hosted many of the world's finest blues, rhythm and blues, jazz, and rock artists. You never know who might show up on Tipitina's stage, but it is always worth the trip. The original club is located at 501 Napoleon Ave., New Orleans, LA 70115. (504) 895-8477. Tipitina's now has an excellent website that occasionally offers live webcasts of its shows and maintains some very interesting archive material. www.tipitinas.com.

Chicago

Jazz Showcase - This club bills itself as the second oldest jazz club in existence. Its line-up of artists includes many national and international jazz acts, as well as some very strong local talent. Like many jazz clubs, the cover charge is for one set only, but unlike a lot of other venues, this club will usually invite you to stay for the next set with no extra cover unless there are others waiting for your seats. These are true jazz fans running the club. A "must see" when in Chicago. This venue has recently changed locations and can now be found at Dearborn Station, 806 S. Plymouth Ct., Chicago, IL 60605. (312) 360-0234. www.jazzshowcase.com.

Andy's Jazz Club - One of Chicago's older jazz clubs, Andy's presents mostly local talent, which is always good. They usually have jazz at noon, as well as early and late sets that can run well into the early morning hours. 11 E. Hubbard St., Chicago, IL 60611. (312) 642-6805. http://www.andysjazzclub.com/.

The Green Mill Jazz Club - This Chicago nightspot features great music every night of the week. Patricia Barber (p. 251) plays a regular Monday night gig at this excellent venue when she's in town. 4802 N. Broadway Ave., Chicago, IL 60640. (773) 878-5552. www.greenmilljazz.com.

Kansas City

The Blue Room & American Jazz Museum - This club offers primarily Kansas City-style jazz and blues as well. The new, multi-million dollar American Jazz Museum alone is well worth the trip. The Blue Room, 1616 E. 18th St., Kansas City, MO 64108. (816) 474-6262. American Jazz Museum, 1601 E. 18th St., Kansas City, MO 64108. (816) 474-8463. www.americanjazzmuseum.com.

The Phoenix - This club bills itself as "A Kansas City Classic," but in truth they've only been in business since 1990. Jazz and blues remains a living art form

in Kansas City, however, and this club does offer regular performances by some of KC's best local talent. Get your BBQ on at Arthur Bryant's before coming to the club (the original is located at 1727 Brooklyn Avenue). The jazz club is about five miles away on the other side of I-70 at 302 W. 8th St., Kansas City, MO 64105. (816) 221-5299. www.thephoenixkc.com.

Memphis

Alfred's - Alfred's is a popular Beale Street spot frequented by locals and tourists alike. They offer a wide variety of great music, including a regular Sunday night gig for the Memphis Jazz Orchestra, a fine big band made up of many of the top jazz musicians in the area. This venue also offers karaoke singing on a regular basis, so don't say I didn't warn you. 197 Beale St. at Third, Memphis, TN 38103. (901) 525-3711. www.alfredsonbeale.com.

B. B. King's Blues Club - This club mostly focuses on the blues, but you can still hear some very good improvisation. Great club with good sight lines, but it can get very loud and crowded. There are several versions of this club, including one in Las Vegas, but there is nothing like hearing the blues played on Beale Street. 143 Beale Street, Memphis, TN 38103. (901) 524-5464. www.bbkings.com/memphis.

Las Vegas

Bellagio - In terms of local jazz talent providing background music in the bars as well as some shows, this is one of the better spots in all of Vegas. You can often find a nice, quiet trio playing great jazz stuck away in the corner of one of this giant hotel and casino's clubs. 3600 Las Vegas Blvd. South, Las Vegas, NV 89109-4303. (888) 987-6667. www.bellagio.com.

Myron's Cabaret Jazz (at The Smith Center) - This venue hosts both local and touring acts in a tasteful 240-seat venue. The Smith Center where the club is housed hosts a wide array of acts and offers various artistic offerings, including the Nevada Ballet Theatre, the Las Vegas Philharmonic, and the Troesh Studio Theater. Get off the strip and enjoy some culture in Vegas! 261 Symphony Park Ave., Las Vegas, NV 89106. (702) 749-2012.

The Dispensary Lounge - Opened in the mid-1970s, recently The Dispensary lounge has been raising the stakes on its position as a "go to" spot for jazz in Las Vegas. The place has good food and cocktails, and you can gamble and listen to live jazz at the same time. This is a classic "dive bar" in the best tradition of those words. 2451 E. Tropicana Ave., Las Vegas, NV 89121. (702) 458-6343.

Los Angeles Area

Catalina Bar & Grill - This fine club features a regular calendar of major touring jazz acts, along with some of the best talent found in Southern California (many of whom also tour and have a national reputation). 6725 Sunset Boulevard, Hollywood, CA 90028. (323) 466-2210. www.catalinajazzclub.com.

Upstairs at Vitello's - Vitello's Italian Restaurant is a well-known (some say infamous) spot. The food is somewhat old school but always excellent (try the al pesto or garlic pizzetti). When you call for reservations, make sure you ask to be seated upstairs for the jazz offerings. Lots of very gifted musicians who work in the film and television industry perform here on a regular basis. 4349 Tujunga Ave., Studio City, CA 91604. (818) 769-0905. www.vitellosrestaurant.com.

San Diego

Anthology - This place bills itself as "fine tuned music and cuisine," and they live up to their advertising on both counts. Be warned, however: the food is not cheap, nor are their ticket prices, but you do get what you pay for. This venue features unique, world-class artists on a regular basis, and they have a killer house band as well. 1337 India St., San Diego, CA 92101. (619) 595-0300. www.anthologysd.com.

San Francisco Area

Savanna Jazz - This noted local spot is actually run by educators who have made a strong commitment to keeping the history of jazz alive. The club offers great live music and also has a unique menu that features a mix of French, Caribbean, and West African dishes. A "must visit" when in the Bay area. 1189 Laurel St., San Carlos, CA 94070, (415) 624-4549 for reservations. www.savannajazz.com.

Yoshi's - This outstanding club is located in Jack London Square in Oakland, and it regularly features some of the finest touring jazz acts in the world. The venue is excellent for music, and the food is outstanding as well. This is the "must visit" club in the bay area. 510 Embarcadero West, Oakland, CA 94607. (510) 238-9200. www.yoshis.com. You'll also find a number of full shows and other great music videos posted by Yoshi's on YouTube.

Seattle

Dimitriou's Jazz Alley - This is a well-established club in downtown Seattle that offers a regular roster of internationally-known jazz acts. 2033 6th Avenue, Seattle, WA 98121. (206) 441-9729. www.jazzalley.com.

Tula's Restaurant and Nightclub - This venue offers great Greek food and solid local jazz every night of the week. The club serves up a diverse set of artists each month, with most Sundays devoted to big band music, which is always great to hear live. 2214 2nd Ave., Seattle, WA 98121. (206) 443-4221. www.tulas.com.

Boston

Scullers Jazz Club - This club is a regular stop for major touring artists from all styles of jazz. The club, while not cheap by any means, offers some interesting packages that give you dinner, a show, and a hotel room. Hey, if you're going to Boston anyway, why not do it up right! Scullers Jazz Club at the Doubletree Guest Suites-Boston, 400 Soldiers Field Rd., Boston, MA 02134. (617) 562-4111. www.scullersjazz.com.

Washington, D.C.

Blues Alley - The most famous jazz club in the D.C. area. Usually a very good line-up of talent, and the food is not bad either. 1073 Wisconsin Ave. NW, Washington, D.C. 20007. (202) 337-4141. www.bluesalley.com.

International Locations

Australia

Melbourne - Dizzy's Jazz Club. www.dizzys.com.au.
Melbourne - The Paris Cat Jazz Club. www.pariscat.com.au.
Sidney - The Basement. www.thebasement.com.au.

Austria

Vienna - Jazzland. www.jazzland.at.

Belgium

Brussels - L'Archiduc. www.archiduc.net.
Liege - Jacques Pelzer Jazz Club. www.jacquespelzerjazzclub.com.

Canada

Edmonton - Yardbird Suite. www.yardbirdsuite.com.
Toronto - Jazz Bistro. http://jazzbistro.ca/
Toronto - The Rex Hotel – Jazz and Blues Bar. https://therex.ca/
Montreal - House of Jazz. https://www.houseofjazz.ca/montreal/?lang=en
Montreal - Upstairs Jazz Bar and Grill. https://www.upstairsjazz.com/en/index.php
Vancouver - Frankie's Jazz Club. http://www.frankiesjazzclub.ca/
Vancouver - Blue Martini Cafe & Jazz. https://www.bluemartinijazzcafe.com/

Denmark

Copenhagen - Jazzhus Montmartre. www.jazzhusmontmartre.dk.

England

London - 606 Club. www.606club.co.uk.
London - Pizza Express. www.pizzaexpresslive.com.
London - Ronnie Scott's Jazz Club. www.ronniescotts.co.uk.
London - Vortex Jazz Club. www.vortexjazz.co.uk.

France

Paris - Le Baiser Salé. www.lebaisersale.com.
Paris - Le Caveau de la Huchette. www.caveaudelahuchette.fr.
Paris - Le Duc des Lombards. www.ducdeslombards.com.
Paris - New Morning. www.newmorning.com.
Paris - Sunset/Sunside. www.sunset-sunside.com.

Germany

Berlin - A-Trane. www.a-trane.de.
Berlin - B-Flat Acoustic Music and Jazz Club. www.b-flat-berlin.de.
Frankfurt am Main - Jazzkeller. www.jazzkeller.com.
Hamburg - Birdland. www.jazzclub-birdland.de.
Munich - Unterfahrt. www.unterfahrt.de.

Greece

Athens. The Half Note. www.halfnote.gr.

Italy

Genova - Count Basie Jazz Club. https://www.countbasie.it/
Milan - Blue Note. www.bluenotemilano.com.
Rome - Alexanderplatz Jazz Club. http://www.alexanderplatzjazz.com/
Rome - BeBop jazz Club – http://new.bebopjazzclub.net/
Rome - Gregory's Jazz Club. https://venicejazzclub.weebly.com/
Torino - Jazz Club Torino. http://www.jazzclub.torino.it/
Venice - Venice Jazz Club. https://venicejazzclub.weebly.com/

Japan

Fukushima City - Mingus. www.jeynet.ne.jp/~mingus/english/english.html.
Nagoya - Blue Note. www.nagoya-bluenote.com.
Osaka - The Royal Horse. www.royal-horse.jp.
Tokyo - Blues Alley. www.bluesalley.co.jp.
Tokyo - Blue Note. www.bluenote.co.jp.

Netherlands

Amsterdam - Bimhuis. http://bimhuis.nl/home.
Amsterdam - Café Alto. www.jazz-cafe-alto.nl.
Rotterdam - Jazz Café Dizzy. www.dizzy.nl.

Sweden

Stockholm - Jazzklubb Fasching. www.fasching.se.
Stockholm - Stampen. www.stampen.se.

Appendix B

Jazz Festivals

There are jazz festivals around the world taking place just about every day of the year. Almost every major city hosts at least one music festival, many of which include jazz as a part of their programing, if not the major focus of the event. Some of the websites listed in Appendix C can be very helpful in locating many of the smaller jazz festivals not listed below. You should also be aware that most music festivals you hear about will have a website to announce the details of its event. Listed below are just a few of the major jazz festivals that take place every year.

The Montreux Jazz Festival

This is the granddaddy of them all. Held in and around Montreux, Switzerland, this multi-week festival features great jazz, blues, and contemporary acts from around the world. Recent festivals have included artists such as Herbie Hancock, The Lincoln Center Jazz Orchestra with Wynton Marsalis, Us3, Buddy Guy, B. B. King, Paul Simon, Jamiroquai, Youssou N'Dour, and Keith Jarrett. The festival's official website can be found at www.montreuxjazz.com.

The New Orleans Jazz & Heritage Festival

For my money, this is the best music festival held in America today. There are lots of stages, great food, and after-hours shows in many of New Orleans' best nightclubs. Plan on spending a lot of money and several days at one, or both, of the festival's two weekends of activity. Check out their website at www.nojazzfest.com.

The Monterey Jazz Festival

This festival bills itself as the second oldest jazz festival in the world. The three-day event usually hosts around 500 artists on a number of different stages. The festival prides itself on offering the biggest name jazz artists along with up-and-coming jazz performers. They also offer a nice golf package for those who won't travel without their clubs. Their website address is www.montereyjazzfestival.org.

Newport Jazz Festival

Founded by jazz impresario (and occasional piano player) George Wein in 1954, this festival has a long and storied history, which is available in great detail on the festival's website. In 2016, noted jazz bassist Christian McBride took over the Artistic Director duties from Wein. Many famous recordings have been made at the festival over the years, and many jazz and blues careers were launched or revived here as well. The original festival currently takes place each August in Newport, Rhode Island. Building on the success of the original festival, Wein later founded Festival Productions and took jazz artists around the world, often working in conjunction with the U.S. Department of State and, later, electronics giant JVC and the Playboy publishing empire, among others. www.newportjazzfest.org.

The Scott Joplin International Ragtime Festival

If you *really* like ragtime, this is the festival for you. Held each year during the late spring/early summer in Sedalia, Missouri and hosted by the Scott Joplin International Ragtime Foundation, this organization and its festival bill themselves as being "dedicated to preserving and promoting an understanding and appreciation of ragtime music and Scott Joplin." Check out their website at www.scottjoplin.org.

Telluride Jazz Celebration

Held during the summer each year in Telluride, Colorado, this is one of the most picturesque settings to ever host a jazz festival. You can also check out the sister Telluride Bluegrass Festival, which offers a wide range of interesting programing. The jazz festival website is www.telluridejazz.org, and the bluegrass festival site is located at www.bluegrass.com.

Bix Beiderbecke Memorial Jazz Festival

Held in July each year in Bix's hometown of Davenport, Iowa, this is another festival that focuses its attention on traditional jazz. When the beer tents shut down in Iowa, everyone walks over the Mississippi River bridge to Rock Island, Illinois, and the party keeps going. For more information regarding this festival go to www.bixsociety.org.

Appendix C

Jazz Websites

There is an amazing amount of jazz material on the Internet, including a wealth of biographical information; club, concert, and festival information; as well as live video of jazz concerts, and extensive legal, and in some cases free, downloadable recordings of great music. In addition to the general sites listed in this appendix, just about every artist and club out there today has some presence on the Internet. The following list offers a few of the most stable and accessible websites as of March 2017.

www.allaboutjazz.com

In my opinion, this is the best jazz site on the web right now. It is very well organized, with a tremendous amount of enjoyable content. The site includes news, reviews, artist interviews and profiles, regular columns, jazz directories, an interesting gallery, and a comprehensive calendar listing of jazz festivals and related events. There are also suggestions about building a jazz library and discovering more information elsewhere on the Internet. This is a great place to start.

www.jazzonline.com

This website is a very strong jazz-oriented Internet destination. Joseph Vella, the man behind this website, was active in helping many of the most important jazz clubs, record companies, and individual artists create their own web presence during the early days of the Internet. There is much to explore here, including podcasts, blogs, an extensive jazz history section, and lots of other "cool stuff." In addition, this site offers some outstanding streaming audio content.

www.jazzreview.com

This extensive website is just what the address says it is . . . full of jazz reviews! The site goes much further, however, offering a solid collection of articles, club listings, and even a series of jazz-themed wallpaper pages and great MP3s you can download for free.

www.downbeat.com

This is now the oldest jazz magazine in existence, but with this website, they are clearly alive and well in the twenty-first century. There is a great deal of good content here, and it changes frequently. One of my favorite things about the site is that they offer access to archived *Down Beat* articles dating all the way back to the swing era.

www.jazztimes.com

Jazz Times is another very good monthly magazine about jazz, similar in many ways to the *Down Beat* magazine website discussed above. This website, however, does not offer extensive archive material, but their current content is outstanding!

www.jazzinsidemagazine.com

Jazz Inside is the relatively new name for another magazine that has been around for a while, *Jazz Improv*. The original publication was a very cool magazine if you were interested in learning to play jazz, and all of the back issues are currently available on the new website. Each back issue is full of great CD reviews and comes with a free compilation CD, and they are well worth the money. The new *Jazz Inside* magazine seems to be following in the older publication's footsteps (but with less focus on the active jazz musician), and the expanded new website offers a great deal of interesting content, including free downloadable electronic versions without the music on the CD that is included with the purchase of a hard copy of the magazine.

www.jazz.org

This is the website for Jazz At Lincoln Center, which is also discussed in the New York City club listings in Appendix B. The website is included again here because its extensive content also offers a great deal of outstanding jazz history and educational tools, as well as live streaming video from the clubs and archived radio shows and other video content. If you ever find yourself teaching young students about the history of jazz and are in need of instructional material, this is an outstanding place to start.

www.smithsonianjazz.org

The Smithsonian labels this site "A Jazz portal intended to preserve and promote one of America's greatest art forms—Jazz." What more do you need to know? There is a great deal of outstanding material, and the website updates frequently. Do note, however, that as of this writing in early 2017, the web address above now redirects to a more complex website address housed under the umbrella website of the Museum of American History, but the content remains essentially the same.

www.pbs.org/jazz

Noted historian and documentary filmmaker Ken Burns did a nine-part series for Public Television titled *Jazz* in 2001. This is the website that accompanies the project, which also includes CDs and a companion book. There is a wealth of great information here.

www.apassion4jazz.net

A hodgepodge of information, this website carries the banner "A Passion for Jazz! Music History & Education." There is good history content here, and the jazz festival listings are extensive, with active links that mostly work well and open in a new window. Beware of the sales links, however, as many navigate you away from the main website without warning to commercial sites such as Sheet Music Plus and Amazon. These aren't bad (and they are what they say they are in terms of content), but there is no warning that it is going to happen. Someone involved with the site is clearly an old-school jazz musician, as there are many links within the site to "inside" jazz humor content that has been passed from generation to generation on mimeographed or typewritten sheets of paper long before the Internet existed. If you're a working jazz musician, you'll get all of the jokes. If you're a jazz fan, well, trust us: every word is absolutely true!

www.jazzpolice.com

This site bills itself as "the jazz and travel website." It offers good club listings in most major American cities, festival listings, current jazz news, and streaming audio previews. Similar to www.allaboutjazz.com mentioned above, this is a great place to start your Internet jazz odyssey.

http://www.kennedy-center.org/video/upcoming

This is, without a doubt, one of the finest performance sites on the web. The Millennium Stage project hosted by the Kennedy Center in Washington, D.C., offers daily live performances on the web. In addition, all of these performances are archived and available for viewing at any time. The rather extensive address above takes you right to the archive search page, where you can look for different styles of music or search for a specific artist. Be careful, as this site can be very addictive.

www.youtube.com

The volume of jazz currently available on YouTube is simply astounding. You can find historical jazz performances, old movie clips that feature jazz, and recent performances that include song clips and full concerts, often shot by professional video production companies. This is a resource that musicians could only have dreamed of just a few years ago, and it seems to be expanding on an exponential basis. Pick almost any artist you have enjoyed in this textbook, and I guarantee you will find a wealth of outstanding video and audio material posted on YouTube. In all honestly, some of the posted recordings constitute copyright law infractions in some instances, but you'll also find rare out-of-print recordings posted in audio format that would not be available in any meaningful way were they not posted on the Internet. When appropriate, always pay for legal listening material so that artists can continue creating the music you enjoy. With a listening and learning tool like YouTube, however, this is a great place for discovery that can then lead you to further support of a given artist.

http://newarkwww.rutgers.edu/IJS

This is the website for the Institute for Jazz Studies at Rutgers University. Many of the photos and historical images found in this book came from this outstanding research facility. Recently, they have undertaken a project to post some of their material on innovative web pages that include both sound recordings and wonderful photos.

Appendix D

Some Thoughts on Shopping for Jazz CDs

New CDs aren't cheap. In fact, as of this writing, some new releases are going for as much as $18.95. There is a common line that goes something like "Boy are the record companies ripping me off, 'cause I know it costs less than a buck to make this thing." While it is true that it doesn't cost much to physically produce a CD or download, the things that lead up to that final production can be VERY expensive. For all music recorded, royalties must be paid to both the composers and/or arrangers (for works composed after 1922) and all of the contracted musicians. Typical studio time can run anywhere from $75 to $250 per hour depending on where you are and how state-of-the-art the recording facility is. The big name studios in New York, Nashville, and L.A. can be even more expensive. In addition, you must pay a photographer to shoot photos and hire a graphic artist (or a full art studio) to create the packaging. Next, there has to be a marketing strategy complete with print ads, complimentary copies to media outlets, and product placement. In particular, you may not realize that the product placement in a record or department store *COSTS* the record label money. When you go walking through some major store such as Barnes & Noble, WalMart, Target, or Best Buy, it costs money to have your recording placed at the end of a store aisle or included at one of those cool listening stations. Finally, you should also realize that the wholesale cost of a record is somewhere between $3.00 and $7.00. Then a distribution company takes its cut and, of course, the retail record store makes a profit as well. Now don't get me wrong, the record industry does make money, but they don't make $17.95 on a CD for which you paid $18.95.

Building a Jazz Record Collection

Here are some general thoughts on buying a good, basic CD collection. First, stay with recordings on the major labels unless you know exactly what you are buying. (Having said that, there will be major exceptions to that statement in the next section on buying used and cut-out CDs.) If you just want to own a few representative jazz titles, stick with the classics including *Kind of Blue* (Miles Davis), *Time Out* (Dave Brubeck), *Ellington Indigos* (Duke Ellington), and *Heavy Weather* (Weather Report), etc. If you'd like to branch out and try different things, look into some of the "greatest hits" albums, some of the collections from Ken Burns' *Jazz* series, or the new *Smithsonian Jazz Anthology*. There are also several good books to help you get started including *The Rough Guide to Jazz*, the *All Music Guide to Jazz*, and the *Penguin Jazz Guide*. Here are a few major labels with which you will rarely go wrong.

Blue Note - The Blue Note record label is one of the best labels for bebop, hard bop, and more "straight ahead" modern jazz styles. They also have an active stable of current artists including Norah Jones. Over the decades, they have recorded just about every major name mentioned in Chapter 10. Musicians including Herbie Hancock, Chick Corea, Horace Silver, John Coltrane, Clifford Brown,

J.J. Johnson, Wayne Shorter, and Art Blakey can all be found on Blue Note. This label is now owned by Capitol Records, which is owned by EMI Music Group. www.bluenote.com.

Concord Music Group - Started as a truly independent jazz record label, the Concord Record Group now has an extensive stable of current artists, and it also owns an extensive back catalog of classic jazz recordings made on a number of different labels that are listed separately in several of the listings that follow. Current Concord recording artists include Esperanza Spalding, Patricia Barber, Eliane Elias, and Chick Corea. www.concordmusicgroup.com.

Telarc - The Telarc record label offers a tried and true collection of jazz artists, mostly recording in the mainstream jazz styles. The quality is always very good, and their boxed-set prices are quite reasonable. The label remains active as a subsidiary of the Concord Music Group, who also owns the back-catalog of the original Telarc label.

Verve - Here is a label that has several different functions. They continue to record new jazz artists, they have retained the rights to older projects they recorded, and they have also purchased the catalogs of some other jazz record labels, which they then re-release, usually at a reduced price. There are lots of great recordings available here. Currently, Verve also holds the catalogs of GRP and Impulse! Records. All of the Verve family now belongs to the even larger Universal Music Group. www.vervelabelgroup.com.

Sony/Columbia - This big conglomerate records a wide range of jazz styles, and they also own an enormous back-catalog of older jazz recordings. Of particular note is the *Columbia Jazz Masterpiece* series. You can't go wrong with any of the recordings in this series, which include many of the masterpieces mentioned in this book, as well as many of the major releases from artists such as Billie Holiday, Louis Armstrong, Thelonious Monk, and Miles Davis. Under the Legacy label, this is the company issuing all of the *Ken Burns' Jazz* series CDs. www.sonymusic.com.

Fantasy, Riverside, and Original Jazz Classics - These three labels (now known as "back catalogs") offer a great deal of straight-ahead jazz and blues from the mid-50s up through today. Many of the best re-release projects currently available can be found among these three labels. All of these labels, along with several other more contemporary jazz labels, are now part of the Concord Music Group. www.concordmusicgroup.com.

Pacific - The Pacific jazz label was formed in the 1950s to record the Gerry Mulligan-Chet Baker "Pianoless" Quartet, and the label went on to record many of the finest West Coast jazz artists, as well as many of the popular New York acts that made visits to the "other" coast. The label is now part of Blue Note Records, and the Pacific label recordings are posted along with all other Blue Note releases. www.bluenote.com.

ECM - This European record label is the place to go if you like more experimental jazz. There are fusion acts, as well as a great deal of free jazz on the ECM label. Pianist Keith Jarrett has made many of his most famous recordings for ECM. Chick Corea and the Return to Forever band, Don Cherry, Charlie Haden, and Barre Phillips have all recorded for the ECM label. www.ecmrecords.com.

Laserlight - This low-end company buys old recordings and re-releases them at cut-rate prices. Most laserlight CDs sell for around $5.99 retail (which is really funny because sometimes used record stores will try to charge as much as $7.99 for the same CD). Many of these recordings, especially from older artists including Louis Armstrong and Nat King Cole, are radio air-checks. These are recordings of live radio broadcasts made in the 1930s and 40s. The performances are

usually excellent, but the sound quality of the recording can be fair to poor. I think they are great historical documents and lots of fun to hear, but be aware of what you are buying. I particularly recommend the 5 CD box set of Nat King Cole recordings. It usually sells for less than $20.00, and three of the discs are solid gold. Their Duke Ellington set of live recordings is also quite interesting.

Mosaic - Here is a rather unusual company geared toward serious jazz collectors. This label makes special deals with other record labels to press limited edition boxed-sets (usually no more than 5000 copies) that bring together numerous tracks from various labels or sometimes the complete works taken from one specific label. Most of these sets come with an excellent historical booklet and 3-10 (or more) CDs. These packages are not cheap, but they are always of the highest quality. You will almost never find these sets in the used bins, so if you want one, spend the money and buy it directly from Mosaic Records at www.mosaicrecords.com.

Stomp Off Records - If you like traditional jazz, this is the label for you. This catalog contains hundreds of recordings made by very fine traditional jazz bands from around the world. You will occasionally find some older Stomp Off titles in the cut-out bins, but traditional jazz fans rarely sell back their personal CDs. The website www.stompoffrecords.com offers a listing of some of the label's most famous recordings, but the label seems to be largely inactive today. There is an order form that can be downloaded off the website that indicates what recordings are still available, and there is also a good active link that takes you to an Amazon shopping page, where a number of great Stomp Off titles can be purchased on CD.

Shopping for Used and Cut-Out Compact Discs

The used CD market is a great place to start building a CD collection, and it can also be a wonderful way to discover composers and artists you have never heard before. I personally own well over 5,000 CDs, and most of them cost less than $5.00. Some of my favorite recordings only cost .25¢. My best day was getting almost 100 CDs (many from wonderful artists I had never heard before) and walking out of the store for less than $20.00. It can be done—if you know how to shop and are willing to spend the time digging through gigantic piles of mostly undesirable recordings. Here are some basic rules of thumb when digging through the used bins at your local record store.

You should rarely have to pay more than $7.99 for a used jazz CD, and most should fall in the $4.00 to $6.00 range. At these prices, look for artists whose names you know, or for any of the labels listed in the previous section. When things get below a buck or two, however, it's time to get bold and try some new stuff. And, of course, when the CDs are less than a buck, the sky is the limit. If the recording is bad, you can always toss out the disc and use the jewel case to replace a broken one in your collection. With bad recordings, you can also try to sell them back to another record store that buys used CDs. There have been times when I've actually made a nice profit doing this, but don't tell the record stores because I'll deny everything! Keep in mind that classical music, jazz, and world music tend to be a relatively low priority at most record stores. The bins are often poorly organized, and some really good recordings end up filed under used rock, punk, soul, new age, or contemporary Christian music. The more you dig through everything, the better your chances are at finding a real deal. The good news about this lack of focus at most record stores is that used classical, jazz, and world music CDs often get marked incorrectly. If you find a recording you want for $5.99, make sure to look at other copies of the same used CD. You will often find the

same CD marked at a lower price in another bin. Don't be afraid to haggle about prices. Often, store clerks will know little or nothing about jazz, and if you are polite and act like you know what you are talking about you can get them to give you a lower price (especially on a boxed-set).

Cut-out recordings are new recordings that have usually gone out-of-print and the label or distributor is clearing out their backlog of old material. You have to be in the right place at the right time, but as with used CDs, you can find some great deals in the cut-out bin if you shop long enough. Beyond the typical record stores, keep your eyes open for cut-out recordings at discount stores such as Big Lots.

Shopping and Listening on the Internet

Shopping for used CDs on the Internet is something of a mixed bag. Sometimes you can find real deals on sites such as www.overstock.com and www.amazon.com, but by the time you pay the shipping charges you will not have saved much money. Having said that, if you find something you know you really want, these can be good places to go hunting for that long lost treasure. Used online bookstores also offer good deals sometimes on used CDs, but it often involves a serious Internet search party to find anything worthwhile.

There are also a few independent music resources that offer new CDs at very reasonable prices. One of the best is www.cdbaby.com. This innovative, and often downright funny, website serves mostly independent artists who want to maintain control over their product without the interference of a major record label. Best of all, to entice new listeners, cdbaby offers a $5 CD bin that artists can elect to place selected recordings in with the hope of finding a broader audience for their music. It's a fun place to waste an afternoon. Each CD offered has selected mp3 samples, and in some cases, you can stream the entire recording before you decide to buy. Once again, be careful because this website is quite addictive!

There are also a number of legal mp3 download sites, and now many more traditional websites, such as Wal-Mart, Target, Amazon, and Barnes and Noble to name but a few, offer mp3 downloads side-by-side with standard CD offerings. The most famous mp3 site today is iTunes, but for my money they are overpriced. Personally, I really enjoy www.emusic.com. Though they have recently changed their pricing structure, it's still the best legal deal on the Internet. The downloads are mostly high quality, and the site is easy to navigate and quick to load.

Obviously, you've been an active Spotify user during the time you've been working out of this book, so you should already know what they have to offer. If for some reason you are reading this and have not experienced Spotify, by all means give it a try. I think you will find it money well spent. Having 24/7 Spotify access has most definitely changed the way I think about shopping for music. The biggest drawback for me is that I miss reliable access to detailed liner notes about a given record.

Finally, the last few years have seen an explosion of streaming radio websites. One of the first, and in my opinion still the best for jazz and classical music, is www.pandora.com. The site is intuitive, easy to customize, and totally free. Similar sites that also work well include www.last.fm, www.tunein.com, and www.slacker.com. In addition, you will also find more and more record label websites and other music websites offering their own streaming radio offerings. Through most computer media player programs today i.e., iTunes, Real Player, Windows Media Player, etc., you will also find a wealth of free online streaming media. Go forth and listen.

Glossary

Towards Building a Technical Jazz Vocabulary

From An Outline of American Jazz by David Sharp, Randall Snyder and Jon J. Hischke, 2nd edition. Copyright © 1998 by Sharp et al. Reprinted by permission of the authors.

Terms Descriptive of Jazz Melodies and Improvisational Approaches

Angular Melodies	Melodies which contain wide leaps and sudden changes in direction (bebop, avant garde).
Arpeggio	Playing the component notes of a chord consecutively, running up and/or down the notes of a chord: VERTICAL: ARPEGGIATED APPROACH
Break	A brief unaccompanied solo, usually two or four measures in length, where the rhythm section and others stop playing and the soloist usually gets very "showy" or technical: SOLO BREAK
Cadenza	A solo played with no accompaniment where there is often no sense of pulse. Cadenzas occur most often at the end of a piece that features a particular soloist.
Crowing	see EXPLODING NOTES
Double-time	The soloist plays twice as fast as the established tempo, though the chord progression continues at the same rate. The rhythm section may also participate in this effect.
Embellishments	The improvised decoration of a pre-existing melodic line: ORNAMENTATION
Emotion Playing	The goal of the improvisation is the attempt to build and portray some emotion or feeling and not primarily the development of a melody (free jazz, John Coltrane).
Energy Playing	An approach to improvisation where the generation of energetic feeling becomes the goal (free jazz, John Coltrane).
Exploding Notes	The technique of ending an upward flurry of notes with a "crowing" disintegration of the last note; a "bursting" sound at the top (Coltrane).

Flexibility of Pitch	The raising or lowering of a note's pitch for expressive purpose: PITCH BENDING: TONAL INFLECTION
Glissando	Literally "to slide". A melodic sequence of rapidly played slurred notes either up or down without any break in the sound.
Harmolodics	Improvisational method by saxophonist Ornette Coleman to freely imply harmonies through melodic playing over tunes with no preset chord changes.
Horizontal	A more melodic, often scalar, approach to improvisation. Opposite of vertical or arpeggiated approach: LINEAR
Improvisation	The extemporaneous creation of music: AD LIB
Inside/Outside	Refers to playing either within (Inside) or playing against (Outside) the harmonic basis of the tune. Outside often means playing "wrong" notes on purpose to create tension.
Laid Back	Describes the relaxed feeling displayed by a performer as they play or sing a melody or rhythm slightly later than expected: BEHIND THE BEAT
Lay Out	When a musician stops playing during a portion of a piece.
Lick	Jazz musicians slang for a short phrase or melodic idea.
Lyrical	Refers to a melody that is singable or song-like.
Melody	Simply, a succession of a single pitches (varying in rhythm) and having a "musical" shape.
Motif	A short musical "germ" idea used as the basis for development: MOTIVE
Motivic Development	An improvisational and compositional technique that repeats a motif with continual modification: MELODIC/RHYTHMIC DEVELOPMENT
Out-of-Time Playing	Playing without a steady rhythmic pulse or outside of or against a steady rhythmic pulse: A-METRICAL
Paraphrase Solo	An improvisational development that stays relatively close to the original melody by using decorations, embellishments, and rhythmic displacement: REFERENTAL DEVELOPMENT
Phrase	The musical equivalent to a spoken phrase or sentence. Often referring to a complete melodic statement: PHRASING
Pointillism	The well-spaced, short sounding of notes, fragmented, seemingly unconnected and disjointed. Often used in conjunction with atonal music: POINTILLISTIC

Quote	During an improvised solo, a reference to the original melody or another usually well-known melody or phrase.
Repetitive Development	An improvisational technique that repeats a (melodic) motif without significant modification. The emphasis is on repetition rather than modification.
Ricky-Tick	The stiff or "jerky" playing characteristic of many early jazz soloists, and of dated ones today, where there is much separation between notes (dixieland): MICKEY
Scaler Playing	An emphasis on the scales associated with or derived from the underlying chords of a piece where there are few skips or large intervals between the notes: HORIZONTAL
Sheets of Sound	The attempt to sound all of the notes of a scale or a chord at once by playing them very rapidly (John Coltrane).
Trading 4s	The practice of exchanging improvised solo sections between two or more soloists, one of which is often the drummer, in a call & response manner—one plays 4 bars and the other(s) play 4 bars. Also trading 2s, 8s, blues choruses, etc.
Vocalese	Setting lyrics to transcribed instrumental jazz solos or preexisting instrumental jazz compositions: VOCALISE

Terms Descriptive of Rhythm

4/4 Time	The most common meter used in jazz and popular music: COMMON TIME. Also refers to the rhythmic feel from the swing era (dance music) characterized by four beats in a measure, walking bass, ride rhythms, and hi-hat accents on beats 2 & 4.
Accelerando	A gradual increase (speeding up) of tempo.
Additive Rhythm	A rhythmic grouping derived from the addition of various asymmetrical subdivisions (usually duple and triple): For example: 2+2+3=7 (*ONE-two-THREE-four-FIVE-six-seven*). (also see ODD METERS)
A-Metrical	Playing without a meter or rhythmic pattern—a natural consequence of the supremacy of melody over rhythm. Often referred to as OUT-OF-TIME PLAYING.
Accent	A stressed note that is played louder than other notes around it. Also a "push" or "weight" on a particular beat emphasizing it over others. (also see SYNCOPATION)

Back-Beat	Usually refers to accents on beats 2 & 4 in 4/4 time which adds to "swing" feel. Is often played by the drummer's hi-hat or snare drum.
Bar	Synonymous with MEASURE.
Beat	The rhythmic pulse in music.
Bombs	Syncopated accents or "kicks" played by the drummer's bass drum behind a soloist that are not necessarily coordinated with other metrical figures in the ensemble (bebop): DROPPING BOMBS
Broken Time	A playing style which lacks a driving or intense feeling of the present pulse: FLOATING TIME: RHYTHM FLOAT
Clave Beat	A syncopated rhythmic ostinato that is played or implied in the performance of Latin music. Each particular style of Latin music (i.e., bossa nova, samba, tango, cha-cha, rumba, etc.) has its own clave beat. The term CLAVE comes from the percussion instrument with the same name that often plays this figure in Latin music.
Comping	The improvised playing of chords in a syncopated rhythmic manner by a pianist, vibraphonist, or guitarist which accompany and complement the rhythms and implied harmonies in the music or by the soloist's improvised melodic line.
Fill	In general, any embellished rhythmic figure played by a drummer.
Flat-Four	A beat pattern characterized by no particular accent on any beat in the measure; an even weight on all four beats. Also refers to the even strumming on each beat by a banjo (or guitar) in New Orleans based jazz.
Hemiola	The mathematical resultant polyrhythm of 2 against 3 which creates the following: *ONE-two-THREE-FOUR-FIVE-six*
Kicks	Rhythmic accents played by the drummer that coincide with the accents played by a soloist or ensemble: PUNCTUATIONS
Measure	The basic unit of time in music; a set of beats where the accent is normally on the first beat. For example, in 4/4 meter: ONE-two-three-four. In musical notation, this unit of time is separated by bar-lines from other similar units: BAR
Meter	The number and type of beats grouped in each measure. For example, 4/4 means 4 quarter-notes per measure, 3/4 means 3 quarter-notes per measure, 6/8 means 6 eighth-notes per measure: TIME SIGNATURE

Metronome Marking	A notational symbol in the music, often at the beginning of the piece or new section, that specifies the tempo. For example, ♩ = 60 means 60 beats per minute (one per second); ♩ = 120 means 120 beats per minute (two per second): TEMPO MARKING
Odd Meters	Refers to meters other than the most common (4/4, 2/4, 3/4, 6/8, etc.), especially time signatures with uneven subdivisions such as 5/4, 7/8, 11/8, 33/16, etc. Most often, odd meters are a result of an additive rhythm (3+2=5).
Polymeter	The simultaneous employment of two or more contrasting meters (such as 6/8 against 4/4), (also see POLYRHYTHM)
Polyrhythm	Literally "many rhythms": the simultaneous employment of two or more contrasting rhythms. (also see POLYMETER)
Pops	Short, accented, usually syncopated notes played by the horn section of a big band as accompaniment figures which add a feeling of precision to the ensemble: BRASS PUNCHES
Pulse	see BEAT
Rest	A silence of specific duration.
Rhythm	In general, the time side of music: the recurrence of pulses, beat patterns, or similar figures giving a feeling of onward motion to the listener. The measurement of sound in its relation to time. All music has rhythm.
Rhythmic Displacement	Moving an expected rhythmic figure to a different beat or subdivision.
Rhythm Pad	A rhythm section effect that is repeated, often using ostinato patterns and frequently modal (or very limited in harmonic motion) over which a soloist improvises (John Coltrane, jazz-rock).
Ride Rhythm	A specific rhythmic pattern played on the drummer's ride cymbal which contributes to jazz swing feel (*Ting, Tick a, Ting, Tick a, . . .*): RIDE PATTERN
Rock Rhythm	Generally, a straight 8th-note beat division with accents on the beat (*TICK Tick, TICK Tick, TICK Tick, TICK Tick, . . .*), (also see STRAIGHT 8th-NOTES)
Rubato	A piece (or section of a piece) that has no pulse or implied beat.
Shuffle Rhythm	A long-short rhythmic feel (within a beat) common to the blues and jazz of many periods, in particular boogie-woogie and Kansas City styles. Also common in early rock & roll but the accents shift to beats 1 & 3: TRIPLET FEEL; 12/8 FEEL

Stop-Time	The practice of stopping or interrupting the normal rhythmic flow with rests while a soloist continues to play. The ensemble plays a rhythmic pattern together to accompany the soloist.
Straight 8th-Notes	Two notes of equal value within a beat (*one & two & three & four &, . . .*), (also see ROCK RHYTHM)
Subdivision	Refers to the mathematical division of a measure or beat. For example, a beat may be divided into two eighth notes, three eighth notes (triplet), four sixteenth notes, etc. A 5/4 measure may be divided 3 + 2 (*ONE-two-three-FOUR-Five*): BEAT DIVISION (also see ADDITIVE RHYTHM)
Swing 8th-Notes	The jazz style of playing 8th-notes (two notes within a beat) in which the first note is slightly longer in duration than the second, but the second note is accented (syncopated): (*doo-BA, doo-BA, . . .*)
Syncopation	Placing an accent on a normally weak beat or on a normally unaccented part of a beat.
Tempo	Refers to the speed of the beats in a musical composition. A piece can be perceived as having a relatively fast, medium, or slow tempo.
Time Signature	A numerical fraction designating the meter (4/4, 3/4, etc.). The top number indicates the number of beats in each measure. The bottom number indicates the type of note which receives a beat: METER
Triplet	A group of three notes of equal duration that normally occupies the time of two (usually 8th-note triplets or quarter note triplets): A TRIPLE SUBDIVISION rather than DUPLE SUBDIVISION.
Two-Beat	A rhythmic feel in which the bass player plays quarter notes only on beats 1 & 3 in 4/4 time which can give the listener the perception that the music is proceeding at half the tempo. Also refers to the stuff "boom-chick" style of much early jazz and commercial styles (dixieland & swing).
Upbeat	The unaccented beat preceding the downbeat: PICK-UP
Up Tempo	A piece with a fast tempo: UP
Walking Bass	A bass playing pattern in which each beat of a measure receives a separate tone, often scaler or arpeggiated that outlines the chord progression: FOUR-BEAT
Waltz	Originally a European dance, it refers to almost anything in 3/4 meter (counted: *ONE-two-three, ONE-two-three, . . .*), A JAZZ WALTZ adds syncopation.

Terms Descriptive of Harmony

Atonality	Music that lacks a tonal center or key, often sounding unusual to the untrained ear. Opposite of tonality: ATONAL (also see SERIALISM)
Blue Notes	Notes that are played or sung lower than the specified pitch, especially the third, fifth, and seventh scale degrees of a major scale. (also see BLUES SCALE)
Blues Scale	A six-note scale that developed as the result of the fusion of the Western European major scale and the African pentatonic scale. Is used extensively in almost all jazz and blues styles.
Chord	Simply, the sounding of three or more different notes simultaneously. In tonal music, chords are constructed with pitches that have specific harmonic relationships to each other.
Chord Alterations	The process of changing one or more notes in an extended chord (9ths, 11ths, or 13ths) by lowering or raising by a half-step to add color or dissonance: ALTERED CHORDS
Chord Extensions	The process of enlarging or thickening a chord by adding additional upper notes to the basic notes of a triad: EXTENDED CHORDS: EXTENDED HARMONY: UPPER EXTENSIONS: EXTENSIONS
Chord Progression	A series of successive chords, or the movement from one chord to the next (usually determined by the gravitational tendencies within a tonality) in harmonizing a melody. The set, predetermined sequence of accompaniment chords intended for the original melody of the tune and used as the basis of an improvisation: CHORD CHANGES: CHANGES
Chord Substitutions	The process of replacing a chord in a standard chord progression with another, usually related, chord: CHORD SUBS: HARMONIC SUBSTITUTIONS: REHARMONIZATION
Chord Symbols	A notational sign that represents a particular chordal sonority. For example, "C9(+11)" means the notes C-E-G-B♭-D-F♯ are played together.
Chromatic Scale	A sequence of ascending or descending pitches consecutively by half-steps. Such a scale lacks an audible tonal center or tonic.
Chromaticism	Literally "coloring": A general term for any type of melodic and/or harmonic movement primarily by half-steps that tend to blur a composition's tonal center or key.

Coltrane Substitution	Refers to a specific chord substitution originally devised by saxophonist John Coltrane to be played over a II-V-I chord progression: TRANE SUB
Consonance	In general, a "pleasant" stable sound. Opposite of DISSONANCE.
Diatonic	Harmonies and melodies derived from a specific major or minor scale.
Dissonance	In general, an "unpleasant" or discordant sound. Dissonant sounds create tension and are usally resolved to consonant sounds (TENSION-RE-LEASE). Too much dissonance without resolution can make a listener feel uncomfortable. Opposite of CONSONANCE.
Dorian Mode	A specific scale built on the 2nd degree of a major scale sharing the same key signature as the (parent) major scale. The most commonly used mode that forms the basis of much post-modern modal jazz and jazz-rock styles.
Functional Harmony	Chord progressions that outline a particular key or tonality. For example: the II-V-I progression, which is found in nearly all standard popular songs.
Half Step	Refers to the smallest interval in Western tonal music (i.e., C-D♭, F♯-G, etc.).
Harmonic Rhythm	The frequency and speed of chord changes.
Harmony	The general term for the tonal organization of notes into scales, chords, and chord progressions.
Interval	The specific distance between two pitches, such as a half-step, a whole-step, a minor 3rd, a major 3rd, a perfect 4th, etc.
Key	Refers to the tonality of a piece or section of a piece. Tonal compositions are usually in either a major or minor key.
Key Signature	The group of sharps (♯) or flats (♭) written on the staff at the beginning of a composition that defines the key (tonal center) of the piece.
Modality	The harmonic structure of a composition that is based on modes rather than on chords: MODAL: MODAL JAZZ
Mode	Literally "a scale". There are seven common modes, each built upon a different scale degree of a major scale. Modes, however, may be derived from other "parent" scales.
Modulation	Literally "to change keys". A transitional musical phrase that connects two sections that are in different keys. (also see TRANSITION)

Non-Functional Harmony	Harmonic movement in which chordal structures do not resolve to their natural tendencies but are organized and driven by other means.
Octave	The interval between the lowest and highest notes of a scale, each of the notes sharing the same name—such as B-flat symbol as used in key signature or the interval of 12 half-steps.
Pantonality	Music that has several simultaneous or quickly changing tonal centers.
Pentatonic Scale	Any of several five-note scales, common to non-Western music. The black keys on the piano represent the most commonly used pentatonic scale in jazz.
Pitch	The relative highness or lowness of a tone, either in its relation to other tones, or in the absolute measurement of the speed of its vibrations.
Plagal Cadence	Refers to a specific chord progression, namely IV-I. Many church hymns end with these two chords: AMEN CADENCE: AMEN CHORDS
Polychord	The simultaneous playing of one chord and another different chord on top of it: SUPERIMPOSITION OF CHORDS
Quartal Harmony	The construction of chords built on consecutive intervals of a perfect 4th (C-F-B♭). Often used in conjunction with modality.
Quarter Tones	The division of the octave into 24 increments rather than the normal 12 (Don Ellis).
Reharmonization	See CHORD SUBSTITUTIONS
Root	The fundamental note of a chord that gives the chord its name. For example, A, is the root of an A♭7 chord. The "1" of a triad (1-3-5).
Scale	Literally "ladder of tones". Any of several series of notes, within an octave that proceed at various identifiable combinations of intervals. (also see MODE)
Serialism	A modern "classical" compositional procedure that arranges the 12 tones of an octave into a mathematically derived sequence: TONE ROW Serial music tends to sound illogical to the untrained ear. Often used in conjunction with atonality.
Static Harmony	Often refers to the harmonic basis of much modal jazz and jazz-rock where there is little, if any, harmonic movement.
Tonality	Music pertaining to a specific key. Opposite of ATONALITY: TONAL

Tonal Center	Most music possesses a feeling of centrality for one "home" pitch (usually the first note of a scale) which is the point of departure and return. The note in which the tonality or modality revolves around: KEY CENTER: CENTRAL PITCH
Tone	A specific pitch or note. Can also refer to the quality of sound (see TIMBRE).
Tone Cluster	A chord, or harmonic structure, built upon primarily consecutive half-steps (C, D♭, D, E♭, E, F, etc.). Used for a dissonant effect more than as a harmonic basis. Often used in atonal music (avant-grade).
Tonic	A note that is the first degree of a scale which defines the key of the composition or section. (also see TONAL CENTER)
Triad	The basic chordal sonority in Western music. The 1st, 3rd, and 5th degrees of a major scale sounding simultaneously is a MAJOR TRIAD. The 2nd, 4th, and 6th degrees of a major scale sounding simultaneously is a MINOR TRIAD, etc.
Upper Extensions	See CHORD EXTENSIONS
Vertical	1) An improvisational emphasis on chords and harmonic structures rather than on melody: ARPEGGIO, 2) a word used to describe the homophonic character of a big band arrangement.
Vertical Modality	Chords derived from various modes and used in a nonfunctional chord progression.
Whole Step	An interval of two half-steps (C-D, or F♯-G♯).
Whole Tone Scale	A symmetrically constructed scale built on consecutive wholesteps (C-D-E-F♯-G♯-B♭-C). Such a scale lacks an audible tonal center or tonic.

Terms Descriptive of Form and Compositional Devices

A Cappella	Without instrumental accompaniment. Most often refers to unaccompanied group or solo singing.
Accidentals	In musical notation a SHARD (♯) raises a note by a half-step; a FLAT (♭) lowers a note by a half-step; a NATURAL (♮) cancels a previously used sharp or flat in the measure.
Accretive Pad	The process by which a rhythm pad is gradually put together by the addition and layering of various musical elements (jazz-rock).
Antiphony	see CALL & RESPONSE

Arrangement	An adaptation of a tune or musical composition. In an arrangement, the arranger writes out the notes each performer is to play on a SCORE. Then the individual PARTS are extracted (copied out) for each individual performer to play: CHART
Ballad	Generally refers to any piece with a slow tempo.
Block Voicings	Chords with the same intervallic shape that move in parallel motion (HOMOPHONY).
Bridge	The contrasting "B" section of an AABA 32-bar standard song form.
Cadence	A sequence of notes or chords that indicate the end of a chorus or piece.
Call & Response	The African element of form that pits a melodic statement (call) against an answer or responding phrase: ANTIPHONAL: ANTIPHONY
Chorus	One complete statement of the melody (theme), or the chords underlying a tune; such as once through the 12-bar blues, 32-bar standard song form, etc. Also refers to the REFRAIN, which recurs after VERSES in popular songs.
Coda	An epilogue or concluding section of a composition. A short coda is often called a TAG.
Collective Improvisation	The simultaneous melodic improvisation (soloing) by several players. Common in New Orleans, free jazz, and early jazz-rock. The resultant texture is polyphonic: GROUP IMPROVISATION (see also OUT CHORUS)
Countermelody	A secondary melody that complements the primary melody. (also see COLLECTIVE IMPROVISATION: COUNTERPOINT: ENSEMBLE CHORUS: POLYPHONY: OUT OF CHORUS)
Counterpoint	Two or more independent melodic lines of equal importance sounding simultaneously: POLYPHONY: CONTRAPUNTAL (also see ENSEMBLE CHORUS)
Cross-Section Voicing	A big band arranging technique in which a harmonized melodic line is voiced utilizing instruments from different sections of the ensemble to create unique instrumental colors (Duke Ellington).
Dirge	A funeral march; always very slow and solemn.
Drone	A sustained tone (or tones) often throughout an entire piece or section used as a backdrop and basis for improvisation. Common in modal jazz, free jazz, jazz-rock, and much ethnic music (East Indian, Islamic, Scottish bagpipes, etc.).

Ensemble Chorus	The opening chorus (choruses) in a New Orleans based jazz performance where the cornet (or trumpet) plays the main melody of the tune while the other "front line" instruments (clarinet, trombone), each play improvised countermelodies. The resultant texture is polyphonic.
Flagwaver	A very fast big band swing tune. A usual favorite among musicians, but not dancers: JUMP
Form	The basic structure or organizing principle of a piece of music. (MACROFORM: MICROFORM)
Free Form	Music in which the form is not determined ahead of time, but evolves as the music develops from the improvisational interaction of the performers. Is often synonymous with free jazz: OPEN FORM
Head	Refers to the initial statement of the melody and accompanying chord progression at the beginning of a performance from which the improvisations will be based. The head is also played after the solo section at the end of the piece.
Head Arrangement	An arrangement, usually based on riffs, that is worked out during the playing and not "locked in" on paper beforehand (Kansas City big bands): HEAD CHART
Homophony	Literally "one sound". A vertical approach to a harmonized melody with all the voices (or parts) moving at the same time: same rhythm-different notes: HOMOPHONIC (also see BLOCK VOICINGS, SOLI, TUTTI)
Hook	The most memorable part of a song where the songwriter attempts to "bring in" the listener. The hook usually occurs at the end of the tune where the title of the song is sung three times.
Interlude	A short transitional section (usually 4 or 8 measures) that connects larger section or choruses. Interludes are often used to change a new key: SEGUE; SEGUEWAY; TRANSITION (also see MODULATION)
Introduction	A preliminary musical phrase, often 4 or 8 measures, before the head: INTRO
Layering	Refers to the simultaneous superimposition of various musical elements, resulting in polyphonic and/or polyrhythmic textures.
Line	Synonymous with MELODY. Often used in reference to bebop melodies.
Monophony	Literally "one voice". When one person is playing a single line melody, or UNISON playing amongst more than one person: MONOPHONIC

Montuno	A rhythmic figure, often two bars in length, repeated by the rhythm section throughout the improvisations in Latin music: VAMP
Motif	A short musical "germ" idea used as the basis for development: MOTIVE
Orchestration	The method a composer or arranger uses when assigning melodies, specific notes of chords and harmonies, rhythms, etc. to specific instruments.
Ostinto	A continually repeated melodic pattern that forms the basis of a rhythmic pad.
Out Chorus	The last climatic ensemble section in the performance of a piece which usually involves the most active collective improvisation in New Orleans jazz. (also see COUNTERPOINT)
Pedal Point	A low pitch which is repeated or sustained in which chords change above it. Similar to a drone but usually only for a short section of a composition rather than the basis of it.
Phrase Extension	A lengthened musical phrase. It is most often two or four bars added to a normally 8-bar phrase.
Polyphony	Literally "many voices"; POLYPHONIC, (also see COUNTERPOINT, COLLECTIVE IMPROVISATION, LAYERING)
Rhythm Changes	Refers to the chord changes and form of the song *I Got Rhythm* by songwriter George Gershwin. Many bebop tunes (lines) are based on this tune: "I GOT RHYTHM" CHANGES
Riff	In a big band music, a short, often improvised, melodic pattern that is repeated by the horns often as a background for a soloist or in a call & response manner between sections of the ensemble (Kansas City big bands).
Riff-Based Melody	A usually simple, "catchy" melody built from a riff.
Rondo	A "classical" music form in which one section of a composition reoccurs intermittently with contrasting sections (*ABACADAEAFA . . .*) (third stream).
Score	see ARRANGEMENT
Sectionalized Form	A musical composition constructed by means of a succession of contrasting sections and various microforms; some sections may be repeated later (ragtime, jazz-rock/fusion, third stream): THROUGH-COMPOSED
Shout Chorus	Refers to the climactic tutti section near the end of a big band composition.

Soli	A big band arranging technique in which one section of the horns (i.e., saxophones) is featured playing a melodic line in harmony (HOMOPHONY). Sometimes arrangers write soli sections that are based on harmonized transcribed solos.
Sonata	A "classical" music form with three basic sections: an *exposition*, *development*, and *recapitulation*.
Standard Song Form	Most often a 32-bar structure (*AABA*, *ABAC*, or *ABAB'*) in which most popular songs of the first fifty or sixty years of the 20th century were written. In addition, many modern JAZZ STANDARDS are written using this form.
Stock Arrangement	A published commercial big band arrangement, often simplified.
Tag	see CODA
Third Stream	A style that incorporates one or more elements associated with Western "classical" music composition and jazz techniques.
Trio	The contrasting second half of a march (ala John Philip Sousa) where there is always a key change (ragtime, New Orleans). May also refer to a jazz combo made up of three musicians.
Turnaround	A short chord progression, usually at the end of a blues chorus or standard song form, that sets up the next chorus.
Tutti	A big band arranging technique in which the entire horn section plays a melodic line in harmony (HOMOPHONY).
Unit Structures	A specialized method devised by avant-garde pianist/composer Cecil Taylor for the organization of musical elements within a composition.
Vamp	A repeated musical phrase often used to "kill time" in anticipation of the next cued section. Similar to an ostinato but not used as the basis of a composition.
Voicing	The process, in big band or small group arranging, of assigning the notes in a chord to each instrument.

Terms Descriptive of Instrumental Techniques and Devices

Acoustic	Natural instrumental and vocal sounds that are not electronically altered or amplified.
Altissimo	The highest register of an instrument's range. Saxophones produce this by playing overtones: HARMONICS

Arco	Playing a string instrument (particularly a violin, viola, cello, or bass) with a bow.
Attack	The beginning of a sound: ARTICULATION
Brushes	A type of drum stick made with wire bristles that produce a soft "swishing" sound.
Circular Breathing	A highly specialized way of blowing out air while simultaneously breathing in air. When developed, a horn player can play a single note or phrase without interruption almost indefinitely.
Crash Cymbal	A suspended cymbal, usually to the drummer's left, that is used for loud, sustained accents.
Double Stop	On stringed instruments, the sounding of two notes at once by playing two strings. TRIPLE STOP—sounding three notes at once.
Doubles	Refers to the instruments a musician is called upon to play in addition to their regular instrument. The most common doubles are in the sax section of a big band where one may be called upon to play clarinet and/or flute: DOUBLE: DOUBLING
Fender Bass	Synonymous with an electric bass guitar. A commercial brand name.
Fret	A raised bar at regular intervals along the neck of a guitar or electric bass.
Growl	A "dirty" sound created when a horn player hums while playing.
Harmonics	see OVERTONES
Hi-Hat	A pair of cymbals on the drum set controlled by a foot pedal: SOCK CYMBAL
Intonation	Accuracy or measurement of pitch. To play "in tune": TUNING
Legato	The notes of a melody or phrase are smoothly connected. Opposite of STACCATO: SLUR: LEGATO TONGUE
Lip Trill	Without changing fingerings, a brass player rapidly alternates between two notes.
Locked Hands	A style of piano playing in which each note of a melodic line is harmonized with both hands as though they are locked together (HOMOPHONY).
Mallets	Any of several types of drum sticks with felt or rubber ends. Different timbres are produced by the varying hardness of each. Can be used on any drum or cymbal but are particularly designed for keyboard percussion instruments such as the marimba, xylophone, and vibraphone.

Mouthpiece	The necessary device inserted on any brass or reed instrument that creates the actual sound, similar to the vocal cords of the human voice. They come in various sizes and can produce varying timbres. Many horn players feel that the selection of the proper mouthpiece is vital for determining their sound quality.
Multiphonic	The sounding of one or more notes simultaneously on any brass or reed instrument by producing overtones.
Mute	Any of several types of devices which, when inserted into the bell of a brass instrument, alters the timbre.
Overtones	Upper partial tones (high pitches) which vibrate along with the fundamental pitch, imparting timbre and tone quality: HARMONICS
Pizzicato	Playing a stringed instrument (particularly a violin, viola, cello, or bass) by plucking instead of bowing.
Press Roll	A tightly played controlled alternation of the sticks on a drum, usually on the snare drum.
Range	Refers to the measured distance between the lowest and highest notes possible on an instrument or within a particular performer's capability. Also refers to the notes within the lowest and highest notes of a melodic line.
Reed	A piece of bamboo cane that vibrates to create the basic sound on a reed instrument (saxophone, clarinet, oboe, bassoon, etc.). Also refers to woodwind instruments (REEDS).
Register	Refers to a certain section (low, middle, high) of an instrument's entire range: TESSITURA
Release	The very end of a sound. Opposite of ATTACK
Ride Cymbal	A suspended cymbal, used for playing continuous ride rhythms or other rhythmic patterns.
Rim Shot	The striking of an edge of a drum (often a snare drum) and drum head simultaneously.
Rip	A fast glissando preceding a note (Louis Armstrong).
Scat-Singing	Vocalizing stylized nonsensical syllables in the manner of an improvised horn solo: SCAT: SCATTING
Shake	A trill on a brass instrument or woodwind usually of an interval of a 3rd. Sometimes produced by literally shaking a brass instrument.
Slap-Tonguing	The hard, crisp, "slapping" sound made by the tongue on the reed of a saxophone or clarinet.
Slur	see LEGATO

Smearing	The complete lack of separation between notes, sliding from one pitch to another (Johnny Hodges): PORTAMENTO: GLISSANDO
Snare Drum	A drum on the drum set that has a characteristic "crisp" sound. Wire snares are stretched along the bottom head that vibrate when the top head is struck.
Staccato	Short and separated notes. Opposite of LEGATO.
Strumming	The "up & down" chording of string instruments. (also see FLAT-FOUR)
Timbre	The unique sound quality or color of an instrument or voice: TONE QUALITY: TONE COLOR
Tremolo	A rapid reiteration of a single tone, interval (larger than a whole-step), or notes of a chord.
Trill	The rapid alteration of two notes a half-step or whole-step apart.
Vibrato	A rapid pitch fluctuation of a (usually sustained) tone. It is a very individual, expressive, and stylized device used by a singer, horn, or string player.

Other Important Terms

Arranger	A person who adapts a composition, song, or tune for a particular type of ensemble, often incorporating their own musical ideas.
Ax	Musician's slang for one's instrument.
Big Band	Refers to a large jazz ensemble, usually 10–20 players. The standard big band instrumentation includes five saxophones, four trumpets, four trombones, and a rhythm section consisting of piano, bass, drum set, and sometimes a guitar. The most common ensemble during the swing era.
Chops	Musician's slang that refers to one's instrumental proficiency ["Man, that cat's got chops."] Also refers to the strength of a horn player's embouchure (or lip muscles).
Crossover	Any style of music that appeals to more than one type of audience. Also refers to a normally creative, artistic musician who commercializes their music in order to make money.
Cutting Contest	A competition between players of like instruments during a jam session. Also a New Orleans competitive tradition between brass bands on the street: CARVING CONTEST: BATTLE
Dynamics	The various volume levels of music. Italian terms: PIANO (soft), FORTE (loud), etc.

Fake Book	A collection of lead sheets to take to a gig in case one is asked to play a tune that they are not familiar with. (also see LEAD SHEET)
Front Line	The horn players (cornet or trumpet, clarinet, and trombone) who are placed in front of the rhythm section in New Orleans jazz.
Ghost Band	A "name" musical ensemble, most often a swing era big band, that continues performing after the original leader has died. They are often lead by a former sideman or family member.
Gig	A performing job that pays.
Horn	In jazz and popular music, a general label for any wind instrument (i.e., saxophone, trumpet, etc.). In "classical" music—the French horn.
Instrumentation	The different types and numbers of instruments that make up an ensemble.
Jam	To improvise.
Jam Session	An informal gathering of musicians who play, often without pay, for fun. Improvisation is always stressed.
Jazz Combo	Refers to a small jazz ensemble, usually not more than seven players.
Jazz Standard	A jazz composition that is known and played by many jazz musicians. May also refer to a jazz composition that uses a 32-bar standard song form.
Lead Sheet	A notated piece of music, usually a standard song or jazz standard, with just the basic melody, chord symbols, and sometimes lyrics. Musicians often learn tunes from lead sheets. (also see FAKE BOOK)
Ledger Lines	The short lines written above or below a staff to accommodate notes that must be notated there.
Notation	The process of writing down music.
Piano Trio	A jazz combo consisting of piano, bass, and drums.
Ride	Synonymous with RIDE RHYTHM. May also refer to a musician playing an improvised solo on a tune ["Man, did you hear that ride he took on *Airegin?*"].
Sideman	A musician in a band who is not the leader, featured vocalist, or featured soloist.
Sight-Reading	Looking at and playing a piece of music for the first time: READING
Society	Musician's slang for commercial music.
Song	A general term for any composition with words. Songs without words (instrumentals) are generally referred to as TUNES.

Staff	A set of five horizontal lines on which musical notation is placed.
Texture	Refers to the density of the music. When there is much activity, the texture is thick; when there is less activity, the texture is thin.
Transcription	The process of notating music that is heard, often an improvised solo.
Transpose	To change the key of a piece of music to a key other than the original.
Tune	Refers to almost any jazz composition, standard song, or arrangement, but not to a specific melody.
Virtuoso	A musician with exceptional ability, technique, and style.
Woodshed	Musician's slang for intense practice.

Terms Descriptive of Electronic Music

Analog	Electronic method of synthesized sound through the use of measured voltages; old method that has been replaced by digital technology.
Amplifier	Electronic device with a loudspeaker that increases the volume of an instrument. Guitarists and bass players are most often amplified: AMP
Clavinet	An electronic keyboard instrument that plays characteristic short, distinctive notes. Used much in "funk" music of the 1970s.
Controller	Any one of several devices, most often a piano-like keyboard, that controls the parameters of a synthesizer.
Digital	Computerized method of synthesized sound through the use of numbers.
Drum Machine	A programmable digital synthesizer that produces percussion-like sounds. Used in much contemporary commercial recording.
Effects	Devices that alter the normal sound of acoustic or electronic instruments to various degrees. Especially common to guitar playing: ECHO-PLEX, PHASE SHIFTER, REVERB, MODULATION, etc.
EWI	Acronym: Electronic Wind Instrument (wind synthesizer).
Feedback	The harsh squeal that occurs when a sound is emitted from a loudspeaker and is picked up by a microphone in an endless cycle. It is sometimes heard on public address systems. It is often a desired effect in rock music.

Fender Rhodes Piano
An electric piano (with tone plates rather than strings) which was the standard electronic keyboard in the early years of jazz-rock. These instruments had weighted keys that felt similar to acoustic piano keys. Other commercial brands came out on the market in later years with improved technology: RHODES

Joy Stick
A controller found on most keyboard synthesizers used for pitch bending or other electronic modifications for expression. WHAMMY BAR on guitar.

MIDI
Acronym: Musical Instrument Digital Interface. Enables a performer to control many electronic instruments by a single controller.

MOOG
Refers to the first analog performing keyboard synthesizer invented by Dr. Robert Moog: MOOG SYNTHESIZER

Musique Concrete
Tape manipulation (SPLICING, TAPE LOOPS, etc.) of recorded sounds. May also refer to the recorded use of normally non-musical sounds.

Oscillator
A module of an analog synthesizer that is the source of electronically generated sounds via WAVE FORMS.

Overdubbing
The addition and layering of pre-recorded TRACKS. Used in most commercial recordings today: MULTI-TRACKING

Sampling
The digital recording of acoustic sounds that are stored and used later in performance or recording. This method has produced much controversy among musicians: SAMPLES: EMULATOR

Sequencer
A programmable device that stores a succession of musical sounds to be used later.

Synthesizer
In general, any electronic device that produces a musical sound: ELECTROPHONE

Bibliography

Books

Axelrod, Alan. *The Complete Idiot's Guide to Jazz*. Indianapolis, IN: Alpha Books, 1999.

Berton, Ralph. *Remembering Bix*. New York: Harper and Row, Publishers, 1974.

Carr, Ian; Digby Fairweather; and Brian Priestley. *Jazz: The Rough Guide*. London: Rough Guides, 1995.

Clayton, Peter, and Peter Gammond. *The Guinness Jazz Companion*. Enfield, Engand: Guinness Publishing, 1989.

Cole, Bill. *John Coltrane*. New York: Da Capo Press, 1993.

Crow, Bill. *Jazz Anecdotes*. New York: Oxford University Press, 1990.

Davis, Francis. *Bebop and Nothingness*. New York: Schirmer Books, 1996.

Davis, Francis. *Outcats: Jazz Composers, Instrumentalists, and Singers*. New York: Oxford University Press, 1990.

Davis, Nathan T. *Writings In Jazz*, 5th ed. Dubuque, IA: Kendall/Hunt Publishing Co., 1996.

DeVaux, Scott. *The Birth of Bebop*. Berkeley: University of California Press, 1997.

Ellington, Edward Kennedy (Duke). *Music Is My Mistress*. New York: Da Capo Press, 1973.

Erlewine, Michael; Vladimir Bogdanov; Chris Woodstra; and Scott Yanow, eds. *All Music Guide to Jazz*, 3rd ed. San Francisco: Miller Freeman Books, 1998.

Feather, Leonard. *The Passion for Jazz*. New York: Da Capo Press, 1980.

Gleason, Ralph J., ed. *Jam Session: An Anthology of Jazz*. New York: G. P. Putnam's Sons, 1958.

Gridley, Mark. *Jazz Styles*, 7th ed. Upper Saddle River, NJ: Prentice Hall, 2000.

Jones, LeRoi. *Black Music*. New York: Quill, 1967.

Locke, David. "Africa," In *Worlds Of Music*, edited by Jeff Titon, 3rd ed. New York: Schirmer Books, 1996.

Lowe, Allen. *That Devilin' Tune*. Berkeley, CA: Music and Arts Programs of America, Inc., 2001.

Martin, Henry, and Keith Waters. *Jazz: The First 100 Years*. Belmont, CA: Wadsworth/ Thomson Learning, 2002.

Megill, David W., and Paul O. W. Tanner. *Jazz Issues: A Critical History*. Madison, WI: Brown and Benchmark, 1995.

Megill, Donald, and Richard S. Demory. *Introduction to Jazz History*, 4th ed. Upper Saddle River, NJ: Prentice Hall, 1996.

Moody, Bill. *The Jazz Exiles: American Musicians Abroad*. Reno: University of Nevada Press, 1993.

Piazza, Tom. *Blues Up and Down: Jazz in Our Time*. New York: St. Martin's Press, 1997.

Nicholson, Stuart. *Jazz Rock: A History*. New York: Schirmer Books, 1998.

Rosenthal, David H. *Hard Bop: Jazz and Black Music, 1955–1965*. New York: Oxford University Press, 1992.

Shapiro, Nat, and Nat Hentoff. *Hear Me Talkin' To Ya*. New York: Dover Publications, 1955.

Sharp, David; Randall Snyder; and Jon J. Hischke. *An Outline History of American Jazz*. Dubuque, IA: Kendall/Hunt Publishing Co., 1998.

Smith, Joe. *Off The Record: An Oral History of Popular Music*. New York: Warner Books Inc., 1988.

Tucker, Mark. *Ellington: The Early Years*. Urbana, IL: University of Illinois Press, 1995.

Waldo, Terry. *This Is Ragtime*. New York: Hawthorn Books, 1976.

Walser, Robert, ed. *Keeping Time: Readings in Jazz History*. New York: Oxford University Press, 1999.

Yurochko, Bob. *A Short History of Jazz*. Chicago: Nelson-Hall Publishers, 1993.

Zwerin, Mike. *La Tristesse de Saint Louis: Swing under the Nazis*. London: Quartet Books, 1985.

Recording Liner Notes

Benny Goodman: Live at Carnegie Hall. Columbia, G2K 40244.

Benny Goodman: On the Air (1937–1938). Columbia, C2K 48836.

Birth of the Cool. Miles Davis. Capitol Jazz, CDP 7 92862 2.

Bitches Brew. Miles Davis. Columbia, G2K 40577.

Bix Beiderbecke, Volume 1, Singin' The Blues. Columbia, CK 45450.

Ellington Indigos. Duke Ellington Orchestra. CBS (Columbia), CK 44444.

Blackbird. Siri's Svale Band. Sonor, SON CD 2001.

Video

Burns, Ken. *Jazz: A Film by Ken Burns*. Washington DC: PBS, 2001.

Giddins, Gary. *Satchmo*. New York: CBS Music Video Enterprises, 1989.

Giddins, Gary. *Celebrating Bird: The Triumph of Charlie Parker*. Long Beach, CA: Pioneer Entertainment, 1999.

World Wide Web Sources

"Tony Bennett, Playin' With My Friends: Bennett Sings the Blues." http://www.tonybennett.net/bio.html (May 20, 2002).

"Ray Charles, Performer," *Rock and Roll Hall of Fame and Museum*. http://www.rockhall.com/hof/inductee.asp?id=76 (May 20, 2002).

"Ray Charles, Biography," *Ray Charles Official Website*. http://www.raycharles.com/bio.htm (May 20, 2002).

"Space Age Musicmaker, George Shearing," *Space Age Pop Music*. http://www.spaceagepop.com/shearing.htm (May 20, 2002)

"Maynard Ferguson, Trumpet Player, bandleader," *Contemporary Musicians*, vol. 7. www.maynard.ferguson.net/bio2.html (May 20, 2002).

Berg, Chuck. "Clark Terry," *Riverwalk*. http://www.riverwalk.org/profiles/terry.htm (May 20, 2002).

"Space Age Musicmaker, Kai Winding," *Space Age Pop Music*. http://www.spaceagepop.com/winding.htm (May 20, 2002)

Winding, Kai. "Letter to Maynard Ferguson." www.store6.yimg.com/l/jukejoint_1668_19914822 (April 3, 2002).

Coleman, Brian. "Read the Bio.," *Official Sex Mob Website*. http://www.sexmob.com/mob.html# (May 20, 2002).

"Jane Ira Bloom, Soprano Saxophonist/Composer," *Jane Ira Bloom Official Website*. http://www.janeirabloom.com/bio.html (May 20, 2002).

"Chick Corea: The Offical Website of Pianist, Composer & Recording Artist Chick Corea." http://www.chickcorea.com/ (May 20, 2002).

Various. "Archives," *Downbeat*. http://www.downbeat.com/default.asp?sect=archives (May 20, 2002).

Index

C